Early
Medieval
Art

Early Medieval Art

CAROLINGIAN · OTTONIAN · ROMANESQUE

John Beckwith

THAMES AND HUDSON
LONDON

© 1964, 1969 AND 1974 THAMES AND HUDSON LTD LONDON

SECOND REPRINTING 1974

Printed and bound in Singapore

ISBN *0 500 18033 4 hardcover*
ISBN *0 500 20019 x paperback*

Contents

Acknowledgements

Among the many friends and colleagues who have helped me in the course of writing this book I should like to offer special thanks to Dr Michael Kauffmann, Dr Peter Kidson, Dr Florentine Mütherich, Professor Dr Otto Pächt, M. Jean Porcher, Professor Dr Hermann Schnitzler, Dr Hanns Swarzenski, Professor Francis Wormald, and Dr George Zarnecki.

For photographs, in some cases permission to publish, and for help in various ways I am grateful to Dr Vinzenz Oberhammer, Director, Dr Hermann Fillitz, Kunsthistorisches Museum, Vienna; the Archives Photographiques A.C.L., Brussels; the Director of the Curtius Museum, Liège; the Librarian of Corpus Christi College, Cambridge; the Trustees of the British Museum, Mr Peter Lasko, Department of British and Medieval Antiquities, and Mr Derek Turner, Department of Manuscripts, British Museum; the Victoria and Albert Museum; the staff of the Warburg Institute, London; Dr Richard Hunt, Bodleian Library, Oxford; the Librarian of Winchester Cathedral; M. Gérard Jasserme and M. M. Rossigneaux, Bibliothèque d'Autun; the Director of the Musée Condé, Chantilly; the Director of the Musée Ochier, Cluny; the Librarian of the Bibliothèque de la Ville, Dijon; the Librarian of the Bibliothèque de la Ville, Épernay; the Conservateur-en-chef, Département des Manuscrits, Bibliothèque Nationale, M. Francis Salet, Director, Musée de Cluny, M. Pierre Verlet, Musée du Louvre, Paris; the Director of the Musée des Augustins, Toulouse; Domvikar Dr Erich Stephany and Herrn Ludwig Falkenstein, Cathedral Treasury, Aachen; the Librarian, Staatliche Bibliothek, Bamberg; Professor Dr Hans Lülfing, Abteilungsdirektor, Deutsche Staatsbibliothek, Dr Victor Elbern and Dr Werner César, Stiftung Preussischer Kulturbesitz, Staatliche Museen, Berlin; the Librarian of the Stadtbibliothek, Bremen; the Librarian of the Landesbibliothek, Darmstadt; the Domvikar, Cathedral Treasury, and Dr Heinrich May, Essen; the Domvikar of the Cathedral Treasury, Hildesheim; Dr H. Reber, Altertumsmuseum und Gemäldegalerie, Mainz; Bildarchiv Foto-Marburg, Marburg an der Lahn; Dr Luisa Hager, Bayerische Verwaltung der staatlichen Schlösser, Gärten und Seen, Schloss Nymphenburg; Dr W. Hörmann, Bayerische Staatsbibliothek, Munich; the Director of the Landesmuseum, Münster; Dr Erich Steingräber, Director, and Dr Peter Strieder, Germanisches National-Museum, Nürnberg; the Librarian of the Stadtbibliothek, Trier; the Custodian of the Treasury of St Servatius, Maastricht; Dr Antonio Brasini, Biblioteca Piana, Cesena; the Librarian of the Biblioteca Comunale, Mantua; the Librarian at Cividale; Dr Gianguido Belloni, Museo del Castello

Sforzesco, and the Custodian of the Cathedral Treasury, Milan; the Custodian of the Cathedral Treasury, Monza; Dr Carlo Bertelli, the clergy of the Basilica of San Paolo fuori le Mura, and Mgr Anselmo Albareda, Prefetto della Biblioteca Apostolica Vaticana, Rome; the Curator of the Batthyáneum, Alba Julia; the Custodian of the Cathedral Treasury, Burgo de Osma; the Librarian of the Escorial, Madrid; Dr H. Lanz, Historisches Museum, Basle; Dr Christian von Steiger, Burgerbibliothek, Bern; Dr K. Renggli, Stiftsbibliothek, St. Gallen; the Director of the Schweizerisches Landesmuseum, Zurich; Mr James J. Rorimer, Director, and Mrs Vera K. Ostoia, the Metropolitan Museum, New York; Mr John Plummer, the Pierpont Morgan Library.

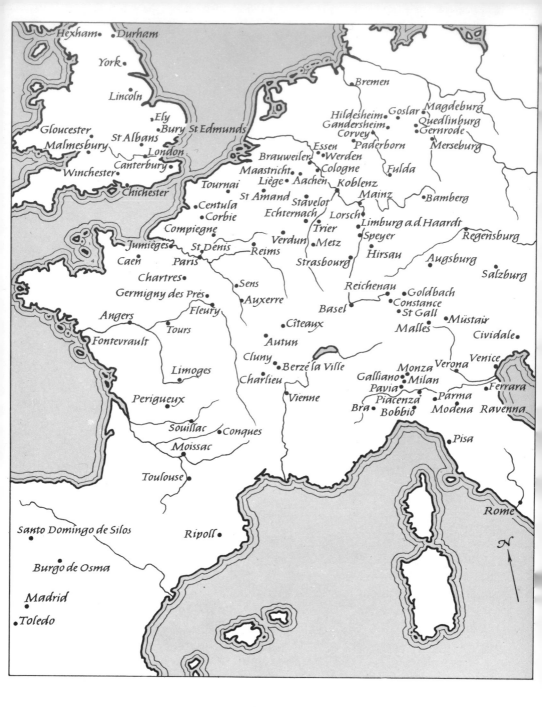

Introduction

Opinions differ over the beginning of the Middle Ages. Some suggest the years 312–313 when the Emperor Constantine the Great recognized Christianity as the official religion of the Roman Empire. Others prefer the year 476 when the last Roman Emperor of the West abdicated before Odovacar the Ostrogoth. Most accept, however, Christmas Day in the year 800 when Charles, King of the Franks, was crowned Emperor by Pope Leo III at Rome. The intention was to recreate the old peace of Rome, but instead the concept of a young Europe had stolen unobserved into history.

By the year 800 more than three centuries of barbarian invasions had obscured the serene and prosperous peace of the Roman Empire. Islam, Christianity's most serious rival, had swept victoriously from the Arabian desert to the Straits of Gibraltar and the walls of Constantinople. Indeed, the victory of the Franks over the armies of Islam at Poitiers in 732 stemmed the dangerous tide which threatened to engulf the West, and encouraged the Frankish leaders to think of themselves as the new people chosen by God. The hallowed tribe of the Bible became the pattern for the Frankish tribe which was to shape the face of Europe. The Frankish king began to represent a new type of ruler modelled on David, and like David he was the Anointed of God. He was, in fact, anointed by the Pope, and the Papacy, by agreeing to this action, could already assert its spiritual authority over the temporal power. The coronation of Charlemagne began a struggle for power lasting several centuries, dominating early medieval history. Charlemagne himself was annoyed by the action of Pope Leo III. He said that if he had known the intentions of the Pope he would not have entered the church however holy the day. It is reasonably clear that he had foreseen the danger and wished to crown himself. He had strong views about the position of the Church which he considered subordinate to the imperial command.

There were other disadvantages. Charlemagne's empire was an unwieldy continental structure, deprived of the Mediterranean Sea, thinly populated, semi-barbarous, unaccustomed to the rule of law. After little more than two generations the Empire dissolved almost of its own accord. However autocratic, responsible and wise, Charlemagne and his successors could never lay claim to the mystique of the Byzantine Emperors, to the intellectual and political traditions of the Great Palace at Constantinople, to the stability of the Byzantine civil service, the army and the fleet which could maintain order on the occasions when the Emperor seemed incapable of fulfilling his destiny. In the Byzantine sense of the words, there was no army in the West, no fleet, and the civil service, such as it was, had to be drawn from the higher secular clergy and the monasteries. In the last respect the Pope was better off than the Frankish Emperors. Until late in the reign of Charlemagne there was not even a fixed capital of the realm. It is significant that, when the time came, the capital was no longer Rome but a small town near the Rhine.

The Revival of the Imperial Tradition

After 794 the old Merovingian custom of continual royal progress through the land was for a time abandoned. Charlemagne made Aachen his chief and permanent place of residence. He, too, would have a 'sacred palace' like the *sacrum palatium* at Constantinople, but it was only fitting that the 'new Constantine', as Charlemagne liked to see himself in opposition to the woman who was ruling the Eastern Empire[1], should also refer to Rome. Aachen was to become *Roma Secunda*[2]. Since the Lateran, according to tradition, had been the palace of Constantine the Great given by him to the Church, the palace of Charlemagne was called the 'Lateran'[3]. In the vestibule of the palace chapel a bronze she-wolf (in fact, it was more like a bear) echoed the Capitoline wolf preserved throughout the Middle Ages in the Lateran. An equestrian statue, probably that of Theodoric, possibly that of the Emperor Zeno (474–491), brought from Ravenna, was set up in the colonnaded forecourt of the palace as a parallel to the bronze image of Marcus Aurelius, now on the Capitol, but in the Middle Ages housed in the Lateran, because it was believed to represent the first Christian emperor[4].

It may be presumed that Charlemagne's architects had studied previous buildings at Rome, Ravenna, Milan, and Trier, perhaps even in England[5], but it is probable that the idea behind the palace-chapel at Aachen was formed by the Chrysotriclinion built by the Emperor Justin II (565–578) as a hall of state within the precincts of the Great Palace at Constantinople. The building (it has not survived) was octagonal in plan with niches opening from the sides, richly decorated with mosaics including a representation of Christ enthroned set above the golden throne of the Emperor. Charlemagne's chapel (*Ill. 1*), designed by Odo of Metz and dedicated to the Saviour and the Virgin possibly by Pope Leo III in 805, is basically a central octagon surrounded by an ambulatory and is usually

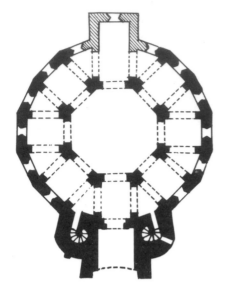

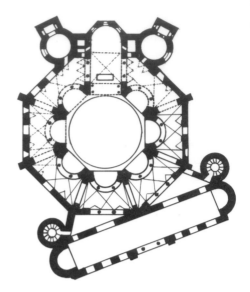

1 Plan of the palace chapel of Charlemagne, Aachen; late eighth century

2 Plan of San Vitale, Ravenna; consecrated in 547

compared to the Church of San Vitale at Ravenna (*Ill. 2*), but the subtle curves and the clear, floating wells of space in the sixth-century church (or, no doubt, of the hall of state at Constantinople) are lost in the Carolingian version (*Ill. 3, 4*). Stocky, angular piers have been substituted for columns on the ground floor; the Byzantine technique of light brick vault construction was replaced by heavy tunnel and groin vaults. Entrance was made from a forecourt with galleries on two levels through a sombre westwork flanked by circular staircases. The large niche in the centre of the westwork (*Ill. 5*) recalls the Palace of the Exarchs at Ravenna (*Ill. 6*), and has been compared to a gateway in a Roman *castellum* but the façade of the Carolingian structure is essentially northern, medieval and unclassical. Roman ruins were demolished to provide the necessary stone, and material of various kinds was transferred from Ravenna[6]. As in the Chrysotriclinion at Constantinople the imperial cult was stressed. Inside the cupola over the octagon, mosaics represented Christ enthroned among the four Evangelical symbols and twenty-four elders (*Apocalypse*, iv) and the imperial throne was placed below[7]. There

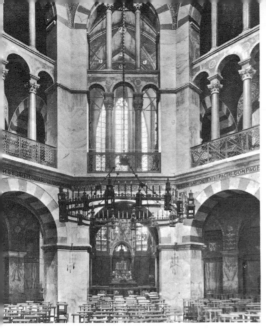

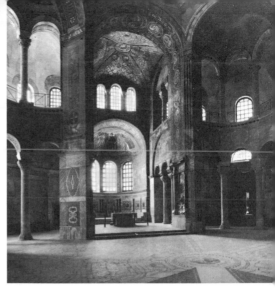

3 (*above left*) Interior of the palace chapel, Aachen; late eighth century

4 (*above right*) Interior of San Vitale, Ravenna; consecrated in 547

5 (*below left*) Westwork of the palace chapel, Aachen; late eighth century

6 (*below right*) Façade of the Palace of the Exarchs, Ravenna; sixth century

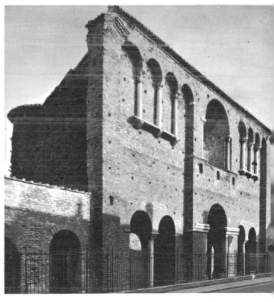

were, in fact, differences of interpretation. The Chrysotriclinion was essentially a secular building with strong religious overtones; the building at Aachen was a court chapel with a religious function from the start and as such was a specifically Carolingian creation[8]. In the Chrysotriclinion the imperial throne stood in the eastern apse in place of the altar and the Emperor was adored as Vicar of God. Charlemagne did not agree with this aspect of the imperial cult, nor did he adopt the intricate, hieratic ceremonial of the Byzantine court. He rendered unto God the things that were God's and he set his throne in the tribune over the west door.

An early source states that the little oratory at Germigny-des-Prés, part of a villa built by Theodulf, Bishop of Orleans and Abbot of Saint-Benoît-sur-Loire (Fleury), one of the most distinguished figures at Charlemagne's court, nicknamed 'Pindar' in the court circle, was an imitation of the chapel at Aachen[9]. Apart from the general characteristic of a central plan and the fact that the oratory was a dependency of the villa just as the chapel was an adjunct of the palace, the similarity is hard to detect. Theodulf's oratory (*Ill. 7, 8*) consists of nine vaulted compartments, the vaults supported by four piers in the middle of the building over which was probably a square tower; there were apses on three sides and a triple apse at the east end. Both the plan and the elevation of the building, which includes

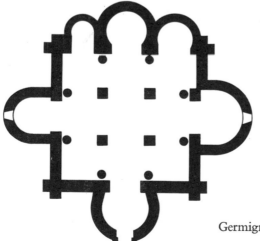

7 Plan of Theodulf's oratory, Germigny-des-Prés; consecrated in 806

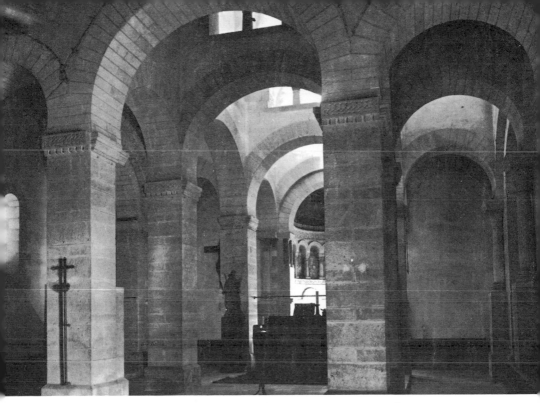

8 Interior of Theodulf's oratory, Germigny-des-Prés; consecrated in 806

horse-shoe arches, were inspired by Visigothic architecture[9]. The fragments of stucco and stone decoration, now in the Museum at Orleans, also suggest Visigothic influence. Since Theodulf was a Septimanian Visigoth, who wrote verse about the garden of the Hesperides, Galicia and Cordoba, who thought quite naturally of Prudentius as a poet of his own country, who had a keen eye for works of art, Visigothic elements are perhaps to be expected in a villa built for his private retreat. At the same time, both stucco and mosaic decoration look to the East (*Ill. 9*). As far as may be judged after three stages of inept restoration, undertaken in the nineteenth century, the large angels on either side of the Ark of the Covenant in the eastern apse have a Byzantine flavour in the treatment of face and hair, although this flavour could well have been drawn from Italy, particularly Rome, at this time. The remains of large palmettes on a

15

stem in the arches below, hark back to the mosaic decoration carried out after the rise of Islam for the Umayyad dynasty, with Byzantine assistance, in the Dome of the Rock at Jerusalem in 691. Indeed, it has been suggested that the entire scheme of decoration reflects a passage in the *Libri Carolini*, I, c. 20, commenting on the Book of Kings, I, vi. 19, which refers to Solomon's decoration of the Temple. The Biblical description is borne out by the stance and attitude of the smaller pair of angels, while the larger conform in every detail to the description of the cherubim of Solomon's Temple. It should be remembered that the Ark of the Covenant was the sole decoration in the earliest Jewish Bibles preserved, dating from the tenth century, and that the Bibles which Theodulf had copied at Fleury were influenced by Spanish Jewish Bibles[12]. Whether Theodulf or Alcuin was the author of the *Libri Carolini* – the Carolingian protest against the decrees of the Council of Nicaea (787) – it is clear that the mosaic decoration at Germigny-des-Prés represents a form of Iconoclast art which seems largely Jewish in inspiration. An inscription in verse below the Ark states that Theodulf was responsible for the work, which can hardly have been begun before he was Abbot of Fleury in 799 or 802 and may have been completed for the consecration in 806. Theodulf was disgraced after a palace intrigue in 818; although he protested his innocence, his property was sequestrated and he died two years later in prison at Angers. Unfortunately, as a result of the barbarous restoration of 1867–1876, carried out in spite of protests from the Société française d'Archéologie, one of the most important monuments of Carolingian eclecticism has been transformed into an 'inaccurate modern counterfeit'[13]. Nothing remains of the villa, which was burnt down in the course of Norman raids in the third quarter of the ninth century, but we know that Theodulf had a 'gallery' of paintings and that there were frescoes depicting the seven liberal arts, the four seasons, and a map of the world[14].

In Frankish eyes the Abbey of Saint-Denis was of greater importance than the palace chapel at Aachen. The abbey had been richly endowed by the Merovingian kings whose pantheon it was. A new church was begun under Pepin, probably after 754, and was con-

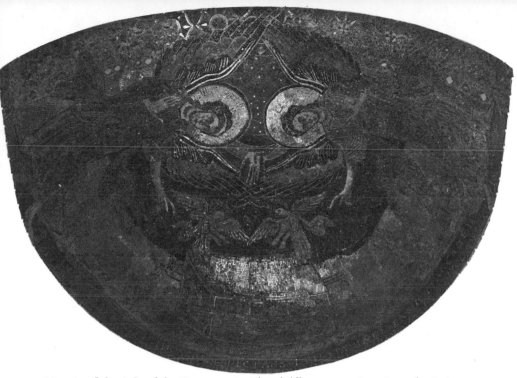

9 Mosaic of the Ark of the Covenant in Theodulf's oratory, Germigny-des-Prés.
Early ninth century

secrated in the presence of Charlemagne in 775. The position of the
Carolingian abbots as advisers and ambassadors of the King increased
the prestige of the abbey, which contained a hundred and fifty monks
by the time of Charles the Bald in 862. Provision for this number
was probably made when the new church was built; it entailed either
the construction of a large choir, which would have been unusual at
this time, or of a nave sufficiently long to accommodate the stalls of
the monks and to provide space for members of the parish and many
pilgrims. For the church was also a shrine. A chapel to contain num-
erous relics was added at the east end in 832 by Abbot Hilduin
who did much to publicize the abbey. The plan of the church
(*Ill. 10*) was that of a three-aisled Roman basilica with the addition
of two towers on the west façade – one of the earliest in the West,
although it has been claimed that this type of west end existed in
France under East Mediterranean influence before the ninth century.

The only portion of this church above the ground today is the lower part of the exterior walls of the eastern end of the building, and scarcely a single stone has escaped the attentions of the nineteenth-century restorer[15].

Saint-Denis was not the only Carolingian church to be built 'romano more'. Under Abbot Rutger the church of Fulda was rebuilt with the deliberate intention of making north of the Alps a replica of St Peter's Basilica in Rome (*Ill. 11*). The relics of St Boniface, who had founded the first church in 742, had been brought to the monastery and to give them a worthy setting a transept and apse were built west of the nave similar to the western transept of St Peter's; for it was meet and just that the tomb of the Apostle to the German peoples should be modelled on the tomb of the Prince of the Apostles. The church was begun about 802 and was dedicated in 819 in spite of a petition to Charlemagne in 812 from the monks begging him to stop the abbot from continuing 'the enormous and superfluous buildings and all that other nonsense (*inutilia opera*) by which the brethren are unduly tired and the serfs are ruined'. Unfortunately, the present church, now the Cathedral of Fulda, is an early eighteenth-century construction; yet the aspect of the Carolingian structure and of a few tenth-century additions have been established beyound doubt through excavations[16].

The church of the monastery of Centula (Saint-Riquier), near Abbeville, has been heralded as 'the most characteristically Northern and energetic of the church designs'. The work was begun about 790 by Abbot Angilbert, nicknamed 'Homer' in the court circle and the declared lover of one of Charlemagne's daughters. The building was placed under Charlemagne's patronage; bases, columns and mouldings were brought from Rome; no expense was spared. The plan (*Ill. 12*) appears to have been cruciform with a second transept at the west end; the apse projected from the eastern transept; above each crossing there was a round or octagonal tower (*Ill. 14*), probably in wood, with open arcaded stages, each stage set back from the face of the stage below – the whole effect being one of tapering lightness and elegance quite different from the massive stone towers of the eleventh and twelfth centuries. Flanking the presbytery at the

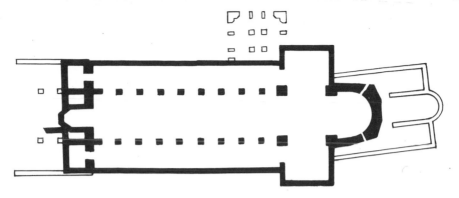

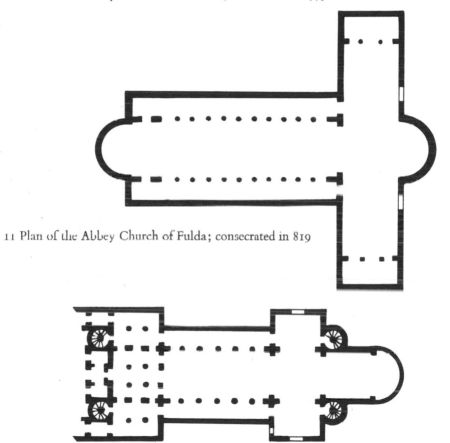

10 Plan of the Abbey Church of St Denis; consecrated in 775

11 Plan of the Abbey Church of Fulda; consecrated in 819

12 Plan of the Abbey Church of Centula (Saint-Riquier); begun about 790

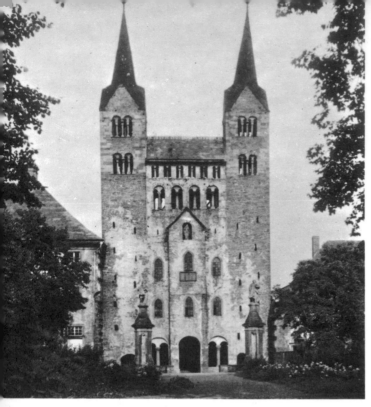

13 Exterior of the west-
work of the Abbey
Church at Corvey;
873–885

14 (*opposite*) View of
the exterior of the Ab-
bey Church of Centula
(Saint-Riquier) from a
seventeenth-century
engraving

west end, two round towers contained spiral stairs and dominated an
open forecourt with roofed galleries. The church was six bays long
with side aisles and a clerestory containing large round-headed win-
dows. It was rebuilt about 1090 and subsequently destroyed. The
plan of this great undertaking has been deduced from contempo-
rary sources and from reproductions of a drawing (*Ill. 13*) made
before the rebuilding at the end of the eleventh century. It seems
clear, amid a good deal of visionary reconstruction, that Centula
epitomized certain general principles of Carolingian architecture:
the forecourt with covered galleries, the double transept, repeated at
Cologne, the large round-headed windows, the importance of the
west work, which contained a low, probably vaulted hall and a
raised gallery used as a chapel above[17]. An example of a Carolingian
west work is still to be found at the abbey church of Corvey on the
Weser (*Ill. 13*), founded from Corbie in north-east France and built
between 873 and 885[18]. Most of these features were to persist for

ECCLESIAR·AB·ANGILBERTO·APVD·CENTVLAM·AN·DCC·XCIX
CONSTRVCTARVM·E·SCRIPTO·CODICE·EKMATEION

S·RICHARIVS

S·BENEDICTVS

S·MARIA

15 Plan of Cologne Cathedral; ninth century

several centuries in the Rhineland. But a feature not predicated by Centula was an apse at both ends of the church, frequently to be found in Carolingian churches. A manuscript plan (*Ill. 16*), dating from about 820, in the Library of St Gall outlines not only this form but the extent of a monastic complex in the Carolingian period. The plan was sent by a member of the court circle to the Abbot of St Gall as an ideal scheme for rebuilding the whole monastery[19]. The ground plan of the church is not dissimilar from that revealed by recent excavations at Cologne Cathedral (*Ill. 15*)[20].

The upper layer of crypt in the Church of Saint-Germain at Auxerre, begun in 851 by Conrad, Count of Auxerre and maternal uncle of the Emperor Charles the Bald, was finished presumably in time for the translation of the relics of St Germain in 859. It is probable that the frescoes which still survive in the upper crypt were also finished before 859, although 865, the year of the consecration, should also be borne in mind. It is equally possible that not all the surviving paintings were made at the same time. Those in the small side-chapel dedicated to St Stephen, executed in colours of red and yellow ochre,

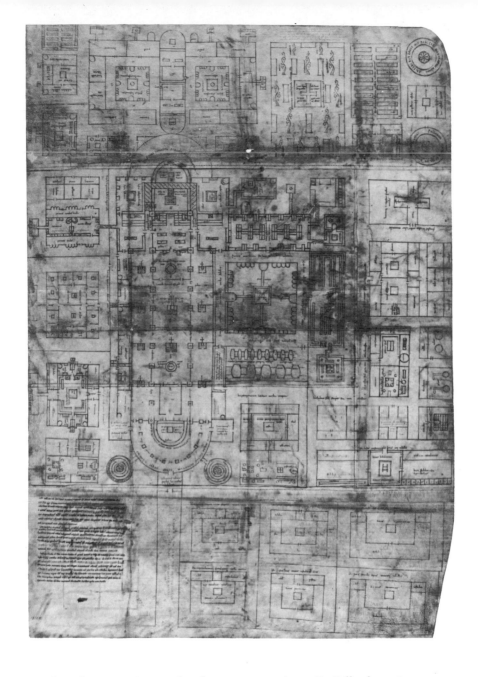

16 Plan of a monastic complex from a manuscript at St Gall; about 820

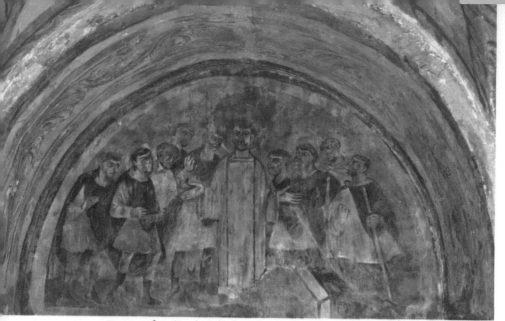

17 Fresco of St Stephen before the Sanhedrin preparing to fall on him, in the upper crypt of the Church of St Germain, Auxerre; probably about 859

white and greyish green, consist of three scenes from the life of the Saint: his judgment before the High Priest, the members of the Sanhedrin preparing to fall upon him, and his martyrdom (*Ill. 17*). The frescoes have been compared to manuscripts executed for Charles the Bald and have therefore been dated between 870 and 877, but the comparison between frescoes and manuscripts is of a rather general kind and does not establish a firm date. A comparison with mosaics and frescoes in Rome suggests possible models; frescoes in the catacomb of Hermes dating from the second half of the fourth century, in the catacomb of Domitilla dating from the first half of the fourth century and mosaics in Santa Maria Maggiore, where the stoning of Moses, Joshua and Kalet might well have been studied by the northern artist[21].

The most important of the diverse and fragmentary fresco cycles surviving from the Carolingian period is to be in found the Church of St John the Baptist at Müstair in the Grisons[22]. The church is believed to have been founded about 780–790, and a monastery is first mentioned in a document dated 805. In the nave, those Old Testament scenes which survive, arranged in five tiers, and a number

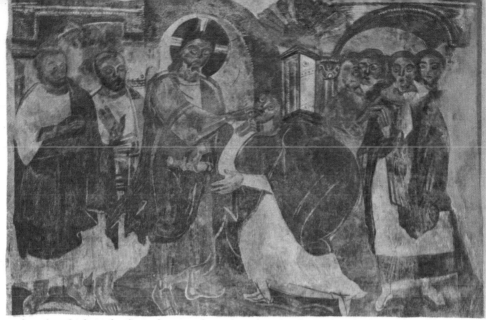

18 Fresco of Christ healing the Dumb in the Church of St John the Baptist, Müstair; early ninth century

of Gospel scenes make abundantly clear the wealth of decoration once to be found in ninth-century churches. The Last Judgment on the west wall is the earliest known in that position. But it should be stressed that the style of these frescoes is not Carolingian in the sense of issue or influence from the court workshops, or their dependencies. The frescoes of Müstair (*Ill. 18*) echo traditions maintained by Roman artists exemplified by their work at Santa Maria Antiqua, in the lower church of San Clemente, and in San Vincenzo al Volturno[23]. The characteristics of this style may be recognized by a rather reduced architectural background, a curious mannerism in the figure-style, in which the proportions from shoulder to hip are equal to those from hip to foot, alternatively in crouching or seated figures, the thigh is unusually elongated, and in the broadly treated, widely spaced folds of drapery[24]. The frescoes at Müstair are complemented by another cycle, painted probably before 881 in the little oratory of San Benedetto at Malles in the Italian Tirol, near Bolzano, which was a dependency of Müstair. In the apses, a standing Christ, St Stephen and St Gregory the Great; on the narrow panels between the apses, two portraits of donors, a nobleman and a priest holding

25

a model of a chapel (*Ill. 19*); on the north wall, scenes from the life
of St Gregory and of other martyrs again echo Roman traditions.
The position of the portraits follows a practice current in Rome and,
although the portrait has been described as 'the finest portrait of the
Carolingian era', the figure has little to do with the art of the court[25].
On the other hand, a series of frescoes in the crypt of St Maximin
at Trier approaches more closely the style of contemporary manu-
scripts and sculpture in the North[26]. The sanctuary, already of con-
siderable age, was devastated by the Normans in 882 but, in the
course of rebuilding under Abbot Ogo about 933, the crypt was left
untouched and was even partially walled in. The frescoes in the
crypt, therefore, almost certainly date to the years immediately
following the Norse raid. Against the back wall above a stone altar
there is a representation of the Crucifixion in which the figure of
St John the Evangelist (*Ill. 20*) reflects in physiognomy, treatment
of drapery and elongation of form, manuscripts and ivory carvings
(*Ill. 57*) executed at Metz about the year 900.

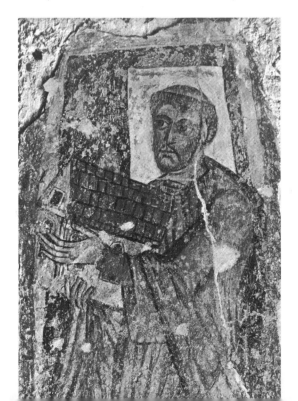

19 Fresco of a priestly
donor in the Oratory
of San Benedetto, at
Malles; before 881

20 Fresco of St John the Evangelist from a representation of the Crucifixion in the crypt of the Abbey Church of St Maximin, Trier; late ninth century

Although much has been done in the course of this century to clarify the ground plans of Carolingian churches and other buildings, and discoveries of wall-painting continue to be made[27], the fact remains that the particular contribution of the Carolingian period to European civilization rests on the evidence of literature and the so-called minor arts of manuscript illumination, ivory carving and goldsmiths' work. It seemed obvious to Charlemagne that the Church should be a pattern of life for the rest of Christendom, but it was equally clear to him that the bishops and clergy must possess the education and intelligence which alone could fit them for the service of God and the empire. Charlemagne himself had received education of a sort at his father's court school. He could say his prayers in Latin, read a little Greek and, like most royalty, he was ready to be informed on any subject. He cared to have scholars about him and he knew that they were not to be found among his own people. The ignorance and illiteracy of the Frankish clergy disturbed him. European civilization owes much to Charlemagne's awareness of the need for education, its urgency, the size of the problem and

the manner of its solution. Teachers were summoned from Anglo-Saxon, Irish, Lombard and Spanish schools to form a literary circle closely attached to the royal school which moved about with the court. Not only Charlemagne's children but the sons of the Frankish noblemen were made to attend, and Charlemagne himself, late in life and after many years of warfare, took lessons in grammar from Peter of Pisa and in the other arts from Alcuin of York.

During the eighth century a great library had been collected at York, attached to the cathedral school, containing a large number of patristic texts and a representative selection of the classics. Alcuin was the most distinguished master of the school of York. In his long poem on the saints of the city, Alcuin outlines the curriculum which included grammar, rhetoric, law, poetry, astronomy, natural history, arithmetic, geometry, the methods of calculating the date of Easter, and the study of the Scriptures. Of all the pagan poets Virgil was the most studied by Alcuin, but he was also familiar with Ovid, though not apparently with Horace. He laid equal stress on the importance of Christian Latin literature and, like Bede, admitted the great religious authors to an equality with the pagan. This attitude was in contrast with that of St Jerome in the late fourth century, who feared that his admiration for the writers of classical antiquity would cost him his salvation. At the same time it would be a mistake to regard the tastes of the Carolingian *literati* as antiquarian. Such humanist studies as there were turned inevitably towards theological ends. Christian Latin and some Greek literature formed the real base of the Carolingian revival. The writings and personalities of pagan authors were frequently re-interpreted so as to make them acceptable to the ninth-century ecclesiastic, who could see the universe only from a Christian point of view. Charlemagne, after all, was not interested in education for education's sake; he wanted trained officials for the proper governing of the empire. Nor, at first, was there any suggestion of religious reform or a high moral tone; most of Charlemagne's scholars were not priests, the standards of morality at the court would in a more censorious age be regarded as lax, and the religious reforms of St Benedict of Aniane were not to occur until the next generation [28]. Nevertheless, the atmosphere of the court

circle was by no means unsophisticated. Einhard, the biographer of Charlemagne and one of his architects, had read Suetonius with such care that he was able to reproduce quite faithfully the Roman historian's general manner even to his disregard of probability or of truth. Theodulf of Orleans admitted that beneath the frivolity of their fables, the classical poets established many truths[29]. The author of the *Libri Carolini* maintained that the value of an image was determined by the success of the artist in fulfilling his intention and by the adaptability and intrinsic worth of the materials he had used, with perhaps the added consideration, in the case of a figure bequeathed by antiquity, of how well it had withstood the ravages of time. The same author alluded to the difficulty of identifying the subjects of antique art; it is commonly assumed, he continued, that a beautiful woman with an infant in her arms represents the Virgin and Child, but how is even an artist to be sure that the two were not originally intended as Venus and Aeneas?[30] The so-called Carolingian renascence of the arts and literature was not a revival of the forms and standards of Antiquity; it was an attempt to recreate what was believed to have been the golden age of early Christian Rome. Contemporaries called it a *renovatio*: a renewal rather than a revival, a series of improvements in art, literature, calligraphy, liturgy, administration, and so on[31]. In a sense, Carolingian art grew out of nothing. Aachen, Reims, Metz, Tours, all these centres drew life from the court which was a personal creation of Charlemagne and his successors. Charlemagne is the Jesse from which springs the tree of medieval civilization[32].

One of the chief tasks before Alcuin and his colleagues was the multiplication of texts. The preservation of the greater part of the works of classical authors which has survived to modern times is the result of the industry of the Carolingian scribes writing in a new, reformed script at Tours, Fulda, Fleury and St Gall. Here, too, the contribution of the Irish was of considerable importance. Irish monasteries had been founded on the continent at Luxeuil in 590, at Bobbio in 613, and at St Gall in 614. It seems probable that the Irish monks took with them, and received later, a few Irish classical manuscripts but they sought codices in Italy and elsewhere. Bobbio, in

particular, became a storehouse of old books, and the books from collections such as these were sent to the mainspring of the intellectual movement which coursed under imperial direction[33]. When Charlemagne summoned representatives of Italian scholarship to his court, Peter of Pisa and Paul the Deacon brought with them a number of books from Italian sources. There seems little doubt that Theodulf of Orleans who, like Alcuin, has left a poem describing the contents of his own library, introduced from Spain to the court circle the works of Martial and Cyprian[34].

Even more important was the need for correct scriptural and liturgical texts. Alcuin was instructed to prepare a correct text of the Bible, a task on which Syrian and Greek 'counsellors' were still engaged when Charlemagne died. The building of new churches involved the presentation of new Gospel books, new collections of sermons, revised forms of Gregorian chant, and the means of knowing that the movable feasts of the Church were celebrated on the correct day. It was inevitable that the Frankish court, when in doubt, should turn to Rome. Pope Hadrian was asked for a copy of ecclesiastical law, for an 'authentic' Sacramentary of Pope Gregory the Great, and when these versions were supplied between 784 and 791, the copies all carried a certificate to the effect that they had been taken from the 'authentic' original. This cult for the 'authentic' is one of the chief characteristics of the Carolingian renewal. Where the decoration of Gospel books and psalters was concerned, there may equally be no doubt of the profound impression which the mosaics, frescoes, panel paintings and illuminated manuscripts in Rome must have made on the first generation of Carolingian artists[35]. It cannot be sufficiently stressed, however, that it was the comparatively recent art of Rome, not necessarily the art of antique and late antique Rome, which served first as a beacon of Mediterranean civilization to the northern barbarian. Thus, the miniature of Christ Blessing in the Evangelistary of Godescalc (Paris, Bibl. Nat., nouv. acq. lat. 1203, fol. 3 recto) (*Ill. 22*), commissioned by Charlemagne and his wife Hildegard in 781 and completed before the death of Hildegard in 783, reflects in its treatment of form, especially the elongation of the body between shoulders and hip, the style of

21 Icon of the Virgin crowned as Queen;
executed for Pope John VII (705–707)

the icon of the Virgin crowned as Queen, now in Santa Maria in
Trastevere, executed for Pope John VII (705–707) (*Ill. 21*), or paint-
ings in Santa Maria Antiqua dating from the middle of the eighth
century. Godescalc's Evangelistary was commissioned for particular
reasons: the commemoration of Charlemagne's visit to Rome for
Easter, 781, and the baptism of his son Pepin on Holy Saturday by
Pope Hadrian I, by which the succession to the power of ancient
Rome was already adumbrated[36]. The Evangelistary is written
throughout in letters of gold and silver on purple vellum – Godes-
calc emphasized in a poem that the golden letters signified the
splendour of heaven and of eternal life – but the style of the min-
iatures stands below the peaks of excellence which the later artists

22 Christ Blessing. The Evangelistary of Godescalc. Court School of Charlemagne; 781–783

of the court were to attain[37]. A comparison, for example, of the miniature depicting the Fountain of Life in the Godescalc Evangelistary (*Ill. 23*) with that in the Gospels of Saint-Médard-de-Soissons (*Ill. 24*), executed later in the reign, makes a clear distinction of quality, but by this time other influences had been brought to bear on the art of the court, including the metropolitan traditions of east Rome[38].

23 The Fountain of Life from Godescalc's Evangelistary. Palace School, Aachen, 781–783

24 The Fountain of Life from the Gospels of Saint-Médard-de-Soissons, Palace School, Aachen; early ninth century

The same stylistic principles may be seen in the ivory bookcovers carved with representations of King David and St Jerome (*Ill. 25*), now in the Louvre but originally encasing the Psalter written by Dagulf (Vienna, Nationalbibliothek, Ms 1861) and intended for presentation to Pope Hadrian I (772–795), where treatment of form, compact forms before spindly architectural backgrounds, echo aspects of the current Roman style[39]. In certain cases, of course, direct copying of earlier models may be detected. The ivory bookcover decorated with the figure of Christ Treading the Beasts and small scenes from the Life of Christ (*Ill. 26*), now in the Bodleian Library, Oxford, is a clear case of debt in a coarse style to a late antique model such as the ivory panels dating about 430 and now divided between Berlin, Paris and Nevers[40]. A diptych at Monza carved with representations of David and Pope Gregory the Great (*Ill. 27*) is also clearly based on a fifth- or sixth-century consular diptych, although the figures of David and Gregory have been transformed from hieratic epiphanies of earthly power into a scarcely major element in a decorative scheme[41]. The ivory bookcovers once binding the Lorsch

(opposite) Ivory bookcovers of Da-
...lf's Psalter showing David choosing
...e poets of the Psalms; David playing
...e harp; the priest Boniface opening
...e letter from Pope Damasus before
... Jerome who is asked to correct and
...lit the Psalms and St Jerome dictating
...e Psalter. Palace School, Aachen;
...fore 795

26 Ivory bookcover showing Christ
treading the Beasts and scenes from the
Life of Christ. Palace School, Aachen;
late eighth or early ninth century

27 Ivory diptych, prob-
ably from an Alpine
monastic school, show-
ing King David and
Pope Gregory the
Great; about 900

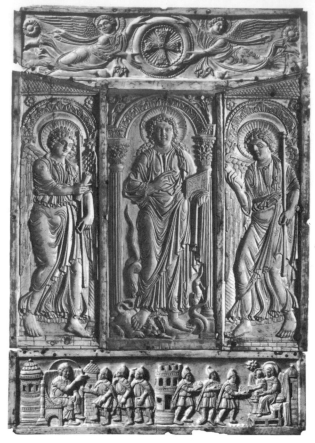

28 Ivory bookcover of the Lorsch Gospels showing Christ treading
the Beasts between Angels; below, the Magi before Herod and the
Adoration of the Magi. Early ninth century

Gospels, now divided between the Vatican and the Victoria and
Albert Museum (*Ill. 28, 29*), the largest and most splendid of the Car-
olingian period, are based almost certainly on an East Roman sacred
diptych which must have had much in common with that now in
Berlin, carved with representations of Christ and the Virgin and
Child enthroned, and with the style of Maximian's Chair at Ra-
venna[42], presented by the Emperor Justinian (527–565) to his Vice-
roy in 547. Such a diptych might well have been introduced to the
court by the 'strangers' responsible for the most beautiful and the
most 'Hellenistic' of all Carolingian manuscripts (*Ill. 30*). In all

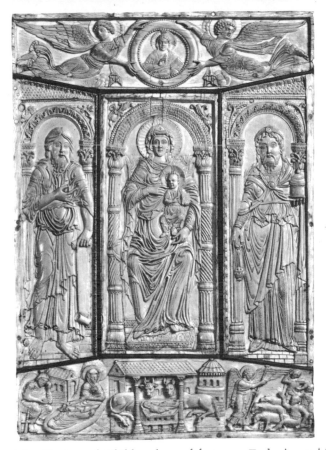

29 The Virgin and Child enthroned between Zacharias and St John the Baptist; below, the Nativity and the Annunciation to the Shepherds. Early ninth century

cases the models have been transformed. In Carolingian ivory carving the relationship of form to setting and of the drapery to the forms becomes a matter of ornamental pattern, the forms become diagrams rather than detailed notations of physical presence, and their relation to space involves an element of chance. The figures of the Virgin, Zacharias and St John the Baptist on the Lorsch bookcover are corporeal voids over which the drapery swirls and eddies in capricious abandon; these paradigms of form float against the architectural setting, poised before the spectator like a strangely abstract vision of heavenly beings.

If the Evangelistary of Godescalc and the ivory covers of Dagulf's Psalter represent the first phase in the Carolingian *renovatio*, by the time the court had settled at Aachen after 794, artists of a different category had been summoned to work for Charlemagne. Once more it is necessary to stress his personal initiative in this attraction of artists. These artists, their nationality is in some doubt, were responsible for a double series of particularly splendid manuscripts. The first has long been classified under the name Ada, since in the Gospel book at Trier a poem refers to '*mater Ada ancilla Dei*'. This lady is traditionally supposed to have been a sister of Charlemagne, although his only recorded sister happens to be Gisela and the name Ada was common enough in the valley of the Meuse and the Rhineland in the ninth and tenth centuries. The style of this series is based partly on Northumbrian models and partly direct imitation of late antique, possibly Roman models, although the influence of Constantinople cannot be ruled out. Technically this group is far in advance of the output of the Anglo-Saxon schools. The entire group was executed before, if not some time before, the death of Charlemagne in 814. The Gospel book, now at Abbeville, was probably a gift from Angilbert (*c.* 790–814) to his monastery at Centula, who died before Charlemagne[43]. The representation of St Mark in British Museum, Harley Ms 2788, is a portrait in the grand manner of the Evangelist (*Ill. 31*) seated in an apse framed by dark blue and white marble columns, rust-coloured Corinthian capitals and a triumphal arch set with gems copied from the antique. The massive, fleshy form, amply veiled in a gold tunic and a rust cloak, is poised rather than seated against a pink bolster on an altar-throne. The atmosphere of an imperial audience in the Chrysotriclinion of the Great Palace at Constantinople pervades the scene. But the ungainly posture of the feet on the stool and the curious twist of the hand dipping the pen into an inkstand placed uncomfortably high suggest that no naturalistic representation was intended. Just as the Gospel perched improbably on the Evangelist's knee is ritually displayed and the act of dipping the pen is no common calligraphic act, so too the Saint, whose face is that of a beautifully modelled mask of youth, offers one idea among four of an author divinely inspired. Yet such is the

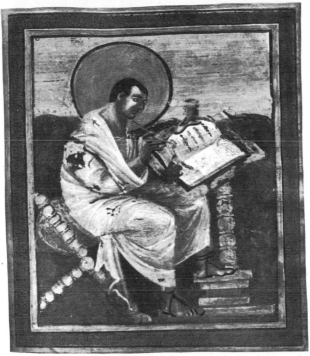

30 St Matthew from the Coronation Gospels of the Holy
Roman Empire, Palace School, Aachen; before 800

magnificence of the scene that the author might be imperial, as
though evoking a Theodosius or a Justinian composing a code of
law. The colours are never garish and even when light in key, have
a dulled texture; although gold is lavishly used in lettering, ornamen-
tation, in details of costume and outlines of drapery, unlike the court
sequence of Byzantine manuscripts in the tenth century, it is never
used as a background.

That there were Byzantine artists working at the court of Charle-
magne however, seems no longer in doubt. The evidence is supplied
by a second series of manuscripts, of which the most celebrated is the
Coronation Gospels at Vienna, said according to one tradition to
have been taken from the tomb of Charlemagne by Otto III during
the recognition of the year 1000, but a Gospel book still at Aachen,
is also of singular beauty (*Ill. 30, 33*). These manuscripts were
created in a full Hellenistic tradition, executed with superb crafts-
manship, and are inconceivable as the work of a northern artist,

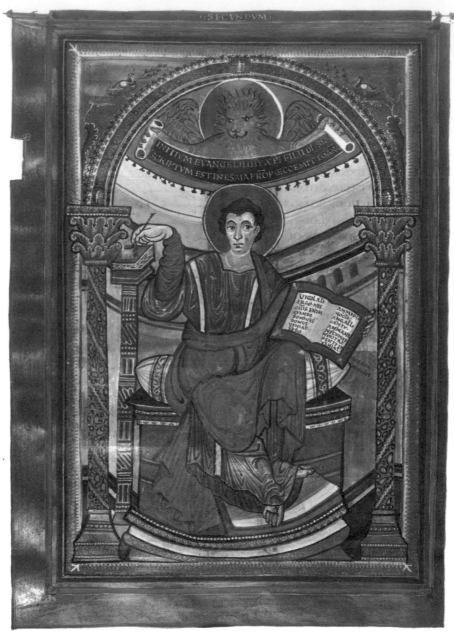

31 St Mark from a Gospel book, Palace School, Aachen;
early ninth century

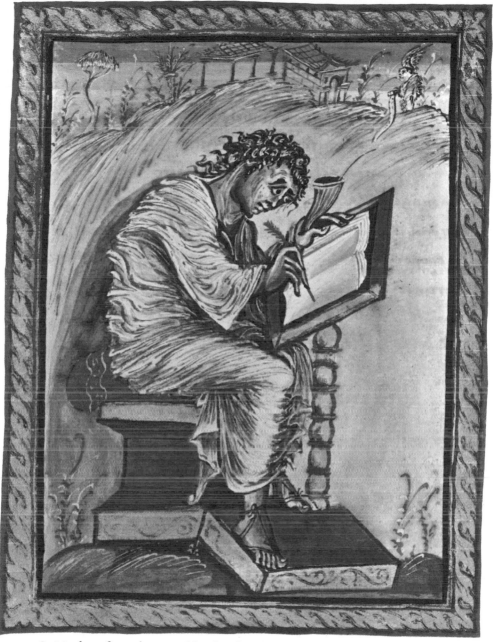

32 St Matthew from the Gospel book of Archbishop Ebbo of Reims, Hautvillers, near Reims; before 823

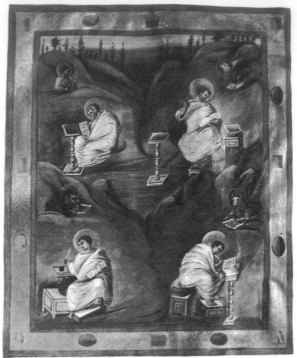

33 The Four Evangelists from a Gospel book, Palace School, Aachen;
early ninth century

even after profound and sensitive study of classical models, or of an
Italian artist of the late eighth century, since even at Rome, a dry
linearism and schematic forms were the rule[44]. Only an artist trained
in the atmosphere of 'perennial Hellenism', which we know to have
survived solely at Constantinople, could have produced such works.
And yet this second series is intimately connected with the first
series. Ornamental details, initials are closely paralleled, but the
palaeographical evidence, the arrangement of texts and canons, the
repetition of variants in the text of the Gospels, not only prove that
the two series must have been executed in the same place, but also
that the Coronation Gospels at Vienna must be related to the earlier
manuscripts of the Ada group and date, therefore, from the last
decade of the eighth century, while the other three manuscripts of
the second series are related to the later manuscripts of the Ada
group, particularly the Gospels of Saint-Médard-de-Soissons, and
must date from the first decade of the ninth century.

42

The representations of the Evangelists in the Vienna and Aachen Gospels differ in almost every respect from those of the Ada group. Whereas the Evangelists of the Ada group are revealed amid all the panoply of an imperial audience, those of the Vienna Gospels are seen composing their text in the open air and dressed in a simple toga. St Matthew (*Ill. 30*), for example, is here a vigorous young man – one might almost say, like a pugilist from the Hippodrome posing as an Evangelist – sitting with assurance on a stool, his feet firmly placed on the ground or on a pile of books at the base of his desk, his left hand firmly grasping an ink-horn and the side of a page; only the hand holding the pen is less satisfactorily drawn. In the modelling of form and drapery – note how the drapery catches against the thrust of knee and shin and how it is tucked under the right thigh – in the shimmering illusion of space, in the soft colours of white, blues, purples and greys, a living Hellenistic tradition is evoked, calm, serene, authoritative.

When this tradition was taken over a generation later at Reims, the new, and no doubt northern, artists began at once to inject into these calm forms a kind of palsy by which everything to do with the subject, space, landscape, evangelist, desk and pen quivers and vibrates[45]. This new development, a travesty of Hellenistic illusionism, took place under Ebbo, Archbishop of Reims (816–835). Ebbo was the son of a royal serf – someone at the time rather acidly observed that the Emperor had granted him freedom but not nobility, for that was impossible[46] – but before he became Archbishop he had been a prominent servant of the imperial house and he was later librarian to Louis the Pious. The dedicatory verses in his Gospels say that the book was made under the direction of Peter, Abbot of the monastery of Hautvillers, near Reims, to an order from Ebbo. Since the panegyric on the achievements of the Archbishop does not refer to his conversion of the Danes, which was completed in 823, the Gospels were probably executed before that date[47]. A comparison of the figure of St Matthew (*Ill. 32*) with the representation in the Vienna Gospels makes admirably clear the new trend which was to become so important to Anglo-Saxon artists in the early Middle Ages. The illustrations of the Gospels are painted in gold and shades

34 Psalm 88 from the Utrecht Psalter. Reims; about 820

of green, red, blue, brown, purple and white, but the painting is dominated by the vivacity of the outlines. Moreover, the close correspondence of style between Ebbo's Gospels and the Utrecht Psalter suggest that this, too, should be dated about the beginning of the third decade of the ninth century.

The Utrecht Psalter (*Ill. 34, 35*) provides one of the most extraordinary sequences of drawings in the whole history of art. The *Libri Carolini* had maintained that the art of the painter had nothing to do with the Scriptures, whose often purely verbal precepts and injunctions were not, in fact, adaptable to pictorial representation[48]. The artists of the Utrecht Psalter, or their patron, thought otherwise. For every psalm and canticle there is a visual interpretation of the text; as metaphor jostles upon metaphor in the poem, so too the visual translation telescopes scene into scene. The total effect is a bewildering richness of imagery drawn in red-brown ink with a dynamic force which transcends any late antique models which may have been used. There are some who consider the Utrecht Psalter

35 Psalm III from the Utrecht Psalter. Reims; about 820

to be an original creation of the Carolingian *renovatio*, and this may
be so, but there is little doubt that the Psalter was meant to look
antique, in other words 'authentic', both in the choice of script and
in the arrangement on the page. The pictures are full of late antique
allusions and the fact that the artists used different sources may ac-
count for some of the obscurities in the illustrations; the visual vocab-
ulary of one story is made to illustrate another. It is clear from a
Physiologus Ms at Berne, a Terence Ms in the Vatican, from Ebbo's
Gospels and the Utrecht Psalter that the artists at Reims were familiar
with a number of late antique manuscripts. Some of the illustrations
can only be explained by references to early commentaries on the
Psalter, particularly those of St Augustine. It has been suggested that
a Roman Sacramentary of about 600 may have served in part as a
model[49]. Nevertheless, whatever the sources at their disposal, the
artists of the Utrecht Psalter injected something quite new in their
reproduction. We are faced, apparently for the first time, with an
art form which is neither wholly narrative nor wholly the expression

45

of theophanic mysteries; the art form derives in part from theological speculation, from learned comment on a poetic text. In view of such comment on such a text it might be thought that academic calm would be the prevailing atmosphere. Nothing of the kind. Violence, agitation and awe jolt the cosmic order and sprawl across the page. Hills melt like wax in the presence of the Lord, God appears with an army of angels, in a mandorla, on the Cross, princes in their palaces are mistrusted and admonished, prophets gesticulate, and the just man guides his affairs with discretion. Since the contents of the drawing are governed by a literal interpretation of the psalm, one scene may dilate over prophetic fragments, as in Psalm 88, wherein God promises favour and mercy to the kingdom of David, or it may contract upon the security of the godly, as in Psalm 111, where the good man gives to the poor, and his horn, a pair of antlers on the housetop, is exalted with honour. In all these scenes the small figures pirouette and posture, fierce and gentle, menaced in all seasons yet full of hope, their arms wildly waving in the air, their clothes vibrant with energy. Small wonder that the Anglo-Saxon artists of the eleventh and twelfth centuries were over-awed by and became obsessed with such a manifestation.

37 Psâlm 50 on an ivory bookcover from Reims; about 860–870

5 (*opposite*) Psalm 50 from he Utrecht Psalter. Reims; ʔout 820

The style was translated into other media. In some ivory carvings scenes from the Psalter were taken almost direct, as in the bookcover in the Bibliothèque Nationale (*Ill. 37*) decorated with Psalms 50 and 56, probably executed some forty years later. There are differences. Psalm 50 (fol. 29 recto) was written at the time when Nathan came to David and upbraided him for slaying Uriah and taking Bathsheba. In the upper left of the drawing (*Ill. 36*) is Nathan's interview with David; Uriah is lying dead before them; Nathan points to the right half of the picture where the story of the ewe-lamb is illustrated (II, Samuel, xii); the rich man is standing beside his sheep and cattle and is directing his servant to take away the ewe-lamb from the poor man, who is seated before a building to the right. In the ivory carving this scene has been abridged, there are differences in the architecture and, generally, the scene is more compact. The same characteristics may be observed in the panels which once bound

47

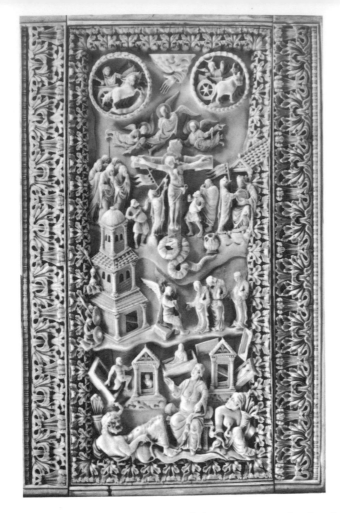

38 Ivory panel later set in the cover of a Book of Pericopes executed for King Henry II before 1014, showing the Crucifixion and the Holy Women at the Sepulchre. Reims; about 870

the Prayer Book of the Emperor Charles the Bald, carved with an adaptation of Psalms 24 and 26 (*Ill. 40*) (Utrecht Psalter, fol. 14 recto, fol. 15 recto). The virtuosity of the carver is stressed by the deepness of the undercutting, the extraordinary complexity of the scenes handled with consummate ease, and the vivacity of form and drapery. The panels are all richly framed in acanthus borders, but the artist never felt constrained by the border and frequently overlaid the lush leaves with an angel's wing, a palace roof or a sleeping soldier – as in a bookcover carved about 870 with scenes of the Crucifixion and the Holy Women at the Sepulchre (*Ill. 38*)[50].

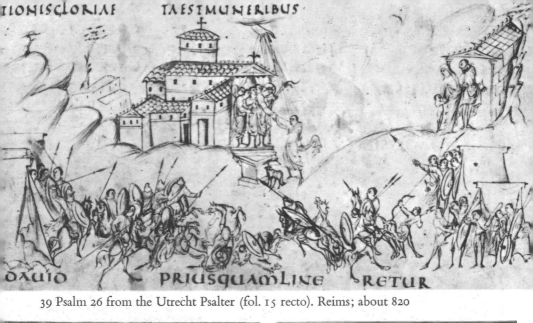

DAUID PRIUSQUAMLINE RETUR

39 Psalm 26 from the Utrecht Psalter (fol. 15 recto). Reims; about 820

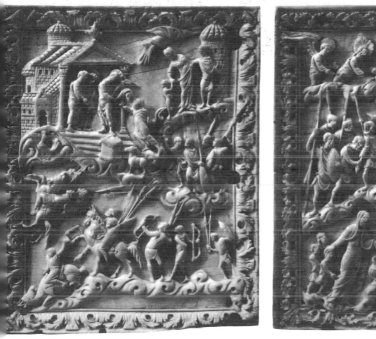
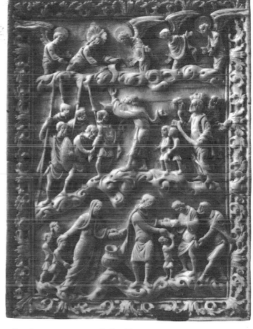

40 (*Left*) Psalm 26 and (*right*) Psalm 24 from the ivory cover of the Prayer Book of Charles the Bald. Reims; about 870

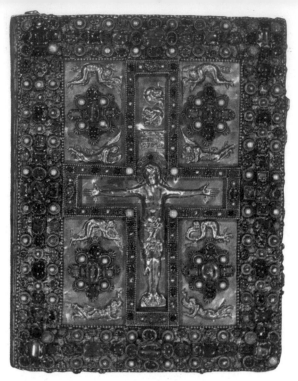

41 Gold cover of the *Codex Aureus* of Lindau showing Christ on the Cross amid Angels. Reims (?); about 870

42 Arnulf's portable altar of gold and precious stones. Reims (?); about 870

In metalwork the relief is less high. The gold portable altar of Arnulf of Carinthia, the golden covers of the *Codex Aureus* of St Emmeram at Regensburg and that of Lindau (*Ill. 42, 43, 41*), all usually assigned to Reims about 870, are chased in comparatively low relief, but the vivacity of the figures, their expressive gestures, their agitated drapery, all point to the same stylistic source[51]. Arnulf's ciborium, resplendent in gold, jewels and enamels, is decorated with scenes from the New Testament; the style of the draperies and the figures is livelier than those on the *Codex Aureus* of St Emmeram or on the Lindau cover, and there is some doubt over attributing all three works to the same centre. Indeed, although the use of bird's-eye perspective and the atmosphere of expressive expostulation on Arnulf's ciborium is closest to the Utrecht Psalter, uncertainties over dating within a time-bracket of some fifty years make a precise attribution almost impossible.

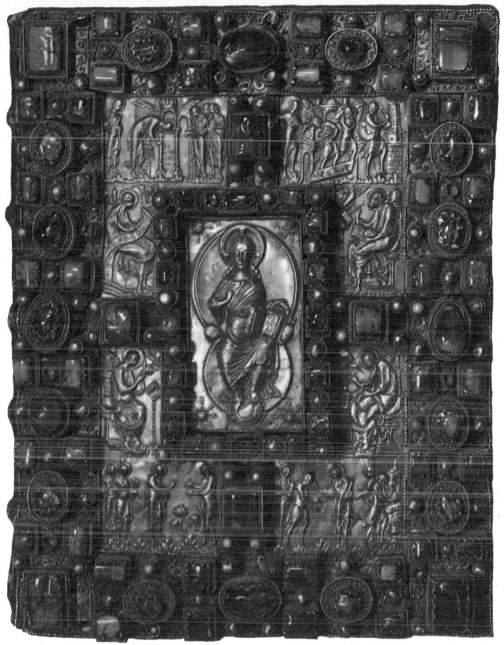

43 Gold cover set with pearls and precious stones of the *Codex Aureus* of St Emmeram, showing Christ in Majesty, the Four Evangelists and scenes from the Life of Christ. Reims or Saint-Denis; about 870

In manuscript illumination, even when the historical facts are known, similar difficulties arise. About this time, under the supervision of Hincmar, Archbishop of Reims (845–875), the scriptorium produced a remarkable manuscript, a Bible, now in the Church of San Paolo fuori le Mura at Rome. The Bible was commissioned by the Emperor Charles the Bald at the time of his marriage to Richildis in January 870. It has been pointed out that all the full-page miniatures, as well as a great number of pages containing large initials or *incipits*, have been subsequently pasted into the Bible. The miniatures betray the hands of different artists; some of the illustrations were executed hastily, ornamental borders remain unfinished and the purple panels inserted for inscription in gold lettering remain occasionally vacant. It seems, therefore, that the illustrations were added with speed and for a special purpose to a Bible text already completed by a certain Ingobert. It has also been suggested that the Bible was a gift from Charles the Bald to Pope John VIII at Christmas, 875, from whom he received the imperial diadem, although the unfinished state of the manuscript seems in this case surprising. Some of the miniatures derive from Bibles made in the School of Tours with the addition of new scenes, and yet the miniature showing the Ascension and Pentecost (*Ill. 44*) seems more in the tradition of Reims than that of Tours. Although the Bible according to some scholars belongs on palaeographical grounds to the school of Reims, there is an element of doubt over the provenance of the miniatures [52].

The school of Tours had been a great centre since the time of Charlemagne, but under Alcuin, who was Abbot from 796 to 804, attention was directed more to the correctness of the text and to the scientific contents of the books than to their decoration. Not until a generation later were the large one-volume Bibles produced which were to be taken as a standard throughout the early Middle Ages. These Bibles, it has been suggested, are based on a fine fifth-century Bible commissioned at Rome by Pope Leo the Great [53]. The illustrations in the Tours Bibles are very limited. There can be little doubt, however, that the Moutier-Grandval Bible and the Bible of Count Vivian, lay-abbot of Tours, sometimes known as the First Bible of

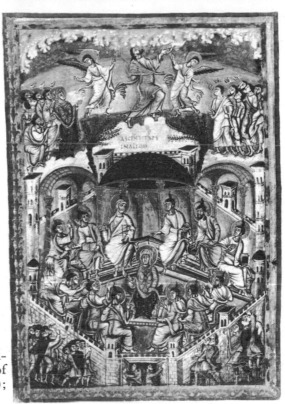

44 The Ascension and Pentecost from the Bible of San Callisto. Reims (?); about 870

Charles the Bald, were undertaken with a late antique model at hand. In the miniature of Moses receiving the Law and his expounding the Law to the Israelites in the Moutier-Grandval Bible (*Ill. 45*), executed under Abbot Adalhard, a late antique prototype seems obvious from the dress, the facial types, broadly sketched forms and the architectural detail. The illusion of perspective in the ceremonial hall has defeated the Carolingian artist and the portrayal of the Israelites smacks strongly of the copyist. On the other hand, Joshua holding the curtain on the left and, above, the trees on either side of Mount Sinai, the entire scene of Moses receiving the Tables, are impressive attempts at reproducing a fifth-century model. The same delicate treatment of trees, flowering shrubs and the garland hung over Eve's bower (*Ill. 46*) is to be found in the Genesis cycle, where, incidentally, God the Father is revealed as a beardless young man and the forms reflect even more strongly their late antique origins.

53

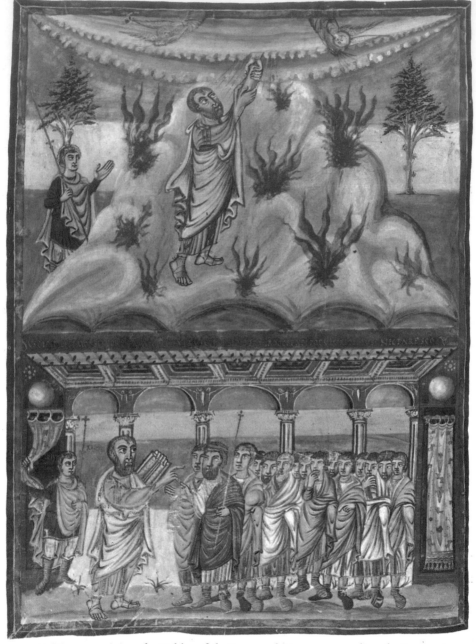

45 Moses receiving the Tables of the Law, and Moses expounding the Law to the Israelites from the Moutier-Grandval Bible. Tours; 834–843

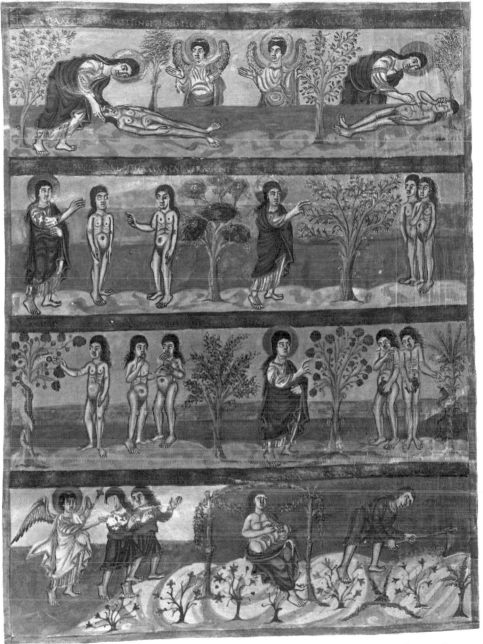

46 Genesis scenes from the Moutier-Grandval Bible: God creates Adam and Eve; the Fall, and the expulsion from the Garden of Eden. Tours; 834–843

As in the court manuscripts of the Ada group, colours tend to be in rather sour, dull tones – purple, brown, rust, blue, green and grey, picked out in gold – but in general the quality of painting is not that of the court.

In the Bible of Count Vivian the number of scenes is doubled and the atmosphere of the court emerges in a heightening of quality and through the presence of miniatures, which reveal King David (*Ill. 47*) playing the harp before musicians, imperial guards and the personifications of the imperial virtues – Prudence, Justice, Fortitude and Temperance – and the monks of St Martin of Tours (*Ill. 49*), headed by their lay-abbot, Count Vivian (843–851), presenting the Bible to Charles the Bald – one of the earliest representations of a contemporary event known in Western medieval art. The idealized portrait of Charles the Bald, in face and crown, comes very close to the idealized portrait of David and is probably intended to stress the '*novus David*' aspect of Carolingian political theory. The identification of the other personalities in the scene has given rise to some controversy, but it seems probable that the crowned dignitaries on either side of Charles are either his Welf cousins, Conrad and Hugh, or the seneschal and count of the palace; the group of ecclesiastics on the right are the palace clergy behind whom stands a chamberlain or treasurer; the group on the left are the canons of St Martin, three of whom are holding the Bible; the figure, bottom centre, slightly isolated from the other groups, has been identified as Count Vivian dressed in ecclesiastical robes. An alternative suggestion identifies the crowned figure on Charles's right as Count Vivian, and the four dignitaries, bottom right, as the personalities mentioned in the dedicatory verses: Sigualdus, Tesmundus, Aregarius, and a fourth unnamed. The Bible was almost certainly presented to Charles the Bald while he was staying at Tours early in 851. The fact that renewed court interest increased the quality of production is also suggested by the Gospels of Lothair, half-brother of Charles the Bald, which was commissioned at Tours as a memorial of their reconciliation some years after 846 and before the death of Lothair's wife, Hermingard, in 851 [54]. The portrait of Lothair in his Gospels (*Ill. 48*) is a superb evocation of an early medieval prince. The

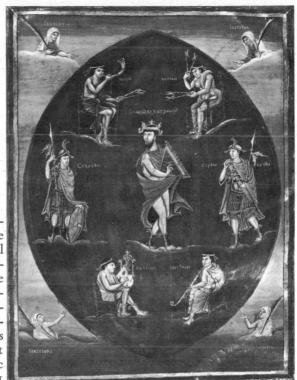

47 King David playing the harp before musicians, imperial guards and the personification of the imperial virtues, Prudence, Justice, Fortitude and Temperance. Count Vivian's Bible, or the First Bible of Charles the Bald. Tours; 843–851

facial type is similar to that of King David in the Bible of Count Vivian, but the lavish use of gold, particularly in this case in the highlights on the dress of Lothair and his bodyguard, the delicacy of form, fold and draped throne emphasize that when a monastic scriptorium reached great heights of excellence, it was the result of imperial patronage. For this reason, among others, it is difficult to speak of Carolingian 'schools' in the sense of a logical development in a given area. Monasteries provided the training ground from which artists were chosen for fulfilling the demands of the court authorities. An artist trained at Tours or Reims might well be active at Metz or in one of the monasteries favoured particularly by the court, such as Compiègne. That is why it is so difficult in the later Carolingian period to distinguish between 'schools' and to place geographically the court school of Charles the Bald. The court itself was once more constantly on the move and, no doubt, the best artists moved with the court.

57

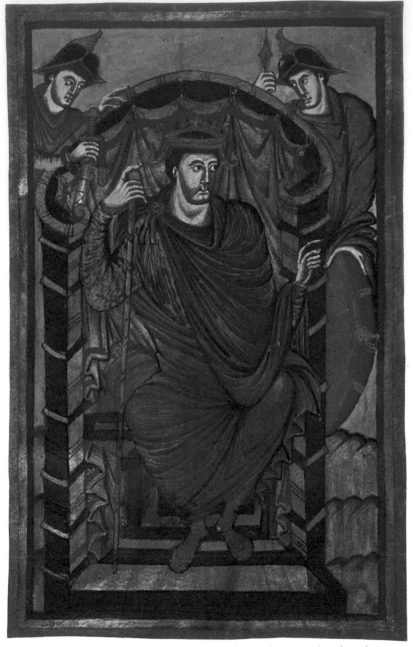

48 The Emperor Lothair I (840–855) from the Gospels of Lothair. Tours; 849–851

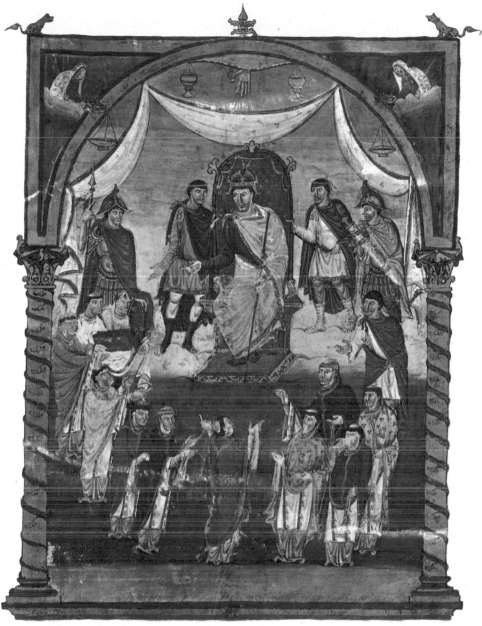

49 The monks of the Abbey of St Martin at Tours, headed by their lay-abbot, Count Vivian, presenting the Bible to King Charles the Bald. Count Vivian's Bible, Tours; 843–851

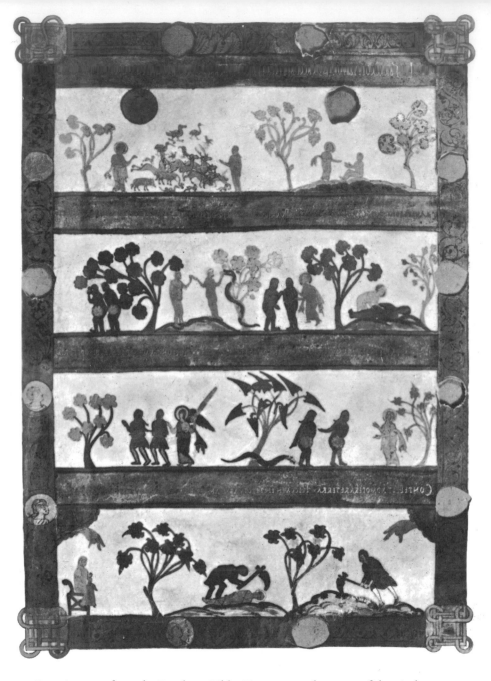

50 Genesis scenes from the Bamberg Bible. Tours; second quarter of the ninth century

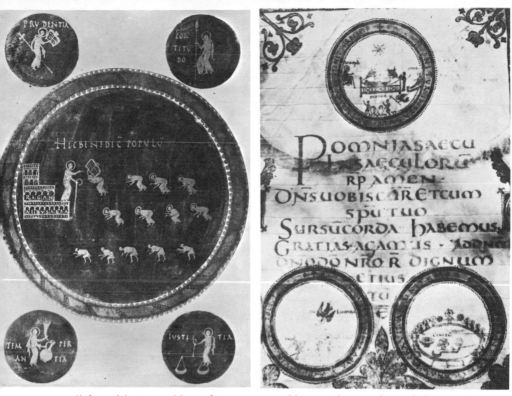

51, 52 (*left, right*) Raganaldus of Marmoutier blessing the people, and the Nativity, Baptism of Christ and the Last Supper from the Marmoutier Sacramentary. Tours; mid-ninth century

Another type of Bible illustration current at Tours, rather different from the court style, is more in the nature of a drawing than a painting. A Bible at Bamberg (*Ill. 50*) contains a Genesis cycle, executed in the second quarter of the ninth century, with small, rather ungainly figures in a stylized landscape; the total effect is almost *en silhouette* and suggests another late antique prototype. But one of the strangest products of the scriptorium at Tours, executed under Count Vivian about 850, is a Sacramentary for Abbot Raganaldus of Marmoutier, brother of Count Vivian, which contains among the full-page illustrations a representation of Raganaldus blessing the people (*Ill. 51*) in a large central medallion surrounded by the Virtues, Prudence, Fortitude, Temperance and Justice in roundels. The little figures are painted in gold on a green ground –

a shimmering hieroglyph of ritual. Elsewhere in the manuscript are medallions containing scenes of the Nativity, the Baptism of Christ and the Last Supper (*Ill. 52*); again the minute figures are painted in gold silhouette and suggest a knowledge of the sixth-century *ampullae* at Monza and Bobbio, late antique gilded glass, and possibly even the influence of carvings in rock crystal, such as that probably executed for Lothair II, although this crystal (*Ill. 59*) in particular was carved later than the decoration of the Sacramentary of Raganaldus[55]. The work of the scriptorium was brought to an end by a Norse invasion in 853, but the influence of the scriptorium did not cease with that calamity; it was felt at Metz, Fulda, St Gall, Trier and Echternach as late, in the latter case, as the eleventh century[56].

A workshop at Metz was also affiliated to the court. The most celebrated manuscript from this workshop is the Sacramentary of Drogo, Archbishop of Metz (826–855), an illegitimate son of Charlemagne, chaplain to Lothair, and later Vicar Apostolic throughout the empire north of the Alps, though this latter title proved to be purely honorary. It has been suggested that the Sacramentary may have been commissioned with a view to enhancing Drogo's prestige as papal legate and was probably produced during the last decade of his life. Manuscript production at Metz before the arrival of Archbishop Drogo was rather nondescript, and the Sacramentary is once more a clear case of court influence over a local workshop producing heightened quality. The manuscript is decorated with a remarkable series of historiated initials, all rather small in scale but containing figures depicted in a lively manner with marked classical overtones (*Ill. 53*). The source of this figure-style is still unknown. In addition, the capital letters are embellished with inter-twining tendrils of acanthus leaves painted in gold which meander sometimes into the surrounding space (*Ill. 54*). Two Gospels of the same group, indeed by the same artist who decorated Drogo's Sacramentary, are influenced in the former by the Vienna Gospels and in the latter by Tours manuscripts, particularly in textual matters and the opening page of each Gospel, and both date to the middle of the ninth century. Moreover, a collection of astronomical and chronological

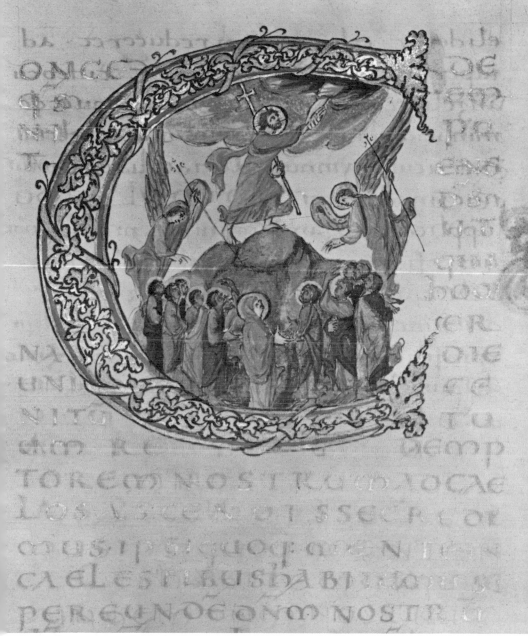

53 The Ascension from the Sacramentary of Archbishop Drogo of Metz (826–855). Metz; about 842

texts, made between 820 and 840, now in Madrid, is based partly on a lost prototype produced at Metz in 809 and partly on a manuscript believed to have been executed at Aachen by the 'strangers' responsible for the Vienna Gospels. Drogo's Sacramentary was also produced under Tours influence, but it has been pointed out that the characteristic Metz ornament, which was to have such influence over later Anglo-Saxon illumination and drawings, occurs in no other Carolingian school; their source, like the source of the iconography and style of the historiated initials, is still unknown[57].

54 *Te igitur*, beginning the Canon of the Mass from Drogo's Sacramentary. Metz; about 842

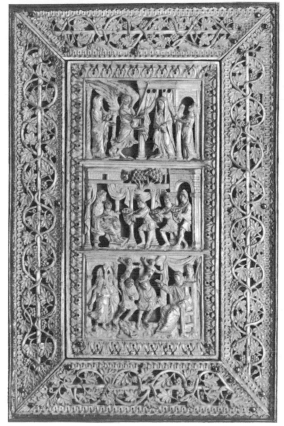

55 Ivory bookcover showing the Annunciation, the Adoration of the Magi and the Massacre of the Innocents. Metz; mid-ninth century

The ivory carvings attributed to the Metz workshops in the middle of the ninth century also bear witness to a close study of an early Christian narrative cycle. The superb reliefs now acting as book-covers on manuscripts formerly in the Cathedral Treasury at Metz are almost a pastiche of late antique style (*Ill. 55*). Architectural details, curtains, trees, the varied movement of the figures, the subtlety of the treatment of the drapery, the realism of each scene, all point to an artist steeped in early Christian antiquity and striving once more at 'authentic' reproduction. The rich vine and acanthus scrolls bordering the narrative panels are carved with equal virtuosity[58]. The tradition continued with cross-currents from other workshops into the tenth century. A panel carved with an allegorical represen-

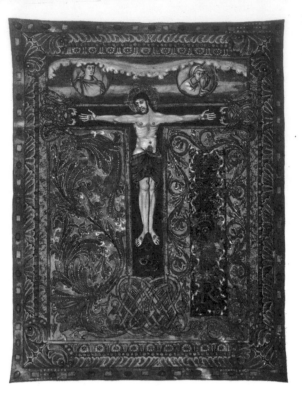

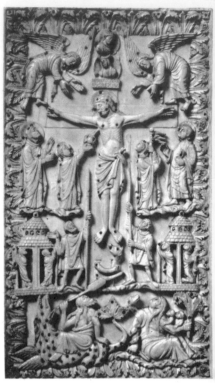

56 Christ on the Cross from the Coronation Sacramentary of Charles the Bald. Court School of Charles the Bald. Second half of the ninth century

57 Ivory bookcover showing the Crucifixion. Metz; late ninth or early tenth century

tation of the Crucifixion, studded in gold, in the Victoria and Albert Museum, betrays a hardening of style (*Ill. 57*) and at the same time the influence of the late court style of the Coronation Sacramentary of Charles the Bald (*Ill. 56*)[59]. But the impact of the early Christian model still remained remarkably vivid. A small panel, carved about 900, with the Adoration of the Magi and the Presentation to the Temple, in the Victoria and Albert Museum, shows, in its handling of architectural details and its understanding of form in movement, an admirable perception of the earlier model (*Ill. 58*)[60]. The workshops produced a series of liturgical combs, one of the finest is now in the Schnütgen Museum at Cologne, and caskets, such as those in Paris and Brunswick, and once more the earlier Metz style, slightly hardened, is combined with influences from the court school[61].

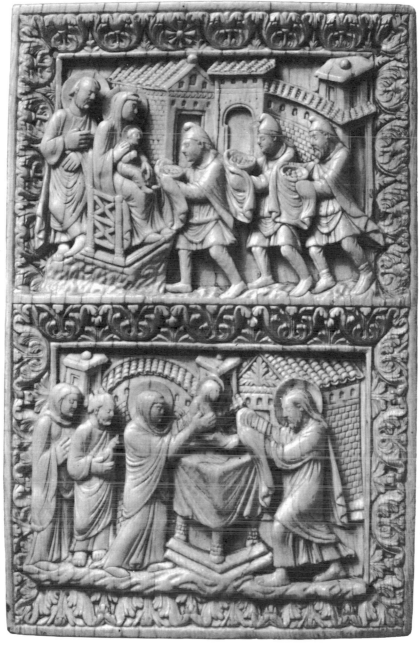

58 Adoration of the Magi and the Presentation to the Temple from an ivory bookcover formerly at Sens. Metz; late ninth or early tenth century

The rock-crystal of Lothair II (855–862), King of Lotharingia, formerly at the Abbey of Waulsort or Vasor on the Meuse, not far from Dinant, now in the British Museum (*Ill. 59*), carved with eight scenes from the story of Suzanna, may also have come from a workshop at Metz[62]. Attempts have been made to attribute the carving to Reims, but the style is quite different from the Utrecht Psalter and its dependents. The calm, rather stocky figures, the parallel folds of drapery, the economy of gesture have greater affinities with that which we know to have been done at Metz. The story of Suzanna was regarded in early Christian times as a symbol of the persecuted Church and of the redemption of Man from the powers of evil, and there can be no doubt that an early Christian model was at hand when the crystal was carved. Quite a number of rock-crystal carvings are known from the Carolingian period – a gem with the bust of Lothair is set in the great Ottonian gold cross at Aachen and the remainder are decorated with either the figure of St Paul, or the Baptism of Christ, or the Crucifixion – but the preciosity and rarity of the material implies exalted and personal patronage. Like the great cameos of the Constantinian house, Carolingian rock-crystals are the direct expression of a court art.

The site of the court school of Charles the Bald is still under debate: Corbie, Saint-Denis, of which Charles was lay Abbot, Reims and Compiègne have all been advocated. The school produced the Coronation Sacramentary, formerly in fact in the Treasury of Metz Cathedral, and it is perhaps not without interest that Charles the Bald was crowned King of Lotharingia at Metz in 869, that his present mistress and future wife Richildis came from a prominent Lotharingian family, that by the Treaty of Meersen concluded with Louis the German in 870 Charles lost Metz and half his kingdom of Lorraine – which might account for the unfinished state of the Sacramentary. On the other hand, there is such a marked element of private patronage in all the manuscripts executed for Charles the Bald that his death in 877 may be the reason for the halt in production. The portrait of a Carolingian prince between two bishops has been variously interpreted (*Ill. 60*): some have recognized the Merovingian King Clovis between St Rémi of Reims and St Arnulf

59 The story of Suzanna on a rock-crystal carved for Lothair II (855–862), King of Lotharingia, formerly in the Abbey of Waulsort on the Meuse. Metz

of Trier, others Pepin between Pope Stephen II and Pope Gregory the Great, Charlemagne between Pope Hadrian and Pope Gregory, Charles the Bald between Hincmar of Reims and Adventus of Metz. The most ingenious suggestion is that the figures are Charlemagne between Pope Gelasius and Pope Gregory the Great; the hypothesis is based on the closed and opened books in the hands of the prelates which are taken to refer to the Gelasian Sacramentary (the closed book) being superseded by the Gregorian Sacramentary (the open book), a change for which Charlemagne was responsible[63]. The main idea, however, may be merely the divine election of the Carolingian house and the support of the Church. Also from the court school are a Book of Hours for the use of Charles, now in

69

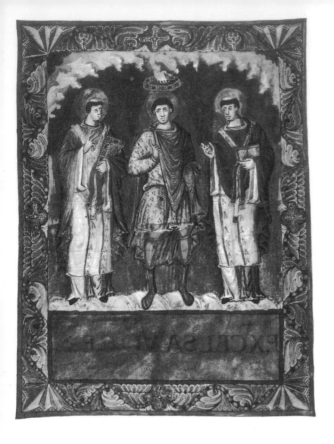

60 Charlemagne between Pope Gelasius and Pope Gregory the Great (?) from the Coronation Sacramentary of Charles the Bald

Munich, his Psalter wherein he is compared to Josias and Theodosius, datable because of a reference to his Queen Hermintrude whom he married in 842 and who died in 869, written entirely in gold lettering, at one time also in the Cathedral at Metz, and the magnificent Gospels, now known as the *Codex Aureus* of St Emmeram. The style of the illustrations in the latter has been compared to that of the Reims scriptorium, but the script is not from this centre. The canon-tables are based on the Gospels of Saint-Médard-de-Soissons, executed for Charlemagne at Aachen, and the rest of the manuscript is eclectic, including influences from Tours and Saint-Amand. The lavish use of gold, gold lettering, rich marblings shot with gold, large acanthus leaves in gold, the splendour of the colours, purples, blues, greens and apricot, the magnificence of the gold cover, all point to direct imperial patronage. It has been suggested that the influence of

the writings of Dionysius the Areopagite may be traced in the iconography of the illuminations and the goldsmiths' work; these writings were translated into Latin at Saint-Denis under Abbot Hilduin between 832 and 835 and later by John Scotus Erigena between 855 and 858 on the command of Charles the Bald. Hilduin also composed the *Areopagitica* identifying Dionysius with St Denis. Liturgical arguments, for example, the litany in the Psalter of Charles the Bald, contains saints especially venerated at Saint-Denis, have been advanced to support the attribution of this group to the Abbey of Saint-Denis[64]. Certainly the combination of so many incidental factors seems to point to that abbey. Wherever the locality, there can be no doubt that for one of the most splendid of the Carolingian monarchs – Charles arrived at the Council of Ponthion, near Châlons, in 876 *'graecisco more paratus et coronatus'*, arrayed and crowned in the Byzantine manner, and like the Byzantine Emperors was received with acclamations chanted by the assembly – the artist of the *Codex Aureus* produced one of the great masterpieces of Carolingian painting. The Adoration of the Lamb (*Ill. 61*) is astonishing by its treatment of an apocalyptic vision. A golden lamb, standing on a scroll, framed by an inscription and layers of glory, surrounded by planets and stars, set above a lilac and gold beam of light and a great star, is adored by a massed flurry of elders proffering crowns, their tunics and robes in shades of pink, orange, purple and blue, heavily underlined in gold. Below again, the personifications of Land and Sea; the whole set in a rich acanthus and egg-and-dart border; the text gleams in gold on a purple ground. The vibrancy of colour, the sense of movement in ecstasy, heighten the mystical vision. The figure-style of the manuscript is rather different from that of the cover (*Ill. 43*) which is more fined down and elegant. The lithe slender forms, the sense of immediate communication, the nervous gestures, the figures perching or floating above the ground, the architectural backgrounds, point to Reims, but again, wherever the cover was made, there can be no doubt that it is one of the great masterpieces of the goldsmiths' art. Even the settings for the jewellery with their filigree arcading and their acanthus stands, set, as it were, on high arcaded stilts, with pylons for

pearls, sometimes grouped in fours like a table – the chalice-shaped mounts were associated with the blood of martyrs, the precious stones with the Heavenly City – are marvellous works of art. Dominating these piled-on riches, for indeed the whole panel is raised above the other reliefs, Christ is revealed in Majesty, looming out from a starry firmament of precious stones, gold cups and enamel sprays. The vision swells out from the gold background in slow curves, Christ, beardless, long-haired, swathed in a rhythmic swirl of narrow and broadly spaced folds, which end in capricious quirks and pleats about the feet, God in Majesty set among His Evangelists and among scenes of His Anger, His Judgment and His Love. In both manuscript and cover, time and again, one may detect the close study of early Christian models. The *Codex Aureus* of St Emmeram must have been intended by the Emperor Charles to evoke the glories of Constantine and Theodosius and to rival the riches of the East Romans. For the roof of Saint-Denis shone with gold; its walls were covered with silver, and the whole building mirrored the splendour of the King of Heaven; the altar was faced with gold and loaded with gold crosses and candlesticks and hung with hanging votive crowns in gold, enamel and precious stones; *splendens, radians, coruscans.*

Monasteries connected with the court might still continue pre-*renovatio* traditions. The Franco-Saxon school, now generally accepted as being at the Monastery of Saint-Amand near Tournai, although its Abbot Milo was a friend of Charles the Bald and tutor to his sons and although another son, Carloman, later became Abbot, produced manuscripts which, while they acknowledged a debt to the artists of Reims, concentrated more on large initials and canon-tables built up from Anglo-Saxon animal forms and interlace. Beautiful though the script may be, the impression made by the manuscripts from this centre, and it was not the only one, is essentially *retardataire*. On the other hand, there can be no doubt that the Second Bible of Charles the Bald, produced at Saint-Amand, is a superb synthesis, a consummation of the insular aesthetic experience. This Bible, bequeathed by Charles to the Abbey of Saint-Denis, contains a reference to the death of Charles's son, Charles,

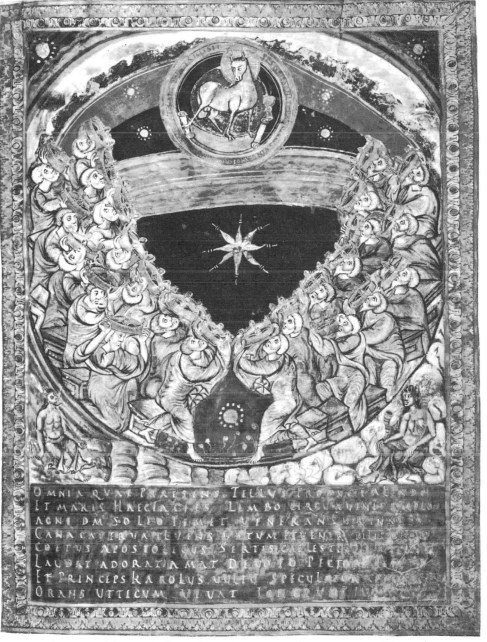

61 Adoration of the Lamb from the *Codex Aureus* of St Emmeram of Regensburg.
Court School of Charles the Bald (Saint-Denis?); about 870

King of Aquitaine in 865, as of recent occurrence, but it was executed probably after 871, the year of the disgrace of Carloman – he was imprisoned and blinded by his father (Charles the Bald was never more Byzantine than when he blinded his son) – and before 877, the year of Charles's death. The verse of dedication has been attributed to Hucbald, Abbot of Saint-Amand, who also wrote a learned and insufferably boring poem, the *Eclogia de Calvis*, justifying and praising baldness, in which not only the best and greatest men had apparently been so distinguished, but every word of the 146 verses begins with the letter 'c'. The decoration of this second Bible (*Ill. 62*) is a reminder that, in spite of the determined acceptance of the art of the Mediterranean sponsored by the imperial court, the old northern barbarian style died hard; it continued in imitations as late as the twelfth century. To this particular centre the North itself put an end. In 881 the monks of Saint-Amand fled before the Normans to take refuge at Saint-Germain-des-Prés[65].

A mixture of insular and *renovatio* elements is to be found in the productions of the monastery of St Gall, an Irish foundation which rose to eminence in the ninth and early tenth centuries. Under a series of great abbots, Grimvald (842–872), a disciple of Alcuin, Hartmut (872–883) and Salomon (890–920), who was also Bishop of Constance and Chancellor of the East Frankish kingdom, the monastery acquired great possessions and became a school renowned for music, literature and the arts. Here Notker Balbulus wrote the *Gesta Karoli* at the command of Charles III, a man of piety and learning, after a Christmas visit to St Gall in 883. The *Gesta*, with its mixture of anecdote and legend, was intended to bring to the generations since his death the meaning of Charlemagne's life. The decoration of manuscripts was chiefly concerned with large initials constructed from interlace, foliate forms and acanthus leaves in particular. A psalter written and decorated by Folchard before 872 is one of the finest of the productions of St Gall. The letter 'Q' on page 135 (*Ill. 63*) is a typical example of the severe elegance of this hybrid style which borrowed from various Carolingian scriptoria. The page is rich with gold and silver on purple vellum; the letter 'Q' is in gold with pale green and light blue ornament; the border, gold

62 Initial *B* from the Second Bible of Charles the Bald bequeathed by him to the Abbey of Saint-Denis. Saint-Amand; 871–877

63 Initial *Q* from Folchard's Psalter. St Gall; before 872

on blue. The use of lush acanthus leaves elsewhere in the manuscript
suggests elements of decoration from the court school of Charles
the Bald. The artists of St Gall tended to be disinterested in figure
subjects, although the representations of King David in Folchard's
Psalter have considerable charm, and the *Psalterium Aureum*, exe-
cuted for Abbot Salomon, is a fine departure from this tendency.
The representation of David in this Psalter shows a strong depend-
ence on the court styles (*Ill. 64*). The figures are outlined in gold
and filled in with shades of pale green and pink on a purple ground;
the archway consists of green columns with gold ornament, or gold
on purple. David sits on a golden throne and the suppedaneum is
gold, although his feet rest on an orange surface. The total effect is
beautiful, but the quality is not that of the court[66].

64 King David playing the
harp before musicians and
dancers from Abbot Sa-
lomon's *Psalterium Au-*
reum. St Gall; 890–920

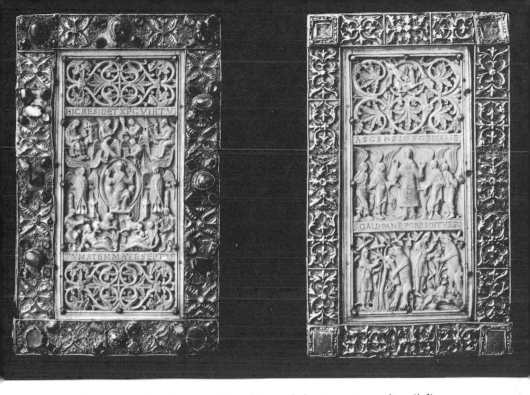

65, 66 Christ in Majesty between Seraphim and the Four Evangelists (*left*), and the Assumption of the Virgin from the Legend of St Gall (*right*). Ivory bookcover executed at St Gall by Tuotilo; about 900

The ivory carvings executed at St Gall are remarkable for the handling of the foliate scrolls and patterns as much as for the figure subjects. The covers of the *Evangelium Longum*, almost certainly executed about 900 by the monk Tuotilo, to whom Ekkehard refers in his *Casus Sancti Galli*, are carved on one side with Christ in Majesty (*Ill. 65*) and on the other with the Assumption of the Virgin (*Ill. 66*) and a scene from the Legend of St Gall in which a bear was commanded by the Saint in the name of Christ to bring wood and put it on the fire. This done, the bear was given bread and told to go – for ever. These scenes are set in conjunction with sizeable panels of acanthus scrolls. The style is quite distinctive from other workshops: a bold treatment of the leaves sprouting from fleshy stems, the figures firmly modelled and draped in a complex system

of parallel folds, a strong sense of movement within a firm overall plan. If anything the carving, which is of the highest quality, seems to be influenced by the court school of Charles the Bald with faint echoes of Reims, Tours and Metz. Considering the scenes on the back panel and the reference in Ekkehard there can be no doubt of the St Gall provenance, yet nothing previously done at St Gall leads up to it. The drapery folds are subtler than they appear in a photograph. The panel carved with Christ in Majesty is highly complex in design and successfully accomplished, in spite of the fact that St Luke appears to be dipping his pen into the cornucopia of Abundantia, or the Earth, and St Mark appears to be sharpening his pen over the head of a river-god, or the Sea. The variety of postures of the angels should be noted. A second bookcover is decorated with foliate scrolls inhabited by wild beasts pouncing on cattle (*Ill. 67*) – note how the bear grips the folds of the skin in the top section of the panel – one such scene occurs on the Assumption panel – or a carpet of foliate devices of supreme elegance of design, conceived in two planes with no irregular projections from the surface. Both sets of covers appear to be carved by the same hand and are a completely isolated achievement[67].

Throughout the second half of the ninth century the civil wars between the kings or between turbulent counts, and an almost annual series of Norse invasions, destroyed the frail peace of the Carolingian empire. Paris was pillaged by the Normans in 861, burnt in 865, and besieged in 885. In 881 and 882 the Danes burnt Liège, Tongres, Cologne, Bonn, Stavelot, Prüm, Aachen, and took possession of Trier. There was no fleet to stop or control them and no army to deal with the menace on land. Free men began to gather in groups around leaders strong enough to protect them in time of need. Southern France was beset by Islamic brigands and freebooters; there is no evidence that the Arabs were in possession of the cities, though they were frequently pillaged, but they were masters of the country and the mountains[68]. Charles III lacked the energy and vigour to deal with the dissensions in the Empire on the one hand,

67 Ivory bookcover carved, probably by Tuotilo, at St Gall; about 900

and on the other, the external menaces. He was deposed in 887 and died a year later. 'Then', said the Lotharingian chronicler, Regino of Prüm, 'the kingdoms which had been subject to the government of Charles split up into fragments, breaking the bond which united them, and without waiting for their natural lord, each sought to create a king of its own, drawn from within itself.' In fact, the political centre of the Empire began to shift more to the East. Arnulf of Carinthia, King of the Germans, was to assume the imperial title and the *ornamenta palatii*, which included the gold portable altar which now bears his name, and the *Codex Aureus* of Charles the Bald, were given to Arnulf. He bequeathed them in 899 to the Monastery of St Emmeram at Regensburg where he was buried. In 892 the Hungarians appeared on the eastern frontiers. In 900 they conducted a plundering expedition into Italy and for the next ten years they devastated Carinthia, Saxony, Thuringia and Alemannia[69]. It was a time of great trouble and unrest.

But the fabric of European Christendom, reinforced by the Emperor Charlemagne and guarded by the Papacy, over which he believed himself to be master, was not to dissolve as easily as his Empire. The new wave of barbarians, fearful though it appeared to be at the moment of onslaught, was to be withstood after sixty years of destruction. The foundations of medieval civilization, buttressed by the Emperor Charles, had been laid, whether he recognized it or not, on the rock of St Peter and upon the See, rather than the Empire, of Rome.

The Consolidation of the Imperial Tradition

After more than sixty years of political confusion the German lands were consolidated under a Saxon duke, Henry the Fowler, later King Henry I. A determined stand was made against the Slavs and the Hungarians who had disrupted for too long the frontiers of the old Carolingian empire. The victories of the new Saxon dynasty in the east culminated in the Battle of Lechfeld, near Augsburg, in 955, when the siege of the city by the Hungarians, prolonged through the courage and ability of Ulrich, Bishop of Augsburg, was relieved by Henry's son Otto. The new cities, however, of Merseburg, Quedlinburg and Magdeburg set the seal on the victories and became centres of Christian missions to the eastern barbarians. These missions combined with insistence on ecclesiastical reform and support of the Papacy were dominant in the policy of the Saxon emperors. The coronation of Otto I as King at Aachen in 936 and his coronation as Emperor at Rome in 962, not only implied that he was the heir to the Carolingian empire, but confirmed his leadership of Western Christendom; it was a leadership, however, which looked to the east and the south rather than to the western seaboard. Henry I married his daughters Gerberga and Hedwig to Louis IV, King of the Franks, and to the Count of Paris, who was to be the father of Hugh Capet; the first wife of Otto I was an Anglo-Saxon princess; but the course of the new empire was in the hands of German princes and later Abbot Siegfried, of the reformed monastery of Gorze, near Metz[1], was to object to the marriage of Henry III with Agnes of Poitou, not only on the grounds of consanguinity – they were descended from Otto I and his sister Gerberga respectively – but because he feared that the frivolity of Agnes's nation would corrupt the old-time sobriety of the German people.

The Saxon Emperors have been blamed for their preoccupation with Italy, but protection of the Papacy meant control of Rome and

its factions and the duty to see that the successors of St Peter were worthy of their office. Moreover, without the support of the Church, without the civil administration of the great ecclesiastics, the Empire might well have foundered among the shifting shoals of feudal alliances. It was convenient for the higher ranks of the Church to be filled by members of the feudal aristocracy; their allegiance to God and the Emperor could be counted on to override the claims and interests of lay feudality. Thus, Bruno, brother of Otto I, educated by Byzantine tutors, was Duke of Lotharingia and Archbishop of Cologne; Matilda, grand-daughter of Otto I by his first wife, the Anglo-Saxon princess Edith, was to become Abbess of the convent of the Holy Trinity at Essen and her brother was Duke of Bavaria and Swabia; Matilda, sister of Otto II, was Abbess of Quedlinburg; Adalheid and Sophia, daughters of Otto II, were to become Abbesses of Quedlinburg, Gandersheim and Essen; Wilhelm, a bastard of Otto I, was Archbishop of Mainz (954–968); Ulrich, Bishop of Augsburg, was connected with the imperial family and the Dukes of Alemannia; Egbert, Archbishop of Trier, Chancellor of Otto II, was a son of Count Dietrich II of Holland; Bernward, Bishop of Hildesheim, was a grandson of the Count Palatine Adalbero and tutor to Otto III. There were exceptions and it would be a mistake to regard early medieval society as closed and rigid. Willigis, Archbishop of Mainz – after the Papacy the most important ecclesiastical office of the time – and Archchancellor of the Empire, seems to have been of humble birth, but he entered the service of Otto I through the influence of Bishop Volkold of Meissen, he was well educated and demanded a high education of his clergy, and he lived to crown Otto III at Aachen and Henry II at Mainz. Gerbert of Aurillac, the most brilliant man of his day, master of the cathedral school at Reims (972–982), Abbot of Bobbio, was the son of a peasant but, thanks to the patronage of Adalbero of Reims and the Emperors Otto II and Otto III, he became Pope Sylvester II in 999. His was without question an imperial appointment, but almost everything that he wrote and did has distinction. He introduced Arabic numerals to the Empire, revived the use of the abacus in calculation, and he was familiar with scholarship throughout the western world

including Muslim Spain. 'He applied to his life the wisdom of the ancients, and created a well-balanced Christian humanism which was to be the mark of the school of Chartres under Fulbert, who is said to have been his pupil. In any case, the ideals of Gerbert came to rich fulfilment in eleventh-century France, and Fulbert's school is the link between the learning of the Carolingians and the early universities'[2].

These great ecclesiastical princes should not be thought of in modern terms. The Empress Theophano, during her great regency, was supported by Willigis of Mainz, Bernward of Hildesheim and Adalbero of Reims, whose secretary Gerbert was. Between them they prevented the feudal lords from profiting by the minority of Otto III; they defended the eastern frontiers against the Slavs. These bishops built castles as well as churches, they fought by the side of the emperor or defended his rights, if need be, by the sword, when the emperor was not present. Archbishop Adalbero of Reims writes to Archbishop Egbert of Trier on 25th August 988 to ask for troops. Gerbert of Aurillac, as Abbot of Bobbio, dared not rely on the trustworthiness of his knights because they were Italian, and he writes in the same letter, quoting Cassiodorus quoting Cicero, of leading an army into Italy[3]. Notker, the Swabian Bishop of Liège (972–1008), devoted servant of the Ottonian Emperors, when re-allotting the increased revenues of his diocese, which had previously been divided between the bishop, the clergy and the poor, had no scruples in switching the third portion from the poor to the upkeep of some 400–500 knights for the protection of the diocese. He could thus summon an array equal to that which the King of France was to lead against the King of England some hundred years later in 1119[4]. These bishops formulated political theory; they acted as viceroy, judge and priest, and many were canonized. To the faithful of this time most of these bishops were saints. Not only the bishops: Matilda, wife of Henry I, was venerated as a saint immediately after her death, Henry II and his Empress Kunigunde were canonized, but even those emperors not blessed by the highest Christian decree were held in awe as beings of a different order. In the tenth and eleventh centuries, times of lawlessness, cruelty, private feud, magic

and superstition, sanctity was in the air; in the twelfth century with the triumph of the Papacy and with the consolidation of the rule of law, sanctity began to decline.

Quite apart from the political aspect and the fact that Rome was the Papal See, the city of Rome still drew to itself the eyes of medieval mankind. In the early Middle Ages Rome was still the main centre of attraction for pilgrims, the city of St Peter and St Paul and the early martyrs. In the words of a late ninth- or early tenth-century poem, probably written at Verona:

> *O Roma nobilis, orbis et domina,*
> *Cunctarum urbium excellentissima,*
> *Roseo martyrum sanguine rubea,*
> *Albis et virginum liliis candida,*
> *Salutem dicimus tibi per omnia,*
> *Te benedicimus: salve per saecula.*
>
> *Petre, tu praepotens caelorum claviger,*
> *Vota precantium exaudi jugiter.*
> *Cum bis sex tribuum sederis arbiter,*
> *Factus placabilis judica leniter.*
> *Teque petentibus nunc temporaliter,*
> *Ferto suffragia misericorditer.*
>
> *O Paule, suscipe nostra precamina,*
> *Cujus philosophos vicit industria.*
> *Factus oeconomus in domo regia,*
> *Divini muneris appone fercula,*
> *Ut, quae repleverit te sapientia,*
> *Ipsa nos repleat tua per dogmata*[5].

Bishops went to Rome as a matter of course to receive the *pallium*, but the city was still a storehouse of antiquities and relics. Bishop Ulrich of Augsburg made two journeys to Rome, one in 910, the other in 952 or 953 to obtain relics. As will be seen the influence of early Christian Rome was still to be preponderant in Ottonian art. This profound genuflection before early Christian Rome, before

even the Rome of pagan antiquity, was not to cease with the tenth century. Archbishop Bernward, with his determined, almost painful, efforts to reflect monuments of antiquity at Hildesheim in the early eleventh century, Henry of Blois, Bishop of Winchester, buying antique statues in Rome in the middle of the twelfth century before the shocked gaze of his retinue, are only two examples of this almost constant medieval proskynesis before the majesty of Rome. St Bernard of Clairvaux was to remind his pupil, Pope Eugenius III – at a time when the Papacy was victorious over the emperors – of the inescapable historical fact that while the keys of his office had been inherited from St Peter, the purple was the legacy of the Caesars. The Roman point of view in the tenth century was rather different. To them the Saxon dynasty, which claimed to rule them, were foreigners. 'Otto had with him peoples and tribes whose tongues our people did not know.' And a Roman monk wailed: 'Woe to thee, Rome, that thou art crushed and trodden down by so many peoples; who hast been seized by a Saxon king and thy folk slaughtered and thy strength reduced to naught!' Without the Saxon king the fate of Rome might have been a great deal worse. When imperial power had been weakened by the Investiture Controversy, Rome was to learn once more the bitterness of conquest and destruction at the hands of the Normans.

As it was part of Ottonian policy to affirm the Carolingian heritage, so it was inevitable that architecture and the arts should develop from a Carolingian basis. Unfortunately, as far as architecture is concerned, the evidence is not easy to trace. Ground plans, excavations, ruins, all emphasize the Carolingian basis to Ottonian architecture; all the general types of building had been established in the Carolingian period, but it is probable that the Ottonian architects were working towards new conceptions of space and mass, new treatment of wall-divisions, galleries, apsidal permutations, tower-groupings which were to culminate in the imperial cathedral of Speyer in the middle of the eleventh century. Moreover, within the Empire already there is evidence of regional styles which were to become so characteristic of the late eleventh and twelfth centuries[6]. The great cathedral of St Maurice and St Catherine in

Magdeburg, the centre of Ottonian power against the Slavs, was begun *more romano* in 955 and, as in the Carolingian period, expensive materials were brought from Italy: columns, slabs of porphyry, marble and granite. Building continued until the middle of the eleventh century, although there were fires in 1008 and 1049, but the entire structure was burnt to the ground in 1208. The cathedral was presumably a columnar basilica with a double choir, a double transept, a pair of towers over the east transept, an atrium and a baptistery; there was a cycle of frescoes[7]. The cathedral of Mainz, undertaken by Archbishop Willigis (975–1011), has been described as one of the most difficult and obscure of all chapters in German architectural research. The building, probably a columnar basilica, was obviously of the greatest importance, if only for its size, but the cathedral was burnt to the ground on the day of its consecration in 1009[8]. The church of St Michael of Hildesheim was begun under Archbishop Bernward (993–1022) in 1001, completed in 1033, but partly destroyed by fire a year later. In this case the damage cannot have been so serious as a new consecration took place in 1035, but the church was entirely rebuilt in 1186. It is presumed that Archbishop Bernward's church was a triple-aisled basilica with a double choir, with apses at both ends, and that it provided the first example of a transept crossing the nave which was clearly defined as such[9]. The Benedictine abbey church of St Maximin of Trier, built between 934 and 952, was destroyed by French troops in 1674[10]. The cathedral of Bamberg was begun between the years 1004 and 1012, but it was almost entirely rebuilt in the thirteenth century. Of the convent of the Holy Trinity at Essen, only the west end is believed by some to date from the time of the Abbess Matilda (974–1011); the eastern crypt was probably undertaken by the Abbess Theophano (1039–1056), as it was consecrated in 1051, but from this time there survives only the west end, the crypt and the remains of the nave and transept[11].

A large number of the churches of Cologne owe their existence to Archbishop Bruno (953–965). St Andrew was begun by him and completed under Archbishop Gero (969–976), but it was rebuilt in the twelfth and thirteenth centuries[12]. The Benedictine abbey of

St Pantaleon was given a new church under Bruno's patronage which was consecrated in 980. The structure existing before the Second World War had been greatly altered, but it is believed that Bruno's church was a basilica including a choir with a crypt and eastern apse; the nave continued without interruption to the apse; the transept arms were entered by a double archway, the arch resting on a pier, and the transept had apsidal chapels; there was blind arcading both inside and out[13]. All this appears to have been completed by 990 and a westwork was finished shortly after, probably 1000–1005, as there was no apparent pause in the construction. The convent of St Maria im Kapitol was provided with new buildings by Archbishop Bruno, in which an altar was consecrated in 1049 by Pope Leo IX, but the whole was replaced between 1060 and 1065 and this structure has been greatly altered[14]. No certain reconstruction can be made of Bruno's work.

The Benedictine abbey of St Mary and St Mark on Reichenau-Mittelzell, founded in the ninth century under Abbot Hatto (806–823), was enlarged under Abbot Witigowo (985–987). The basilica was enlarged in the three years after his death. The west end was restored under Abbot Berno about 1030[15].

The convent of St Cyriakus at Gernrode, on the other hand, although it has been considerably restored, in its present state allows for some estimate of Ottonian architecture. Founded in 961 by the Markgraf Gero with the intention of emphasizing the spread of Christianity between the Elbe and the Oder, the church was held up by the death of Gero who was, nevertheless, buried there. The nave and western part were continued under the Emperor Otto II (973–983) and later by the Empress Theophano (d. 991). The 'new' elements in the structure of the church, which is basilical in type, are the thickening of the walls (Ill. 69, 70), allowing for semi-blind arcading on the outside – pilaster strips mounted by a simple arch, either round or gable – the alternation of columns and piers, the latter of considerable thickness, in the nave, and the use of galleries copied no doubt from the galleried basilicas of Rome, such as Sant'Agnese, built in the seventh century. There can be little doubt that these 'new' elements, which were to be of such importance in

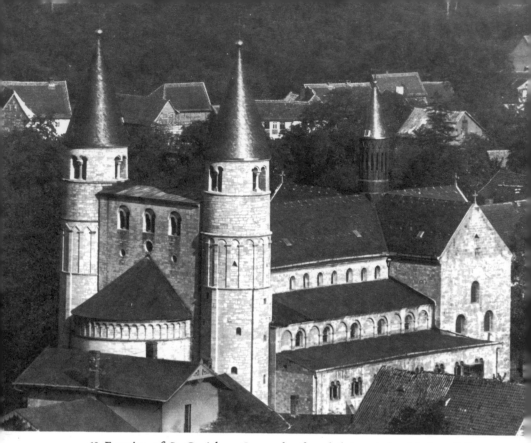

68 Exterior of St Cyriakus, Gernrode; founded in 961 by Markgraf Gero

the development of the architecture now called Romanesque, did
not necessarily originate at Gernrode nor were confined to that
church in the Ottonian period. The convent of St Maria auf dem
Münzenberg in Quedlinburg (986–1015/17) is believed to have been
a similar structure – it was also a three-storied church with galleries.
It has already been remarked that blind arcading is supposed to have
been a feature of St Pantaleon at Cologne; it is likely that the 'new'
elements were established elsewhere in the great imperial founda-
tions at Magdeburg and Mainz [16].

It is known that the cathedral of Magdeburg was decorated with
a cycle of frescoes, and this type of decoration was undoubtedly
common enough. One rather dubious cycle has survived, incom-
plete and grossly restored in 1880, in the Church of St George on

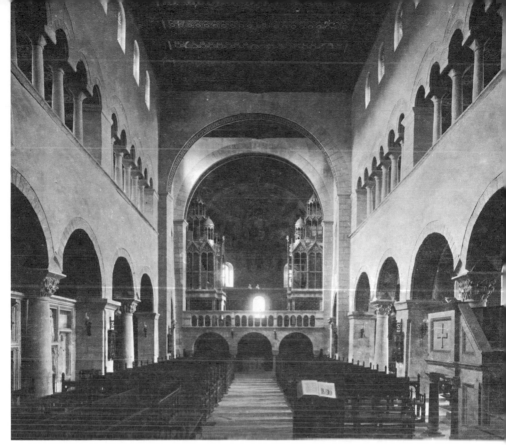

69 Interior of St Cyriakus, Gernrode; founded in 961

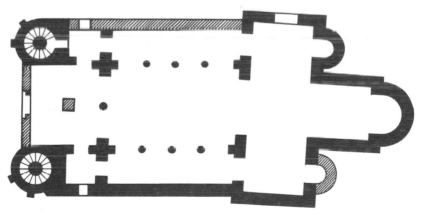

70 Plan of St Cyriakus, Gernrode

CIPIS ECCE FIDES V VADE

71 Fresco of Christ healing the woman with an issue of blood. Detail from the Raising of Jairus's daughter. Church of St George, Reichenau-Oberzell. Late tenth century (?)

Reichenau-Oberzell. The abbey church was built by Abbot Hatto III about 890 and the frescoes are developed from a style which appears to have been current at the nearby monastery of St Gall, at Konstanz or at Reichenau itself towards the end of the ninth century. A manuscript, now in Bern (Burgerbibl., cod. 264), of which the script may well be that of Reichenau[17], is decorated with figures in a style which forecasts that of the frescoes (*Ill. 72*), and with scenes in which single figures or groups are isolated against a neutral background and sometimes on a continuous ground-line. There is, so to speak, an emphasis on the space between the figures in a particular scene. Most scholars are agreed, however, that on general stylistic principles the frescoes in the church of St George are not earlier than the second half of the tenth century and, although the style of the frescoes (*Ill. 71*) is not particularly close to the style of the later 'Reichenau' manuscripts, the frescoes are characterized by a monumentality of form and a feeling of power within the form not to be

EXVRIT VICTRIX LEGIO QVAM MILLE COACTAM
Martiribus regina fidel animant inhosten
Nunc fortes focios parta plaude coronat
Floribus ardentiq; rubet uestiet oftro

DE PVDICITIA ET EST PA
RAGO
GE

72 Faith offers the Crown of Victory to the Martyrs and below, Modesty
in combat with Lust. Psychomachia of Prudentius, St Gall, Reichenau or
Constance; late ninth century

found in the Carolingian cycles at Müstair and looking forward to the art of the twelfth century. Indeed, two scholars would prefer to date the frescoes to the end of the eleventh century[18]. The figure of an Apostle (*Ill. 74*), on the other hand, in the apse of St Sylvester's chapel at Goldbach, near Überlingen, on the German shore of Lake Constance, comes very close to the style in which Evangelists may be depicted in 'Reichenau' manuscripts[19].

Perhaps the most impressive example of wall-painting to have survived from the Ottonian period is that in the apse of the little church of San Vincenzo at Galliano, south of Como. The church was restored by Ariberto da Intimiano, later Archbishop of Milan, and dedicated in 1007. An inscription records the date of consecration and the name of Ariberto, and his portrait, now in the Ambrosiana at Milan, once formed part of the decorations of the apse. There seems no reason to doubt, therefore, that the frescoes were executed either shortly before or shortly after 1007. The fresco in the apse has been described as 'one of the key works of Romanesque art'. A large standing figure of Christ in a mandorla is accompanied by Archangels (*Ill. 75*) holding scrolls with the words '*petici(o)*' and '*postulatio*' referring to the western concept of Christ as Supreme Judge of the tribunal before which mankind will be arraigned on the Last Day. Although the Archangels are wearing the *loros* of the Byzantine imperial regalia, there is no middle-Byzantine influence in the style of representation. The heavy features, dilated eyes, and the simplified though stressed drapery folds reflect Ottonian court art. The prophets Jeremiah (*Ill. 73*) and Ezekiel adoring this vision of Christ – the inclusion of Old Testament characters in a theophany may also be found in the ninth-century mosaics of Santa Maria in Domnica at Rome – are revealed with the same massiveness of effect, deliberate, stylized draperies, and an astonishing monumentality of form. Rome and the court art of Otto III are the sources of this style, not Constantinople where renewed Hellenism and re-affirmed naturalism were the fashion of the day[20].

The Carolingian basis for much of Ottonian manuscript illumination is made abundantly clear in a book of pericopes (Darmstadt, Landesbibl., Ms. 1948) made possibly at Reichenau for *Custos*

73 Fresco of Jeremiah at San Vincenzo, Galliano; about 1007

Gero – presumably Archbishop Gero of Cologne (969–976) – wherein the miniatures (*Ill. 78*), apart from the dedicatory portraits, are based on the Lorsch Gospels, executed for the Emperor Charlemagne at Aachen (*Ill. 76*) – one might expect for that reason the Gero Codex to have been copied at Lorsch, but the situation is complicated by other factors – and by the portraits of the Evangelists in the *Codex Wittikindeus* (Berlin, Staatsbibl., lat. fol. 1, fol. 1 verso) produced at Fulda in the late tenth century; these (*Ill. 77*) are ponderous rescripts of Carolingian court versions of the Ada type. The large initials, however, in the Gero Codex, filling a whole page and consisting of elegant, foliate scrolls and interlace in silver and gold against blue, green and purple grounds, show the influence of St Gall (*Ill. 79*). By the late tenth century, incidentally, the monks of St Gall had lost their pre-eminence in the arts and letters. Towards the middle of the century a general decline had set in: the

93

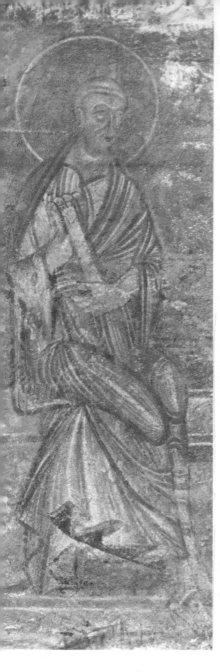

74 (*left*) Fresco of an apostle from St Sylvester's Chapel, Goldbach; late tenth century

75 (*below*) Fresco of an Archangel at San Vincenzo, Galliano; about 1007

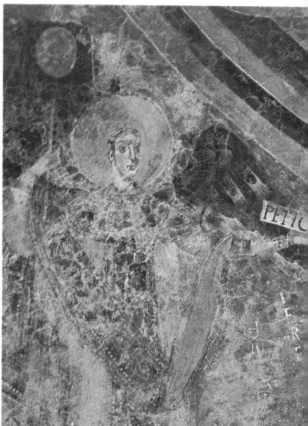

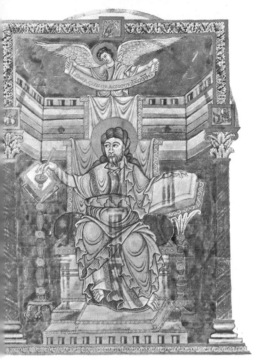

77 St Matthew from the *Codex
Wittikindeus* executed at Fulda;
late tenth century

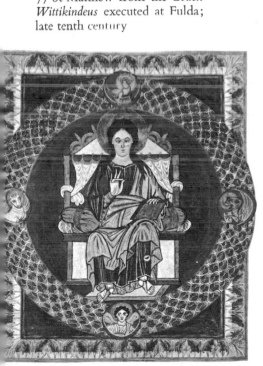

76 Christ in Majesty from the Lorsch
Gospels executed at Aachen in the
early ninth century

78 (*left*) Christ in Majesty from
the Book of Pericopes executed
at Reichenau (?) for Gero, Arch-
bishop of Cologne (969–976)

79 Initial *V* from Gero Codex.
Reichenau (?); about 969

successors of Abbot Salomon were men of inferior ability; the
Hungarians attacked the monastery in 925 or 926; there was a serious
fire in 937; the monks were subjected to Saracen raids; they refused
to co-operate with the attempts of Otto I to reform the monasteries
in the German lands and, as a result, were deprived of imperial
favour. Reichenau, on the other hand, benefited considerably from
privileges granted by the Ottonian Emperors and from Pope Gre-
gory V, who was a cousin of Otto III; the monastery was an imperial
abbey, whose abbot was subject only to the authority of the Emperor
and with a political rank equal to that of a bishop and even with an
archbishop; the monastery is believed by some scholars to have been
for a time the seat of the German chancery and, therefore, by impli-
cation the chief centre of imperial art. By the year 1000 Reichenau
was one of the leading ecclesiastical centres and according to one
inscription preceded Mainz, Trier and Cologne[21].

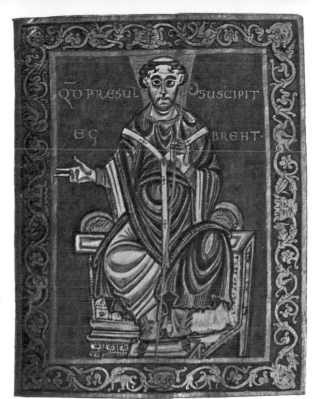

80 Egbert, Archbishop of Trier (977–993), from Egbert's Psalter given by Ruodprecht to the Archbishop of Trier about 983. Executed at Reichenau or Trier

The problem of artistic production at Reichenau is, nevertheless, highly complex, partly because manuscripts with a supposed Reichenau provenance present different stylistic phases, partly because aspects of these phases are visible in manuscripts which appear to have additional links with other centres, Trier, Cologne, Lorsch, Salzburg and Echternach, partly because the identity of some of the dedicatory portraits is not certain, and partly because when the dedicatory portrait is certain, it is clear that the patron has sponsored at least two different styles. These elements of doubt are, of course, grist to the mill of erudition and expertise. One scholar has maintained that the names Eburnant, Ruodprecht and Liuthar, which previously have served to denote different phases of the Reichenau output, have nothing to do with that monastery. The Psalter, now in Cividale, given by Ruodprecht to Archbishop Egbert of Trier (977–993), imperial chaplain and Chancellor of the Empire (*Ill. 80*) (it has been presumed when the Archbishop visited Reichenau on

his way to, or on his way back from the Council of Verona in 983), has been denied to that monastery on stylistic and palaeographical grounds and because the Psalter contains fourteen portraits of Egbert's predecessors at Trier, the dedicatory inscription refers to St Peter (and St Peter was the patron saint of the cathedral and diocese of Trier) – Ruodprecht is to be identified as the 'choir-bishop' and archdeacon of Trier. Another scholar, of greater eminence than the first, has seen no palaeographical objection to a Reichenau provenance and has pointed out that the order of Egbert's predecessors is so peculiar as to preclude a Trier provenance, and that the initial ornament in the Egbert Psalter is related to the style of the Eburnant group, which is the first phase of the 'Reichenau' style. But the first scholar maintains that Eburnant was a *praepositus* of Hornbach, and a third scholar that he was possibly at Fulda although with connexions either at Reichenau or at Trier. The debate is by no means concluded. One way out of the impasse would seem to be a comprehensive scrutiny of all the manuscripts concerned on palaeographical grounds; this has not yet been done. There can be no doubt of the divergencies in style in these 'Reichenau' groups. In quality Egbert's Psalter is considerably higher than that of Gero's Codex, part of the Eburnant group, and the fact that Egbert is shown with a square nimbus suggests that the artist or his patron was familiar with monuments at Rome, but the forms, built up into essentially linear effects and set sometimes against a background of writhing, self-gnawing beasts, are essentially retrograde in spirit, and resistant to the Mediterranean heritage of which Egbert was keenly aware. The style of the initials in the Egbert Psalter is certainly dependent on the style of manuscripts executed at St Gall. Moreover, a third manuscript, a Book of Homilies, with decorated initials in the same style, now at Karlsruhe (Aug. XVI), is known to have come to that city direct from Reichenau[22].

The Trier v. Reichenau hypothesis is complicated by the fact that the second manuscript, made about 985 for Archbishop Egbert, the *Codex Egberti*, a book of pericopes now at Trier, contains no liturgical indications that Trier was the place of manufacture, but it does contain portraits of two monks of Reichenau, Keraldus and

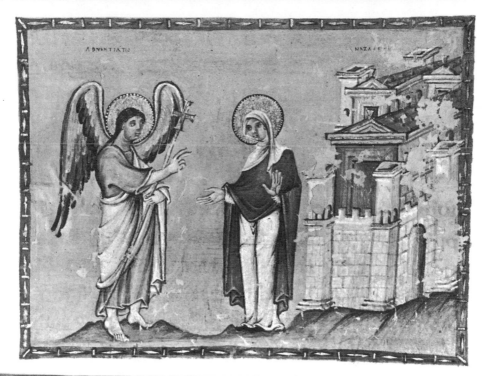

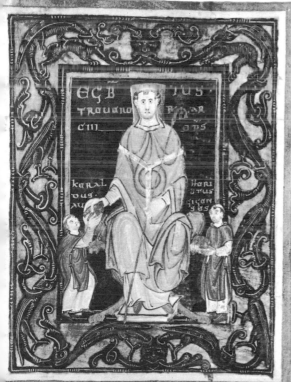

81 (*above*) The Annunciation by the Master of the *Registrum Gregorii*; about 983

82 Egbert, Archbishop of Trier (977–993), presented with the *Codex Egberti* by two monks of Reichenau, Keraldus and Heribertus. Reichenau or Trier

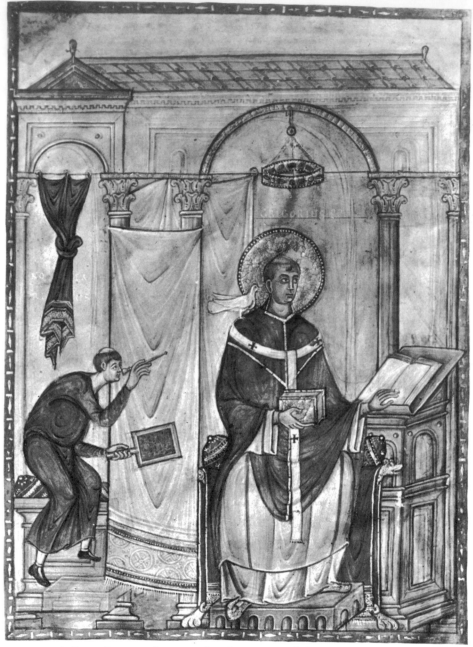

83 Pope Gregory the Great by the Master of the *Registrum Gregorii*.
Presented by Archbishop Egbert to the Cathedral of Trier, about 983

84 Otto II or Otto III enthroned receiving the homage of the personifications of the four parts of the Empire, Germania, Alemannia, Francia and Italia, by the Master of the *Registrum Gregorii*. From a copy of the Registrum Gregorii presented by Archbishop Egbert to the Cathedral of Trier; about 983

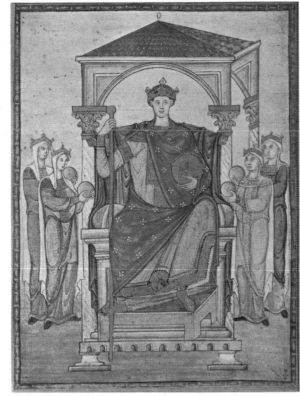

85 (*below*) Otto III enthroned receiving the homage of the four parts of the Empire, Slavinia, Germania, Gallia and Roma, from the Gospel book of Otto III. Reichenau or Court School of Otto II; 997–1000

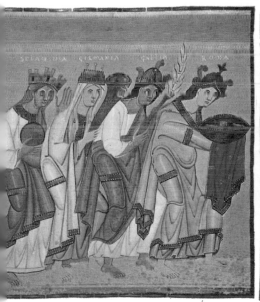

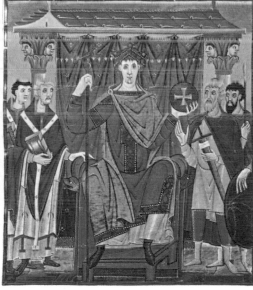

Heribertus, offering the book to Egbert (*Ill. 82*). The fact that these monks are described as being of Reichenau might mean that they were working away from the monastery, but the complication is increased by the differences of style in the manuscript itself. The illustrations of the manuscript, which provide an extensive series of scenes from the Life of Christ for which no Carolingian model is known and which are certainly based on a late antique manuscript, probably a Roman manuscript of the fourth or fifth century close to the Vatican Virgil and the Quedlinburg Itala-fragment, are the work of at least three, possibly more, artists; one appearing to have some knowledge of contemporary Byzantine illumination, another adapting the late antique model to serve the more typical 'Reichenau' idiom of rather flattened form, conceptualized draperies and expressive gesture and another, almost universally identified as the Master of the *Registrum Gregorii*, who executed six scenes with a profound understanding of late antique forms, draperies and illusion of space. In the representation of the Annunciation (fol. 9 recto) (*Ill. 81*), for example, the Angel and the Virgin stand on gently undulating ground outside the walled, late Roman town of Nazareth against a pale blue, slightly clouded sky. The forms, for all their late tenth-century cast, reveal a sense of modelling beneath the drapery which is touched-in with some feeling of depth, and the whole scene looms out of the soft blue light in a remarkable evocation of the late antique original. Now it is certain that the Master of the *Registrum Gregorii* worked for some time at Trier, but the fact remains that the monks in the dedicatory miniature came from Reichenau, the Master of the *Registrum Gregorii*'s style was not adopted in the later 'Reichenau' group of manuscripts, and some very characteristic animal ornament in gold on a purple ground links together the Psalter of Egbert, the Codex of Egbert, and indeed the Liuthar group of manuscripts, which is the name given to the last phase of 'Reichenau' production and which includes the grandest of them all[23].

The copy of the *Registrum Gregorii* from which the Master derives his name was presented by Archbishop Egbert to the Cathedral of Trier shortly after 983. The codex is now lost, but two miniatures from it are divided between the Stadtbibliothek at Trier and the

Musée Condé at Chantilly. The first (*Ill. 83*) reveals Pope Gregory the Great at his desk inspired by the Holy Ghost. When the Pope was dictating his homilies on Ezekiel, a curtain was drawn between Gregory and his secretary. As there were long periods of silence the secretary made a hole in the curtain through which he saw a dove seated upon Gregory's head with its beak between his lips. When the dove withdrew its beak the Pope began to speak and the secretary took down the words, but when he became silent again the secretary again looked through the hole in the curtain and saw that the dove had replaced its beak between the lips of the Pope (Paul the Deacon, *Vita*, xxviii). The second miniature (*Ill. 84*) portrays Otto II or Otto III enthroned (Otto II died in 983; Otto III was aged three at the time) and attended by the personifications of the four parts of the Empire, Germania, Alemannia, Francia and Italia. In both miniatures the grasp of form beneath the draperies, the handling of space, the recession of planes, the use of light and of graded tones establish a landmark in the history of early medieval art. There can be no doubt, judging from the *Codex Egberti*, that the artist had studied late antique models – the representation of the Emperor may well have been copied from a portrait of a Theodosian prince – but the figure of St Gregory suggests that he also knew various paintings and mosaics in Rome. It has even been proposed that at some time he had stood before the eighth-century icon of the Virgin crowned as Queen (*Ill. 21*) in the Church of Santa Maria in Trastevere[24]. The hypothesis has also been advanced that this Master should be identified as one Johannes Italicus or Johannes pictor who was summoned by Otto III to decorate the walls of Aachen Cathedral and later worked at Liège. 'Otto', he lamented in an inscription, 'took me away from the cradle of my fatherland'. It is unlikely that this hypothesis will ever be confirmed, but it is more important to note the emphasis on imperial initiative, the switching of artists from one part of the empire to another, and the fact that the style of the Master of the *Registrum Gregorii* was to have considerable influence in the valley of the Meuse. The bishoprics of Metz, Toul and Verdun were all subject to the Archbishop of Trier; it seems probable that Mosan artists of the eleventh and twelfth centuries had

studied the work of the Ottonian master – the forms and treatment of the drapery in Mosan art are in part a development of the style of the Master of the *Registrum Gregorii* [25].

It has already been pointed out that whether this Master worked at Reichenau or at Trier during the preparation of the *Codex Egberti*, his style was not developed in the former locality. The artists at Reichenau, preferably perhaps the artists sponsored by the imperial court, evolved an idiom which, however much it was based on late antique and Carolingian models and whatever it owed to the personality and theocratic ideas of Otto III, carried transcendentalism to an extreme. A Byzantine artist of the late tenth century, such as those working on the Menologion of Basil II at Constantinople about 985, and certainly a Byzantine patron, like the Emperor Constantine VIII, would have regarded the later 'Reichenau', or the later imperial, style as quite *outré* and provincial. In the Gospel Book of Otto III (*Ill. 85*) now in Munich (Staatsbibl., Clm. 4453), Otto III is revealed receiving the homage of the four provinces of the Empire, but this time they are Sclavinia, Germania, Gallia and Roma; on his right two ecclesiastics, on his left two soldiers represent the Church and the Army. The livid faces of the young Emperor, the clergy, Rome and Germania, contrast with the light tan of the Army and the healthy brown of Sclavinia and Gallia, but it would be rash to push the symbolism of these contrasting tones too far. The marked schematization of the forms and colours, especially those of the Provinces – all human aspect seen in a geometric abstraction – is in contrast to the style of the Master of the *Registrum Gregorii*, although the spreading of the scene of homage over two pages may be compared in general with the juxtaposition of Gregory and Otto. In the latter case the implication was the glory of the combined rule of Emperor and Pope. Both sets are intended to serve as a dialectical epiphany of imperial power. The former dates presumably after Otto's victory over the Slavs in 997 and reflects the triumphant words of Gerbert of Aurillac writing probably from Reichenau on 26th December 997 to his Emperor; 'Ours, ours is the Roman Empire. Italy, fertile in fruits, Lorraine and Germany, fertile in men, offer their resources and even the strong kingdoms of the Slavs are

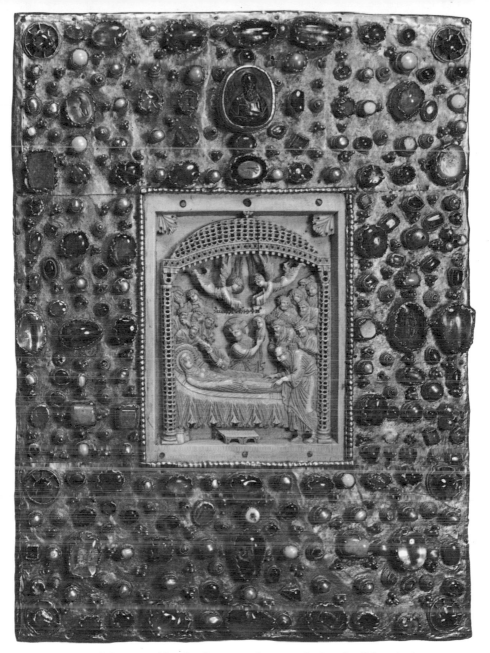

86 Cover of the Gospel book of Otto III showing the Death of the Virgin.
Ivory panel executed at Constantinople in the late tenth century set with
classical intaglii, Byzantine bloodstones, pearls and precious stones in filigree
on a gold ground; about 1000

not lacking to us. Our august emperor of the Romans art thou, Caesar, who, sprung from the noblest blood of the Greeks, surpass the Greeks in Empire and govern the Romans by hereditary right, but both you surpass in genius and eloquence.' [26] Such a scene had a number of precedents in Carolingian imperial manuscripts, but in a second Gospel Book of Otto III, offered to him by a certain Liuthar, produced probably about 990, now in the Cathedral Treasury at Aachen, the page portraying the Emperor (*Ill. 87*) not only refers to St Augustine's commentary on Psalm 90 – the 'imperial' Psalm *par excellence* – but illustrates a loftier concept of government by Divine Right. Otto III is crowned by the Hand of God, raised up by Earth, attended by two subject kings and the representatives of Church and State. In addition, he is enthroned in a mandorla, like Christ in Majesty, accompanied by the symbols of the Evangelists. The veil across the breast of Otto has been variously interpreted, but it is probably a scroll and refers to the inscription on the opposite page: *Hoc Auguste Libro Tibi Cor Deus Induat Otto* (With this book, Otto Augustus, may God invest thy heart). Charlemagne had always insisted on rendering to God the things that were God's and, in spite of the hyperbole of his courtiers, was essentially pragmatic about his position; Otto III had a more mystical approach. Otto III was truly *christomimetes*, the impersonator and actor of Christ. The invisible Christ in heaven was made manifest in the *christus*, the Anointed, on earth. The two natures of Christ were transferred to the Emperor; the Emperor was Christ on earth. The idea of imperial *christomimesis* is Byzantine. Such views of imperial action go back to Eusebius of Caesarea, the contemporary and biographer of Constantine the Great. With the help of the Logos, he wrote, the Emperor Constantine, God's friend, wears the image of the highest kingship; he imitates God, he steers and stands at the helm of all earthly things. But no Byzantine Emperor was represented in the manner of Otto III. Indeed, the Byzantine court would have thought such a representation both *outré* and bizarre. Such telescoping of the natural with the supernatural order was to them deplorable [27].

The Gospel book at Munich with its magnificent cover (*Ill. 86*) – a wide frame of dull gold erupting into filigree mounts for pearls,

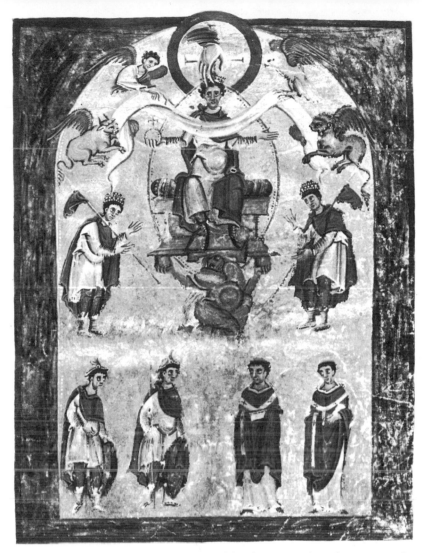

87 Otto III *Christomimetes* from a Gospel book presented to the Emperor by Liuthar. Reichenau or Court School of Otto III; about 1000

classical intaglii, Byzantine bloodstones, encasing a Byzantine ivory relief still with traces of gold leaf and carved with a representation of the Dormition – epitomizes much of Ottonian art. The book is again lavishly illustrated with scenes from the Gospels in contrast to Carolingian manuscripts which have survived, scenes portrayed with

88 Christ's entry into Jerusalem from the Gospel book of Otto III; about 1000

89 (*opposite*) Cover of the Book of Pericopes executed for King Henry II and given by him to the Cathedral of Bamberg, probably for the consecration in 1012

great power and dignity in an atmosphere diametrically opposed to that of late antique illusionism. Gone is the multifarious activity of Divine and human beings in an illusion of landscape typified by the Utrecht Psalter. In spite of the coldly ecstatic representations of the Evangelists, the narrative scenes, unlike the late antique models on which they are based, are presented as a quasi-liturgical act, dialogues of divinity, divided sometimes into two parts, half the scene on one page, half on another, the division sometimes emphasized by the architectural framework. Scales differ according to the importance of the persons of the drama; landscapes when they occur are improbable; colours are not 'naturalistic', but are mystically appropriate to a solemn theme concerned with mysteries, visions and the fulfilment of God's purpose by God incarnate. In the Adoration of the Magi (*Ill. 90*) the scene has become a sublime moment, antiphonally expressed, of earthly wisdom and majesty adoring the infant God. In

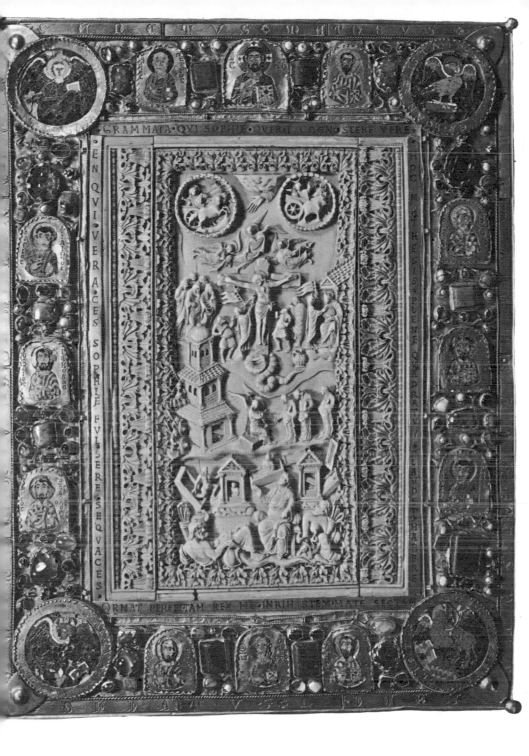

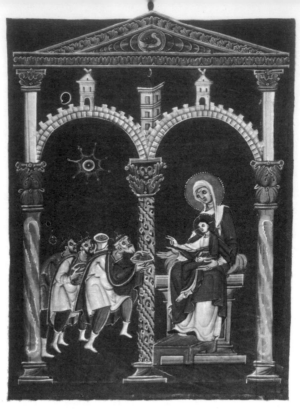

90 Adoration of the Magi from the Gospel book of Otto III; about 1000

the Entry into Jerusalem (*Ill. 88*) the joyous acclamation of the people is subdued, dominated by the sombre figure of Christ gazing with dilated eyes bestride a doom-laden donkey. The earthly incidents of the life of Christ have been swallowed up in a drama which hurled God from worldly acclamation down to the Harrowing of Hell. Emphasis is not so much on movement as in gesture and glance; there is a marked rhetorical aspect to Ottonian art. Christ, incidentally, is beardless, which again points to the use of a late antique illustrated Gospel cycle without recourse to a ninth- or tenth-century Byzantine intermediate model. The portraits of the Evangelists (*Ill. 91*) have been compared to the figure of Atlas supporting the heavens, but perhaps more they are evocations of a mystic grasping to himself the powers and dominions of Divinity; the transcendental cloud, loaded with prophets and kings and heavenly messengers,

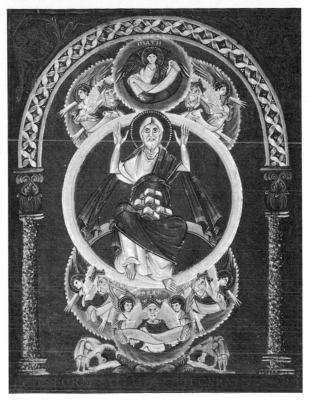

91 St Matthew from the Gospel book of Otto III; about 1000

the New Testament proceeding from the Old, is drawn down to the breast of the visionary and at the same time revealed to the eyes and hearts of the spectators[28].

These characteristics become more exaggerated in a Book of Pericopes (Munich, Staatsbibl., Clm. 4452) executed for King Henry II between 1002 and 1014 before he was crowned Emperor and given by him to the Cathedral at Bamberg, probably in 1012, the year of consecration. The cover of this large book (*Ill. 89*) is equally splendid. On a gold base a series of Byzantine enamels, possibly part of a votive crown, set in no proper sequence, four western enamels, probably produced at Regensburg – roundels containing symbols of the Evangelists – pearls and precious stones frame a Carolingian ivory panel; on the back, a silver and silver-gilt panel contains roundels with representations of the Agnus Dei and per-

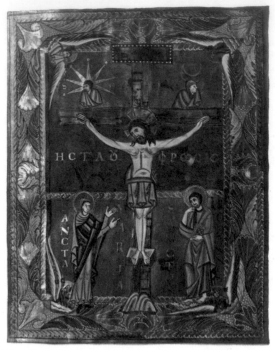

92 The Crucifixion from King Henry II's Sacramentary;
1002–1014

sonifications of Justice, Prudence, Fortitude and Temperance. The
narrative miniatures are nearly all on a partially gold ground and
range through pale, luminous tones of purple, blue, tan, yellow,
green and pink. The figure-style has become more monumental,
more rarified and sublime, at the same time thin in density, insub-
stantial, mere silhouettes of colour against a shimmering void. The
visit of Christ to the house of Martha (fol. 162 recto) becomes a
strange, mysterious event (*Ill. 96*) rather than a domestic incident,
an event outside Time involving the solemn, frozen participation
of paradigms of persons. But the mystical mode of thought is best
represented, perhaps, by the confrontation of the Holy Women at
the Sepulchre (*Ill. 93*) by the Angel of the Resurrection (fol. 116
verso, 117 recto). Out of the golden void awe, mystery, hope and
Divine power made manifest through His ministers, are revealed
by a few terse lines and some clear pale tones[29].

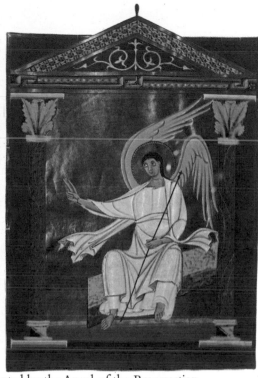

93 The Holy Women at the Sepulchre confronted by the Angel of the Resurrection from King Henry II's Book of Pericopes; 1002–1014

The dedicatory page (fol. 2) presents against a gold ground a beardless Christ crowning King Henry II and Queen Kunigunde between St Peter and St Paul, the patrons of Bamberg, and with personifications of the provinces below (*Ill. 94*). The royal pair wear German crowns but quasi-Byzantine court costume. On the whole, however, there is little Byzantine influence in the representation of this imperial epiphany, as may readily be seen when compared with the dedicatory page (fol. 11 recto) of a Sacramentary executed for Henry II at Regensburg (Munich, Staatsbibl., Clm. 4456). Here again Henry is crowned by Christ (*Ill. 95*) but this time attended by angels and supported by ecclesiastics. The head of Christ is completely in the Byzantine idiom, although the highly complex coloured backgrounds and frames introduce something quite new in manuscript illumination and have nothing to do with Constantinople. There is a lavish use of gold in the ornament, in the back-

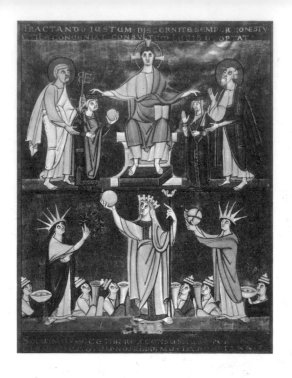

94 Christ crowning King Henry II and Queen Kunigunde between St Peter and St Paul, the patrons of Bamberg. Below are the personifications of the Empire. King Henry II's Book of Pericopes; 1002–1014

95 Christ crowning King Henry II attended by angels and supported by the Church. King Henry II's Sacramentary; 1002–1014

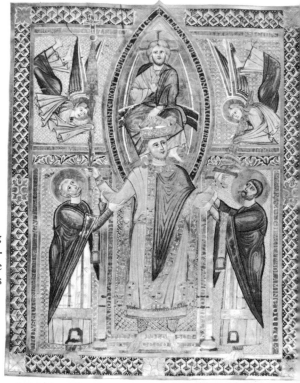

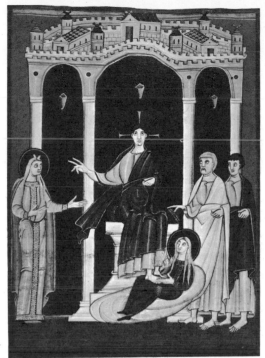

96 Christ in the house of Martha from King Henry II's Book of Pericopes.
Reichenau or Court School of King Henry II; 1002–1014

ground to Christ's mandorla and on Henry's buskins. This use of
gold and a second portrait of Henry II (fol. 11 verso) recall the
Codex Aureus of Charles the Bald, which had long been in the
monastery of St Emmeram at Regensburg, but once more all the
faces in the miniature have a strong Byzantine cast. The head of
St Gregory on another page (fol. 12 recto) looks almost as if it had
been added later by a Byzantine artist. Judging, however, from the
Crucifixion scene (fol. 15 recto) with its mixture of Latin inscrip-
tions and oddly spelt Greek (*Ill. 92*) it seems that a western artist
was trying to synthesize Byzantine and Carolingian models. The
series of highly decorated letter pages with script in gold and large
foliate borders, reminiscent of St Gall, the renewed emphasis on
the integration of script and ornament, suggest backward glances at
more than one Carolingian model[30].

The artistic life of Regensburg was centred on two Benedictine
establishments: St Emmeram and the nunnery of Niedermünster.

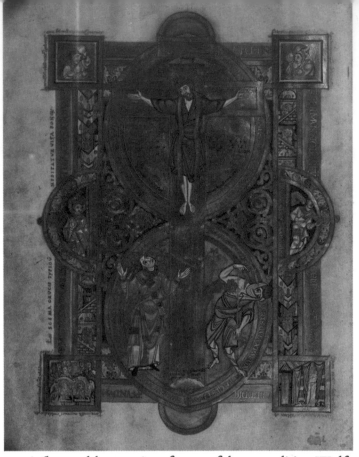

This life was influenced by a series of powerful personalities, Wolf-
gang, first Bishop of Regensburg (972–994), Ramwald, Abbot of
St Emmeram (975–1002), and the two Abbesses Uota of Nieder-
münster (c. 975–995? and 1002–1025). The bishop and the abbot
were cousins; they had served at St Maximin of Trier and were
colleagues of Archbishop Egbert of Trier. The second Abbess Uota
was evidently a woman of considerable intellectual abilities and
exacting taste. The Gospel book made for her contains a represen-
tation of St Erhard celebrating Mass before the *ornamenta palatii* of
the Carolingian house (*Ill. 97*) with Arnulf's ciborium, the *Codex
Aureus* of Charles the Bald, a votive crown and a silk antependium
decorated with winged horses decked with Sassanid ribbons. St Er-
hard wears a curious mitre like a turban (his robes, in fact, are sup-
posed to be those of a priest of the Old Testament); according to the

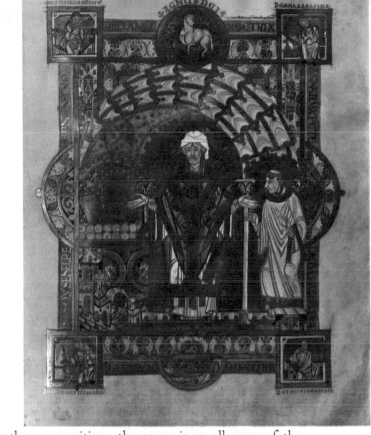

97 Christ on the Cross between personifications of Life and Death, and St Erhard celebrating the Mass before the *ornamenta palatii* of the Carolingian House. Gospel book of the Abbess Uota of Niedermünster (1002–1025)

texts included in the composition, the scene is an allegory of the triads of the ecclesiastical hierarchy described by the Pseudo-Dionysius in the Latin translation of John Scotus Erigena, produced at Saint-Denis in the ninth century; the vessels of the Mass, the priest and the acolyte represent three degrees of approach to God. Both priest and acolyte are drawn with curved lines which sweep down to the knee-joint and then articulate the leg, reminiscent of Roman wall-paintings of the time. There is again a lavish use of gold: gold background, many details of dress and ornament in gold, only a few red lines prevent parts of the figures from merging into the sheet of gold. Scripts and texts are an integral part of the pattern. Christ on the Cross, for example crowned as King and stoled as a priest, is represented between personifications of Life and Death and against a network of diagrams, texts and antitheses by which the four

phases of the Redemption ranging from the Fall of Adam to the immolation of God as Man are compared to the four basic figures of geometry, the four elements of music, and so on. The codex of the Abbess Uota consists in fact of a series of glossed theological pictographs devised apparently by a theologian called Hartwic, who had studied under Fulbert of Chartres and who was living at Regensburg at the time the Gospel book was undertaken. Before these pictographs the onlooker was expected to be overwhelmed by the splendour of the materials used, the order of design, the reverence for holy things and scholastic learning; measured piety without enthusiasm, awe without ecstasy, and ceremony without histrionics. Here, for the first time, it has been remarked, the miniature is put to the service of scholastic philosophy; it reflects the clear system of the *Summa theologica* and the entire range of encyclopaedic learning of the time. Once again this order of design was to be copied later by twelfth-century artists in the Meuse valley; the whole book heralds certain aspects of an art which is usually called Romanesque[31].

It has been noticed that a 'Reichenau' manuscript was presented to a certain Gero, who was later Archbishop of Cologne (969–976). Under Archbishop Heribert (999–1021), a close friend of Otto III and for a time Chancellor of Italy, the links with 'Reichenau' were maintained. During his episcopate two monks from 'Reichenau' – *'non solum spiritu sed etiam carne germani'* – Purchardus and Chuonradus were invited to Cologne to write and illustrate a Gospel book for the Cathedral (Cathedral Treasury, cod. 12). Apart from the initials, which are the work of a local calligrapher, the remainder of the manuscript is in the imperial court style (*Ill. 100*). Later manuscripts produced at Cologne, however, show a mixture of Byzantine and court influence. There can be no doubt that the artists of the Cologne school had knowledge of tenth- and eleventh-century Byzantine manuscripts. Archbishop Heribert, himself, was in close touch with the Greek ascetics who had so much influence over Otto III towards the end of his life. Throughout the Middle Ages Greek merchants were constantly in Cologne; later, indeed, in the eleventh century a small Psalter and Song of Songs of good quality was ordered at Constantinople for the Church of

98, 99 (*left, right*) Abbess Hitda (978–1042) offering the codex to St Walburgis, and the Marriage at Cana from the Hitda Gospel book

St Gereon (Vienna, Nationalbibl., theol. gr. 336). Consequently it is not surprising that in a codex (Darmstadt, Landesbibl., cod. 1640) ordered at Cologne by Abbess Hitda of Meschede (978–1042) the miniature representing the Abbess offering the Gospel book to St Walburgis (*Ill. 98*) portrays the saint in quasi-Byzantine idiom, while the majority of the narrative scenes are painted in a free, sketchy version of the imperial style. The style of Abbess Hitda's Gospel book is a unique expression of different cultures fusing together – miniatures such as the Marriage of Cana (*Ill. 99*) or Christ asleep during the storm on the Sea of Galilee (*Ill. 101*) are isolated from the mainstream of development at Cologne during the eleventh century, which held to painstaking rescripts of 'Reichenau' evangelist portraits or imitations of the work of the Master of the *Registrum Gregorii*[32].

Archbishop Heribert did not get on particularly well with the Emperor Henry II, and Cologne was deprived for a time of the imperial patronage from which it had benefited under the Ottos. Henry II devoted his own patronage to 'Reichenau' and Regensburg, to Bamberg and Basle. Henry III (1039–1056) was interested in Speyer and Goslar, but the manuscripts executed under his command at Echternach may be treated here, as they are, so to speak, the final flowering of the Ottonian schools. Under Abbot Humbert (1028–1051), who had been sent from the Abbey of St Maximin of Trier by Poppo of Stavelot, Abbot of St Maximin and Chancellor of the Emperor Conrad II, the monastery of Echternach was reformed according to the Cluniac discipline. However, the Cluniac reforms, in spite of their influence at Hirsau in Swabia, had no permanent success in Germany. After 1038, when Cluny began to show strong anti-imperialist tendencies, the court, not surprisingly, no longer supported the reform. A number of the German bishops objected to their authority being overridden by the abbots of Cluny. At the same time it should be stressed that the German emperors were as determined as Cluny on the necessity for reform. One of the immediate tasks of Henry III, for example, was to reform the Papacy itself. The dissolute life of Pope Benedict IX, the scandal of an anti-Pope, Sylvester III, set up by the Crescentii, a patrician family of Rome, the sale of the Holy See by Benedict IX to John Gratian, who became Gregory VI, had produced a deplorable tangle which needed a powerful authority to unravel it. At the Council of Sutri the Emperor Henry III sacked three Popes. With the election of Bishop Suidger of Bamberg as Pope Clement II in 1046, Henry III did not necessarily intend to make the Pope subordinate to the Emperor. He wanted a strong leader prepared to enforce reform, a Papacy freed from the intrigue of Roman factions, whose prestige was enhanced, not diminished by imperial support. After a reign of nine months and sixteen days Pope Clement died suddenly – so suddenly that there were rumours of poison – but the events of the last few months of 1046 had brought a phase of medieval history to a close. From this time the power of the Papacy, backed by Cluny, was to increase until it finally overcame the secular authority that had raised it up[33].

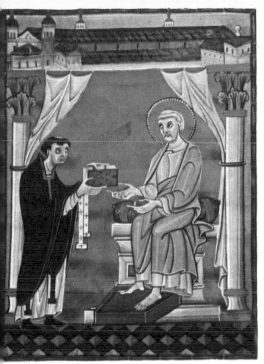

100 Canon Hillinus offers the codex to St Peter. The Hillinus Codex, which was intended for the altar of St Peter in Cologne Cathedral, was produced by two monks, Purchardus and Chuonradus working in the Reichenau or Court style at Cologne in the early eleventh century

101 Christ asleep during the storm on the Sea of Galilee from Abbess Hitda's Gospel book. Abbess Hitda (978–1042)

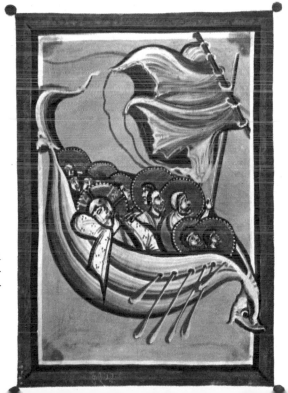

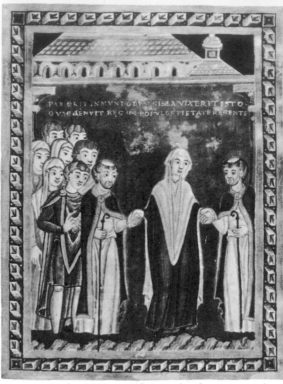

102 The Empress Gisela visiting Echternach, from a Book of Pericopes executed at Echternach between 1039 and 1043

Henry III, early in his reign, made a visit to Echternach with his mother, the Empress Gisela (d. 1043). Abbot Humbert showed him what is now known as the *Codex Aureus Epternacensis*, at present in the Germanisches Museum at Nuremberg, and Henry was so impressed that he proceeded to commission manuscripts from the scriptorium. A book of pericopes now at Bremen (Stadtbibl., Hs. b. 21), executed between 1039 and 1043, contains two miniatures showing the visit of Henry III and Gisela: Henry III accompanied by Abbot Humbert and probably Abbot Poppo of Stavelot, Gisela supported by the same abbots and followed by a mixed retinue (*Ill. 102*). This manuscript was followed by the *Codex Aureus* made for Speyer Cathedral, now in Madrid (Escorial Lib., cod. Vitrinas 17), which contains an inscription referring to King Henry III and Queen Agnes of Poitou as father and mother and must therefore allude to a date after the birth of their first child, Matilda, in the

autumn of 1045 and before his coronation as Emperor by Pope Clement II at Christmas 1046. A *Codex Caesareus* was presented to Goslar Cathedral at its dedication in 1050 or shortly after (Uppsala, Univ. Bibl., C93). Finally, a Gospel was commissioned by an Abbot Gerhard of Luxeuil for a church of St Peter, whose precise location is uncertain, but the commission is of interest, since it shows that a Burgundian abbot was well aware of the importance of the current imperial workshop.

The Bremen book of pericopes, of fairly modest proportions, is partly based on the miniatures in the *Codex Egberti* and the imperial style, including that of the Master of the *Registrum Gregorii*, as practised at Trier dominates the scriptorium. But it is clear from the *Codex Aureus Epternacensis* that the scriptorium had before it models from various Carolingian schools, of which Tours is perhaps the most important. Both in style and iconography the Bible made for Count Vivian at Tours seems to have served as a basis. It has been observed, moreover, that the *Codex Aureus* of Speyer was also influenced by models from Tours. In addition, the purely decorative pages owe something to the patterns on Byzantine silks (*Ill. 105*) or western textile interpretations of such silks. Although all the Echternach manuscripts of this period are remarkable for the lavishness of their decoration, the richness of colours and the monumentality of forms, the *Codex Aureus* of Speyer, the work of six artists, is by far the most splendid. This magnificent codex, an imperial gift, at the height of German imperial power, to the greatest church in the Empire, the pantheon of the Salian emperors, should be regarded as one of the key works of early medieval style. The figure of Christ in Majesty (*Ill. 104*) adored by the Emperor Conrad II and the Empress Gisela is portrayed with a new grandeur and monumentality of form, a new power and subtlety in the treatment of the drapery and the disposition of folds, for all its partial dependency on a Carolingian model. This treatment of drapery and disposition of fold was to be caricatured by artists of different regions and nationalities in the late eleventh and twelfth centuries. The monumentality of form is such, that it should be remembered that no fresco decoration in the great imperial foundations has survived from the

103 King Henry II and Queen Agnes offering the codex to the Virgin from the *Codex Aureus* of Speyer, executed at Echternach between 1045 and 1046

middle of the eleventh century; if it had, it may be suspected that much that seems surprising in what is known as Romanesque art might cease to be so. It seems, moreover, probable that in the dedicatory miniatures showing the Emperor Conrad and the Empress Gisela adoring Christ, and King Henry III and Queen Agnes offering the book to the Virgin (*Ill. 103*), a Byzantine artist contributed to the work. The heads of Christ, the Virgin and the head of the symbol of St Matthew at the base of Christ's mandorla are painted in a totally different tradition which was not followed at Echternach in subsequent productions. It may be that this additional work was done after the codex had left Echternach and was the property of Speyer Cathedral. A clear proof of the importance of imperial patronage at this time is given by the output of Echternach after the death of Henry III. Although scholarly standards were maintained until the death of Abbot Thiofrid (1081–1108), the size of the books undertaken was immediately reduced and there is a general decline in artistic standards[34].

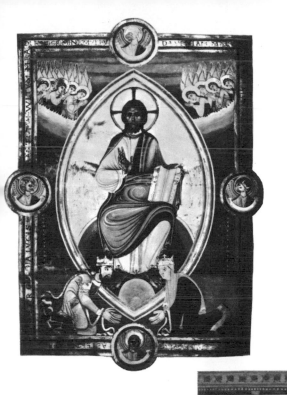

104 Christ in Majesty adored by the Emperor Conrad II and the Empress Gisela from the *Codex Aureus* of Speyer executed at Echternach between 1045 and 1046

105 A page of decoration based on a textile from the *Codex Aureus Epternacensis* which was executed at Echternach about 1040

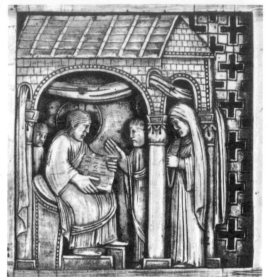

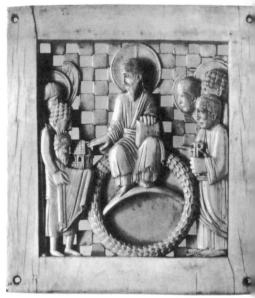

106 (*left*) Christ teaching in the Temple. An ivory panel from the so-called Magdeburg Antependium, probably North Italian; tenth or early eleventh century

107 (*right*) An emperor offering a church to Christ. An ivory panel from the so-called Magdeburg Antependium, formerly in the Abbey of Seitenstetten

Attempts have been made to relate various groups of ivory carvings and metalwork to workshops at Reichenau, but these have not met with general acceptance. The first group of ivory carvings, sixteen panels now scattered among a number of collections, is the so-called Magdeburg Antependium. One panel from this complex, carved with a representation of Christ teaching in the Temple (*Ill. 106*), was incorporated at a later date with three others – carved with the *Traditio Legis*, the Raising of Lazarus, and Jesus Giving Instruction for the Feeding of the Multitude – into the cover of the *Codex Wittikindeus* (Berlin, Staatsbibl., lat. fol. 1), and it is believed that this panel was previously fixed to a silver-gilt book cover decorated with a number of saints – all with particular significance for Magdeburg – and bearing an inscription stating that Archbishop Engilhardus ordered it to be made. Engilhardus was Archbishop of Magdeburg (1052–1063), and this cover must date,

therefore, from the middle of the eleventh century. The number and the shape of the panels surviving is such that it seems unlikely that they were first intended as book covers but rather for some complex like an antependium. The panel must date, therefore, before Engilhardus's book cover and yet was probably at hand in Magdeburg at the time. A second panel, part of the same complex, formerly in the Abbey of Seitenstetten, Lower Austria, now in the Metropolitan Museum, New York, shows an emperor, bearded, wearing the Crown of the Holy Roman Empire (*Ill. 107*), attended by angels and saints including St Peter, offering a church to Christ. It has been suggested that the church represents Magdeburg Cathedral, although the patrons of that church were St Maurice and St Catherine, and the donor is Otto I; the ivory panels would date accordingly between the coronation of Otto I as Emperor in 962 and his death in 973. The cathedral suffered from fires in 1008 and 1049 and it has been presumed that on one or other of these occasions the antependium was damaged and the surviving fragments put to other purposes. The style of the carvings, homogeneous within the group, is quite individual: against a background pierced with small crosses or a chequered pattern, compact groups of solid, stunted figures with stylized features, hair and drapery, take part in a series of *tableaux liturgiques*. This style would seem to derive in part from the monumental splendour of two ivory panels carved with liturgical scenes now divided between the Fitzwilliam Museum, Cambridge, and Frankfort (Stadtbibl., Nr. 20), and a panel carved with a representation of St Gregory in the Kunsthistorisches Museum, Vienna[35], but it has been related to manuscripts executed at Reichenau, in particular the Psalter given to Egbert of Trier in 983. It has been shown that the attribution of the Psalter to Reichenau is under debate; the figure of Christ in 'Reichenau' manuscripts tends to be beardless, whereas in the remaining twelve panels of the antependium He is heavily bearded, and the figure-style and drapery are not particularly close to the 'Reichenau' idiom. Nor is it certain that the emperor is in fact Otto I. While attempts have been made to place the existing, fragmentary Crown of the Holy Roman Empire (*Ill. 108*) to the time of Otto I, the characteristic arch over the top

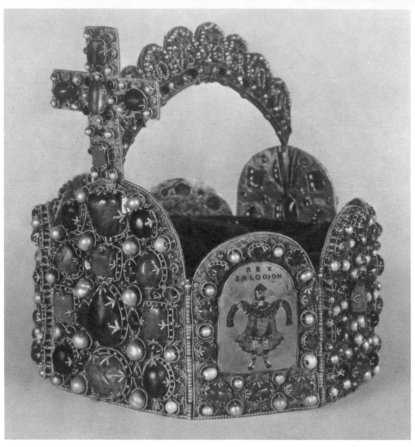

108 The Crown of the Holy Roman Empire in enamels, pearls and precious stones set in filigree on a gold ground. The arch bears the name of the Emperor Conrad II (1024–1039). Late tenth or early eleventh century

of the Crown bears an inscription referring to Conrad II (1024–1039), and there are so many conflicting theories about the date and place of workmanship that this venerable imperial relic is not a sure guide to the date of the ivory carvings[36]. Otto I and his successors are represented on their seals with a double-arched crown, and in the court manuscripts, when the Emperors are represented, the particular form of the Crown at Vienna does not appear.

This group of ivory carvings has been related, in addition, to a second group which includes a panel showing an imperial family adoring Christ between the Virgin and St Maurice and bearing the

109 Ivory panel showing Christ in Majesty between the Virgin and St Maurice attended by angels and adored by the Emperor Otto II, the Empress Theophano and the future Otto III. Milan; about 980

inscription Otto Imperator (*Ill. 109*). The Emperor, the Empress and the young prince are all crowned with Germanic diadems and the patrons were particular favourites of the Ottonian house. This panel is closely related in style to an ivory *situla* in the Cathedral at Milan (*Ill. 110*), once in the Church of Sant'Ambrogio, which bears an inscription stating that it was given by Gotfredus to St Ambrose in preparation for the arrival of the Emperor. Now this Gotfredus was Archbishop of Milan in 974 or 975 and he died in 980 before the arrival of the Emperor Otto II. Both the imperial panel and Gotfredus's *situla* are related at slightly further remove to a second ivory *situla*, now in the Victoria and Albert Museum, which bears an inscription referring to Otto Augustus. It is not without interest that the narrative scenes of the Passion and Resurrection of Christ (*Ill. 111*) on this bucket are based in part on an ivory diptych (*Ill. 114*), known to have been in the Treasury of Sant'Ambrogio

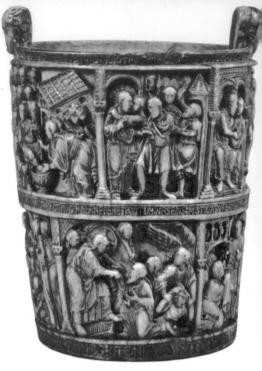

110 St Matthew from an ivory situla given by Archbishop Gotfredus of Milan (974/975–980) to the Basilica of Sant'Ambrogio at Milan about 980

111 The Basilewsky Situla. An ivory bucke carved with scenes of the Passion and Res urrection of Christ. An inscription refers to Otto Augustus; Milan, about 980

since the twelfth century, over which scholars differ in dating it from the fifth or the ninth century. The tenth-century artist transformed, of course, the earlier model, and it is of particular interest that in the scene showing Judas receiving the thirty pieces of silver from the High Priest (*Ill. 113*), the diadem worn by the High Priest, which in the diptych is a copy of a fifth-century crown, here is changed into a Germanic crown; both crown and facial type are similar to those on the imperial panel. There seems little doubt that this second group was made in Milan about 980 when Otto II made his state entry into that city with the Empress, the Byzantine princess Theophano, and his young son, the future Otto III. It seems possible that the so-called Magdeburg Antependium may also be North Italian work dating from the late tenth or early eleventh century.

112 Detail from the Basilewsky Situla showing Judas receiving the thirty pieces of silver from the High Priest; Milan, about 980

113, 114 Ivory diptych showing scenes from the Passion and Resurrection of Christ. Detail shows Judas receiving the thirty pieces of silver from the High Priest. Probably Milan; ninth century

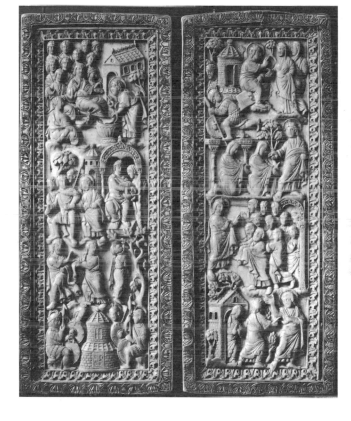

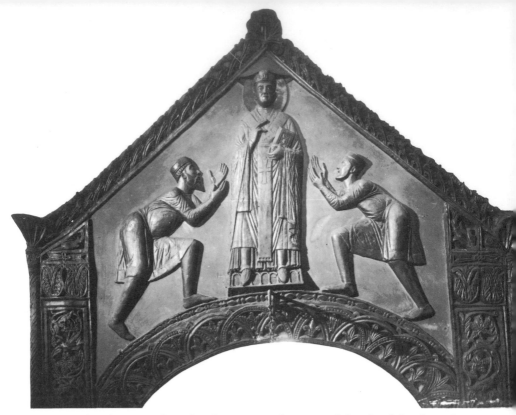

115 The ciborium of Sant'Ambrogio in Milan; second decade of the eleventh century

Both groups should be considered with the ciborium of Sant'Ambrogio in mind (*Ill. 115*), where, allowing for differences of scale, facial characteristics and certain mannerisms of drapery are not dissimilar; the ciborium dates from about the second decade of the eleventh century[37].

In this Milanese series of carvings the scenes represented appear to be wholly in a western tradition and no specifically middle-Byzantine influence may be detected. Within the series, however, there are a few panels, such as that in the British Museum (*Ill. 116*), which seem to be direct copies of Byzantine ivory reliefs. The overall characteristics of style point to the same Milanese workshop which produced the two buckets and the imperial panel. It is evident, therefore, that two separate traditions could exist side by side without necessarily overlapping[38].

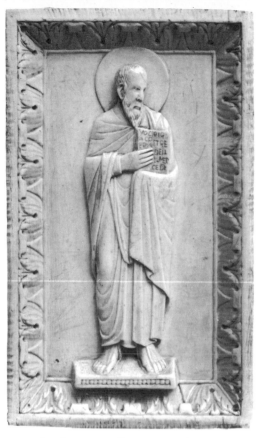

116 Ivory panel showing St Matthew. Milan; late tenth century

A third group of ivory carvings was possibly executed at Trier in the last twenty years of the tenth century. The group starts with a panel of the Crucifixion set in the gold cover of the *Codex Aureus Epternacensis* (*Ill. 120*), although it is generally agreed that the cover was not made for that codex but originally belonged to a Gospel book, at one time in the Sainte-Chapelle (Paris, Bibl. Nat., lat. 8851), made either at Trier or Echternach, the cover almost certainly made at Trier. The reliefs on the front reveal the patrons of Echternach: St Willibrord, St Peter, St Boniface, St Liudger, Bishop of Münster in Westphalia; in addition, the Empress-Regent Theophano and Otto III as King. Otto III was crowned King of the Germans in 983, King of the Lombards in 995, and Emperor at Rome in 996. The Empress Theophano died in 991. The cover must date, therefore, between 983 and 991. There seems little doubt that the gold-

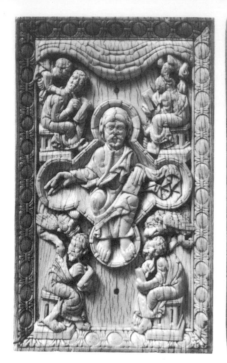

117 Ivory relief showing Christ in Majesty between the Four Evangelists. Trier; late tenth century

118 Ivory reliefs showing Moses receiving the Tables of the Law, and St Thomas and the Risen Christ. Trier; late tenth century

smiths' work and enamels were produced at Trier in view of their relationship with the Reliquary of the Foot of St Andrew (*Ill. 121*) and the reliquary of the Holy Nail, both in the Cathedral Treasury of Trier, with the cover of the Staff of St Peter, formerly at Trier, now at Limburg, and possibly a small ivory, gold and enamelled cross at Maastricht (*Ill. 140*). Inscriptions show that some of these works were gifts of Archbishop Egbert of Trier (977–993). There is considerable literary evidence of the importance of Trier as an artistic centre, amongst which a letter of Gerbert of Aurillac to Egbert makes particular reference to glass paste as being a speciality of the city. But the style of the ivory relief on the cover of the *Codex Aureus Epternacensis* is quite unlike the style of the metalwork. The carving may be related to reliefs carved with representations of Christ in Majesty, now in Berlin (*Ill. 117*), St Paul, now in the

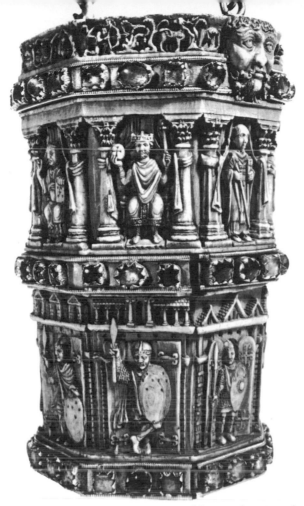

119 Ivory situla with precious stones on a gold ground. Trier; about 1000

Musée de Cluny, Paris, and with Moses receiving the Law and Doubting Thomas (*Ill. 118*), believed to have come from the Abbey of Kues on the Mosel, now also in Berlin – perhaps one of the most original of all high medieval ivory carvings. These reliefs are so close in style that they might almost be the work of one artist, one with an astonishing perception of the human form, of movement beneath the drapery – note in the relief of the Doubting Thomas the juxtaposition and the carving of the heads, the reaching-upward and searching movement of St Thomas, and the raised arm

of Christ – and an equally astonishing facility in handling the material. Wholly within a strong sculptural tradition as they are, the reliefs, like those of Tuotilo at St Gall at the end of the ninth century, seem to spring out of nowhere. Probably from the same workshop, but of slightly later date, an ivory *situla* in the Cathedral Treasury at Aachen carved with the figure of an Emperor, a Pope, two Archbishops, two Bishops, an Abbot and sentinels guarding the Heavenly City was clearly made for a liturgical ceremony of great importance (*Ill. 119*). From the point of view of style and in view of the other reliefs the most likely Emperor would be Otto III. Indeed, a metal band studded with precious stones obscures the contemporary inscription 'Otto' placed under the representation of the Emperor. The Emperor on the bucket is a grown man with a beard and moustache; none of Otto's coronations quite fit since they took place when he was three, fifteen and sixteen, but the recognition of the tomb of Charlemagne in the year 1000 might well have been the occasion for such a commission, although it must be remembered that the recognition was carried out quasi secretly and people spoke of sacrilege. It has been argued, however, that the bucket was originally a support for a reading desk attached to the pulpit of Henry II in the palace chapel at Aachen, a suggestion which seems rather far-fetched, but it is possible that the bucket might have been used at the coronation of Henry II at Mainz in 1002. The carvings on the bucket are court art of the highest quality; the little figures are beautifully modelled and executed with great delicacy; the small frieze at the top of the bucket is almost Anglo-Saxon in its refinement and liveliness, while the masks on the sides clearly depend on a classical model. In many ways this little *situla* is unique in iconography, style and level of excellence. Wherever these reliefs were carved, it should be noted that there is no middle-Byzantine influence to be found in them; the reliefs are a highly personal reanimation of types and forms established during the Carolingian *renovatio* and persisting for several centuries in the Rhine-Moselle area[39].

Variously assigned to Mainz and Trier, an ivory relief of the Virgin and Child (*Ill. 122*) has been related to the style of the Master of the *Registrum Gregorii* and, indeed, there are striking simi-

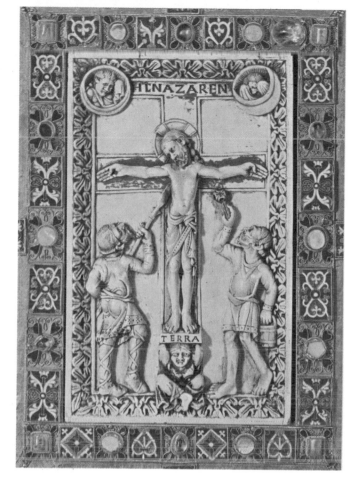

120 (*left*) Ivory panel set with enamels, pearls and precious stones on a gold ground showing Christ on the Cross between Longinus and Stephaton. The cover of the *Codex Aureus Epternacensis;* Trier; 983–991

121 (*below*) Reliquary of the Foot of St Andrew. Gold set with enamels and precious stones; Trier; 977–993

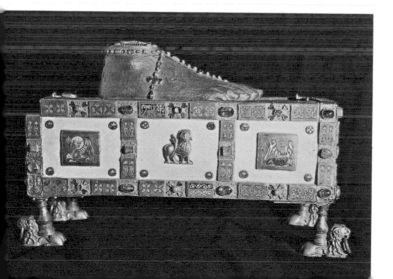

larities between the carving and the miniature painting (*Ill. 83*) in the monumental simplification of the human form, the build-up of the form in a series of ovals, the flattening and tense in-drawing of the drapery, and the relation of the figure to the architectural setting[40].

It has been suggested when reviewing briefly the Ottonian contribution to architecture that already a series of regional styles, so characteristic of the late eleventh and twelfth centuries, may be distinguished. This is equally true in the case of ivory carving. Two distinct groups of North Italian and Trier-Echternach products have been isolated, but Liège and Cologne were also important centres. An ivory relief carved with Christ in Majesty, the four symbols of the Evangelists, the Vision of Ezekiel, bears an inscription referring to Notker, Bishop of Liège (972–1008), a member of Otto I's chapel, and once Bishop, a strong cultural force in the city. This relief (*Ill. 124*), though clearly based on Carolingian models, is far removed from the harsh realism of the Trier-Echternach group or the solid plasticity of the Virgin and Child at Mainz. The Liège style, with its sensitive perception of idealized form, its subtle carving – note the drapery sunk in between the legs of Christ and the curious leaf ornament in the corners – its faint evocation of an illusion of space, looks back to the Carolingian school of Reims and beyond that to the 'Hellenistic' aspect of the court workshops of Charlemagne[41].

At Cologne, on the other hand, judging from a relief showing Christ blessing St Victor and St Gereon, from the Church of St Gereon in that city (*Ill. 123*), the style there in the first half of the eleventh century is harsher in outline, more schematic, the forms stiffer and less sensitively modelled, and there is a faint suggestion that nothing must be left out even at the cost of a crush in the heavenly spheres. This tendency to simplify the form and, at the same time, to overload richly, is present in Cologne metalwork which starts in the Ottonian period with the magnificent first Cross of the Abbess Matilda (973–1011) of the convent of the Holy Trinity at Essen (*Ill. 126*). The cross is resplendent in gold, gold filigree, pearls, precious stones and enamels more ambitious than those of Arch-

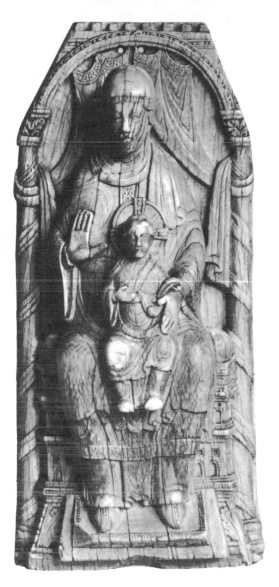

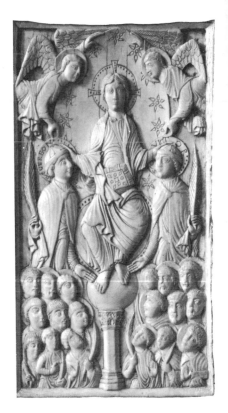

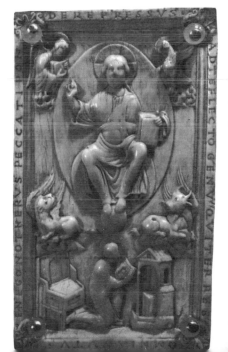

122 (*above left*) Ivory relief showing the Virgin and Child enthroned. Trier or Mainz; late tenth century

123 (*above right*) Ivory relief from the Church of St Gereon, Cologne, showing Christ in Majesty blessing St Victor and St Gereon; about 1000

124 (*below right*) The Vision of Ezekiel with an inscription referring to Bishop Notker of Liège. Liège; late tenth or early eleventh century.

125 (*right*) The cameo of Augustus set into the Cross of Lothair II of Lotharingia. Cologne; about 1000

126, 127 (*below*) First Cross of the Abbess Matilda of Essen (973–1011). Enamels, pearls and precious stones set in filigree on a gold ground. Cologne; 973–982. (*below right*) Detail shows Abbess Matilda of Essen and her brother Otto, Duke of Bavaria and Swabia

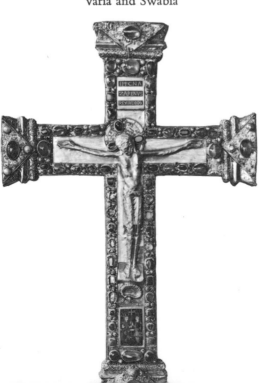

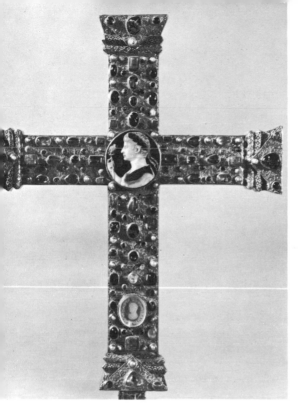

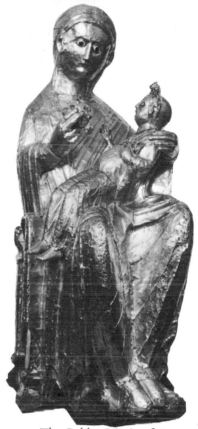

128 The Cross of Lothair set with the cameo of
Augustus and (below) the seal of Lothair. Cologne;
about 1000

129 The Golden Virgin of Essen.
Cologne; about 1000

bishop Egbert's workshop at Trier; one of the enamels *en cloisonné*
portrays the Abbess Matilda and her brother Otto, Duke of Bavaria
(d. 982) – they were grandchildren of the Emperor Otto I by his
first wife Edith, daughter of Edward I of England (*Ill. 127*). The
modelling of the face of Christ is marvellously sensitive and delicate;
the heavy eyelids and the drawn face of death are framed by slow-
curving tresses, mounted by the long, nervous moustaches which
fall over the stylized beard. The loin-cloth hangs lank but body-
clinging. The long, gaunt frame of the dead God is nailed like a
glorious golden banner to the glinting Tree of Life. The serpent
under the suppedaneum is coiled in submission. And like a standard
the Abbess Matilda and her brother Otto grasp the Cross as though
reaffirming the faith of the imperial house. The form of Christ on

the Cross has been compared not very convincingly with the large Christ on the Cross carved in wood and associated with Archbishop Gero (969–976) in the Cathedral at Cologne (*Ill. 141*). The style of the goldsmiths' work, the filigree, mounts and general shape of the cross, should be compared to the magnificent Cross of Lothair (*Ill. 125*), so called because of the rock-crystal seal of Lothair II of Lotharingia (855–869) incorporated in the decoration which, with its superb cameo of Augustus in the centre and the quality of its mounts, ranks as one of the masterpieces of Ottonian craftsmanship. Also believed to be of Cologne workmanship, the Golden Virgin of Essen, dating from about the year 1000, is something of a landmark in three-dimensional sculpture (*Ill. 129*) or quasi-sculpture, for the Virgin is essentially a work of a goldsmith's rather than a sculptor's art. From whichever point of view, however, there can be no doubt that this astonishing apparition with its reduction of the human form into hieratic geometry, with its concentration of different levels of power within mass and line, and with its smouldering richness of effect heralds the chapter in the history of art which is now called Romanesque[42].

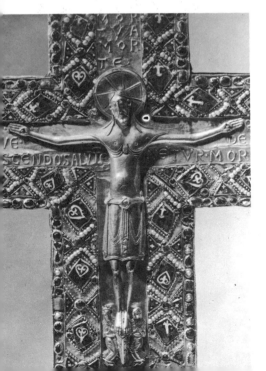

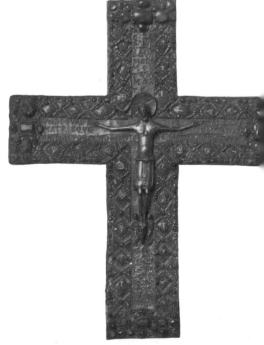

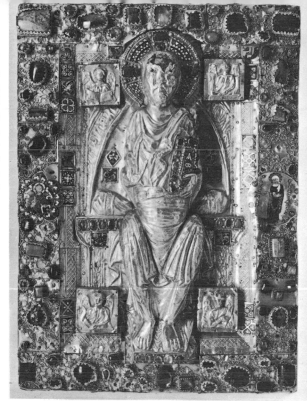

132 (*right*) Cover of the Codex of Abbess Uota of Niedermünster in gold set with enamels, pearls and precious stones, showing Christ in Majesty between the Symbols of the Evangelists. Regensburg; early eleventh century

131 (*opposite*) The ross of Gisela of Hun-y made of gold set h enamels, pearls and cious stones. Regens-g; 1006. (*far left*) tail

This same chapter is heralded in a different school, that of Regensburg, by the superb cross (*Ill. 130*) given by Gisela of Hungary, sister of the Emperor Henry II, in memory of her mother, Gisela of Burgundy, Duchess of Bavaria, in the year 1006, to be placed on her tomb in the Abbey of Niedermünster at Regensburg. For here the figure of Christ, the form once again reduced to a geometrical abstraction, has become a taut symbol of Divine immolation, and with the tension of line and mass, a total sum of aesthetic power is unleashed from the shimmering cross, bedizened with enamels, jewels and pearls. Similarly, on the cover of the codex of the second Abbess Uota of Niedermünster (*Ill. 132*) the monumental gold figure of Christ, with gold, enamelled and jewelled halo, holding an enamelled, jewelled book, feet resting on an equally glittering suppedaneum, is monolithically represented, hands close to the taut, elongated pear-shaped body, almost in the round, a tense structure of spiritual majesty[43].

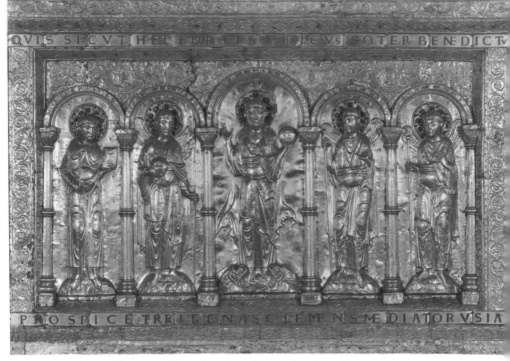

QVIS SICVT HEL FORTIS EDICVs SOTER BENEDICTv

PROSPICE TERRIGENAS CLEMENS MEDIATOR VSIA

133 Gold antependium showing Christ adored by the Emperor Henry II and the Empress Kunigunde between the Archangels Michael, Gabriel and Raphael and St Benedict. Mainz or Fulda; about 1019

Attempts have been made to assign another group of goldsmiths' work, consisting of a gold antependium and a gold book cover, both at Aachen, and the Basle Antependium, now in the Musée de Cluny, Paris, to a workshop at Reichenau, but this has not met with general acceptance. Two scholars have argued that these were executed at Fulda, while others incline to Mainz, in whose diocese Fulda is. Undoubtedly the masterpiece of the group is the Basle Antependium (*Ill. 133*) which was presented to the Cathedral of Basle by the Emperor Henry II, presumably some time after he had seized the city in 1006 and probably for the consecration of the Cathedral in 1019 at which Henry was present; his effigy with that of the Empress Kunigunde is to be found at the feet of Christ. This magnificent work is of the utmost importance since in scale it far

outshines the other two (the Aachen Antependium is a complex of small panels though close in style and must be about the same date; the bookcover, on the other hand, is rather different in style, suggesting another workshop, possibly at Aachen), and since the treatment of the figures, while clearly issuing from the imperial court style, suggests a new stage in the development of the artist's approach to the human form. Once again these preternaturally tall figures looming out of the gold ground, jutting out almost in the round, look forward to the art of the twelfth century. They look forward but do not categorically determine it, for in fact the forms for all their size are essentially masterpieces of metalwork, chased, beaten out into the near-round rather than a conception of mass, an organic physical entity chiselled and carved. The forms for all their elongation and abstraction, their evocation of heavenly majesty, lack any inner tension; the drapery masks, rather than moulds, the form and when it breaks away from the form, puffs into a fold without any feeling of force behind it; it is a decorative adjunct. All that the artist of the Basle Antependium is doing is to take the ingredients of Carolingian and Ottonian style and bring them together into something more compact and monumental[44].

Equally retrospective in general atmosphere of style, the bronze doors (*Ill. 135*), which Archbishop Bernward of Hildesheim (993–1022) caused to be cast for the Church of St Michael in 1015, are also highly ambitious since they are the first decorated bronze doors cast in one piece in the West since Roman times. They witness a new conquest by the artist over the representation of figurated sculpture in northern art. Charlemagne had bronze doors cast for his chapel at Aachen; Archbishop Willigis had another set cast for his Cathedral at Mainz which was burnt down in 1009; both these sets are comparatively plain sheets of bronze. Even in Italy in the eleventh century it was the custom to order bronze doors from Constantinople, and many of these consist of a series of bronze plaques attached to a wooden frame. The bronze doors executed for the Cathedral of Augsburg in the late tenth or early eleventh century were constructed in this manner. Archbishop Bernward, who had been tutor to Otto III and a chaplain at the imperial court, had made several

journeys to Rome. It is possible that the fifth-century wooden doors of Sant'Ambrogio at Milan or those of Santa Sabina at Rome were in his mind when he commissioned the doors. The artists – the doors appear to be the work of different hands after a cartoon produced either by a single artist or one of the sculptors – were directed no doubt to study the Genesis cycles in the Bibles produced by the Carolingian school of Tours (note the alternation of figures and stylized trees and the scenes placed vertically) and current New Testament cycles, such as those of the *Codex Egberti*. The influence of the Trier-Echternach school has been remarked. The scenes on one wing of the door are taken from Genesis; the other wing illustrates scenes from the life of Christ. Both sets are a palpable imitation of a miniature cycle, harking back to the sprawling Carolingian tradition, with a loose sense of space, not only in the organization of a particular scene, but in the way the upper parts of the forms jut out three-dimensionally and in different planes from the surface of the relief. As in all Ottonian copies of late antique and Carolingian models the forms have become more compact, springy, elongated, harsher in outline and, although little attempt is made to create a distinction between the major and minor characters of a scene, the tension between the protagonists has become more acute: as in the scene after the Fall (*Ill. 136*), with its chain of accusatory gestures, or in Christ's meeting with Mary Magdalene after the Resurrection (*Ill. 138*), where the falling movement of Mary before the feet of Christ stresses the ascending movement of Christ[45].

But Archbishop Bernward's interest in recreating the glories of the Roman heritage is made clearer by the bronze column, decorated with scenes from the Life of Christ, which he commissioned for the Church of St Michael about 1020. The column is in fact an outsize candlestick; it was intended for the Paschal candle. But the inspiration for such an undertaking came from the Columns of Trajan and Marcus Aurelius at Rome; whereas the latter represented imperial triumphs, Bernward's Column (*Ill. 134, 137*), cast just over a thousand years later with scenes ranging from the Baptism of Christ to the Entry into Jerusalem, was intended to commemorate the Triumph of Christ on Earth. The figures are much more confined to the sur-

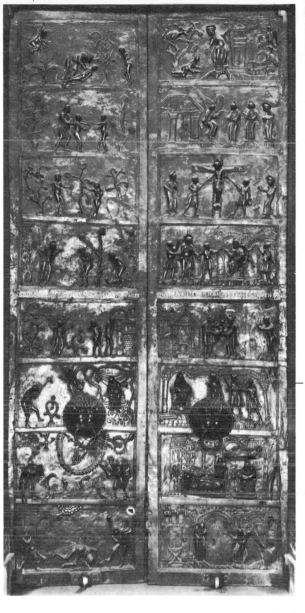

Scenes from the Life of Christ on a bronze column cast for Archbishop Bernward of Hildesheim and set up in the Church of St Michael about 1020

135 The bronze doors cast for Archbishop Bernward of Hildesheim (993–1022) for the Church of St Michael in 1015. Left, Genesis scenes and, right, scenes from the Life of Christ

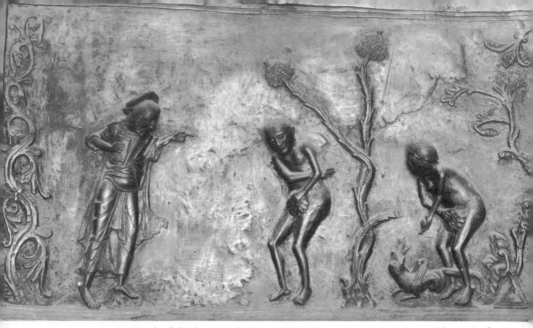

136 Detail of the bronze doors at Hildesheim showing Adam and Eve before God after the Fall; 1015

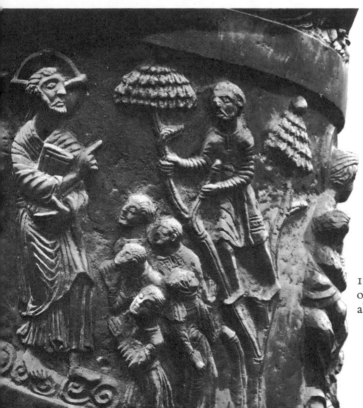

137 Detail of the bronze column of Hildesheim showing the parable of the fig-tree

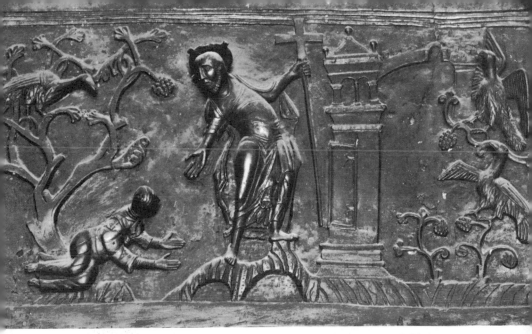

138 Detail of the bronze doors at Hildesheim showing the meeting of Christ and St Mary Magdalene after the Resurrection

face of the column, and their general appearance is harsher in outline than those on the doors. There is a tendency to make the chief character in a particular scene larger than the others, but this tendency is by no means constant. There is no attempt to stress the upward movement of the spiral or the structure and shape of the column, no feeling that the figures are bursting from the surface by the force of their own nervous tension and no great inner tension within a particular scene. Bernward's Column, therefore, for all its ambitious conception, and for all its backward look at Rome, cannot be said to be Romanesque in the current art-historical sense. It stands apart as a curious Ottonian pastiche of a Roman monument, utterly provincial in form and execution, and never to be repeated[46].

On the other hand, the small silver crucifix, executed for Bernward about 1007–1008 (*Ill. 139*), echoing in some respects the small ivory figure of Christ on the Cross, carved perhaps for Egbert of Trier (*Ill. 140*), looks forward in every respect to the art of the twelfth century. The articulation of the form, the feeling for bone structure beneath the flesh, for the sagging weight of the dead

139 Silver crucifix made for Archbishop Bernward of Hildesheim about 1007–1008

140 Crucifix of ivory enamels and precious stones on gold. Trier; 977–993

Christ, for the poignance of death, all point away from the idealized and sometimes etiolated copies of past models and on to the astonishing 'realism' of Rainier of Huy and Nicholas of Verdun. Both these masters of the twelfth century were workers in metal. But there is evidence in the Ottonian period of a new stirring of talent in what appears to be the lost art of monumental sculpture. The great Christ on the Cross, carved in wood with traces of pigmentation, now in the Cathedral of Cologne, was probably executed for Archbishop Gero about 980. Many scholars have assigned the work to the second half of the twelfth century. But a comparison with Bernward's crucifix, and keeping in mind ivory carvings from Trier-Echternach and the Rhineland generally, leaves little doubt that the wood carving dates from the late tenth century (*Ill. 141, 142*). The approach to the nude figure of Christ shows the most skilful handling of the planes of the torso, the undulating curves of pectoral and stomach

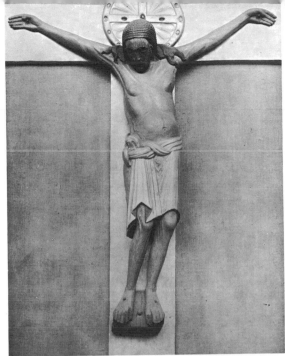

141 Christ on the Cross in wood with traces of pigmentation, probably carved for Archbishop Gero of Cologne (969–976)

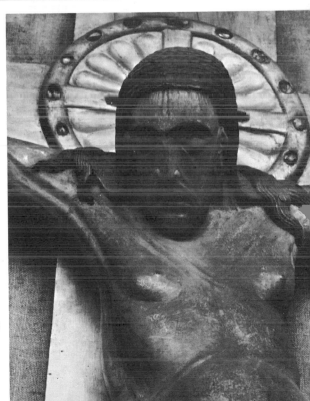

142 Detail of above. Head of Christ

muscles, the feeling of weight in the head fallen over the shoulder. The face of the dead Christ is carved with the utmost poignancy and yet without a flicker of sentiment. It is a reminder that the theme of tenderness and compassion for the suffering and helplessness of the Saviour of the world dates from this time and was developed throughout the eleventh century, to be voiced in the earliest writings of St Anselm of Bec, later Archbishop of Canterbury. 'Why, O my soul, were thou not present to be transfixed with the sword of sharpest grief at the unendurable sight of your Saviour pierced with the lance, and the hands and feet of your Maker broken with nails?'[47] Moreover, in this great new sculptural concept there is no trace of Byzantine influence; once again evidence is to hand of a wholly western tradition of Christian representation coming to fruition without the direct participation of Constantinopolitan art. This development is important since scholars in the past have been too ready to see in the medieval art of the West the constant presence of Byzantium. This was not the case. During the course of the eleventh century at Regensburg, at Cologne, possibly at Echternach, at Milan, there may be in certain undertakings an intervention of Byzantine artistic influence, but a large proportion of the work done under the Ottonian emperors evolved out of the western artists' own perception of late antique and Carolingian models. There can be no doubt that this development in the Rhineland in the late tenth century is of paramount importance when considering the opening-up of western achievement throughout the West in the twelfth century. Ottonian art provided, indeed, an imperial gateway to the art which is now called Romanesque[48].

Diffusion and Development

Imperial architecture in the eleventh century was more than a gateway to the new style. Romanesque style in Germany was born at Limburg an der Haardt[1]. Founded in 1025 by Conrad II in thanksgiving for his imperial elevation, the great Benedictine abbey was completed by 1042. The church was a three-aisled columnar basilica, cruciform with a choir and transept, with apses on the transept arms, an octagonal tower rising from the corners of the crossing and round side-towers, a vaulted crypt of which the altars were consecrated in 1026, possibly vaulted side-aisles but a flat wooden roof over the nave, and a main door at the west end. The importance of Limburg, however, apart from its size, lies in the fact that the walls no longer merely confine space; they cease to be a flat, thin screen. By the use of piers, half-columns and pilaster strips, the latter running the full height of the building (*Ill. 143*), component parts of the wall become a structural group which was in later experiments to support the overall vaulting of nave and side-aisles. Limburg, now a ruin (it was destroyed largely in 1504 during a plundering expedition by a neighbouring count), is the first stage on the main road to High Gothic architecture. It is possible that this principle had been adumbrated at Strasbourg Cathedral[2], begun in 1015 by Bishop Wernher von Habsburg and completed in 1025, but there can be no confirmation of this since the present Gothic structure was built on the old foundations. The Cathedral of Trier, rebuilt by Archbishop Poppo of Stavelot (1017–1047), extended by him to the west about 1040 and completed by 1070, is also an important stage in the development. Archbishop Poppo's building, although greatly altered, survives today, and indeed, the west front (*Ill. 145*) with its square towers above the aisles and its round stair turrets is the only surviving example of an early Salian façade. The Cathedral of Trier was taller than the early Gothic cathedrals: Sens, Senlis and Laon. The

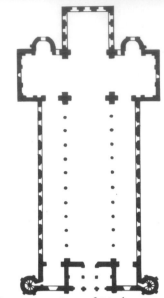

143 (*left*) Interior view of Limburg an der Haardt; 1025–1042

144 (*above*) Plan of Limburg an der Haardt; 1025–1042

thickening of the wall, the opening out of the wall by exterior galleries, the device for making one arch span two sections of the elevation, based on the Constantinian basilica at Trier, influenced the architects of Speyer and Mainz[3]. The plan of Limburg was developed at the imperial abbey of Hirsau[4], now also a ruin, but built between 1059 and 1071, and above all, at the imperial cathedral of Speyer[5].

Speyer, in length, breadth and height, is one of the largest churches in the West. '*Ecclesia Spirensis*', wrote the German humanist Wimpfeling in 1500, '*corona omnium ecclesiarum*'. Built to celebrate the zenith of imperial power, as the pantheon of the Salian Emperors, the first church was begun under Conrad II about 1030 and consecrated in 1061, but considerable building, amounting to a second church, was undertaken between 1092 and 1106 under Henry IV. The history of these churches, like that of Mainz, is important and difficult. Some scholars have argued that Speyer I in ground plan and general appearance was much the same as it is today: the choir was probably barrel-vaulted, the side-aisles were groin-vaulted, as was certainly the present huge crypt (*Ill. 147*) extending beneath

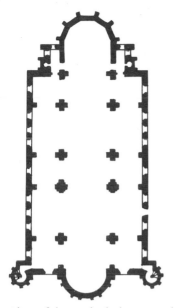

145 Plan of the Cathedral, Trier, rebuilt in the early eleventh century and completed by 1070

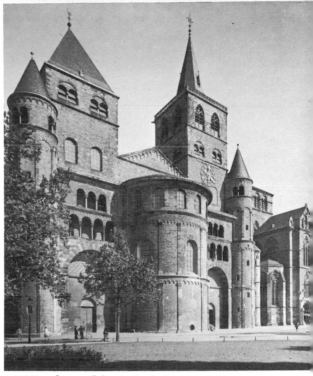

146 West front of the Cathedral, Trier

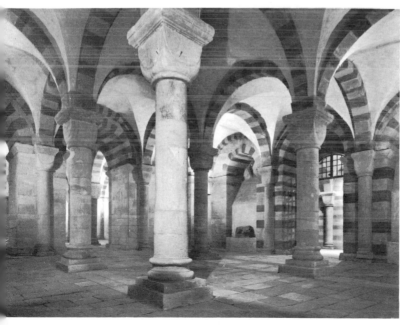

147 Crypt of the Cathedral, Speyer; 1030–1040

the choir and the transept; the blind arcades of the east end of Limburg were continued at Speyer into the nave; only the centre aisle bore a flat wooden roof[6]. The groin-vaulted side-aisles of Speyer I were certainly not unique; they are to be found in the Church of Santa Maria Maggiore at Lomello in Lombardy, dating from the first half of the eleventh century, at Hirsau, and possibly at St Maria im Kapitol at Cologne, whose crypt should be compared to that of Speyer, although the general appearance of the latter church, rebuilt about 1060, is highly problematical[7]. Other scholars, however, have argued that Speyer I was never actually completed, that the crucial elements of the elevation date from the reign of Henry IV and that the building was not completed until more than a hundred years after its foundation[8]. During this time the east end, apart from the crypt, was rebuilt and vaulted, the central aisle of the nave was groin-vaulted with prominent transverse round arches, and the vast west end, which contained a deep choir, an outer hall and staircase towers encased in thick walls, was radically altered. In Speyer II choir and nave were envisaged as an entity beneath the vault; there was no longer a division between eastern and western parts. It is important to note that this plan was certainly in the minds of Henry IV's architects. The vaults were supported by massive square piers combined with half-columns; the pilasters dividing the wall space ran the full height of the building; blind arches framed the windows. Outside, blind arcades and tiers of galleries emphasized the thickness of the walls. Height, breadth, mass and the regular rhythm of galleries and arcades, all contribute to the grandeur of the conception (*Ill. 148*). In the attempt to subordinate all architectural parts to an over-riding system – and this is the first principle of the style called Romanesque – Speyer provided the imperial solution. There can be no doubt that Speyer and its related structures in the Rhineland influenced Norman and Anglo-Norman architecture.

The two-tower façade, common in the Upper Rhine region, exemplified by Strasbourg Cathedral (begun 1015), Basle Cathedral (consecrated 1019) and St Kastor at Koblenz (first half of the eleventh century), was adopted in Normandy at Notre-Dame de Jumièges (1037–1066) and at the two abbeys built by William the Conqueror

148 East end of the second Cathedral building, Speyer; early twelfth century

149 Plan of the Cathedral, Speyer. Shaded area indicates First, Second and Third building campaigns; 1092–1106 and later

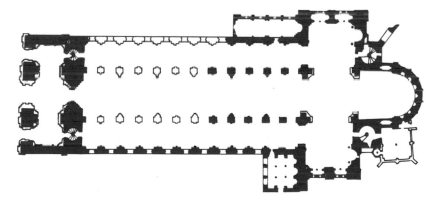

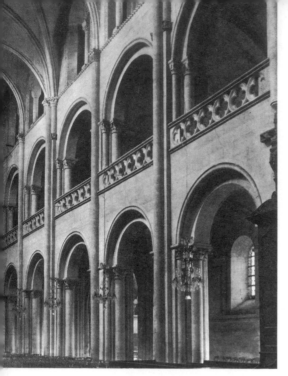

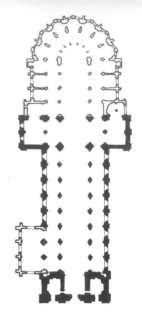

150 Interior of Saint-Etienne, Caen; 1064–1087

151 Plan of Saint-Etienne, Caen

and his wife Matilda in expiation for their marriage within the pro-
hibited degrees, La Trinité (1062–1083) and Saint-Etienne (1064–
1087) at Caen[9]. These last two abbeys not only adopted the vaulted
side-aisles, the double bays of the nave, the augmentation of piers
by engaged columns and the articulation of the wall space mapped
out by the imperial buildings, but the Norman architects carried the
technique of piercing the thick walls with galleries and clerestory
passages, and of augmented pier design to a new solution of archi-
tectural space visualized as a system of mass and voids. At Saint-
Etienne the organized system of arches raised in tiers one above the
other, the dominant idea that every arch, or visible part of every
arch should be upheld by its own supporting member, the piercing
of the thick walls by passages establish a new stage (*Ill. 150*) on the
road to High Gothic[10]. This stage was further elaborated in Eng-
land. Edward the Confessor's abbey at Westminster (*c.* 1050–1065)
was built by Norman architects and was grander than anything
existing in the country with its western towers, six double bays in
the nave, a transept with a crossing tower and a triple system of

158

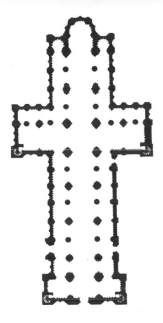

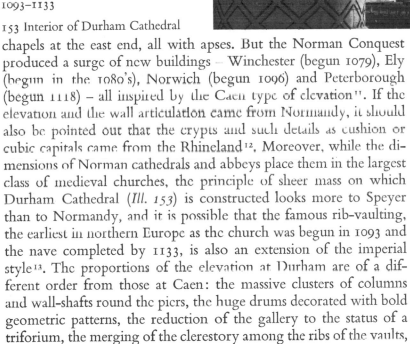

152 Plan of Durham Cathedral;
1093–1133

153 Interior of Durham Cathedral

chapels at the east end, all with apses. But the Norman Conquest
produced a surge of new buildings – Winchester (begun 1079), Ely
(begun in the 1080's), Norwich (begun 1096) and Peterborough
(begun 1118) – all inspired by the Caen type of elevation[11]. If the
elevation and the wall articulation came from Normandy, it should
also be pointed out that the crypts and such details as cushion or
cubic capitals came from the Rhineland[12]. Moreover, while the di-
mensions of Norman cathedrals and abbeys place them in the largest
class of medieval churches, the principle of sheer mass on which
Durham Cathedral (Ill. 153) is constructed looks more to Speyer
than to Normandy, and it is possible that the famous rib-vaulting,
the earliest in northern Europe as the church was begun in 1093 and
the nave completed by 1133, is also an extension of the imperial
style[13]. The proportions of the elevation at Durham are of a dif-
ferent order from those at Caen: the massive clusters of columns
and wall-shafts round the piers, the huge drums decorated with bold
geometric patterns, the reduction of the gallery to the status of a
triforium, the merging of the clerestory among the ribs of the vaults,

all stress the vaults themselves which are the key to the whole design. The theme of rib-vaulting was not developed further in England until the second half of the twelfth century, but it was at once taken up in Normandy and transmitted from there to other parts of France. On the other hand, the buildings at Tewkesbury and at Gloucester developed the system of monumental drum-piers already found at Durham into a three-storey elevation which at once stresses the vertical lines of the church and the sense of rhythmic voids; the choirs, in addition, were built as a four-storey elevation with piers rising from the floor to the top of the gallery, containing at the same time arches which formed the floor of the gallery – usually termed 'Giant Order'. Now the four-storey elevation, probably derived from the German westwork, played an important part in the development of Gothic architecture in northern France, but the immediate source was once again the Rhineland – Trier, Speyer and Mainz – and its presence in England is not surprising in view of the Lotharingian clergy known to be in the west country at this time[14].

The great churches of Lombardy – all built in the course of the late eleventh and twelfth centuries – were not, as previously supposed, the germinal structures of the Empire but merely a synthesis of imperial and French Romanesque tendencies[15]. Thus, the cathedral of Parma, rebuilt after the earthquake of 1117, was planned with a huge crypt like Speyer and transept arms recalling St Maria im Kapitol at Cologne. The Cathedral of Modena, begun in 1099 by the architect Lanfranc but not vaulted until the fifteenth century, and the Cathedral of Piacenza, built in three campaigns, as it were, between 1122 and 1235, have a German exterior but are French within; even Sant'Ambrogio at Milan, begun about 1080 but not vaulted in all probability until after the earthquake of 1117, and copied at San Michele, Pavia, between 1100 and 1160, reflects the imperial style[16]. The vaults of Sant'Ambrogio, however, are ribbed and in view of similar vaults in the Church of San Sigismondo at Rivolta d'Adda, dating about 1099, and those in San Nazzaro Maggiore at Milan, restored by Archbishop Anselm III (1086–1093) with diagonal brick ribs in the nave, it may be that this new step in the direction of High Gothic architecture was made first in Lombardy[17].

154 Plan of the third Abbey Church of Cluny; 1088–1130

There can be no doubt that the third Abbey Church of Cluny, begun about 1088 and built according to the most highly developed Romanesque plan (*Ill. 154*), was erected in open rivalry to Speyer. Under a series of great abbots, which culminated in the rule of St Hugh (1049–1109), the Congregation of Cluny became the spearhead of reform, resistance to imperial power and reconquest of lands under Islam in Western Christendom. In 1042 there were some seventy monks at the mother abbey, but under Abbot Hugh this number had increased to about three hundred at the time of his death. The increase in numbers, not only of monks, but of visitors from all parts of Christendom, meant a considerable extension of the monastic buildings and the construction of a church, both large enough to house the assembled faithful, and worthy of the liturgical ceremonies for which Cluny was famous. The first great patron of the church was King Alfonso VI of Spain who, after the capture of Toledo in 1085, sent ten thousand talents as a thank-offering and in 1090 promised an annual subsidy of two hundred ounces of gold. The new church was a five-aisled basilica with two transepts, the western longer than the eastern, each with a series of subsidiary chapels, and a narthex at the west end. Five altars in the apse were dedicated in 1095 by the Cluniac Pope Urban II on his way to preach the First Crusade at Le Puy and at Clermont-Ferrand. A

chapel in the western transept was consecrated in 1100 by Pedro de Roda, Archbishop of Pamplona. The nave was barrel-vaulted between 1115 and 1118, although there was a partial collapse in 1125. The church as a whole was dedicated by Pope Innocent II in 1130, but the monastery was not fully erected and walled until after 1180. To the monks, Cluny represented the heavenly city of Jerusalem, and indeed with its walls and cluster of fifteen towers, with a soaring nave and radiating chapels in the church, the monastic complex was the symbol of ultramontane spiritual power. If in monastic eyes imperial Speyer had been outdone by the Order of Cluny, the profound originality of Speyer nevertheless remains, and without Speyer the complex masses of the third church of Cluny could hardly have come into being. Moreover, the Emperors might have observed with some irony that by the time Cluny was completed the torch of ecclesiastical reform had passed to St Bernard of Clairvaux and the Cistercian Order, and that of intellectual stimulus had passed to the cathedral schools and the universities[18].

There were other rivalries. The monastic church of Santa Maria of Ripoll in Catalonia, begun about 1020 and dedicated in 1030, in spite of radical restoration in the nineteenth century, is clearly inspired by Roman imperial architecture[19]. The intention, here, as it was to be in the building of the pilgrim churches of Saint-Martin of Tours, Saint-Sernin at Toulouse and Santiago de Compostela, was to rival the Church of St Peter in Rome. Just as in Carolingian times the abbots of Saint-Denis and Fulda had strained their resources to erect in the north counterparts to the Church of the leading Apostle, so too it was fitting that Tours, the greatest pilgrimage centre within the confines of France, should build for the Apostle of Gaul, that Toulouse, capital of the rich and prosperous Languedoc, should build for St Saturninus, that Compostela, the shrine of St James the Apostle, the only prominent New Testament figure apart from St Peter and St Paul whose grave was agreed to be in Europe, should raise a church worthy of comparison with the Constantinian basilica dedicated to the Prince of the Apostles. Indeed, after Jerusalem and Rome, Santiago de Compostela (*Ill. 156*) had become the third most important pilgrimage of Christendom – much to the dislike

155 Plan of the church of Santiago de Compostela; 1078–1124

156 Interior of the church of Santiago de Compostela

of the Holy See which excommunicated the Bishop of Santiago in 1049 for using the words 'apostolic see' in his title. These churches in their turn served as sources for the design of smaller churches on the pilgrim route. The church of Sainte-Foy at Conques, finished about 1130, is a small replica of the great pilgrim churches of Saint-Martin of Tours, begun after the fire of 997 but altered about the middle of the eleventh and in the early twelfth century; Saint-Martial of Limoges, which became Cluniac in 1063 and was immediately rebuilt on the plan of Saint-Martin; Saint-Sernin begun in the 1080's; and Santiago de Compostela, founded in 1078 and substantially completed by 1124[20]. The plans of these churches were conditioned by the need for space in which impressive liturgical ceremonies could be conducted before a considerable assembly, space

in which large crowds could move with ease, a proliferation of chapels to contain relics and to enable numbers of priests to say Mass, and a setting worthy of an occasion which was a major experience in the life of the faithful, combining a sincere love of God, veneration of the holy martyrs, and penance for the sins of a lifetime. As a result the majority of these churches were planned, or altered, to have five aisles, a large apse and transept arms, all with ambulatory and radiating chapels, and impressive doorways[21].

There were other models. The great Church of the Holy Apostles at Constantinople, founded by the Emperor Justinian in 536, was not only the burial place of the Byzantine Emperors until the early eleventh century, but housed the relics of St Andrew, St Luke and St Matthew[22]. The three churches at Venice, successively dedicated to St Mark from the ninth century onwards to house the relics of St Mark acquired from Alexandria in 829, were based on the Church of the Holy Apostles. The third church was begun about 1063 and consecrated in 1111; it was intended to be a *martyrium*, a dynastic church, and to a certain extent a pantheon of the Doges[23]. There seems little doubt that the Cathedral of Saint-Front of Périgueux, built between 1120 and 1173, was modelled on the Church of San Marco at Venice; Saint-Front, since he founded Christianity in the Périgord, was believed by local tradition to be equal with the Apostles[24]. But the series of domed churches in Aquitaine, apart from Saint-Front, appeared to have followed other oriental models: the cathedral of Angoulême, begun about 1105, the cathedral of Cahors, consecrated by Pope Callixtus II in 1119, and the abbey church of Fontevrault, consecrated in the same year by Pope Callixtus, although the nave was not finished until the second quarter of the twelfth century, all present a chain of domes over the nave and crossing, rather like the reduplication of cupolas used for centuries in the East for baths, bazaars and pavilions. Fontevrault in Anjou, for a time the pantheon of the House of Aquitaine and the Plantagenets, dedicated to St John the Evangelist, St Mary Magdalene and St Lazarus, is a curious amalgam of 'pilgrimage' chevet with radiating chapels and a nave roofed by a file of four domes[25]. It is not without interest to note in connection with the marked oriental characteristics

of the churches of Aquitaine, that, in addition to his consecrations, Pope Callixtus II held a council at Toulouse in 1119 to condemn certain heretics in that district who denied the Sacraments of Holy Communion, Baptism and Marriage, and disbelieved in the priesthood and the ecclesiastical hierarchy. The eastern heresy of the Cathars was already well established in Aquitaine[26].

It has also been suggested that the Cathedral of Pisa, founded in 1063 after the victory of the Pisan fleet over the Saracens near Palermo, consecrated in 1118 but not completed after considerable alteration until the fourteenth century, is a variation in plan of an East Mediterranean basilica (it is in fact a conjunction of three basilicas), and influences from Armenia, Syria and Mesopotamia have been invoked[27]. But it seems more likely that the Cathedral of Pisa (*Ill. 157*) as it stands today, in one of the most beautiful architectural complexes in the world, is a variant of imperial-Lombard architectural design with strong Roman and Byzantine overtones and some Islamic influence; the granite columns in the nave were taken from Roman temples on the Isle of Elba, the capitals range from imperial Roman to Byzantine, the walls are studded with Roman gravestones, altarpieces and inscriptions treated as trophies in the Byzantine manner, and faced with marble panelling, inspired possibly by Roman models and certainly by Byzantine practice, the dome in shape and manner of construction (rising on the inside from very high and narrow pointed arches) looks to Islam[28]. This fusion of stylistic influences was by no means confined to Pisa. Even as far north as Piedmont the Cathedral of Casale Monferrato is built with a narthex containing vaulting derived from Islamic architectural principles and the Church of Saint-Michel d'Aiguilhe at Le Puy, one of the places of assembly for the crusades and for pilgrimages to Santiago de Compostela, reflects in its polychrome decoration on the walls, its doorway with lobed compartments and vegetable arabesque, the influence of the Great Mosque at Cordoba or some similar building[29]. But in a sense the greatest monument to the recently expired Western Caliphate is the superb doorway at Moissac (*Ill. 195*), executed about 1120 and generally recognized as one of the supreme achievements of Romanesque sculpture.

What is Romanesque? In its widest sense any architectural or artistic work which was executed *more romano* is Romanesque, and the term, if applied to a period of time, could be said to range from the Carolingian renewal until the end of the twelfth century. Attempts have been made to divide the works of this considerable period of time into 'premier art roman', 'high Romanesque', 'late Romanesque', and so on, or to link the style with the growth of the Romance languages and by analogy to contrast the court styles of the Carolingian, Ottonian and Salian Emperors with the 'popular' styles current in the late eleventh and twelfth centuries[30]. 'Romanesque', it has been remarked, 'came largely as a mutation in a more or less continuous process[31]. The tendency, indeed, in the second quarter of this century, was to restrict the art-historical term 'Romanesque' to about the last quarter of the eleventh and the greater part of the twelfth century, although it was agreed that 'Gothic' begins with the rebuilding of the Abbey of Saint-Denis about 1145.

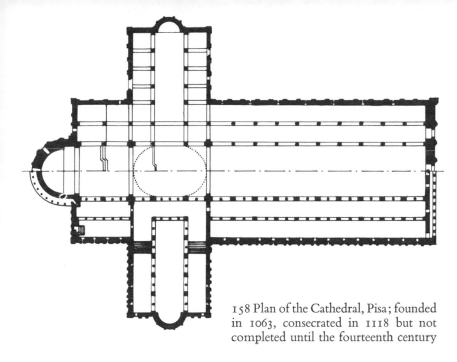

158 Plan of the Cathedral, Pisa; founded in 1063, consecrated in 1118 but not completed until the fourteenth century

157 (*opposite*) Exterior of the Cathedral, Pisa

This tendency is particularly noticeable in studies of architecture and sculpture; studies in monumental painting, manuscript illumination and the various branches of metalwork found the principles laid down for the first group less valid. It is clear that throughout the early medieval period styles multiplied. It has been pointed out that in one comparatively small area of northern France manuscript illumination and drawing shows 'la plus extrême variété: il n'y a rien de commun entre le Mont-Saint-Michel et l'art contemporain, tout proche, de la Basse-Normandie, celui des ateliers de Saint-Evroult, Lyre, la Croix-Saint-Leufroi, Préaulx et le Bec, en admettant que ce soient là des centres picturaux distincts'[32]. And yet amid this proliferation of styles certain general principles may be established, particularly with the first group. If the attempt to combine under a vault all the subordinate parts of a building into a system may be said to be the first principle of the currently accepted art-historical term 'Romanesque', the second principle is the decoration of some of the subordinate parts with ornamental sculpture in such a way

167

as to define and stress the architectural function. Once this principle has been stated, however, a whole chain of reservations and modifications should follow. It has been sapiently remarked in connection with the tympanum of Moissac, for example, that 'the independence of architecture and sculpture is already visible on the tympanum, which is composed of separate blocks applied to the wall and offers no strict correspondence of the figures and the blocks as in Gothic portals. The designer of the porch not only disregards the character of the wall in the applied members, but even the latter, in the distribution of the sculpture between them. This is hardly the unity of structure which a sentimental aesthetic theory has called the essential character of medieval architecture'[33]. On the other hand, the decoration of a Romanesque capital, for example, frequently serves both to stress the function of the capital and to stand out as an independent element in an ornamental scheme. If, as sometimes occurs, the ornament does not arise organically out of the capital but is applied to the surface, the function of the capital is still the dictating factor. The ornament tends not to overflow beyond the capital to the arch above or to the pier below[34]. Strictly speaking, Romanesque sculpture is always confined by the block of stone from which it is carved; whatever the nature of the material used, a tension is set up by a kind of conflict of dimensions; the effect given is that of mass compressed within a limited space. Romanesque sculpture presents three concepts of form: it is dominated by two external forms – the limits of the block from which the figure is carved and the architectural framework for which the figure is designed – and thirdly, by the specific form of the subject. These principles are valid, however, and then not consistently, in only two areas of southern France, Burgundy and Aquitaine, with extensions from Aquitaine into northern Spain and with extensions from Burgundy and Aquitaine into northern Italy; the time during which they are valid lasts little more than thirty years in the first half of the twelfth century. The *portail royal* of Chartres, dating about 1150, because the long, stylized figures are almost freed from the column to which they are attached, is proto-Gothic rather than Romanesque; the sculpture of Saint-Gilles in Provence, dating from about 1175–1185 is 'romanizing'

proto-Gothic but certainly not Romanesque; the artefacts of the valley of the Meuse, even in the first half of the twelfth century, are in certain cases too 'classical' to be Romanesque; indeed, the art of the Holy Roman Empire tends always to be 'romanizing' rather than Romanesque. Yet there can be no doubt that the art of the Empire contributed to the formulation of Romanesque style in Burgundy and, perhaps to a lesser extent, in Aquitaine [35].

Burgundy had been annexed to the Empire in 937 by Otto I, and Conrad, King of Burgundy, was kept a virtual prisoner at the imperial court. In the eleventh century the submission of Burgundy to the Empire was once more stressed when the Emperor Conrad II caused his son Henry III to be recognized as King of Burgundy. In fact the emperors were far from successful in asserting their authority; the Burgundian vassals were in constant revolt. Provence, moreover, was kept unsettled for more than a century by the various attempts of the Emperor to make effective his rights over Burgundy and by the quarrels of the rivals to the County of Provence, the Counts of Toulouse and Barcelona. Renaud, Count of Burgundy (1032–1076), was little more than a common bandit; his life was spent in pillaging the lands of his own vassals and especially those of the Church. The emperors always tried to make the Church an ally against the feudal laity; a special chancery was set up for the realm by Henry III, and Hugues I, Archbishop of Besançon, was nominated Archchancellor of Burgundy. The marriage of Henry III with Agnes of Poitou, sister of Renaud I, Count of Burgundy, was intended to cause among other things a *détente* in the hostility of the Burgundian feudatories. The Emperor tried to enforce the Truce of God. Feudal tenants-in-chief with interests outside Burgundy were summoned to play their part in establishing peace; Rudolph of Rheinfelden, who had lands in Swabia and Burgundy, was set up as viceroy in 1057 by the Empress Agnes [36]. Until the middle of the eleventh century the Emperors had been strong supporters of the Abbots of Cluny and, as usual in the early Middle Ages, cultural expansion was fostered by this union of imperial and ecclesiastical interests. The Dukes of Aquitaine and Gascony, on the other hand, though skilful at extending and maintaining their authority, were unscrupu-

159 Limestone relief of seated nuns from an altar or an altar screen, probably

lous, profligate, and thought nothing of robbing the estates of the Church at their pleasure. Most typical of these tenants-in-chief is perhaps Fulk Nerra, Count of Anjou (987–1040), unscrupulous, ambitious, governed by a passion for war, checked suddenly by the thought of eternal retribution, violent in penance as he was violent in transgression[37]. During these bouts of penance Fulk Nerra founded the abbey of St Nicholas in 1020, the monastery of St Julien between 1020 and 1028, and Ronceray, a nunnery for women of noble birth, in 1028. Throughout the century the French monarchy, apart from some moral power generated by instinctive respect for royalty, was politically and culturally insignificant and with difficulty proved itself a match for the petty barons within its domain.

Unfortunately a large part of the monuments sponsored by the Holy Roman Emperors has been destroyed and the line of development which extended from the work executed in the Empire to

carved about the time of Abbott Adalwig (1066–1081). Werden, abbey church

the Burgundian achievements at Cluny, Autun and Vézelay is difficult to trace. But some figures in arcades, possibly from a tomb or an altar frontal, now in the crypt of the abbey church at Werden (*Ill. 159*), probably executed about the time of Abbot Adalwig (1066–1081), point in their forms, their drapery, and the shapes of the head to the work of the Master Gislebertus at Autun between 1120 and 1135[38]. The fragments of a large Christ from a Last Judgment originally on the west front of Abbot Adalbert's church at Bremen (*Ill. 160*), dating about 1050, starts the sequence of tympana carved with this subject in the late eleventh and twelfth centuries[39]. Moreover, the figure of Christ in Majesty in a mandorla supported by two angels, represented on the gold bookcover of the Abbess Theophano of Essen (1039–1056), grand-daughter of the Emperor Otto II, was later to be echoed constantly in twelfth-century Burgundian sculpture. The female saint in a niche from the Church of

160 Christ, from a representation of the Last Judgment on the west front of Abbot Adalbert's church at Bremen, carved about 1050

St Mauritz, built by Bishop Friedrich of Meissen (1063–1084), now in the Landesmuseum at Münster (Westphalia), not only in form and drapery but in the way in which the figure looms out of a concave background (*Ill. 162*), provides a preliminary stage on the road leading to the capitals of the choir of Cluny III executed between 1088 and 1095 [40]. One of these capitals, carved with the personification of a river, seems to suggest knowledge of a relief at one time on the north wall of the north side-tower of the abbey church of Brauweiler, near Cologne, about 1065–1085 [41]. But perhaps the most beautiful of the capitals at Cluny III are those with no known model, representing the eight Gregorian modes (*Ill. 161*), and forming a fusion of religious and secular motifs so typical of Romanesque art; for it is clear that the author of the *tituli* had some knowledge of music and the text of the Bible, but the sculptor, following a secular model and portraying the *jongleurs* familiar to the courts of

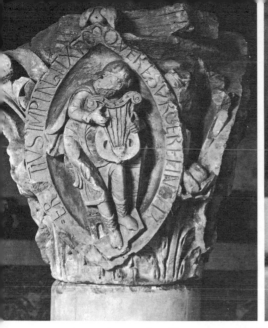
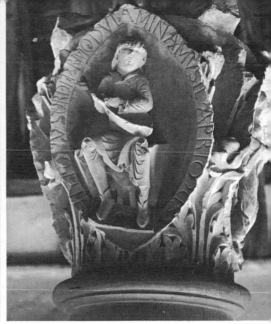

161 Gregorian modes. Limestone capitals from the third Abbey Church of Cluny, carved about 1088–1095

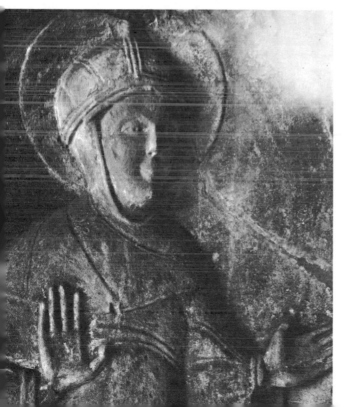

162 Limestone relief of a female saint from the east tower of the Church of St Maurice built by Bishop Friedrich von Meissen (1063–1084)

the time, seems to have had only the vaguest idea of music or the technique of playing instruments[42]. It must be remembered that in most Rhenish churches capitals tend to have plain cubic shapes, or, in imperial buildings like Speyer, are carved with acanthus forms. The proliferation of sculpture over the subordinate parts of the building and the use of sculpture to stress structure is Romanesque rather than imperial.

The sculptors and bronze-casters of the Empire were moving in the direction of mastery over the problems set by isolated figurative art, rather than those set by a series of reliefs closely integrated with the structure of a building. Thus, the bronze tomb-figure of Rudolf, King of Swabia (d. 1080), the oldest extant tomb-figure in the West (*Ill. 164*), in Merseburg Cathedral, has a distinction of form, design and execution which makes an isolated detail of Burgundian sculpture look 'provincial'. It establishes a type of figure which was to be continued in other media, both stone sculpture, as in the monument of the Saxon Duke Widukind in the former collegiate church at Enger (Westphalia), about 1100, and in illumination, as exemplified by the figure of St Pantaleon (*Ill. 163*) in the Gospel Book of St Pantaleon at Cologne, dating from the middle of the twelfth century[43]. The bronze Christ on the Cross, from the Abbey of Helmstedt at Werden (*Ill. 165*), cast about 1070, which should be compared to a half life-size crucifix in copper-gilt at Minden (Westphalia) of slightly later date, presents with its fined-down simplification of form, its majestic head – a noble evocation of Divine submission to death – and its size, a superb example of Rhenish mastery in monumental figure sculpture and wholly within the Ottonian tradition. The export of German metalwork to England during the later part of the eleventh century is recorded in contemporary sources: a pulpit and a bronze and silver-gilt crucifix in Beverley Minster are described as *opus teutonicum*[44]. German metalwork, indeed, provides the earliest evidence of a characteristic of style – 'damp fold' drapery – which was to become current in England in the middle of the twelfth century and has caused confusion over the dating of wall-paintings at Berzé-la-Ville in Burgundy: the germ of this characteristic seems to have been provided by the work of

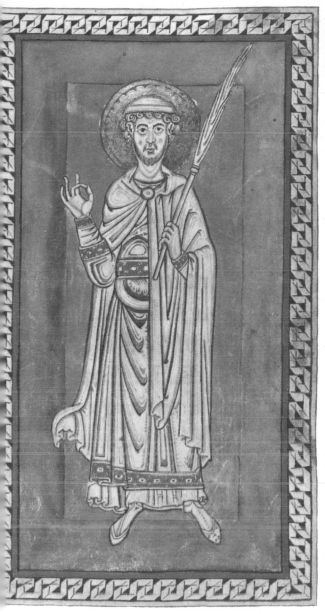

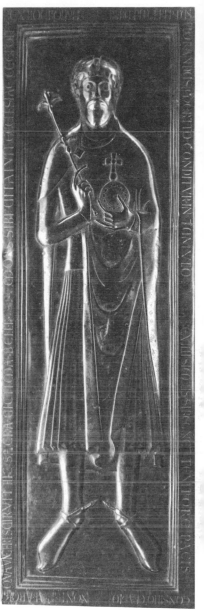

3 St Pantaleon from the Gospel book of St Pantaleon.
ologne; mid twelfth century

164 Bronze tomb cover of Rudolph,
King of Swabia (d. 1080)

Roger of Helmarshausen, whose silver portable altar in Paderborn (*Ill. 166*), about 1100, is decorated with figures on which the drapery is conceived in abstract, geometric terms, and his was certainly not an isolated essay [45].

165 Christ on the Cross. Bronze cast about 1070, formerly in the Abbey of Helmstedt at Werden

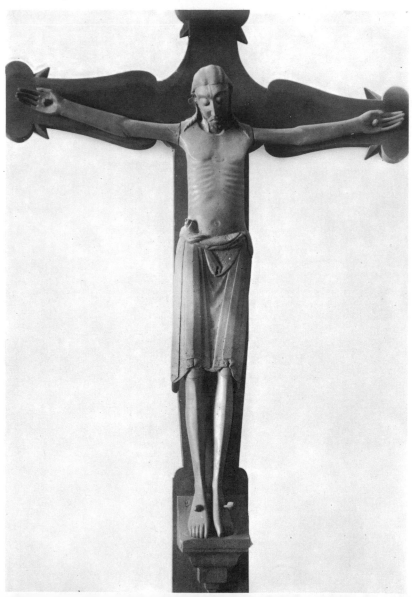

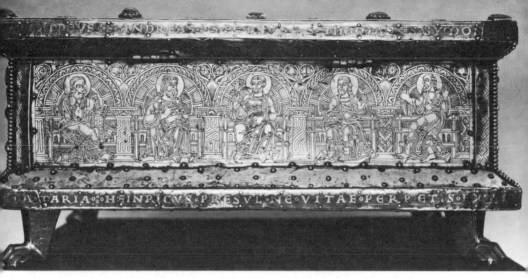

166 Five Apostles. The silver nielloed portable altar of St Kilian and
St Liborius, commissioned from Roger of Helmarshausen by Bishop
Heinrich von Werl (1085–1127) for Paderborn Cathedral about 1100

Mosan art is imperial rather than Romanesque. Since Bishop
Notker's time (972–1008) the example had been set of a strengthened,
enlightened episcopacy united with imperial service. In the late
eleventh and twelfth centuries the Emperors made frequent visits to
Liège; the Emperor Henry IV died there in 1106. Not only the
bishops were loyal servants of the Empire. Abbot Wibald of Stavelot,
at one time Abbot of Montecassino, was Chancellor and counsellor
to three Emperors, he accompanied Lothar II to Italy (1136–1137),
served Conrad III (1138–1152) throughout his reign and informed
the Pope of the election of Frederick I, whom he accompanied to
Italy in 1154; he commanded the fleet against Sicily in 1136; he was
tutor to Prince Henry while Conrad III was on the Second Crusade;
he was Papal Legate on an expedition against the Slavs in 1147; he
was ambassador to the Byzantine Emperor and died, indeed, in Asia
Minor while returning from his second journey to Constantinople
in 1158. Wibald of Stavelot was exceptionally gifted and learned, a
great admirer of Cicero and a patron of the arts. There can be little
doubt that the combination of imperial patronage, loyal, learned
and vigorous ecclesiastics, order and prosperity provided the at-
mosphere in which the phenomenon of Mosan art could appear.

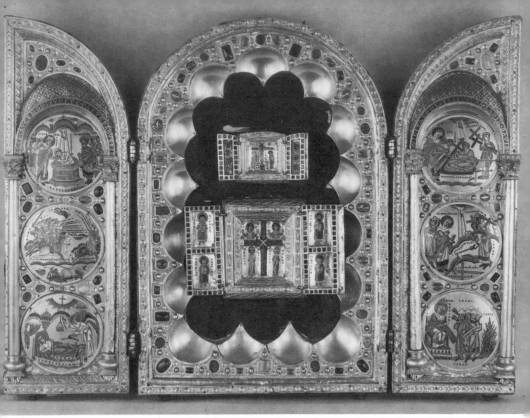

167 Scenes from the life of the Emperor Constantine the Great in champlevé enamel on gilt copper from the Stavelot portable altar; after 1154

The brass font of Rainier of Huy commissioned by Abbot Hellinus (1107–1118) for the Church of Notre-Dame-des-Fonts at Liège, now in the Church of Saint-Barthélemy, completed without question before the death of the abbot, is astonishingly free and classical in form without any of the exaggeration and tension of Romanesque art. On this font (*Ill. 169, 170*) the scenes are represented with a naturalism of form and drapery, with an understanding of the nude, with a subtlety of gesture and posture far in advance of contemporary western achievement. Rainier of Huy is referred to as a goldsmith (*aurifaber*) in a document of 1125 and he is believed to have died about 1150. The style of Rainier of Huy should be seen in a direct line of development from that of the Master of the *Registrum Gregorii* and extending into the work of Nicholas of Verdun at the

168 The Alton Towers Triptych in champlevé enamel on gilt copper, borders stamped and engraved. Mosan; about 1150

end of the twelfth century, the 'classical' sculptures of Reims and Bamberg in the thirteenth century and flowering again in the art of Claus Sluter in the late fourteenth century. Mosan style betrays a profound understanding of antique and late antique models – Nicholas of Verdun must have pondered deeply before antique sarcophagi – but the influence of contemporary art at Rome and Constantinople also played its part. The Stavelot portable altar was made to contain two small Byzantine reliquaries of the True Cross, which Wibald of Stavelot obtained possibly as a gift from the Emperor Manuel (1143–1180) during his first diplomatic mission in 1154. The narrative cycle on the wings (*Ill. 167*) attributed to Godefroi de Claire, based on Byzantine iconography, is reinterpreted in a characteristic Mosan mixture which suggests that the

artist not only knew the work of Rainier of Huy, but had studied in Rome and had fused all these influences into a remarkably free and cursive style. This fluid 'naturalistic' Mosan phenomenon must have had considerable influence on the development of Gothic sculpture[46]. At the same time the Mosan workshops were prepared to pay lip-service to the more conventional tastes of the early Middle Ages. The Stavelot portable altar, now at Brussels, and the Alton Towers triptych, in the Victoria and Albert Museum (*Ill. 168*), with their compartmented, schematic approach, encyclopaedic, allegorical and literary, look back to the glossed pictographs of the Codex of Abbess Uota of Niedermünster at Regensburg. This passion for juxtaposing types and antetypes of the Crucifixion, of allegories and personifications, may equally be seen in Mosan illumination – for example, the Averbode Gospel Book (Liège, Bibl. de l'Université, cod. 3 [363], fol. 86 verso, fol. 87) or the Floreffe Bible (Brit. Mus., Add. Ms 17.738, fol. 3 verso) which themselves look forward to the *Bibles moralisées*, the *Biblia pauperum* of the later Middle Ages[47].

(*opposite*) The Baptism of Christ
m a brass font executed by Rainier
Huy on commission from Abbot
llinus (1107–1118) for the Church of
tre-Dame-des-Fonts

170 Detail from the font of Rainier of
Huy showing two male figures

The influence of the imperial traditions of manuscript illumination, and no doubt wall-painting, were equally dominant in the West in the eleventh and early twelfth centuries. The Missal of Saint-Denis (Paris, Bibl. Nat., lat. 9436, fol. 106 verso), executed at Saint-Denis in the middle of the eleventh century – for example, the miniature of Christ, St Denis and his companions (*Ill. 171*) – in forms, draperies and composition is heavily endebted to the manuscripts executed for the Ottonian Emperors[48]. The Crucifixion in the Psalter of Saint-Germain-des-Prés (Paris, Bibl. Nat., lat. 11550, fol. 6), although drawn with a delicacy which is almost Anglo-Saxon (*Ill. 172*), derives its figure and drapery style from the sculpture and illumination of the Empire[49]. The death of St Aubin in a *Life of St Aubin*, executed at Angers in the second half of the eleventh century (Paris, Bibl. Nat., nouv. acq. lat. 1390, fol. 5), is represented by a massed group of monks, the heavy, solid forms, the stiff gestures (*Ill. 175*) of the so-called Magdeburg Antependium carved in ivory[50]. Even the angels represented in fresco in the Church of Saint-Savin, thirty miles east of Poitiers, about 1100, owe their

171 Christ, St Denis and his companions from the Missal of Saint-Denis, executed about the middle of the eleventh century at Saint-Denis

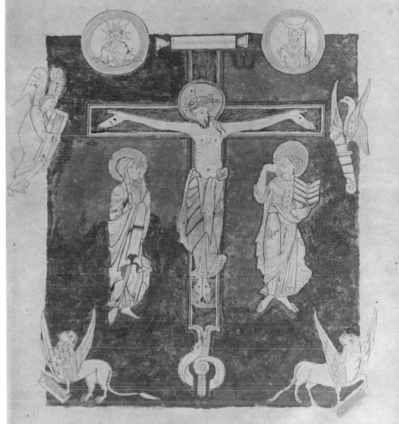

172 Christ on the Cross between the Virgin and St John the Evangelist, the Symbols of the Evangelists and personifications of the Sun and Moon from a Psalter executed at Saint-Germain-des-Prés in the middle of the eleventh century

forms to Ottonian and Salian models (*Ill. 173*)[51]. At Brinay, at Saint-Gilles-de-Montoire, where the Christ in Majesty has been compared with reason to the Christ crowning Henry III and Agnes in the *Codex Caesareus* (formerly at Goslar, now at Uppsala), at Saint-Chef, at Berzé-la-Ville, where again the Christ in Majesty and the martyrdom of St Blaise and St Lawrence (*Ill. 174*) not only parallel in style that of a Cluniac lectionary (Paris, Bibl. Nat., nouv. acq. lat. 2246) dating from the late eleventh century, but to a certain extent that of Roger of Hemarshausen, Ottonian and Salian influences constantly prevail[52]. Even in south-western France, the Sacramentary of the Cathedral of Saint-Etienne at Limoges (Paris, Bibl. Nat. lat. 9438), executed about 1100, although in part related to the 'Second Bible of Saint-Martial de Limoges' (Paris, Bibl. Nat.,

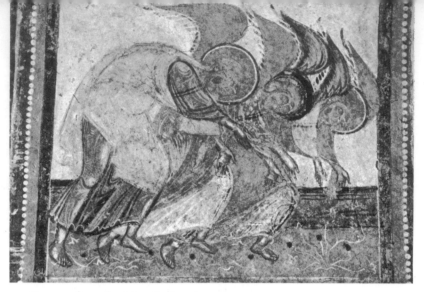

173 Fresco of angels. Saint-Savin; about 1100

lat. 8) by its vigorous drawing and the schematic composition (*Ill. 176*), is yet more dependent on imperial manuscripts issued from workshops at 'Reichenau', Regensburg and Echternach. Adhémar de Chabannes, chronicler of Saint-Martial, relates that William III, Duke of Aquitaine, and the Emperor Henry II were on cordial terms and exchanged gifts; an imperial gift would seem to be the main source of inspiration for the Sacramentary[53].

At Rome the eleventh century was a period of complete artistic sterility. Not a single work, not even of architecture, is listed in the *Liber Pontificalis* under any of the Popes from John XVIII (1003–1009) until Paschal II (1099–1118) and Callixtus II (1119–1124), both Cluniac Popes. About 1100, at Farfa, the scriptorium produced a series of illustrations based on work done by the northern schools; the scriptorium never achieved any great virtuosity and merely confirms the indifferent standards that were general in the Umbro-Roman region, even in one of the most important monastic establishments[54]. Whether the schools were Umbro-Roman or Lombard, whether they drew upon Byzantine or local traditions, the style of the imperial workshops was still a considerable ingredient. In the great Roman Bibles which were undertaken in the second or third decade of the twelfth century, particularly those at Parma (Bibl.

174 Fresco of the martyrdom of St Lawrence at Berzé-la-Ville; late eleventh or early twelfth century

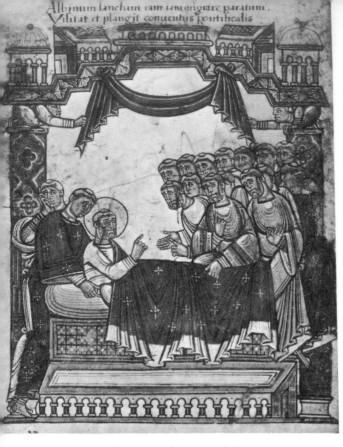

Albinum lanchim iam iam migrare paratum.
Visitat et plangit conuentus pontificalis

175 The death of St Aubin from a Life of St Aubin executed at Angers in the second half of the eleventh century

Palat., Ms lat. 386, fol. 165 verso, 166 recto) and at Genoa (Bibl. Com., cod. RB. 2554.2), with the exception of the Genesis scenes in the former, 'the *naïveté* of psyche and a roughness of execution... are most likely to be provincial'[55]. David playing the harp (*Ill. 177*), in a Psalter possibly produced at the Cluniac monastery of Polirone about 1125 (Mantua, Bibl. Com., Ms. C. III. 20, fol. 1 verso), although under strong Roman influence, clearly reflects the achievements of the northern schools[56]. A drawing at Cesena (Bibl. Piana, cod. 3.210, fol. 1 verso), dated 1104, executed at Rome or under Roman influence (*Ill. 178*), is a very characteristic mixture of Byzantine and northern elements[57]. But as the result of the Paschalian revival and under the patronage of his successors, Honorius II (1124–1130), Innocent II (1130–1143), the Anti-pope Anacletus (1130–1138) and Eugenius III (1145–1153), artistic traditions revived in Rome.

186

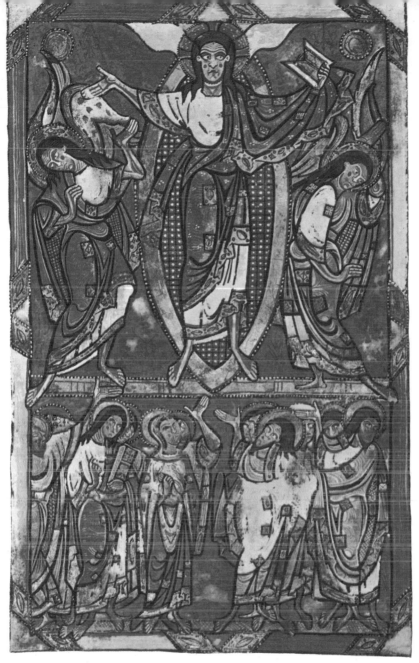

176 The Ascension from the Sacramentary of the Cathedral of Saint-Etienne at Limoges executed at Limoges about 1100

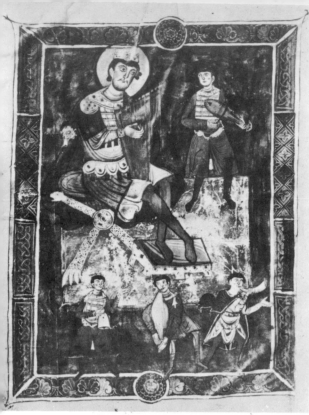

177 David playing the harp among musicians, from a Psalter executed probably at Polirone about 1125

Byzantine and Romanesque influences may be detected in the frescoes of the lower church of San Clemente, about 1100, and in the Basilica of Castel Sant'Elia, near Nepi; the youngest of the three painters working in the latter church came to maturity when he was commissioned to paint in Santa Pudenziana. New frescoes were undertaken in San Paolo fuori le Mura, San Vincenzo and Sant'Anastasio alle Tre Fontane, at Santa Croce in Gerusalemme; mosaics were begun in Santa Maria in Trastevere (1130–1143). The resulting style, however, can only be called Romanesque in the widest sense of the term; the general atmosphere is that of provincial Byzantinism grafted onto local traditions. As in Campania and at the monastery of Montecassino, these traditions produced an individual style, idiosyncratic, full of charm, and not without influence on passing northern artists and patrons, but the general level is far removed from Ottonian and Salian court art, on the one hand, or the aspects of Comnene court art as revealed at Cefalù[58].

188

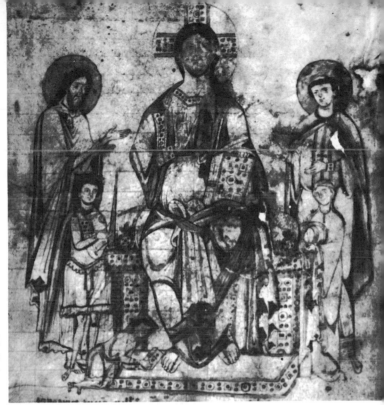

178 Christ enthroned between saints with three patrons. Drawing dated to 1104

If in painting and mosaics throughout Italy Byzantium was the dominant factor, the northern Romanesque schools carried the day in Lombard sculpture. Wiligelmo's school at Modena was essentially a popular art produced by sculptors who were studying afresh provincial Roman reliefs, but it seems likely that the achievements in Aquitaine and Burgundy had been scanned. The influence of Moissac in the treatment of drapery folds, of forms, in the approach to the study of the late antique models, is combined with an awareness of work undertaken at Milan in the late tenth and early eleventh centuries. The result is a wholly individual style, broadly conceived figures, modelled with a sense of volume, primitive vigour, and archaic majesty, set against a neutral background in terms of a frieze applied to the building (*Ill. 179*), rather than stressing the component parts of the structure[59]. With the second generation of Lombard sculptors, Niccolò and his large workshop, architectural decorative schemes in which figures form only a part became current

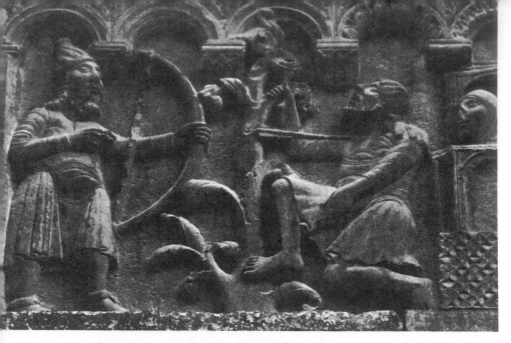

throughout north Italy. Niccolò's work is based on the achievement of Wiligelmo, but he had also studied in Aquitaine. He had been twice probably to Toulouse, had studied the sculpture in Saint-Sernin, in the chapter-house of Saint-Etienne, and his work from the Porta dello Zodiaco in the Sacra di San Michele, near Turin (about 1120), to the west doorway of Santo Zeno, at Verona (about 1138), shows marked Toulousan influence. The sheer bulk of his figures, with their heavy, peasant features and with the drapery falling in finely incised lines, as seen in the north porch of the cathedral at Piacenza, 1120–1135, derives from Wiligelmo, but in the figure of Jeremiah on the west doorway of Ferrara Cathedral, 1135–1141, the vertical lines emphasized by the position of hands, legs and the edge of the inscribed scroll, the dancing posture of the Prophet (*Ill. 180*), all reflect the jamb-figures in the chapter-house of Saint-Etienne at Toulouse, about 1120. It should be remembered that this figure is almost contemporary with the west front of Saint-Denis and that fifteen years later the Portail Royal of Chartres was completed. But the figures at Ferrara, set in niches, are carved completely within the mass of the pilasters they occupy; they are Romanesque rather than proto-Gothic[60].

179 Marble relief by Wiligelmo of the slaying of Cain; 1099–1106

180 Marble relief of Jeremiah by Niccolò; 1135–1141

The twelfth century was a period of astonishing artistic achievement for the English schools of illumination. The pre-Conquest traditions of refined line-drawing, of nervous outline if applied to sculpture, based on memories of the Carolingian court style and its offshoots at Reims and Metz, were never relaxed. The artists went on using the same mannerisms: the reduction of form to pattern, the use of a never-ending pattern to express movement, a violently expressionistic outline, a strong sense of vivacity. They continued to copy the Utrecht Psalter and Carolingian versions of classical texts and astronomical manuscripts[61]. Other styles took their place beside the old 'Winchester' aesthetic dialect: the styles of Canterbury, St Albans, Bury St Edmunds and, towards the middle of the twelfth

181 Historiated initial.
St Gregory, *Moralia in Job,*
executed by an English artist
at Cîteaux before 1111

century, a superb new artistic manifestation at Winchester. The in-
fluence of Canterbury reached as far south as Cîteaux; most scholars
accept the possibility of English artists working on the Bible of
Stephen Harding (Dijon, Bibl. Mun., Mss. 12–15), which was com-
pleted in 1109, and on a copy of St Gregory's *Moralia in Job* (Dijon.
Bibl. Mun., Mss 168–170), finished on 24th December 1111.
Stephen Harding, of noble birth, had been professed as a monk at
Sherborne in Dorset, but he studied in Ireland and in France, made
a pilgrimage to Rome and, on his return, stopped at Molesme to
take an active part in the foundation of Cîteaux. In 1108 he succeeded
St Aubry as abbot, resigning in 1132, and died in 1134. His interest
in establishing a correct text of the Bible was probably influenced by
St Anselm of Bec, Archbishop of Canterbury, and it is reasonable
to suppose that he introduced the Canterbury style of illumination
and drawing to the monastery of his adoption: the large, historiated
initial, the long, thin figure-style with the structure of the limbs
articulated by a careful accentuation of the folds (*Ill. 181*)[62]. But
Canterbury was in close touch with Rhenish and Mosan schools. A
comparison of the portrait of St John the Evangelist in the Gospels

182 St John the Evangelist from the Gospels of Liessies illustrated by the English
artist responsible for the Lambeth Bible about 1146

of Liessies (*Ill. 182*), now at Avesnes, written in a Flemish script, but illustrated by the English artist responsible for the Lambeth Bible, about 1150 (the Avesnes Gospel Book dates to the year 1146), with the dedicatory pages in the *Codex Aureus* of Speyer, suggests that the soft, fine lines of the Echternach artist when delineating the figure of Christ in Majesty have merely become caricatured by the English artist who reduced the delicate modelling and the gentle sweeps of drapery into a vigorous pattern of abstract line. Moreover, the initial letter of Habakkuk's prophecy in the Lambeth Bible (fol. 307 recto), with Christ on the Cross between the Church and the Synagogue, the compartments and inscriptions which form part of the general design, all suggest a Mosan model[63]. It should be remembered that Theobald, Archbishop of Canterbury, was in exile in Flanders at a time when Wedric, who had been Abbot of Liessies in 1146, was Abbot of Saint-Vaast in 1147, and that in 1148 Theobald was at Saint-Omer. The style of the St Albans Psalter has been shown to be a complex mixture of Ottonian and contemporary Roman influences allied to French literary trends, the latter introduced no doubt by Geoffrey of Maine, Abbot of St Albans (known to have been a producer of miracle plays), but the influence of the Empire, particularly the Rhineland and the Meuse, seems to be the dominant feature. The representation of St Edmund crowned by angels, executed in the style of the Alexis Master, the principle artist of the St Albans Psalter (if not by his own hand), in a Life of St Edmund (Pierpont Morgan Lib., Ms. 736) is a direct descendant from Ottonian coronation portraiture, even to the shape of the crown (*Ill. 184*); the manuscript was written unquestionably at Bury St Edmunds in the early 1130's[64]. The Bury Bible, produced between 1130 and 1140 by the Master Hugo, is one of the glories of English Romanesque art. Elements of the earlier St Albans style combine with renewed Flemish influences, but throughout this great work emerges the presence of the immediate impact of Byzantium. The thin features, large eyes and flowing hair, the folds of drapery modelling the forms, a new sense of monumentality (*Ill. 186*) combine to overcome the ingrained English habit of producing an impression of vitality by an endless continuity of design. Here again it is tempt-

ing to see the personal intervention of the reigning abbot, Anselm of Bury (1121–1148), an Italian who, as Abbot of San Saba in Rome, had been in touch with Greek monasteries in southern Italy [65]. But one of the greatest patrons was Henry of Blois, Abbot of Glastonbury and Bishop of Winchester, who dominates the artistic scene in England in the middle of the twelfth century, whose Bible at Winchester maps the development of English painting in the second half of the century and synthesizes the work of different schools. For it seems likely that the Winchester Bible is the product of a team of artists, drawn from various centres to Winchester by Henry of Blois, and its style ranges from a mixture of old-fashioned Anglo-Saxon conventions and the St Albans idiom, the Bury synthesis of monumental vitality and Byzantine physiognomy, to the 'Master of the Gothic Majesty' whose forms, no longer disintegrated into pools of pattern, coalesce and retreat behind the flowing Gothic line (*Ill. 183, 185*) [66].

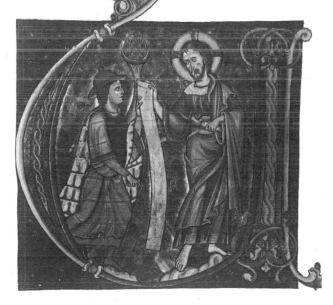

183 The Word of the Lord given to the Prophet. Illuminated initial to the Book of Isaiah by the Master of the Gothic Majesty; late twelfth century

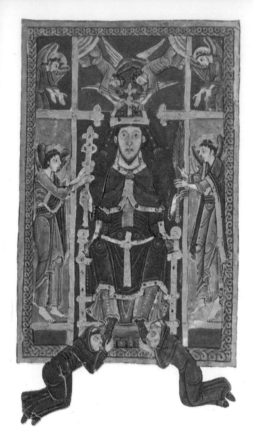

184 St Edmund crowned by angels, from the Life of St Edmund illustrated in the style of the Alexis Master at Bury St Edmunds about 1130–1133

185 Illuminated initial showing the Calling of Jeremiah from the Winchester Bible. Executed middle to second half of the twelfth century

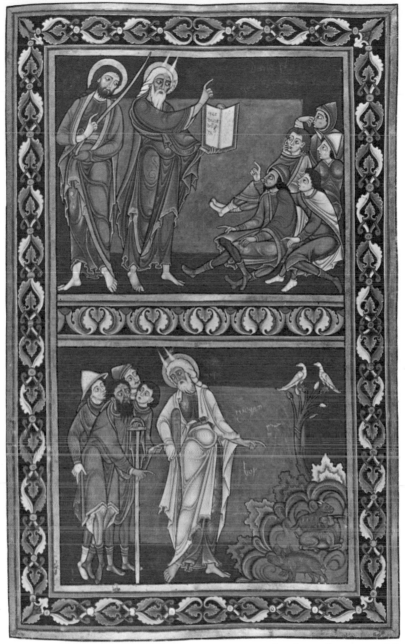

186 Moses expounding the law of the unclean beasts from the Bury Bible.
Executed at Bury St Edmunds by Master Hugo between 1130 and 1140

Metalwork in England descends almost directly from the art of the Empire. The candlestick, given by Abbot Peter (1104–1113) to the monastery of St Peter at Gloucester, now in the Victoria and Albert Museum (*Ill. 187*), although it combines both Canterbury and Winchester stylistic elements, is in direct line of descent from those undertaken in the early eleventh century for Archbishop Bernward of Hildesheim[67]. The enamel plaque with a representation of the Last Judgment, executed at Winchester between 1150 and 1160 with remarkable virtuosity (*Ill. 189*) – note the foreshortening of the angel on the left – the panels decorated with scenes from the life of St Paul, about 1160 (*Ill. 190*), the Balfour ciborium (about 1180), owe much in line, colour and technique to the Mosan schools[68]. There is constant evidence to show not only that English patrons and artists travelled much in the course of the twelfth century but that there were frequent visitors from abroad. Sculpture in Herefordshire reflects knowledge of the churches in the Charentais and buildings along the pilgrimage route to Santiago de Compostela. An ivory relief of the Deposition, produced by the school of Hereford about 1150, is a direct reflection of such a journey[69]. Sculpture at Ely, where the Prior's Doorway provides the richest Romanesque example in the country, combines strong Anglo-Saxon and Viking influences with a second-hand knowledge of Italian models; reliefs at Chichester depend closely on sculpture at Cologne; and at Lincoln, where for the first time in England a truly monumental decoration was carried out about the middle of the century, the influences of Wiligelmo's school at Modena combine with an awareness of the latest sculptural achievements at Saint-Denis[70]. It would seem, nevertheless, that there was a marked lack of monumental sculpture in England. Although Reading Abbey was built during the reign of Henry I under the supervision of monks sent from Cluny, its sculpture bears no trace of Burgundian influence[71] and the quality of that which has survived is not particularly high. At Canterbury, among the many capitals in the crypt, there is not a single religious subject and the inspiration of almost every carving on the capitals executed about 1120 could be traced to books produced in the scriptorium[72]. Even at Lincoln, under direct influence from Saint-Denis, there were

187 Candlestick
given by Abbot
Peter (1104–1113)
to the monastery
of St Peter at
Gloucester

188 English stone carving of the Virgin and Child. York Minster; mid-twelfth century

no tympana, no figure-carved voussoirs, no columns with figures attached, so essential to the decoration of Suger's church[73]. A small relief of the Virgin and Child in the crypt of York Minster, carved under strong Byzantine influence (*Ill. 188*), some ravaged remains of a stone screen at Durham with scenes connected with the Resurrection of Christ, and the rustic grandeur of the Apostles in the south porch at Malmesbury (*Ill. 191*), about 1170–1175, suggest that, whatever may have been destroyed by time, the puritans and the restorer, the art of the sculptor in England could in no way compare with the achievement of Burgundy and Aquitaine[74].

It has been suggested that the Burgundian school was almost certainly indebted to the Empire. It should be pointed out that among the first efforts at Toulouse, a relief of Christ in Majesty, probably carved between 1094 and 1096, in the Church of Saint-

189 (*left*) The Last Judgment in champlevé enamel on gilt copper. Winchester; 1150–1160

190 *(below)* St Paul disputing with the Greeks and the Jews. Champlevé enamel on gilt copper. Winchester; about 1160

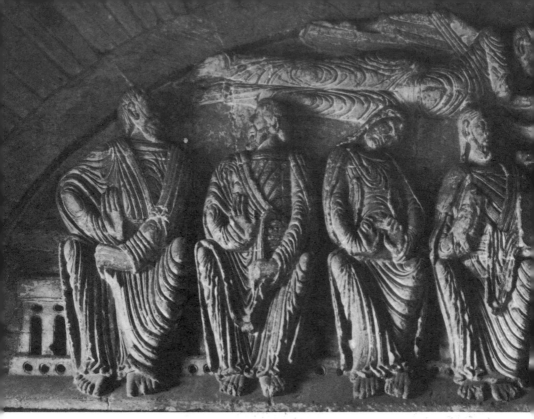

Sernin may well have been modelled on an Ottonian gold altar frontal. The beardless Christ, the heavy, fleshy form, the position of the symbols of the Evangelists, look back indeed to Carolingian ivory reliefs, but the ornament on the edge of the mandorla suggests a metalwork intermediary (*Ill. 192*). The seraphim and angels at Saint-Sernin also look back to ivory reliefs possibly of Carolingian date. The tombstone of Abbot Durandus (1047–1072) in the cloister of Moissac probably reflects the funerary monuments of the Empire[75]. Moissac had submitted to Cluny in 1047, and, in the Cluniac Order, the Abbot of Moissac was second only to the Abbot of Cluny. Abbot Durandus, who was later Bishop of Toulouse, consecrated a new church in 1063. Under Abbot Hunaud (1072–1085) the monastery acquired considerable property and building forged ahead. According to the chronicler Aymeric, the cloister and the sculptured tympanum were executed under Abbot Anquetil (1085–1115); there is an inscription of the year 1100 in the cloister. Under Abbot Roger

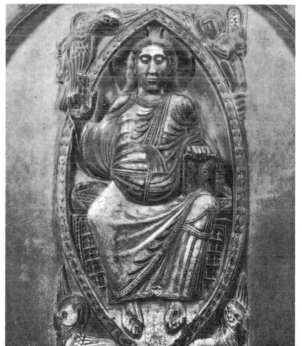

191 Limestone carving of six Apostles and an angel in the south porch of Malmesbury Abbey; 1170–1175

192 Marble relief of Christ in Majesty, now in the ambulatory of the choir of Saint-Sernin, Toulouse; 1094–1096

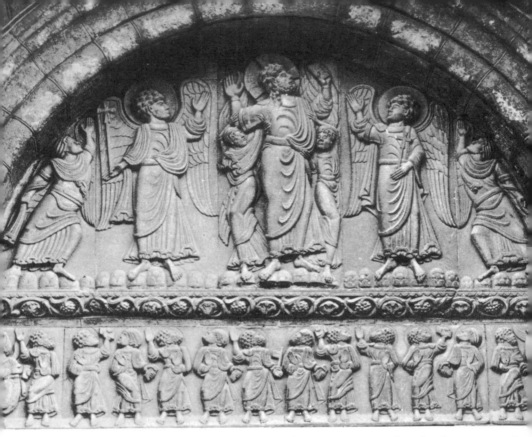

193 The Miègeville tympanum showing the Ascension, carved in the first or second decade of the twelfth century. Saint-Sernin, Toulouse

(1115–1131) a new church was built, domed like those of Cahors and Souillac, and his portrait is carved on the exterior of the south porch. The porch and the jamb-figures of Isaiah and St Peter date probably about 1120–1130. The Miègeville Tympanum in the Church of Saint-Sernin at Toulouse dates to the first or second decade of the twelfth century. The sculptures at Souillac date from about 1115 to 1120[76]. With the appearance of this sequence of sculptures it is evident that a great new school had been formed, a school which was not confined to Moissac, Toulouse and Souillac; it operated at various stages on the pilgrim route to Santiago de Compostela, in the town itself, and exerted an influence which radiated out to northern Italy and the Ile-de-France. The Miègeville tympanum (*Ill. 193*)

204

is carved with a remarkable Ascension of Christ in which Christ is borne upwards by two dancing angels between four other angels attitudinizing in wonder, and above the twelve Apostles and two angels holding scrolls; the stylized, twisted postures of the Apostles emphasize the awe of the scene. The forms are revealed with considerable solidity and the simple, stylized folds of the draperies emphasize the dense posturings. There is considerable evidence to show that the sculptor had made a close study of early Christian sarcophagi, possibly even earlier pagan sculpture, particularly in the carvings on the bases of the statues of St James (*Ill. 194*) and St Peter, but his working-out of the problems of form and drapery proposes a new, individual style, quite different from, and indeed diametrically opposed to, the solution of an artist like Rainier of Huy [77].

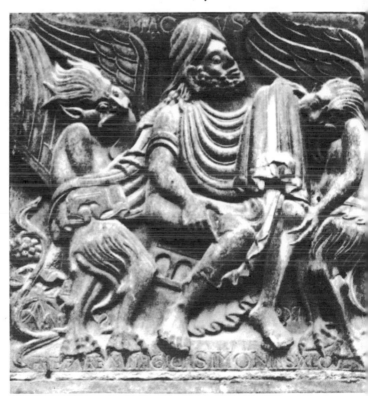

194 Base of the statue of St James from the Miègeville Door

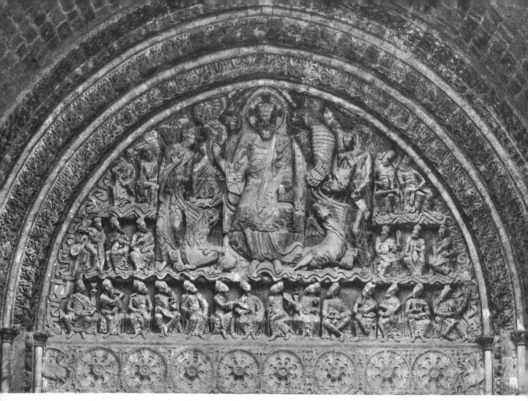

195 Stone tympanum showing the Last Judgment, over the doorway of the south porch of the Abbey Church of Saint-Pierre, Moissac. Executed about 1115

When the doorway at Moissac (*Ill. 195*) is considered, it is equally evident that a series of traditions has been brought to bear which are 'opposed' to the classical canons on which the Miègeville sculptor had based his variants. In the first place, the influence of Islamic architecture is revealed by the decoration of the doorways with scalloped sides and the foliated medallions on the lintel; the pairs of lionesses intercrossed also bear witness to the influence of Hispano-Arabic art. It has long been pointed out that the scheme of decoration of the Apocalyptic Vision on the tympanum seems to have been inspired by an illumination in the Apocalypse of Saint-Sever, written in the middle of the eleventh century when the Spaniard Gregory of Montana was Abbot of the monastery[78]. All the Commentaries of Beatus executed in Spain in the tenth and eleventh centuries naturally show marked Islamic influence, and of these one

206

of the most beautiful is in the Cathedral of Burgo de Osma, executed in 1086 (*Ill. 196*). A series of manuscripts grouped round the Sacramentary of Figeac in southern France and dating from the eleventh century show an interest in Islamic ornament[79]. But the scene on the tympanum at Moissac is a *diwan* of Divinity, Christ holding court like an Umayyad or Buwaiyid prince[80], crowned like a Spanish king, and surrounded by the elders playing lutes and viols, themselves derived from illustrations of Islamic musicians. The head of Christ is in the tradition of the Christ on the Cross carved in ivory for King Ferdinand I of León and Castile about 1063 (*Ill. 197*); the flattened forms of drapery – as if pressed by an iron – on the tympanum are also to be found in the loin-cloth of the Christ carved in ivory and in a series of ivory panels on caskets at Oviedo and San Millan de Cogolla, dating about 1070–1100[81].

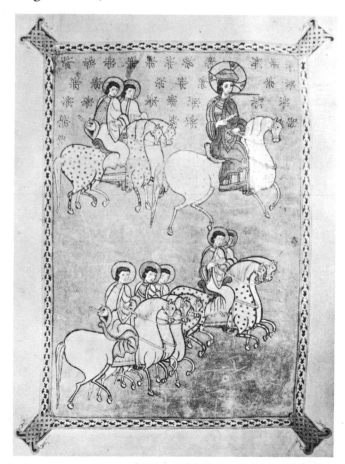

196 The Host of God, from Beatus's Commentary on the Apocalypse, XIX, 11–16; executed about 1086

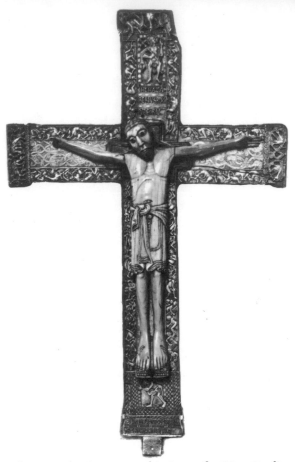

197 Christ on the Cross carved in ivory for King Ferdinand I
of León and Castile about 1063

The presence of such marked Hispano–Arabic influence on the
tympanum at Moissac is a reminder of the considerable standards of
civilization sponsored by the Islamic dynasties. After the destruction
of Cordoba by the Berbers in the early eleventh century, the im-
portance of the courts of Toledo, Badajoz, Valencia, Deria, Almería,
Granada and Seville cannot be sufficiently stressed. The princes were
enlightened and lavish in patronage. Poets, men of letters, doctors,
philosophers, scientists teemed at the courts. Among these centres
Toledo gradually became the centre of Muslim learning in Spain
and it maintained its position after the Christian reconquest in 1085.

The court of Alfonso VI, though nominally Christian, was as much saturated with Muslim civilization as the Norman court at Palermo in the middle of the twelfth century and as the Emperor Frederick II Hohenstaufen's was to be in the thirteenth century. Alfonso proclaimed himself the 'Emperor of the two religions', and his patronage of Cluny III has already been noticed. The schools at Toledo attracted students from all parts of Europe, including England and Scotland. The patronage of the Spanish kings and nobility entailed awareness of artistic currents in all parts of Europe. The series of frescoes in Catalonia owe their existence in part to earlier models in north Italy and in Rome; the Counts of Barcelona were in constant touch with Rome. In the same area the Roda Bible was produced which began to take over the fluttering drapery, vigorous movement and rolling ground line of English style in the second half of the eleventh century; the rest of Spain adopted its own peculiar translation of the style somewhat later[82]. It has been shown that one cycle of frescoes at Sijena is the work of an English artist towards the middle of the twelfth century[83]. But it is also important to note that the great thinkers of Muslim Spain, the philosophers and the mathematicians, continued the study of Aristotle and Euclid which had so marked an influence on western medieval thought after the collapse of the Caliphate. With the beginnings of the Reconquest silks, jewellery and works of art of all kinds flowed from Spain into the feudal households of northern Europe, and just as Hispano Arabic poetry was to exert its influence on the poetry of the troubadours in Aquitaine, so too the ingredients of Hispano-Arabic art began to play its part in the forming of Romanesque style. The proximity of Languedoc naturally opened it to all aspects of the hybrid culture which comprised an ease of living and a toleration of difference of people and thought in day-to-day life quite unknown to the North. The tympanum at Moissac is the supreme artistic example of this fusion[84].

The trumeau figures of Jeremiah and St Paul, which support the tympanum of Moissac, stand out as equally supreme works of the Romanesque artistic achievement. These delicate attenuated figures (*Ill. 198*) with flowing locks and moustaches, swathed in sinuous

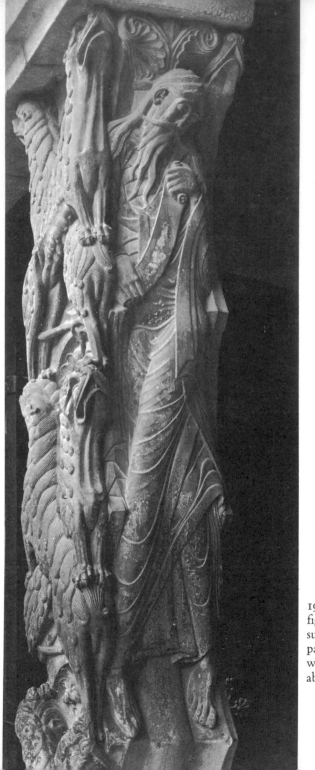

198 Stone trumeau figure of Jeremiah supporting the tympanum of the doorway at Moissac; about 1115

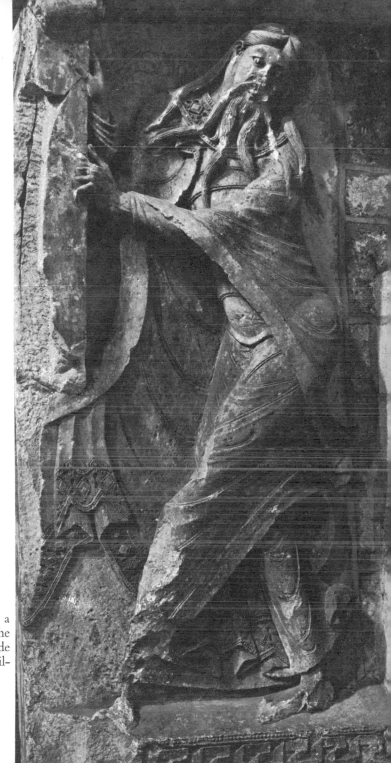

199 Isaiah from a stone abutment of the doorway now inside the Church at Souillac; about 1120

drapery, strain with nervous, febrile energy to emerge from the block in which they are carved, caryatids in travesty whose dancing, elegant forms seem physically incapable of supporting the mass of masonry above them. The Romanesque conflict of dimensions, the Romanesque contradiction of stresses, the Romanesque exaggeration of effect – nervous tension, ecstatic expression – are crystallized in these marvellous manifestations. The prophet Isaiah at Souillac (*Ill. 199*), dating about 1120, carries these effects to an even richer conclusion. More broadly conceived than the Moissac figures, the drapery carved with even greater virtuosity, the figure of the prophet dances within the confines of the block, his hands gripping one side of the block, his feet balancing on the edge of the block, ecstasy made manifest yet stone-bound. But at Toulouse an artist called Gilabertus was already calming the fever. The apostles, St Thomas and St Andrew, carved by him for the chapter-house of Saint-Etienne, lack the ecstatic wonder of the work at Moissac and Souillac and avoid the distortions and caprices of his contemporary Gislebertus at Autun and Vézelay; the elongation of the forms (*Ill. 200*), the complex system of folds and draperies falling into multiple, tight pleats closely hugging the body down to the jewelled borders, forecast the Portail Royal of Chartres[85].

It should be said at once that for all the influences detectable from the Spanish world, the quality of these Aquitanian sculptures far exceeds anything produced in Spain. The reliefs in the cloister of Santo Domingo at Silos, often dated to the end of the eleventh century but more probably executed after 1130, charming and elegant though they may be, are pale, attenuated, stiff spectres in comparison with the apocalyptic visions of the artists at Moissac and Souillac. At Santiago de Compostela, when considering the Romanesque of the early twelfth century as opposed to the proto-Gothic sculpture of the late twelfth century, it is clear that the best artists came from Aquitaine[86].

200 Stone figure of St Thomas executed for the chapter-house of Saint-Etienne at Toulouse and signed by Gilabertus about 1120–1130

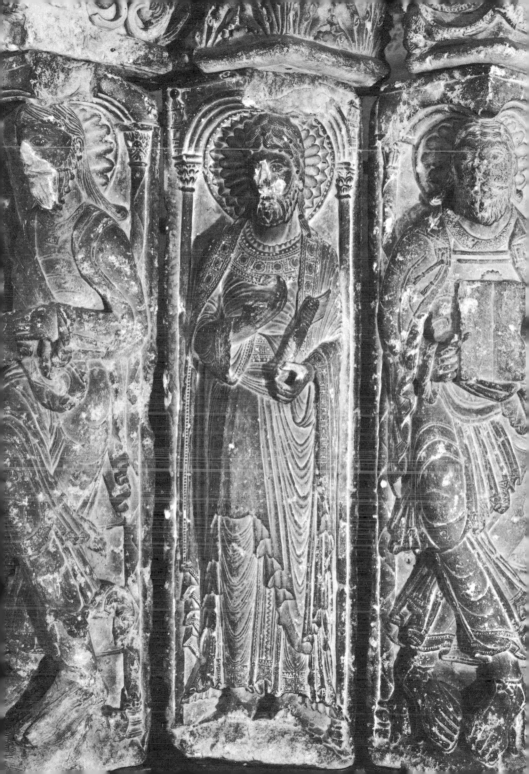

201 Christ in Majesty from the tympanum of the west doorway of the third Abbey Church of Cluny, *c.* 1109–1115, from an eighteenth-century engraving

In Burgundy the tensions and nervous expressiveness took on a different form. From the eighteenth-century engraving (*Ill. 201*) of the tympanum of Cluny III it is difficult to come to any aesthetic conclusion about the sculptural effects. But the capitals (*Ill. 161*) from the choir of the church suggest that the Burgundian artists started with a far less stylized treatment of the figures and a more fluid attitude to the drapery, as might be expected from an art which owed its origins in part to the imperial style. With the Master Gislebertus, working at Autun between 1120 and 1135, distortion and exaggeration of act and posture (*Ill. 202*), figures drawn up like wrought tubes of dynamism, drapery raked into furrows of line and fold, parallel but on a different wave-length, so to speak, the manifestations in Aquitaine[87]. These characteristics are carried to an extreme of virtuosity in the serene, majestic vision of the Ascension

202 The Last Judgment from the tympanum of the west doorway of the Cathedral of Saint-Lazare at Autun. Carved by Gislebertus before 1135

combined with the Mission to the Apostles, on the tympanum (*Ill. 203*) of the inner door at Vézelay, about 1125–1130, where the structural stability of the overall scheme of the design emphasizes the ultracosmic nature of the vision in spite of the flurry and agitation of the component parts, the whorls, quirks and ripples of the drapery, the babel of gesture, and the pandemonium of the lintel. According to medieval interpretation the Tower of Babel is the antitype of the Descent of the Holy Ghost, but the whole content of the tympanum has its sources in the Gospels, the Acts, in the prophecies of Isaiah and in geographical writings of antiquity and of the Middle Ages which describe the appearance of foreign and monstrous races. The plan must have been drawn up by a theologian, possibly Peter the Venerable, once prior of Vézelay, then Abbot of Cluny in 1122, who took a great interest in the liberation of the

203 The Ascension combined with the Mission to the Apostles, from the stone tympanum of the inner west doorway of the Abbey Church of Sainte-Madeleine at Vézelay. Executed about 1125–1135

204 *above* Christ in a mandorla supported by two angels and the symbols of the Evangelists. Below, the Virgin, two angels and the Apostles.

205 (*below*) Christ in Majesty and, below, the Last Supper. Stone tympanum executed in the middle or third quarter of the twelfth century. Saint-Julien-de-Jonzy

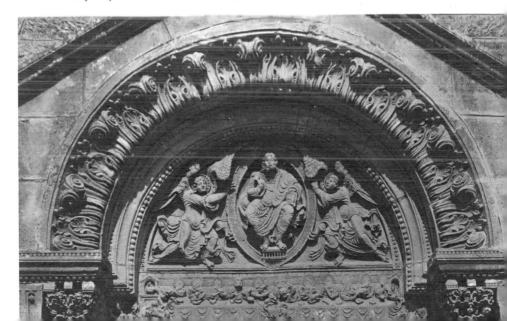

Holy Land, at a time in Christian history when the crusaders seemed again to be accomplishing the tasks of the Apostles. At Vézelay in 1146 St Bernard of Clairvaux preached the Second Crusade and King Louis VII took up the cross; from Vézelay in 1190 Richard I of England and Philip Augustus of France started for the Third Crusade[88].

The Burgundian sculptors were to continue masterly variations of these stylistic principles – the tympana at Saint-Fortunat-de-Charlieu (*Ill. 204*) and at Saint-Julien-de-Jonzy (*Ill. 205*) confine almost greater dynamic tension within a smaller scale, capitals at Saint-André-le-Bas at Vienne, about 1152, explode from the dimensions of the block (*Ill. 206*) into concepts of Samson and Job – but none was to equal the presentation of the Godhead, Christ Redeemer, God the Holy Ghost, at Vézelay. Indeed with the consecrations of Saint-Denis and Chartres in the middle of the twelfth century, the Ile-de-France was to witness a synthesis of the southern French achievements and gradually all the multiple tendencies of the Romanesque will over form were poured into the crucible of one Gothic mould.

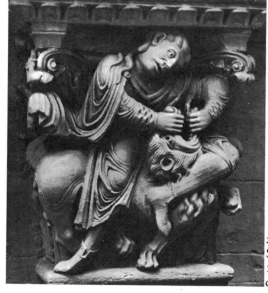

206 Samson and the Lion. Stone capital executed about 1152. Church of Saint-André-le-Bas at Vienne

Notes

List of Illustrations

Bibliography

Index

Notes

CHAPTER ONE

1 Charlemagne was prepared to think quite romantically about the Empress Irene. There were even proposals of marriage with the Empress who was then of considerable age, and indeed Irene was prepared to consider them favourably. Not, however, the Byzantine patricians, who deposed her in 802 for this and other reasons before the eyes, so to speak, of Charlemagne's envoys. The accession of a new Emperor, Nicephorus I, was a considerable embarrassment to Charlemagne, since he could no longer argue that it was not fitting that a woman should bear the imperial title. There had also been proposals of marriage between Rothrude, eldest daughter of Charlemagne, and the young Constantine VI during the years 781 and 787. Constantine VI was deposed and blinded by his mother, the Empress Irene, in 797; Rothrude died in 810. Cf. E. H. Kantorowicz, *Laudes Regiae, A Study in Liturgical Acclamations and Ruler Worship*, Berkeley and Los Angeles, 1946, p. 37.

2 Cf. J. von Schlosser, *Quellenbuch zur Kunstgeschichte des abendländischen Mittelalters, Quellenschriften für Kunstgeschichte*, N.F. VII, Vienna, 1896, p. 25.

3 Cf. Krautheimer in *Art Bulletin*, XXIV, 1942, p. 3; H. Fichtenau, *The Carolingian Empire*, Oxford, 1957, p. 67. There is no evidence that the Popes had a *sacrum palatium* before 813. Charlemagne was well informed on Constantinople through his envoys. There were Greeks not only in Italy but in his own retinue who could give an account of the buildings in the metropolis. Cf. also, Krautheimer, 'An Introduction to an "Iconography of Mediaeval Architecture"', *Journal of the Warburg and Courtauld Institutes*, V, 1942, 2 ff.

4 H. Hoffmann, 'Die Aachener Theoderichstatue', *Das erste Jahrtausend, Kultur und Kunst im werdenden Abendland an Rhein und Ruhr*, Düsseldorf, 1962, I, 318 ff.

5 Alcuin described York Cathedral; it had thirty altars and many columns and arches. Hexham, about 700, was *mirabili longitudine et altitudine* and had many columns. With regard to the surmised T-plan of Hexham, it should be pointed out that such a plan is scarce in early Christian Italy, and its revival in Charlemagne's time may be due to Northumbrian influence. Semi-circular corridor crypts occur in Rome (e.g. St Peter's, c, 590), but the more irregular, more catacomb-like type first found at Hexham was copied at Soissons (817–841) and Steinbach (821). The latter was built by Einhard, who could have been informed by Alcuin about Northumbrian architecture. Canterbury was a patched-up Roman basilica, burnt down in 1067. The first cathedral of Paderborn shows Anglo-Saxon influence. On the other hand, St Albans, a major building, may have been built under Carolingian influence. Cf. P. Kidson and P. Murray, *A History of English Architecture*, London, 1962, p. 28; E. A. Fisher, *The Greater Anglo-Saxon Churches*, London, 1962.

6 The western tradition of centrally planned palace chapels begins with no less than three examples dating from the late eighth and early ninth century: a church at Benevento built by the Lombard ruler, Arechis II, about 765; Aachen dedicated possibly by Leo III in 805; Germigny-des-Prés, dedicated in 806. Cf. I. Lavin, 'The House of the Lord. Aspects of the Rôle of Palace Triclinia in the Architecture of Late Antiquity and the Early

Middle Ages', *Art Bulletin*, XLIV, 1962, 1 ff., esp. 15 ff. Einhard, one of Charlemagne's architects, had studied Vitruvius. Cf. E. de Bruyne, *Études d'Esthétique Médiévale*, I, Bruges, 1946, 243 ff. Charlemagne had permission from Pope Hadrian (772–795) to strip the walls of Ravennate churches of mosaics and marble panels. '*Musive et marmorea urbis Ravennae tam in templis quam in perietibus et stratis, tam marmorea quamque musivum, caeteraque exempla de eodem palatio vobis concedimus auferenda.*' Cf. del Medico in *Mon. Piot.*, XXXIX, 1943, p. 85.

7 Cf. H. Fichtenau, 'Byzanz und die Pfalz zu Aachen', *Mitt. des Inst. für österreich. Geschichtsforschung*, LIX, 1951, 1 ff. There is some doubt that Leo III actually dedicated the church in 805; it was probably completed and consecrated by 800. Cf. J. Hubert, 'La mosaïque disparue de la chapelle du palais de Charlemagne', *Bull. de la Soc. des Antiquaires de France*, 1936, 132 ff. The bronze doors and the balustrades in the tribunes, according to Einhard (*Vita Karoli*, 2–6), date from the time of Charlemagne; the mosaic was also to be dated to the beginning of the ninth century.
Hermann Schnitzler argues that in Charlemagne's time the twenty-four elders adored the Lamb of God; the figure of Christ in Majesty was substituted towards the end of the twelfth century by Frederick Barbarossa, probably when the great chandelier, which still hangs in the palace chapel, was installed. Cf. H. Schnitzler, 'Das Kuppelmosaik der Aachener Pfalzkapelle', *Aachener Kunstblatt*, XXIX, 1964, p. 1 ff.

8 Cf. J. Fleckstein, 'Die Hofkapelle der deutschen Könige', *Schriften der Mon. Germ. Hist.*, XVI, 1, Stuttgart, 1959, ch. I, esp. p. 43 and *passim*; I. Lavin, in *Art Bulletin*, XLIV, 1962, p. 24. Cf. also, E. von Sommerfeld, 'Westbau der Palastkapelle Karls des Grossen', *Repertorium für Kunstwissenschaft*, XXIX, 1906, 195 ff., 310 ff.; J. Buchkremer, 'Untersuchungen zum karolingischen Bau der Aachener Pfalzkapelle', *Zeitschrift d. Deutschen Vereins f. Kunstwissen-*

schaft, I, 1947, 1 ff.; H. Beenken, 'Die Aachener Pfalzkapelle. Ihre Stellung in der abendländischen Architekturentwicklung', *Jb. des Rhein. Vereins f. Denkmalpflege und Heimatschutz*, 1951, 67 ff.; F. Kreusch, 'Über Pfalzkapelle und Atrium zur Zeit Karls des Grossen', *Dom zu Aachen, Beiträge zur Baugeschichte*, IV, 1958.
On the influence of the palace chapel at Aachen, cf. G. Bandmann, *Mittelalterliche Architektur als Bedeutungsträger*, Berlin, 1951, 103 ff., 201 ff.; L. Grodecki, *Au Seuil de l'Art Roman, L'Architecture ottonienne*, Paris, 1958, 168 ff.; A. Grabar, *Martyrium*, I, 559 ff.
For recent literature on Carolingian architecture in general, cf. H. E. Kubach and A. Verbeek, 'Die vorromanische und romanische Baukunst in Mitteleuropa. Literaturbericht', *Zeitschrift für Kunstgeschichte*, XIV, 1951, 124 ff.; *ibid.*, XVIII, 1955, 157 ff.

9 Cf. Schlosser, *Schriftquellen*, p. 216. No. 682: '*Basilica instar eius quae Aquis est constituta*'. Horse-shoe arches are rare in France; cf. Deshoulières, 'Le premier art roman d'après M. Puig i Cadafalch', *Bull. Mon.*, LXXXVII, 1928, p. 103; A. Khatchatrian, 'Notes sur l'architecture de Germigny-des-Prés', *Cahiers archéologiques*, VII, 1954, 161 ff.

10 Cf. H. Liebeschütz, 'Théodulphe of Orléans and the problems of the Carolingian Renaissance', *Fritz Saxl, 1890–1948, a Volume of Memorial Essays*, London, 1957, 77 ff.; A. Freeman, 'Theodulf of Orléans and the *Libri Carolini*', *Speculum*, XXXII, 1957, 663 ff.
Cf. also, F. J. Raby, *Secular Latin Poetry*, I, 178 ff.; M. G. H., *Poetae carolingii aevi*, I, ed. Dummler, 1881, Theodulfus, *Carmina*, XXVIII, *Versus ad Judices*, v. 171 ff., p. 498, v. 211–221, p. 499; M. R. Pfister, 'Les tissus orientaux de la Bible de Théodulphe', *Coptic Studies in honor of Walter Ewing Crum*, Boston, 1950, 501 ff.

11 G. Bouet, 'Germigny-des-Prés', *Congrès Archéologique*, LIX, 1892, 254 ff.; J. Hubert, 'Germigny-des-Prés', *Congrès Archéologique*, XCIII, 1931, 534 ff. The

mosaic was restored in 1841 by an Italian, Ciuli, and later by Chrétain and Lisch; A. Grabar, 'Les mosaïques de Germigny-des-Prés', *Cahiers archéologiques*, VII, 1954, 171 ff.; H. E. del Medico, 'La mosaïque de l'abside orientale à Germigny-des-Prés', *Mon. Piot.*, XXXIX, 1943, 81 ff., suggests that it is the work of a Byzantine refugee using partly *tesserae* from Ravenna and partly local materials. Grabar compares the style of the archangels with the angel in the imperial lunette at Sancta Sophia, Constantinople, and with an angel in Sancta Sophia at Salonika, although these are later in date. It is perhaps more instructive to consider the mosaics in Roman churches: S. Maria in Domnica, S. Prassede, San Marco, etc. Technical considerations, the mixture of *opus sectile* with mosaics, suggest Italian rather than Byzantine traditions. Grabar also stresses the marked Islamic influences, the links with Umayyad art in Syria and, no doubt, in Spain. Cf. also G. de Francovich, 'Osservazione sull'altare di Rateling in Cividale', *Scritti di storia dell'arte in onore di M. Salmi*, Rome, 1961, 208 ff., Note 82, who stresses Syrian influence and M. Vieillard-Troiekouroff, 'Tables de canons et stucs carolingiens', *Atti dell'8° Congresso di Studi sull'arte dell'Alto Medioevo*, Milan, 1962, 154 ff.

12 A. Freeman in *Speculum*, XXXII, 1957, 700; M. Metzger, 'Quelques caractères iconographiques et ornementaux de deux manuscrits hébraïques du X^e siècle', *Cahiers de Civilisation Médiévale*, X^e–XII^e Siècles, I, 1958, 205 ff. On manuscripts executed at Fleury, cf. O. Homburger, 'Eine unveröffentlichte Evangelienhandschrift aus der Zeit Karls des Grossen', Codex Bernensis 348, *Zeitschrift für schweizerische Archäologie und Geschichte*, V, 1943, 149 ff. Miss Freeman emphasizes the importance of the use of liturgical literature of the old Spanish church, the use of an Old Latin (i.e., pre-Vulgate) Bible. She also points out that after considering the relevant passages in I, Kings, vi. 23–28, II Chronicles, iii, 10–13; *Libri Carolini*, I, c. 20, it is clear that it is something more than the dimensions and curve of the apse at Ger-

migny, which determines that the inner wings of the great angels should touch one another, and their outer wings the walls. Two important chapters in the *Libri Carolini* are devoted to the Ark and the Cherubim and their significance in the tabernacle of Moses and the Temple of Solomon; there would seem to be a strong connection between the iconography of Germigny and the argument of the *Libri Carolini*. For the importance of the Jewish community in Spain, cf. Freeman, *op. cit.*, 677, 692. 'Theodulf's Bibles are unique in their epoch in their fidelity to the Hebrew tradition.' Miss Freeman's plausible arguments have been opposed by L. Wallach, 'The unknown author of the *Libri Carolini*', *Didascaliae*, New York, 1961, 469 ff., who argues that the final editing of the *Libri Carolini* was probably done by Alcuin, does not accept Theodulf as author, and points out that the *Libri* were never published and had little to do with contemporary Carolingian art.

13 K. J. Conant, *Carolingian and Romanesque Architecture*, 800–1200, Pelican History of Art, 1959, p. 17.

14 Theodulf's map of the world may be reproduced in Vatican, *Regina*, 123, a manuscript from Ripoll which contains a circular map of a type well known through Einhard's description of Charlemagne's silver table; cf. F. N. Estey, 'Charlemagne's Silver Celestial Table', *Speculum*, XVIII, 1943, 112 ff. The Ripoll map is decorated with a small figure of Terra bordered by the twelve winds and inscribed with sixteen lines taken from Theodulf's poem. Ripoll was in close touch with Fleury in the eleventh century; cf. M. A. Vidier, 'La mappemonde de Théodulfe et la mappemonde de Ripoll', *Bulletin de Géographie historique et descriptive*, 1911, 285 ff. It has been suggested that the villa was damaged by fire within Theodulf's lifetime, but an assembly of noblemen and prelates was held there in 843 or 844 and Charles the Bald stayed there twice in 854 or 855; cf. del Monico in *Mon. Piot.*, XXXIX, 1943, pp. 81–82.

15 S.K. Crosby, *The Abbey of St Denis*, 475–1122, I, Yale University Press, 1942; J. Formigé, *L'Abbaye royale de Saint-Denis. Recherches nouvelles*, Paris, 1960; cf. also J. Hubert, *L'Art préroman*, Paris, 1938, 191 ff. On the importance of the cult of relics in connection with the architectural development of Western churches, cf. A. Grabar, *Martyrium, Recherches sur le culte des reliques et l'art chrétien antique*, Paris, 1946, I, ch. V.; idem, 'Saint-Front de Périgueux et le chevet-martyrium', *Miscellanea Guillaume de Jerphanion, Orientalia, Christiana Periodica*, XIII, 1947, 501 ff.; F. Deshoulières, 'Les cryptes en France et l'influence du culte des reliques sur l'architecture religieuse', *Mélanges à la mémoire de Fr. Martroye*, Paris, 1940, 213 ff.; cf. also J. Hubert, *L'Art préroman*, 53 ff.

Abbot Hilduin composed the *Areopagitica* identifying the Pseudo-Dionysius with St Denis and directed the writing of the *Miracula sancti Dionysii*, which has been ascribed to Hincmar of Reims; cf. J.M. Wallace-Hadrill, *The Long-haired Kings*, London, 1962, p. 97.

On the two-tower façade, cf. J. Hubert, *L'Art préroman*, pp. 11–13, 83; H. Schäfer, 'The Origin of the Two-Tower Façade in Romanesque Architecture', *Art Bulletin*, XXVII, 1945, p. 102.

16 D. Groszman, 'Kloster Fulda und seine Bedeutung für den frühen deutschen Kirchenbau', *Das erste Jahrtausend*, I, 1962, 344 ff.; Krautheimer in *Art Bulletin*, XXIV, 1942, pp. 7–8; J. Toynbee and J. Ward Perkins, *The Shrine of St Peter and the Vatican Excavations*, London, 1956, 240 ff.

17 W. Effmann, *Centula. Saint-Riquier. Eine Untersuchung zur Geschichte der kirchlichen Baukunst in der Karolingerzeit*, Münster, 1912; J. Hubert, *L'Art préroman*, p. 21; G.H. Forsyth, Jun., 'St Martin's at Angers and the Evolution of Early Mediaeval Church Towers', *Art Bulletin*, XXXII, 1950, 308 ff., esp. pp. 315–316. 'A Carolingian belfry was an enormous tapering wooden structure composed of several circular bell-housings which were hung from a central king-post, and these bell-housings were ringed with decorative arcades and were separated from each other by roofs of conoidal form. At Saint-Riquier the supporting lantern was round . . .'; Conant, *Carolingian and Romanesque Architecture*, p. 11 ff.

18 The function and the ideas behind the westwork have been discussed at length. Cf. A. Fuchs, *Die karolingischen Westwerke und andere Fragen der karolingischen Baukunst*, Paderborn, 1929; idem, 'Entstehung und Zweckbestimmung der Westwerke', *Westfälische Zeitschrift*, 1950, pp. 227–291; idem, 'Zum Problem der Westwerke', *Karolingische und ottonische Kunst, Forschungen zur Kunstgeschichte und christlichen Archäologie*, III, Wiesbaden, 1957, 109 ff.; H. Reinhardt and E. Fels, 'Étude sur les églises-porches carolingiennes et leur survivance dans l'art roman', *Bull. Mon.*, XCII, 1933, p. 331, *Bull. Mon.*, XCVI, 1937, p. 425; O. Gruber, 'Das Westwerk: Symbol und Baugestaltung germanischen Christentums', *Zeitschrift des Deutschen Vereins f. Kunstwissenschaft*, III, 1936, 149 ff.; E. Lehmann, *Der frühe deutsche Kirchenbau*, Berlin, 1938, p. 89, where he sums up the main German position: 'Der Kern des Westwerks sei die Kaiserloge in der Mitte der Westempore. Die Westwerke seien Symbole der Kaiseridee'. Lehmann, incidentally, regards Centula as the most germinal of all the Carolingian architectural concepts. W. Lotz, 'Zum Problem der karolingischen Westwerke', *Kunstchronik*, V, 1952, 65 ff.; E. Gall, 'Zur Frage der Westwerke', *Jb. des röm.-german. Zentralmuseums*, Mainz, 1953, pp. 245–291; Bandmann, *Mittelalterliche Architektur*, 207 ff., but cf. also p. 112: 'So ist das Westwerk nicht nur Schutz- und Trutzburg für die anschliessende Basilika, nicht nur Eigenkirche für den Herrscher, sondern auch Abbreviatur der Gesamtkirche unter dem Symbol der Stadt', and Note 289 for an inscription at Corvey in the westwork dating from the time of the building (873–885): '*Civitatem istam tu circumda, Domine, et angeli tui custodiant muros eius*'; C. Heitz, *Recherches et les rapports entre Architecture et Liturgie*, Paris, 1963.

On Corvey, cf. W. Effmann, *Die Kirche der Abtei Corvey*, ed. A. Fuchs, Paderborn, 1929; F.J. Esterhues, 'Zur frühen Baugeschichte der Corveyer Abteikirche', *Zeitschrift Westfalen*, XXXI, 1953, 320ff.; *Corvey (Führungsheft)*, Höxter o.J.

19 J.M. Clark, *The Abbey of St Gall as a centre of Literature and Art*, Cambridge University Press, 1926, 71ff. On the plan of St Gall, cf. H. Reinhardt, 'Comment interpréter le plan carolingien de Saint-Gall?', *Bull. Mon.*, 1937, 265ff.; *idem, Der St-Gallener Klosterplan*, St Gall, 1952; W. Boeckelmann, 'Die Wurzel der St-Galler Plankirche', *Zeitschrift für Kunstwissenschaft*, VI, 1952, 107ff.; *idem*, 'Zur Interpretation des Pergamentplanes von St Gallen', *Kunstchronik*, VII, 1954, 277ff., for the suggestion that the plan is a copy of an original made at Reichenau, cf. B. Bischoff, 'Die Entstehung des Klosterplanes in paläographischer Sicht', *Studien zum St-Galler Klosterplan (Mitteilungen zur vaterländischen Geschichte. Herausgegeben vom Historischen Verein des Kantons St Gallen, XLII)*, St Gallen, 1962.

20 O. Doppelfeld, 'Die Ausgrabung des karolingischen Doms', *Der Kölner Dom (Festschrift 1248–1948)*, Cologne, 1948, 159ff.; *idem*, 'Der alte Dom von Köln und der Bauriss von St Gallen', *Das Münster*, V, 1948–1949, 1ff.; *idem*, 'Stand der Grabungen und Forschungen am Alten Dom von Köln', *Forschungen zur Kunstgeschichte und christlichen Archäologie*, I, 2, Frühmittelalterliche Kunst, Baden-Baden, 1954, 69ff.

21 On upper and lower crypts in general, cf. A. Verbeek, 'Die Aussenkrypta. Werden einer Bauform des frühen Mittelalters', *Zeitschrift für Kunstgeschichte*, XIII, 1950, 7ff.; J. Hubert, '"Cryptae inferiores" et "cryptae superiores" dans l'architecture religieuse carolingienne', *Mélanges Louis Halphen*, Paris, 1951, 351ff. J. Hubert, *L'Art préroman*, pp. 123ff.; R. Louis, *Autessiodorum christianum. Les églises d'Auxerre des origines au XI^e siècle*, Paris, 1952, 123ff.; E.S. King, 'The Carolingian Frescoes of the Abbey of St Germain d'Auxerre', *Art Bulletin*, XI, 1929, 357ff. Louis thinks it more than probable that the frescoes were executed before 859. In the ambulatory east of the *martyrium* containing the relics of St Germain there are two symmetrical panels in which four canonized bishops without inscriptions are portrayed standing on high pedestals decorated with a series of long, narrow niches. The relics of several bishops of Auxerre were translated here about 862 and presumably the portraits date between 859 and 862, certainly before the translation of some of the relics about 885 because of Norse raids. The style of the portraits is in the same tradition as the frescoes painted at Rome during the pontificate of John III (560–573) in the catacomb of Lucina, representing two groups of canonized bishops, Sixtus and Optatus, Cornelius and Cyprian, on the tomb of St Cornelius (cf. Wilpert, *Römische Mosaiken und Malereien*, IV, 1917, pl. 256). The style may also be related to Mss. executed at Tours between 845 and 855 (Lothair's Evangeliary and Vivian's Bible) or at Fulda before 844 [Amiens, Bibl., Ms. 223, Rabanus Maurus, *De laudibus sanctae crucis*, fol. 2 verso, dedication page to Pope Gregory IV (827–844); Paris, Bibl. Nat., lat. 2423, which once belonged to Raoul, Archbishop of Bourges (840–866)].

22 J. Zemp and R. Durrer, 'Das Kloster St Johann zu Münster in Graubünden', *Mitt. der Schweiz. Ges. zur Erhaltung hist. Kunstdenkmäler*, Geneva, 1910; L. Birchler, 'Zur karolingischen Architektur und Malerei in Münster-Müstair', *Akten zum III. Internationalen Kongress für Frühmittelalterforschung*, Lausanne, 1954, 167ff.; G. de Francovich, 'Il ciclo pittorico della chiesa di S. Giovanni a Münster (Müstair) nei Grigioni', *Arte Lombarda*, II, 1956, 28ff.; A. Grabar in *Early Medieval Painting*, London, 1957, 54ff.; de Francovich, 'I problemi della pittura e della scultura preromanica', *Centro italiano di studi sull'Alto Medioevo, Spoleto, Settimane*, II, 1955, 435ff., suggests the work of a Lombard artist and accepts a date in the ninth century.

The paintings date probably from the beginning of the ninth century.

23 There was a considerable number of Old and New Testament scenes in S. Maria Antiqua, dating from the second half of the eighth century, and in San Clemente, Rome, dating from the middle of the ninth century. Cf. also a scene from the Legend of SS Quiricus and Julitta in fresco in S. Maria Antiqua, executed under Pope Zacharias (741–752) (Wilpert, IV, I, pl. 187; Grabar and Nordenfalk, *Early Medieval Painting*, London, 1957, p. 49). Charlemagne visited Montecassino and San Vincenzo al Volturno in 787 and asked the abbot to send monks and books to the North. The Crucifixion at S. Vincenzo has analogies with Carolingian Mss. and ivory carvings; cf. E. W. Anthony, *Romanesque Frescoes*, Princeton, 1951, p. 43 and pl. 117. A representation of the Virgin, vested as Queen, a specifically Roman theme, adored by Epiphanius, Abbot of the monastery of S. Vincenzo al Volturno, dates the frescoes between 826 and 843.
According to de Francovich (see above) Lombard traditions are to be discerned in the frescoes at Müstair.

24 Cf. Old Testament scenes in the left side-aisle of S. Maria Antiqua, executed under Pope Paul I (757–767) (Wilpert, *op. cit.*, pl. 192–193) and New Testament scenes in S. Clemente, executed under Pope Leo IV (847–855), Wilpert, *op. cit.* Part 2, pl. 209, 3).

25 On the architecture at Malles, cf. P. Verzone, *L'architettura dell'alto medioevo nell'Italia settentrionale*, Milan, 1942, 119 ff.
J. Garber, 'Die karolingische St-Benedikt-Kirche in Mals', *Zeitschrift des Ferdinandeums*, LIX, 1915; A. Grabar in *Early Medieval Painting*, London, 1957, pp. 58–59; de Francovich, 'I problemi della pittura', *Settimane*, II, 452 ff., compares the paintings at Malles with those in S. Satiro at Milan, executed about 876; N. Rasmo, 'Note preliminari su S. Benedetto di Malles', *Atti dell' 8° Congresso di studi sull'arte dell'Alto Medioevo*, Milan,

1962, 86 ff. For a general survey of early medieval fresco painting in Italy in the early medieval ages, cf. also, *La Chiesa di San Salvatore in Brescia, Atti dell' 8° Congresso di studi sull'arte dell'Alto Medioevo*, II, Milan, 1962. The basilica, built with three aisles and a triple apse, dates from 816; the fresco and stucco decoration, now in fragmentary condition, are assigned by Gaetano Panazza to about the same date.
In connection with the portrait of the priest at Malles, cf. the representation in fresco of St Lawrence in the Church of S. Saba in Rome, dating from the beginning of the eighth century (Wilpert, IV, I, pl. 169), although St Lawrence is depicted frontally.

26 H. Eichler, 'Peintures murales carolingiennes à Saint-Maximin de Trèves', *Cahiers archéologiques*, VI, 1952, 83 ff.; idem, 'Karolingische Wandmalerei aus St Maximin in Trier', *Neue Beiträge zur Kunstgeschichte des 1. Jahrhunderts, Forschung zur Kunstgeschichte und christlichen Archäologie*, I, 2, Baden-Baden, 1954, 211 ff.

27 P. Deschamps, 'Peintures murales de l'époque carolingienne en France', *Arte del Primo Millennio, Atti del II° Convegno per lo Studio dell'Arte dell'Alto Medioevo*, Turin, 1953, 335 ff.

28 St Benedict of Aniane was a Septimanian Visigoth, born Witiza, son of a Count of Maguelonne in southern Gaul, who had been in the service of Pepin and Charlemagne. St Benedict was greatly admired by Louis, King of Aquitania, later Emperor Louis the Pious, and in 817 he became the chief propagator of monastic reforms.

29 E. de Bruyne, *op. cit.*, I, p. 200. Among the scholars assembled by Charles, Angilbert (d. 814) was the only Frank.

30 Freeman in *Speculum*, XXXII, 1957, p. 697.

31 E. Panofsky and F. Saxl, *Classical Mythology in Mediaeval Art*, p. 235; Kraut-

heimer in *Art Bulletin*, XXII, 1942, pp. 30–31.

32 On the Carolingian age, cf. M. L. W. Laistner, *Thought and Letters in Western Europe*, A.D. *500–900*, London, 1931; F. J. Raby, *Christian Latin Poetry*, p. 155; idem, *Secular Latin Poetry*, I, pp. 182–183; E. de Bruyne, *Études d'Esthétique Médiévale*, I, 165 ff.; W. von der Steinen, 'Karolingische Kulturfragen', *Welt als Geschichte*, X, 1950, 156 ff.; *Centro italiano di studi sull'Alto Medioevo, Spoleto, Settimane, I, 1954, I Problemi della Civiltà Carolingia*.
On Carolingian art, cf. E. Patzelt, *Die karolingische Renaissance*, Vienna, 1924; R. Hinks, *Carolingian Art*, London, 1935; G. de Francovich, 'Arte carolingia ed arte ottoniana in Lombardia', *Rom. Jb. f. Kunstgeschichte*, VI, 1942–1944, 113 ff.; idem, 'Problemi della Pittura e della Scultura preromanica', *Centro italiano di studi sull'Alto Medioevo, Spoleto, Settimane*, 1955, 355 ff.; E. Kitzinger, *Early Mediaeval Art*, London, 1955; W. Oakeshott, *Classical Inspiration in Mediaeval Art*, London, 1959; J. Hubert, 'Quelques sources de l'art carolingien', *Centro italiano di studi sull'Alto Medioevo, Spoleto*, I, 1954, 215 ff.; V. H. Elbern, 'Die bildende Kunst der Karolingerzeit zwischen Rhein und Elbe', *Das erste Jahrtausend*, I, Düsseldorf, 1962, 412 ff. C. Beutler, 'Documents sur la sculpture carolingienne', *Gazette des Beaux-Arts*, XI, 1963, 193 ff., X, 1962, 445 ff. cf. also P. E. Schramm and F. Mütherich, *Denkmale der deutschen Könige und Kaiser*, Munich, 1962.

33 M. D. Knowles, 'The Preservation of the Classics', *The English Library before 1700* (ed. F. and C. E. Wright), University of London, 1958, p. 40; Raby, *Secular Latin Poetry*, I, p.247.

34 Raby, *Secular Latin Poetry*, I, pp. 178–182. Theodulf was critical of the Irish; cf. *ibid.*, pp. 191–192.

35 C. Bertelli, *La Madonna di S. Maria in Trastevere*, Rome, 1961, p. 91.

36 W. Koehler, *Die karolingischen Miniaturen*, II, 22 ff.

37 Contrast Godescalc's Evangelistary with a Gospels, executed by the scribe Gundohinus near Luxeuil in 754 for a lady called Fausta and a monk Fuculph, which combines strong insular influence with Lombard elements (Autun, Ms. 3, fol. 12 verso). J. Porcher, 'Les débuts de l'art carolingien et l'art lombard', *Atti dell'8o Congresso di studi sull'arte dell'Alto Medioevo*, Milan, 1962, 55 ff.

38 W. Koehler, *op. cit.*, 70 ff.; P. A. Underwood, 'The Fountain of Life', *Dumbarton Oaks Papers*, V, 1950, pp. 67 ff. The Gospels of Saint-Médard-de-Soissons may have belonged to Charlemagne; they were presented to the Abbey Church of Saint-Médard at Easter in 827 by Louis the Pious together with a chalice and a paten which bore the monogram of Charlemagne.

39 Koehler, *op. cit.*, 42 ff.; A. Goldschmidt, *Die Elfenbeinskulpturen aus der Zeit der karolingischen und sächsischen Kaiser*, Berlin, I, 1914, Nos. 3, 4. The Dagulf Psalter may be dated on palaeographical and stylistic grounds probably after 783 and before the death of Pope Hadrian (795). There are no miniatures; the decoration consists of comparatively simple and restrained ornament – small panels of classical ribbons and florets – but gold is lavishly used with a little red and blue, on the beautiful script. The Psalter with its ivory covers, probably belonged in the eleventh century to the treasury of Speyer Cathedral, only a few miles distant from Lorsch. H. J. Hermann, *Die frühchristlichen Hss.: Beschreibendes Verzeichnis der illuminierten Hss. in Österreich*, N. F., VIII, 1, Leipzig, 1927, 53 ff., attributes to Dagulf part of the Lorsch Gospels.
For the style of the ivory covers, cf. scenes of martyrdom, fresco in S. Prassede, Rome, executed during the reign of Paschal I (817–824) (Wilpert, IV, I, pl. 202, 203); scenes from the Legend of SS Quiricus and Julitta in S. Maria Antiqua, painted by Theodotus in the middle

of the eighth century (Wilpert, IV, 1, pl. 166, 1); the Healing of the Paralytic in S. Saba, second half of the eighth century (Wilpert, IV, 1, pl. 188, 2).

40 W. F. Volbach, *Elfenbeinskulpturen der Spätantike und des frühen Mittelalters*, Mainz, 1952, Nos. 112–114, 221; J. Schwarz, 'Quelques sources antiques d'ivoires carolingiéns', *Cahiers archéologiques*, XI, 1961, 145 ff.

41 Volbach, *op. cit.*, No. 43, and cf. with No. 6.

42 Goldschmidt, I, Nos. 13, 14; Volbach, *op. cit.*, Nos. 137, 140; H. Schnitzler, 'Die Komposition der Lorscher Elfenbeintafeln', *Münchner Jb.*, I, 1950, 21 ff.

43 Koehler, *op. cit.*, 49 ff.; A. Boeckler, 'Die Evangelistenbilder der Adagruppe', *Münchner Jb. der bild. Kunst*, 3rd series, III–IV, 1952–1953, 121 ff., argues for Byzantine models for the Evangelist portraits; *idem*, 'Formgeschichtliche Studien zur Adagruppe', *München, Bayerische Akad. d. Wissenschaften, Abhandlung Phil.-Hist. Kl.*, N. F., Heft 42, Munich, 1956. Cf. also, R. M. Walker, 'Illustrations to the Priscillian Prologues in the Gospel Manuscripts of the Carolingian Ada School', *Art Bulletin*, XXX, 1948, 1 ff. The scriptorium at Fulda was strongly dependent on the Ada group. Cf. A. Goldschmidt, *German Illumination*, I, p. 21; E. H. Zimmermann, 'Die Fuldaer Buchmalerei in karolingischer und ottonischer Zeit', *Kunstgeschichtliches Jb. d. K. K. Zentralkommission*, IV, 1910, 1 ff. For a group of ivory carvings attributed to Fulda, cf. K. Weitzmann, 'Eine Fuldaer Elfenbeingruppe', *Festschrift Goldschmidt*, 1935, 14 ff.

44 Koehler, *op. cit.*, II, 56 ff.; III, 57 ff. For Roman monuments, cf. the mosaic in the triumphal arch of SS Nereo and Achilleo under Leo III (795–816), the mosaic in S. Marco under Gregory IV (827–844), and mosaics in S. Prassede, S. Cecilia, S. Maria in Domnica under Pope Paschal I (817–824) (Wilpert, *Römische Mosaiken und Malereien*, III,

pl. 114 ff.). Cf. E. Kitzinger, *Römische Malerei vom Beginn des 7. bis zur Mitte des 8. Jahrhunderts*, Munich, 1934, p. 28. Cf. also the ninth-century Roman Juvenianus-Codex (Rome, Bibl. Vallicell., Ms. B. 25), W. Messerer, 'Zum Juvenianus-Codex der Biblioteca Vallicelliana', *Miscellaniae Bibliothecae Hertzianae*, Munich, 1961, 58 ff., and the silver containers for crosses in the Sancta Sanctorum, of which one bears an inscription referring to Pope Paschal I (817–824), A Haseloff, *Preromanesque Sculpture in Italy*, Florence, 1930, pl. 57, 58.
It is reasonable to suppose that a great many Byzantine artists escaped to the West during the Iconoclast persecutions. At Bari alone there were 5,000 Byzantine refugees; cf. del Medico in *Mon. Piot.*, XXXIX, 1943, p. 87. Cf. also, H. Swarzenski, 'The Xanten Purple Leaf and the Carolingian Renaissance', *Art Bulletin*, XXII, 1940, 7 ff.; *idem, Early Medieval Illumination*, London, 1951, p. 10; M. Schapiro, 'The Carolingian Copy of the Calendar of 354', *Art Bulletin*, XXII, 1940, 270 ff.

45 Reims was the key bishopric of the Carolingian empire. Hardly any king of the ninth and early tenth centuries failed to grasp the tactical importance of Reims or failed to do all he could to control it. Cf. J. Wallace-Hadrill, *The Long-haired Kings*, London, 1962, p. 22. On Reims as a centre of spiritual life in the Carolingian period, cf. Schade in *Wallraf-Richartz-Jb.*, XXI, 1959 p. 32. Cf. also H. Reinhardt, *La Cathédrale de Reims*, Paris 1963.

46 Cf. Fichtenau, *Carolingian Empire*, p. 148.

47 Paris, Bibliothèque Nationale, *Les Manuscrits à Peintures en France du VII^e au XII^e siècles*, 1954, No. 41; Grabar and Nordenfalk, *Early Medieval Painting*, London, 1957, 144 ff.

48 Cf. Freeman in *Speculum*, XXXII, 1957, p. 701.

49 The manuscript of the Psalter of St Jerome is in the Gallican version accompanied by

228

a set of Canticles, the Lord's Prayer, the Apostle's Creed, and the *Quicunque vult*. At the end of the book is the supernumerary Psalm '*Pusillus eram*' commemorating David's victory over Goliath. Three versions of the Latin Psalter of St Jerome are known: Roman, Gallican and Hebrew. Mrs Panofsky has shown that the Utrecht Psalter is dependent on the Hebrew as well as the Gallican version, although the latter is preferred, probably because it was more susceptible to a visual translation. Cf. G.M. Benson, 'New Light on the Utrecht Psalter', *Art Bulletin*, XIII, 1931, 13 ff.; D.T. Tselos, 'The Greek Element in the Utrecht Psalter', *Art Bulletin*, XIII, 1931, 53 ff.; E.T. de Wald, *The Illustrations of the Utrecht Psalter*, Princeton, 1933; D. Panofsky, 'The Textual Basis of the Utrecht Psalter Illustrations', *Art Bulletin*, XXV, 1943, 50 ff.; F. Wormald, *The Utrecht Psalter*, Utrecht, 1953; D. Hemmerdinger-Ilindou, 'L'illustration du Psautier d'Utrecht et le sacramentaire léonien', *Cahiers archéologiques*, XI, 1961, 257 ff. Cf. also, H. Woodruff, 'The Physiologus of Bern', *Art Bulletin*, XII, 1930, 226 ff.; C.R. Morey, *The Miniatures of the Manuscripts of Terence*, 1931; O. Homburger, *Die illustrierten Handschriften der Burgerbibliothek Bern, Bern, 1962, 101 ff.* It is not without interest to compare the style of the Utrecht Psalter with a fresco depicting the Angel of the Annunciation in S. Maria Antiqua, Rome, executed under Pope Martin I (649), Wilpert, *Römische Mosaiken und Malereien*, IV, I, pl. 143, 1.

50 Goldschmidt, I, Nos. 40, 41, 42, 43. G. Swarzenski, 'Die karolingische Malerei und Plastik in Reims', *Jb. d. kgl. preuss. Kunstsamml.*, XXIII, 1902, 81 ff.

51 To this group has sometimes been assigned the gold antependium of Vuolvinus, given by Archbishop Angilbertus II (824–859) to the Church of Sant'Ambrogio at Milan about 835; cf. H. Swarzenski, 'The Dowry Cross of Henry II', *Studies in honor of A.M. Friend, Jun.*, Princeton, 1955, 301 ff. There

seems little reason to doubt, however, that this antependium was made in Milan, possibly by northern artists; cf. V.H. Elbern, *Der karolingische Goldaltar von Mailand*, Bonn, 1952; *idem*, 'Der Mailänder Goldaltar in neuerer Forschung', *Relationes, Festschrift Mgr. H. Krey*, Milan, 1961, 1 ff.; G.B. Tatum, 'The Paliotto of Sant'Antonio at Milan', *Art Bulletin*, XXVI, 1944, 25 ff. The suggestion by de Francovich that the Milan antependium dates from the Ottonian period has not been generally accepted; cf. de Francovich, 'Arte carolingia ed ottoniana in Lombardia', *Röm. Jb. für Kunstgeschichte*, VI, 1942–1944, 182 ff. Elbern suggests that the antependium is the work of four hands, among which Vuolvinus must have been the master craftsman. The representation of Archbishop Angilbertus offering the altar to St Ambrose reflects contemporary Roman style, and the fact that there are elements of the Reims style in some of the panels may suggest that Roman monuments are in part the source; cf. Note 49. The style of the antependium in general is more solid, deliberate, and expansive than the Reims school. According to Friend, the 'Reims group' together with the high altar, formerly in the abbey of Saint-Denis but destroyed during the French Revolution, were all made at Saint-Denis; cf. A.M. Friend, Jun., 'The Carolingian Art in the Abbey of Saint-Denis', *Art Studies*, I, 1923, 67 ff. But this does not resolve the problem set by Arnulf's ciborium, which is so close to the Reims style. The Abbey of Saint-Denis, however, was famous for its goldsmiths' work under Abbot Louis, predecessor of Charles the Bald, who became lay-abbot. Lupus of Ferrières, in one of his letters to Louis, announces that he is sending two of his monks to be trained as gold- and silversmiths at Saint-Denis, famous far and wide for its skill in this work. Werckmeister proposes Saint-Denis as the workshop for the Codex Aureus of St Emmeram and suggests that it was an Easter gift to the Abbey in 871; cf. O. Werckmeister, *Der Deckel des Codex Aureus von St. Emmeram, Ein Goldschmiedewerk des 9. Jahrhunderts, Studien zur deutschen Kunstgeschichte, 332, 1963.*

The 'escrain' of Charlemagne, destroyed in 1794, except for one engraved gem now in the Cabinet des Médailles, Paris, was probably a portable altar given by Charles the Bald to the Abbey of Saint-Denis. Cf. J. Hubert, 'L'escrain dit de Charlemagne au trésor de Saint-Denis', *Cahiers archéologiques*, IV, 1949, 71 ff. On a fragment from the Cross of St Éloi at one time in the Abbey, cf. M. B. de Montesquiou-Fezensac, 'Une épave du trésor de Saint-Denis. Fragment retrouvé de la croix de Saint Éloi', *Mélanges en hommage à la mémoire de Fr. Martroye*, Paris, 1940, 213 ff. Neither assists any decision on the Codex Aureus of St Emmeram.

For Arnulf's ciborium, cf. H. Thoma, *Schatzkammer der Residenz, München, Katalog*, 1958, 17 ff.: 'probably Reims, about 890'. Inscription refers to King Arnulf, crowned in 887 as King, in 896 as Emperor. In spite of the inscription, the date for the ciborium appears to be too late from the stylistic point of view; R. Otto, 'Zur stilgeschichtlichen Stellung des Arnulf-Ciboriums und des Codex Aureus aus St. Emmeram in Regensburg', *Zeitschrift für Kunstgeschichte*, XV, 1952, 1 ff.; H. Swarzenski, *Monuments of Romanesque Art*, London, 1954, Nos. 8, 10, 11.

A very tentative sequence of dating might run: Milan antependium, *c*. 835; Arnulf's ciborium, which was part of the *ornamenta palatii* of Charles the Bald, *c*. 860; Codex Aureus of St Emmeram, also part of the *ornamenta palatii*, *c*. 870; Codex Aureus of Lindau, *c*. 870.

52 F. M. Carey, 'The scriptorium of Reims during the Archbishopric of Hincmar (845–882)', *Classical and Mediaeval Studies in honour of E. K. Rand*, New York, 1938, 41 ff. This lists 22 Mss. which bear the *ex-dono* of Archbishop Hincmar; in his hand-list of Mss. written at Reims before 1100, Carey does not include the Bible of San Paolo fuori le Mura, but cf. H. Schade, 'Studien zu der karolingischen Bilderbibel aus St. Paul vor den Mauern in Rom', *Wallraf-Richartz-Jb.*, XXI, 1959, 99 ff.; XXII, 1960, pp. 13 ff., who strongly advocates Reims.

P. Durrieu, 'Ingobert, un grand calligraphe du IX^e siècle, *Mélanges offerts à Emile Chatelain*, Paris, 1910, 1 ff., suggested that Ingobert might have been a monk at the abbey of Saint-Germain-des-Prés. A. M. Friend, Jun., 'The Carolingian Art in the Abbey of Saint-Denis', *Art Studies*, I, 1923, 132 ff.; idem, 'Two manuscripts of the School of Saint-Denis', *Speculum*, I, 1926, 59 ff.; E. H. Kantorowicz, 'The Carolingian King in the Bible of San Paolo fuori le Mura', *Late Classical and Mediaeval Studies in honor of A. M. Friend, Jun.*, Princeton, 1955, 287 ff.; A. Boeckler in *Ars Sacra*, Munich, 1950, 21–22; C. Nordenfalk in *Early Medieval Painting*, London, 1957, p. 151.

53 W. Koehler, *Die karolingischen Miniaturen, I: Die Schule von Tours*, Berlin, 1930–1933. Koehler supposes three models for the Tours school: a Roman Bible of the second quarter of the fifth century, a Roman Evangeliary of about 650–750, and a Reims Evangeliary of the early ninth century. The latter influenced, for example, Brit. Mus. Add. 11848, from Nevers, executed under Abbot Fridugisus (807–834), Koehler, I, 2, p. 239. But cf. the scepticism of E. B. Garrison in *Studies in the Hist. of Med. Italian Painting*, IV, 1960–1961, 196 ff., who avers that none of the illustrations in any of the actually surviving Italian Mss. give any grounds for believing in the past existence of a Roman, or even a more generally Italian, cycle of Bible illustrations from which the scenes in the later Roman Bibles might have been gathered. C. Nordenfalk, 'Beiträge zur Geschichte der touronischen Buchmalerei', *Acta Archaeologica*, VII, 281 ff.; J. Croquison, 'Une vision eschatologique carolingienne', *Cahiers archéologiques*, IV, 1949, 105 ff. In fact, Koehler's three models seem almost too restricted a number, and it is reasonable to suppose that like the scriptorium of Reims the Tours scriptorium had several late antique and later Mss. at its disposal.

54 Ph. Lauer, 'Iconographie carolingienne. Vivien et Charlemagne', *Mélanges à la*

mémoire de Fr. Martroye, Paris, 1940, 191 ff. The Treaty of Verdun in 843 between the brothers Lothair, Louis the German and Charles the Bald was the first stage in the dissolution of the Carolingian empire. In 843 Lothair had retained the imperial title but he had been unable to secure, even by obtaining a large extent of territory which stretched from Italy to the North Sea, any real superiority over his brothers, Louis, King of the East Franks (i.e., the German lands), and Charles, King of the West Franks (i.e., France and Spain). When Lothair died in 855, his kingdom was further divided by his sons: the imperial title and Italy went to Louis II, Lorraine went for a time to Lothair II, the Lyonnais and the Viennois went to the feeble and epileptic Charles. Cf. J. M. Wallace-Hadrill, *The Long-haired Kings*, London, 1962, pp. 18–19. By the two great partition treaties of Verdun and Meersen the economic power of the Carolingians was split and ruined for ever.

55 A. Grabar, *Les Ampoules de Terre Sainte*, Paris, 1958; G. Ferrari, *The Gold-glass Collection in the Vatican Library, Catalogo del Museo Sacro della Biblioteca Vaticana*, IV, 1959.

56 For Tours influence at Fulda, for example, cf. J. Schlosser, 'Eine Fuldaer Miniaturhandschrift der K. K. Hofbibliothek', *Jb. d. kunsthist. Samml. d. allerh. Kaiserhauses*, XIII, 1892, 1 ff. He refers to Vienna Nationalbibl., Ms. 652, Rabanus Maurus, *Liber de laudibus sanctae crucis*, and another copy, Vatican, cod. Reg. 124. Rabanus Maurus was born at Mainz in 776, but he was largely educated at the school of Tours and was a favourite disciple of Alcuin; later he was Abbot of Fulda and Archbishop of Mainz. The book was finished in 806; copies were sent to his friend Hatto who succeeded him as Abbot of Fulda, to Pope Gregory IV to whom the book was dedicated, to Count Eberhard, Markgraf of Friuli, to Otgar, Archbishop of Mainz, and to the monks of Saint-Denis. Presumably the abbey of Saint-Martin at Tours received a copy. Cf. also, A. Boinet, 'Notice sur deux ma-

nuscrits carolingiens à miniatures exécutés à l'abbaye de Fulda', *Bibl. de l'École de Chartres*, LXV, 1904, 355 ff., who refers to Amiens, Bibl. mun., Ms. 223, and Paris, Bibl. Nat., lat. 2423, both of the same date and by the same hand as Schlosser's Mss. The text, inspired by the fourth-century Porphyry and by certain poems of Fortunatus (sixth century), is in hexameters and prose, the prose giving a detailed interpretation of the verse. The book had a considerable reputation, and a whole series of copies was executed at Fulda. The Amiens, Vienna and Vatican Mss. have dedicatory portraits: the Amiens Ms. has also a portrait of the Emperor Louis the Pious dressed as a warrior (fol. 3 verso). One of the dedicatory portraits in the Vatican Ms. shows St Martin of Tours holding the book and blessing Rabanus Maurus and Alcuin; the second portrait shows Rabanus offering his book to Pope Gregory IV. According to a letter from Rabanus to Count Eberhard, Rabanus sent his book to Pope Gregory IV by two priests Ascrih and Hrudpert, who were going to Rome, but the Pope had died before their arrival and the priests gave the book to his successor, Sergius.

57 W. Koehler, *Die karolingischen Miniaturen*, III, 97 ff. Metz was the greatest centre in northern Europe for Gregorian chant; cf. Friend in *Speculum*, I, 1926, p. 69.

58 L. Weber, *Einbanddecken, Elfenbeintafeln, Miniaturen, Schriftproben aus Metzer liturgischen Handschriften, I, Jetziger Pariser Handschriften*, Metz and Frankfurt am Main, 1912; Goldschmidt, *Elfenbeinskulpturen*, I, 38–39, Nos. 72, 73; H. Schnitzler, 'Eine Metzer Emmaustafel', *Wallraf-Richartz-Jb.*, XX, 1958, 41 ff.; J. Schwartz, 'Quelques sources antiques d'ivoires carolingiens', *Cahiers archéologiques*, XI, 1961, 145 ff.

59 Goldschmidt, *Elfenbeinskulpturen*, I, No. 85; Longhurst, *Catalogue*, I, 66–67; both date the relief to the late ninth or early tenth century; H. Fillitz, 'Die Wiener Gregor-Platte', *Jb. d. kunsthist. Samml.*

in Wien, LVIII, 1962, 7ff., esp. 16ff.
Fillitz argues that this Metz group should
be dated from the middle into the third
quarter of the tenth century, but cf.
Goldschmidt's evidence, historical and
otherwise, on the related Gandersheim
Gospel cover. The Gospels undoubtedly
belonged to Queen Aedgifu and King
Athelstan of England, her brother
(d. 940). Aedgifu was the widow of
Charles the Simple, sister of Otto I's first
wife, Edith, and her son married a sister
of Otto I; she may have brought the Ms.
from England to France and finally to
Gandersheim. The Ms. is Metz work,
about 860 (cf. W. Koehler, *op. cit.*, III,
2, p. 106). The cover of the Ganders-
heim Gospels, which was probably al-
most contemporary with the Ms., is
divided between the Victoria and Albert
Museum (Nos. 251–1967) and the Her-
zoglichen Sammlungen, Veste Coburg.
It should be pointed out, however, that
other reliefs – Paris, Bibl. Nat., lat. 9383,
9390 – bind respectively Mss. dating from
the first half of the ninth and the middle
of the tenth century. Whether 9383 be-
longs to 9390 or vice versa is a moot
point; 9453 covers a Gospels dating from
the first half of the eleventh century. All
the Paris books came from Metz in 1802,
but there is evidence that some jumbling
up of the covers took place before leav-
ing. The Gandersheim bookcover was
restored in 1555; already at that time one
of the ivory covers was missing.

60 Goldschmidt, *Elfenbeinskulpturen*, I, No.
118: Longhurst, *Catalogue*, I, p. 69.

61 Goldschmidt, *Elfenbeinskulpturen*, I, Nos.
92, 95, 96.

62 O.M. Dalton, 'The Crystal of Lothair',
Archaeologia, LIX, Part 1, 1904, pp. 24ff.;
H. Swarzenski, *Monuments of Romanesque
Art*, No. 13, suggests Reims or Corbie;
G.E. Pazaurek, 'Glas- und Gemmen-
schnitt im ersten Jahrtausend', *Belvedere*,
1932, 1ff., esp. 14ff.; J. Baum, 'Ka-
rolingische geschnittene Bergkristalle',
*Frühmittelalterliche Kunst in den Alpen-
ländern, Akten zum III. Internationalen
Kongress für Frühmittelalterforschung*, Olten

and Lausanne, 1954, pp. 111ff.; F. Müthe-
rich, 'Das Bergkristallsiegel des Erz-
bischofs Radpod von Trier', *Festschrift
Erich Meyer*, Hamburg, 1959, 68ff.

63 Ph. Lauer, 'Iconographie carolingienne.
Vivien et Charlemagne', *Mélanges à la
mémoire de Fr. Martroye*, Paris, 1940,
201ff.; Lautier and Hubert, *Les ori-
gines de l'art français*, Paris, 1946, p. 173;
J. Croquison, 'Le "Sacramentaire Charle-
magne"', *Cahiers archéologiques*, VI, 1952,
pp. 55ff.; Paris, Bibliothèque Nationale,
*Manuscrits à Peintures du VIIe au XIIe
Siècles*, 1954, No. 53.
On Corbie: cf. Mss. listed by Porcher
which include a Psalter (Amiens, Bibl.
mun., Ms. 18), a Latin translation of an
Alexandrian chronicle (Paris, Bibl. Nat.,
lat. 4884), a Martyrology of Corbie fol-
lowed by a Pastoral of St Gregory (Paris
Bibl. Nat., lat. 12260) and a collection of
grammatical treatises (Paris, Bibl. Nat.,
lat. 13025), all dating from the beginning
of the ninth century. The style is very dif-
ferent from the court school of Charles
the Bald. Cf. J. Porcher, 'Les débuts de
l'art carolingien et l'art longobard', *Atti
dell'8° Congresso di studi sull'arte dell'Alto
Medioevo*, Milan, 1962, 55ff. Cf. also
H. Janitschek, *Die Trierer Handschrift*,
72ff.; Friend in *Art Studies*, I, p. 70:
'The only Ms. which could be put de-
finitely to Corbie is the Sacramentary of
Rodradus who was ordained priest at
Corbie in 853. This manuscript is far
from being typical of Janitschek's school.'
Janitschek assigned part of the Franco-
Saxon school to Saint-Denis, based on
the Sacramentary of Saint-Denis (Paris,
Bibl. Nat., lat. 2290) and most closely
resembling the Second Bible of Charles
the Bald. O. Homburger, 'Eine spät-
karolingische Schule von Corbie', *Karo-
lingische und ottonische Kunst, Forschungen
zur Kunstgeschichte und christlichen Archäo-
logie*, III, Wiesbaden, 1957, 412ff. The
manuscripts assigned by Homburger to
Corbie are 'Franco-Saxon' in style.
On Saint-Denis: A.M. Friend, Jun., 'The
Carolingian Art in the Abbey of Saint-
Denis', *Art Studies*, I, 1923, 132ff.;
idem, 'Two Manuscripts of the School of
Saint-Denis', *Speculum*, I, 1926, 59ff.

232

Friend thought that the late Metz school was 'really the continuance of the Saint-Denis school'.
On Compiègne, cf. Nordenfalk in *Early Medieval Painting*, London, 1957, p. 154.

64 Friend in *Speculum*, I, 1926, 59 ff.

65 A. Boutemy, 'Le style franco-saxon, style de Saint-Amand', *Scriptorium*, III, 1949, 260 ff.; C. Niver, *A Study of certain of the more important Mss. of the Franco-Saxon School, Summaries of theses*, Harvard University Graduate School of Arts and Sciences, Cambridge, Mass., 1941; V; Leroquais, 'Les Évangiles de Jouarre, un manuscrit inconnu de l'École franco-saxonne', *Miscellanea Giovanni Mercati, VI, Studi e Testi*, 126, Città del Vaticano, pl. IV, p. 249. The finest Prudentius Mss. were made at Saint-Amand; cf. Nordenfalk in *Early Medieval Painting*, London, 1957, p. 147. The so-called Gospels of Francis II (Paris, Bibl. Nat., lat. 257) and the Gospels of Arras are the only works of this school with figure subjects. For the Second Bible of Charles the Bald, cf. Paris, Bibl. Nat., *Manuscrits à Peintures du VIIe au XIIe Siècles*, 1954, No. 58. Milo dedicated a life of St Amand in verse to Charles the Bald; also a poem *De sobrietate*.

66 A. Hardegger, *Die alte Stiftskirche und die ehemaligen Klostergebäude in St Gallen*, Zurich, 1917; J.M. Clark, *The Abbey of St Gall as a centre of Literature and Art*, Cambridge University Press, 1926; A. Fäh, *Die Stiftsbibliothek in St Gallen, der Bau und seine Schätze*, St Gallen, 1929; F. Landsberger, *Der St-Galler Folchard-Psalter*, St Gall, 1912; A. Merton, *Die Buchmalerei in St Gallen*, Leipzig, 1923, 2nd edition; J. Dufe and P. Meyer, *The Irish Miniatures in the Abbey Library of St Gall*, Olten, Berne, Lausanne, 1954.

67 Goldschmidt, *Elfenbeinskulpturen*, I, Nos. 163, 164, 165, 167; E.T. de Wald, 'Notes on the Tuotilo ivories in St Gall', *Art Bulletin*, XII, 1933, 202 ff.

68 Ekkehard, *Casus S. Galli*, c. 3; *Mon. Germ. SS.*, II, p. 137. 'Saracenos quorum

natura est in montibus multum valere.' Quoted in R. Poupardin, *Le Royaume de Bourgogne (888–1038)*, Paris, 1907, p. 89, note 2. It was not until 972 with the capture of the fortress of Frainet that the Arabs were expelled from Provence.
For Saracen invasions in southern France in the late ninth and early tenth century, cf. R. Poupardin, *Le Royaume de Provence sous les Carolingiens*, Paris, 1901, 243 ff.

69 On the Hungarian invasions, cf. R. Poupardin, *op. cit.*, 61 ff.; G. Fasoli, *Le incursioni ungare in Europa nel· sec. X*, Florence, 1945; *idem*, 'Points de vue sur les incursions hongroises en Europe au Xe siècle', *Cahiers de Civilisation Médiévale*, Xe–XIIe Siècles, II, 1959, pp. 17 ff.

CHAPTER TWO

1 The monastery of Gorze was founded in 933. The reform spread through Lotharingia. St Maximin of Trier was reformed in 934, and from there the movement spread to Reichenau (972) and Regensburg (974). Several of the monasteries were under the direct control and patronage of the Emperor and were used as a recruiting ground for the imperial chancery. Cf. K. Hallinger, O.S.B., *Gorze-Kluny, Studien zu den monastischen Lebensformen und Gegensätzen im Mittelalter*, 2 vols., Rome, 1950–1951. For Abbot Siegfried's letters, cf. W. von Giesebrecht, *Geschichte der deutschen Kaiserzeit*, II, Brunswick and Leipzig, 1855–1888, *Dokumente*, 10, 11.

2 Raby, *Secular Latin Poetry*, I, p. 308.

3 H.P. Lattin, *The Letters of Gerbert with his Papal Privileges as Sylvester II*, Columbia University Press, 1961, p. 137.

4 S. Collin-Gevaert, *Art Roman dans la Vallée de la Meuse aux XIe et XIIe siècles*, Brussels, 1962, 35–36.

5 O noble Rome, mistress of the world, most excellent of cities, red with the rosy

blood of the martyrs, white with the snowy lilies of the virgins, we greet thee above all others, we bless thee: hail throughout all ages.

Peter, thou mightiest bearer of the keys of heaven, ever hear the prayers of thy votaries. When thou sittest to judge the twelve tribes, be favourable to us and judge us leniently. Mercifully support those who are now praying to thee in this world.

Paul, receive our prayers, thou whose zeal overcame the philosophers. Thou that art steward in God's house, bring us food full of divine grace, so that the wisdom which nourished thee may feed us too through thy teaching. (F. Brittain, *The Penguin Book of Latin Verse*, London, 1962, p. 155.)

6 E. Gall, *Karolingische und ottonische Kirchen*, Burg bei Magdeburg, 1930; E. Lehmann, *Der frühe deutsche Kirchenbau*, Berlin, 1938; H. Jantzen, *Ottonische Kunst*, Munich, 1947; L. Grodecki, *Au Seuil de l'art roman. L'architecture ottonienne*, Paris, 1958, divided Ottonian architecture (much of which is in fact Salian) into three groups: basilica with transept, basilica without transept, and different sorts of non-basilical buildings. On Ottonian conservatism in architecture, cf. G. Bandmann, *Mittelalterliche Architektur als Bedeutungsträger*, Berlin, 1951, 115 ff. For recent literature, cf. H. E. Kuback and A. Verbeek, 'Die vorromanische und romanische Baukunst in Mitteleuropa, Literaturbericht', *Zeitschrift für Kunstgeschichte*, XIV, 1951, 124 ff.; *ibid.*, XVIII, 157 ff., cf. also P. E. Schramm and F. Mütherich, *Denkmale der deutschen Könige und Kaiser*, Munich, 1962. No architectural construction can be assigned with certainty to the tenth century in Italy, but cf. Verzone, *L'architettura religosa dell'alto medioevo nell'Italia settentrionale*, Milan, 1942; H. Thümmler, 'Die Baukunst des 11. Jahrhunderts in Italien', *Röm. Jb.*, III, 1939, p. 154.

7 H. Kurze, 'Der Dom Ottos des Grossen in Magdeburg', *Geschichteblätter für Stadt und Land Magdeburg*, 1930, pp. 1–72; Lehmann, *op. cit.*, p. 125; Jantzen, *op. cit.*,

117–118; Grodecki, *op. cit.*, 95 ff., with more recent bibliography. R. Hamann and F. Rosenfeld, *Der Magdeburger Dom*, Berlin, 1910.

8 Lehmann, *op. cit.*, 126–129; Grodecki, *op. cit.*, 27 ff.

9 The crossing was divided from the nave and the choir by so-called triumphal arches. Gall, *op. cit.*, 34, 78, suggests that the existing crossing pillars and arches date from the eleventh-century church. Lehmann, *op. cit.*, 116–117; Jantzen, *op. cit.*, 35 ff.; H. Beveler and H. Roggenkamp, *Die Michaelskirche in Hildesheim*, Berlin, 1954; Grodecki, *op. cit.*, p. 84, points out that a similar transept crossing existed at Germigny-des-Prés.

10 St Maximin of Trier was one of the richest and most important abbeys in Lotharingia in the Merovingian and early Carolingian period; in the tenth century the abbey became a leading power in monastic reform. Lehmann, *op. cit.*, p. 142.

11 W. Zimmermann, *Das Münster zu Essen*, Essen, 1956, accepts the later date for the west end which may offer the first example of 'emptying out' the wall. Piers alternated with columns in the nave.

12 E. Lang, *Ottonische und frühromanische Kirchen in Köln*, Koblenz, 1932; Lehmann, *op. cit.*, 116 ff.; P. A. Tholen, 'Neue baugeschichtliche Ergebnisse in den frühen Kirchen Kölns', *Wallraf-Richartz-Jb.*, XII–XIII, 1943, 7 ff.

13 Lehmann, *op. cit.*, p. 121.

14 The crypt of St Maria im Kapitol, very similar to that of Speyer, dates before the crypt of Brauweiler which is dated 1048 and was an imitation of the church in Cologne. On the crypt of Brauweiler, cf. W. Bader. *Die Benediktinerabtei Brauweiler bei Köln*, Berlin, 1937, 74 ff. Some capitals on the arcaded west wall in St Maria im Kapitol have been dated to about 960; it is claimed that these were re-used in the rebuilding of 1060; cf. W. Meyer-Barkhausen, 'Die Westarka-

denwand von St. Maria im Kapitol im Zusammenhang ottonischer Kunst', *Wallraf-Richartz-Jb.*, XIV, 1952, 9–40. The eleventh-century church had a transept with rounded arms, a development of the choir; an ambulatory in the transept arms and the apse; a triple-aisled nave of seven bays; a westwork with two stair-case towers. The church was influenced by central-plan buildings: an equal-armed triconch unified under a central tower. H. Rahtgens, *Die Kirche St. Maria im Kapitol zu Köln*, Düsseldorf, 1913; Lehmann, *op. cit.*, 120–121; Jantzen, *op. cit.*, 42–43; Grodecki, *op. cit.*, 112ff.

15 Lehmann, *op. cit.*, 136–137.

16 Gall, *op. cit.*, 24ff.; Lehmann, *op. cit.*, 113–114; Jantzen, *op. cit.*, 61ff.; Grodecki, *op. cit.*, 251ff. Gall points out that the alternation of columns and piers has Carolingian precedents (cf. Werden an der Ruhr, beginning of the tenth century), p. 32. The arcading at Gernrode and Quedlinburg was probably influenced by Ravennate churches; the arcading at St Pantaleon in Cologne points to Trier.
The church of St Mary at Walbeck, now in ruins, may have been built before 962; it has certain similarities with Gernrode: similar in scale, narrow 'continuous' transept only slightly extending beyond the walls of the side-aisles, a bay separating the apse from the transept. Cf. H. Feldkeller, *Die Stiftskirche zu Walbeck im Kreise Gardelegen, ein Bauwerk des 10. Jahrhunderts*, Burg bei Magdeburg, 1937; Lehmann, *op. cit.*, p. 143; Jantzen, *op. cit.*, 18–19; Grodecki, *op. cit.*, p. 23. On Sant'Agnese fuori le Mura, Rome, rebuilt by Honorius I (625–638) and restored by Hadrian I (772–795) and many times again at a later date, cf. F. W. Deichmann, *Frühchristliche Kirchen in Rom*, 1948, 72ff., plan 109, pl 67

17 O. Homburger, *Die illustrierten Handschriften der Burgerbibliothek Bern*, Bern, 1962, 136ff.

18 J. Sauer, 'Die Monumentalmalerei der Reichenau', *Die Kultur der Abtei Reichenau*, Munich, 1925, II, 902ff.; M. Thibout, 'Les peintures murales de l'église d'Oberzell', *Congrès archéologique de France CV–CVI*, Souabe, 1947, Baden, 1949, 43ff.; A. Grabar in *Early Medieval Painting*, London, 1957, pp. 78–80. Dr C. R. Dodwell and Dr G. Zarnecki have expressed the opinion that the frescoes may date from the end of the eleventh century.

19 F. X. Kraus, *Die Wandgemälde der St.-Silvester-Kapelle zu Goldbach am Bodensee*, Freiburg im Breisgau, 1902; J. Sauer, *op. cit.*, p. 950, fig. 12; P. Deschamps, 'Goldbach', *Congrès archéologique de France CV–CVI*, Souabe, 1947, Baden, 1949, 59ff.; Grabar, *op. cit.*, pp. 80–82.

20 G. R. Ansaldi, *Gli affreschi della Basilica di S. Vincenzo a Galliano*, Milan, 1949; Grabar in *Romanesque Painting*, London, 1958, 39ff.; de Francovich, 'I problemi della pittura e della scultura pre-romanica', *Centro italiano di studio sull'Alto Medioevo, Spoleto, Settimane*, II, 1955, 393ff.

21 A. Schmidt, *Die Miniaturen des Gero-Codex*, Leipzig, 1924; E. H. Zimmermann, 'Die Fuldaer Buchmalerei in karolingischer und ottonischer Zeit', *Kunstgeschichtliches Jb. der K. K. Zentralkommission*, IV, 1910, 1ff.; A. Boeckler, *Der Codex Wittekindeus*, Berlin, 1938; idem, *Der Codex Wittekindeus*, Leipzig, 1938.
K. Beyerle, 'Von der Gründung bis zum Ende des freiherrlichen Klosters (724–1427)', *Die Kultur der Abtei Reichenau*, I, Munich, 1925, 112ff. At the time of Abbot Alawich II (997–1000) the following inscription is quoted:
Deo digna preconia
Roma regnarum domina
Augia cum Moguntia
Treveris et Colonia
Mettis et Argentina
Favebant applaudentia.
G. B. Tatum in *Art Bulletin*, XXVI, 1944, 35ff., points out that in 998 Pope Gregory V asked that in return for a privilege granted to Reichenau three manuscripts should be sent to him in Rome.

235

22 A. Haseloff and H. V. Sauerland, *Der Psalter Erzbischof Egberts von Trier* (Festschrift der Gesellschaft für nützliche Forschungen), Trier, 1901; A. Boeckler, 'Die Reichenauer Buchmalerei', *Die Kultur der Abtei Reichenau*, Munich, 1925, II, 956ff.; A. Goldschmidt, *German Illumination*, II, 4–5; H. Swarzenski, *Early Medieval Illumination*, p. 18; Boeckler, 'Bildvorlagen der Reichenau', *Zeitschrift für Kunstgeschichte*, XII, 1949, 7ff.; A. A. Schmid, 'Die Reichenauer Handschrift in Brescia', *Arte del Primo Millennio, Atti del II° Convegno per lo Studio dell'Arte dell'Alto Medioevo*, Turin, 1953, 368ff., refers to Brescia, Bibl. Queriniana, cod. mbr. 20. P. Bloch, 'Das Hornbacher Sakramentar und seine Stellung in der frühen Reichenauer Buchmalerei', *Basler Studien zur Kunstgeschichte*, XV, Basle, 1956. 'Die Lokalisierung der Handschrift auf die Reichenau ist seit Haseloff nicht mehr bestritten worden', p. 17. Bloch admits on p. 19 that Eburnant does not figure in any lists of monks at Reichenau. R. Bauerriss, 'Gab es eine "Reichenauer Malschule" um die Jahrtausendwende?', *Studien und Mitteilungen zur Geschichte des Benediktinerordens und seiner Zweige*, LXVIII, 1957, 40ff.; idem, 'Das Kalendarium im Egbert-Psalter in Cividale', *ibid.*, LXIX, 1958–1959, 134ff.; A. Fauser, *Die Bamberger Apokalypse*, Wiesbaden, 1958; idem, 'Zur Frage der Reichenauer Malschule, Ein Nachwort zur Ausstellung der Bamberger Apokalypse im Sommer 1958', *Jb. für fränkische Landesforschung*, XVIII, 1958, 305ff. Fauser is critical of Bauerreiss's theories and stresses the importance of a court style. H. Schnitzler, 'Eine frühchristliche Sarkophagszene und die Reichenauer Buchmalerei', *Festschrift Friedrich Gerke*, Baden-Baden, 1962, 93ff. Cf. also, D. Miner, 'A Late Reichenau Evangeliary in the Walters Art Gallery Library', *Art Bulletin*, XVII, 1936, 168ff.

23 F. X. Kraus, *Die Miniaturen des Codex Egberti*, Freiburg im Breisgau, 1884; H. Schiel, *Codex Egberti der Stadtbibliothek Trier*, 2 vols., Basle, 1962; Egbert of Trier was Chancellor of Otto II, 30th June 976–30th July 977, Archbishop of Trier, 5th June 977–December 983. He was probably twice at Reichenau, once between 970 and 973 and again in 993, either on the way to or from the Council of Verona. He left very late for the Council, he did not accompany the Emperor into Italy in 980, but was still in his diocese in 981 when he consecrated a church. Schiel argues that the Psalter was executed at Trier and also the Codex, but this time with the help of two monks from Reichenau. The manuscripts connected with Egbert are: Egbert's Psalter (Cividale), *Codex Egberti* (Trier), *Registrum Gregorii* leaves (Trier, Chantilly), a Psalter with an interlinear Greek translation, and an Epistolary given to the Trier monastery of St Maria ad Martyres (Berlin, ehemals Preuss. Staatsbibl., theol. lat. fol. 34). Boeckler pointed out, *op. cit.*, p. 974, that the initial ornament in the Egbert Psalter is related to the Eburnant group, that the animal ornament in gold on a purple ground links together the Egbert Psalter, the *Codex Egberti* and the Liuthar group of manuscripts. Cf. also Nordenfalk in *Early Medieval Painting*, London, 1957, 208ff.
In an informal talk at the Warburg Institute on 21st March 1963, Dr C. R. Dodwell, 'A more critical approach to the Reichenau School of Illumination', was opposed to the Eburnant and the Ruodprecht groups being assigned to Reichenau, expressed doubt on the importance of Reichenau as a political or cultural centre and supported substantially the Trier hypothesis.

24 C. Bertelli, *La Madonna di S. Maria in Trastevere*, Rome, 1961, 91ff.

25 C. Nordenfalk, 'Der Meister des Registrum Gregorii', *Münchner Jb. d. bild. Kunst*, III, 1956, 61ff.; idem, in *Early Medieval Painting*, London, 1957, p. 203; H. Schnitzler in *Festschrift H. Kauffmann*, Berlin, 1956, 17ff.; *Ars Sacra*, No. 99; *Werdendes Abendland*, No. 420; Schnitzler, *Rheinische Schatzkammer*, I, No. 7; J. Croquison, 'Les origines de l'iconographie grégorienne', *Cahiers archéologiques*, XII, 1962, 249ff.

For connections between the Master of the *Registrum Gregorii* and a scriptorium at Lorsch, cf. D.H. Turner; 'The "Odalricus peccator" Manuscript in the British Museum', *British Museum Quarterly*, XXV, 1–2, 1962, 11 ff.

26 H.P. Lattin, *The Letters of Gerbert*, p. 298.

27 S. Beissel, *Die Bilder der Handschrift des Kaisers Otto in Münster zu Aachen*, Aachen, 1886; G. Leidinger, *Das sog. Evangeliarum Kaiser Ottos III. (Miniaturen aus Handschriften der Kgl. Hof- und Staatsbibliothek I)*, Munich, 1912; H. Wölfflin, *Die Bamberger Apokalypse*, Munich, 1921, 2nd edition; A. Fauser, *Die Bamberger Apokalypse*, Frankfurt am Main, 1958; P. Metz, *Ottonische Buchmalerei. Evangeliar Ottos III., Perikopenbuch Heinrichs II.*, Munich, 1959; Schnitzler, *Rheinische Schatzkammer*, I, No. 35, pl. 102; P.E. Schramm, *Die deutschen Kaiser und Könige in Bildern ihrer Zeit*, I, Leipzig and Berlin, 1928, No.74, 93 ff.; E.H. Kantorowicz, *The King's Two Bodies*, Princeton, 1957, 61 ff. W. Messerer, 'Zum Kaiserbild des Aachener Ottonencodex'; *Nachr. d. Akad. d. Wiss. in Göttingen, Phil.-hist. Kl.*, 1959/2, pp. 27 ff.; P.J. Alexander, 'Empire and Capital through Byzantine Eyes', *Speculum*, XXXVII, 1962, p. 253.
The Carolingian concept of a David-like kingship was decisively theocentric: 'Thou art the vicegerent of God, and the bishop is in the second place only, the vicegerent of Christ', as the English scholar Cathwulf wrote to Charlemagne; cf. Kantorowicz, *King's Two Bodies*, p. 77. The Ottonian concept was Christocentric: a kingship centred in the God-man rather than God the Father.
F. Haeberlin, 'Grundzüge einer nachantiken Farbenikonographie', *Röm. Jb. f. Kunstgeschichte*, III, 1939, 77 ff.

28 Boeckler, however, sees contemporary Byzantine influences in the Liuthar group; cf. 'Die Reichenauer Buchmalerei', 985 ff.; W. Gernsheim, *Die Buchmalerei der Reichenau*, Munich, 1934, p. 81, for the comparison with Atlas; Charles Tolnay, 'The "Visionary" Evan-

gelists of the Reichenau School', *Burlington Magazine*, LXIX, 1936, 257 ff., refers to *Coelus* on the breast-plate of the statue of Augustus at Prima Porta, but cf. W.R. Hovey's reply to Tolnay in *Burlington Magazine*, LXX, 1937, p. 145; W. Weisbach, 'Les images des Évangélistes dans l'Évangéliaire d'Othon III et leurs rapports avec l'antiquité', *Gazette des Beaux-Arts*, XXI, 1939, 132 ff.: B. Bischoff, 'Das biblische Thema der Reichenauer "Visionären Evangelisten"' in *Festschrift Josef Pacher*, Munich, 1963, pp. 25 ff.

29 A. Boeckler, *Das Perikopenbuch Heinrichs II*, Berlin, 1944. The influence of the 'Reichenau' imperial style was not only felt at Minden, Trier, Echternach, Salzburg, Regensburg, Tegernsee, Schaffhausen, Weingarten and Cologne, but it permeated into North Italy, northern France and later England.

30 G. Swarzenski, *Die Regensburger Buchmalerei des 10. und 11. Jahrhunderts*, Leipzig, 1901.

31 B. Bischoff, 'Literarisches und künstlerisches Leben in St Emmeram während des frühen und hohen Mittelalters', *Studien und Mitt. zur Geschichte des Benediktiner-Ordens*, LI, 1933, pp. 102 ff.; A. Boeckler, 'Das Erhardbild im Uta-Kodex', *Studies in Art and Literature for Belle da Costa Greene*, Princeton, 1954, 219 ff.; Nordenfalk in *Early Medieval Painting*, London, 1957, p. 213.

32 H. Ehl, *Die ottonische Kölner Buchmalerei (Forschungen zur Kunstgeschichte Westeuropas IV)*, Bonn and Leipzig, 1922; E. Schipperges, 'Die Miniaturen des Hitdacodex in Darmstadt', *Jb. des Kölner Geschichtvereins*, LXXIX, 1937; idem, *Der Hitda-Kodex, ein Werk ottonischer Kölner Buchmalerei*, Bonn, 1938; A. Boeckler, 'Kölner ottonische Buchmalerei', *Beiträge zur Kunst des Mittelalters*, Berlin, 1950, 144 ff.; Nordenfalk in *Early Medieval Painting*, London, 1957, p. 210.

33 On the 'spiritual' opposition of Cluny and the rivalry of Cluny III *vis-à-vis* Speyer, cf. G. Bandmann, *Mittelalterliche*

Architektur als Bedeutungsträger, Berlin, 1951, pp. 237–238, and note the quotation from Gilo of Cluny in connection with the building of Cluny III: 'Deo juvante talem basilicam levavit intra viginti annos, qualem si tam brevi construxisset imperator, dignum admiratione putaretur.' On Cluny, cf. W. Weisbach, *Religiöse Reform und mittelalterliche Kunst*, Zurich, 1945.
Sigrid Müller-Christensen and Alexander von Reitzenstein, *Das Grab des Papstes Clemens II. im Dom zu Bamberg*, Munich, 1960.

34 P. Clemen, *Der Echternacher Evangeliencodex in Gotha*, Bonn, 1930; C. Nordenfalk, 'Neue Dokumente zur Datierung des Echternacher Evangeliars in Gotha', *Zeitschrift für Kunstgeschichte*, I, 1932, 153 ff.; A. Boeckler, *Das goldene Evangelienbuch Heinrichs III.*, Berlin, 1934; H. Schnitzler, 'Südwestdeutsche Kunst um 1000 und die Schule von Tours', *Trierer Zeitschrift*, XIV, 1939, 154 ff., tries to prove that the Tours Bible in St Maximin at Trier was the actual stylistic and iconographic model for the whole New Testament cycle of the schools of Reichenau and Trier-Echternach, but H. Swarzenski in *Art Bulletin*, XXIV, 1942, p. 289, is sceptical. Ph. Schweinfurth, 'Das goldene Evangelienbuch Heinrichs III. und Byzanz', *Zeitschrift für Kunstgeschichte*, X, 1941–1942, 40 ff.; P. Metz, *Das goldene Evangelienbuch von Echternach im Germanischen Nationalmuseum zu Nürnberg*, Munich, 1956.

35 H. Fillitz, 'Die Gregor-Platte', *Jb. d. kunsthist. Samml. in Wien*, LVIII, 1962, 7 ff.

36 V. Gröber, 'Reichenauer Plastik bis zum Ausgang des Mittelalters', *Die Kultur der Abtei Reichenau*, II, Munich, 1925, pp. 876–877; R. Berliner, 'Aus der mittelalterlichen Sammlung des Bayerischen Nationalmuseums, I, Drei ottonische Elfenbeinreliefs', *Münchner Jb. d. bild. Kunst*, XII, 1921–1922, p. 43; idem, *Bayerisches Nationalmuseum, Katalog*, IV, 1926, Nos. 11, 12, 13; Goldschmidt, *Elfenbein-*skulpturen*, II, Nos. 4–16; H. Fillitz, 'Die Spätphase des "langobardischen" Stiles', *Jb. d. kunsthist. Samml. Wien*, LIV, 1958, 64 ff.
F. Bock, *Die Kleinodien des Heiligen Römischen Reiches Deutscher Nation*, Vienna, 1864; A. Weixlgärtner, 'Die weltliche Schatzkammer in Wien, Neue Funde und Forschungen', *Jb. d. kunsthist. Samml. Wien*, N. F. I, 1926, 49 ff.; H. Deckerhauf in *Herrschaftszeichen und Staatssymbolik*, ch. 25; H. Fillitz, 'Studien zur römischen Reichskrone', *Jb. d. kunsthist. Samml. Wien*, L, 1953, 23 ff.; idem, *Die Insignien und Kleinodien des Heiligen Römischen Reiches*, Vienna-Munich, 1954, p. 16, 52, takes the view that the crown was made either for Otto I or Otto II; J. Deer, 'Kaiser Otto der Grosse und die Reichskrone', *Akten zum VII. Internationalen Kongress für Frühmittelalterforschung* (1958), Graz-Köln, 1961, 261 ff. Both Deckerhauf and Deer argue that the crown was made for Otto I, possibly for his coronation in Rome in 962. But cf. Lord Twining, *A History of the Crown Jewels of Europe*, London, 1960, 297 ff., 329 ff., for a summary of the conflicting views: made in a workshop at Trier or Mainz in 993 for Rudolph III, King of Burgundy, and passing on his death to Conrad II, who had married Rudolph's niece (*N.B.* Conrad's name is on the arch of the Crown); a gift from Pope Benedict VIII to Emperor Henry III; made at Reichenau for Otto I about 961, the cross made in the same workshop, the present arch a replacement of a former arch. Lord Twining points out that it is doubtful whether Otto I was crowned Emperor with a crown he had made, although he may have included it in the new set of ornaments which he took to Rome (Liutprand of Cremona relates that he arrived for his coronation 'miro ornatu novo apparatus' and that the Emperor's robes were specially made for him). If we are to accept the deep religious symbolism of the Crown and the emphasis on Otto's position as *Rex et Sacerdos*, it seems likely that the Pope would have been reluctant to place such an ornament on Otto's head (p. 332). It seems more likely that Otto wore his crown on his entry into Rome

and was crowned by the Pope with another crown. There is no record as to what crowns were used at the coronations of Otto II and Otto III, but Henry II was crowned with a new crown which was a gift from the Pope. With the Franconian and Salian Emperors we know definitely that the Pope provided crowns for Conrad II, Henry III, Henry IV, and Henry V.

At least from the time of Henry II the possession of the Crown was considered to be a matter of great importance.

37 Goldschmidt, *Elfenbeinskulpturen*, II, Nos. 1 ff; J. Beckwith, *The Basilewsky Situla*, London, 1963; cf. also A. Haseloff, *Preromanesque Sculpture in Italy*, Florence, 1930, 66 ff.

For a possible indication that certain ivory carvings of the 'Ada' group may be Milanese or North Italian, cf. *A Gradual, Processional and Troper in Rome*, Bibl. Angelica, cod. 123, probably executed at the monastery of S. Stefano in Bologna in the second quarter of the eleventh century, which would seem to be based on, or rather developed from, a similar style. E. B. Garrison, *Studies*, IV, 1960–1961, 4, 93 ff. Some sculptured reliefs at Nonantola by the Master of Astolfo appear to be based on the style of the Milanese ivory carvings, of the late tenth or early eleventh century; cf. R. Salvini, *Wiligelmo e le origini della scultura romanica*, Milan, s. d., figs. 146, 148, 149.

G. de Francovich assigns the ciborium to the time of Archbishop Ariberto da Intimiano in the beginning of the eleventh century; cf. 'Arte carolingia ed ottoniana in Lombardia', *Röm. Jb. f. Kunstgeschichte*, VI, 1942–1944, pp. 116 ff.; idem, 'Problemi della pittura e della scultura preromanica', *Centro italiano di studio sull'Alto Medioevo, Spoleto, Settimane*, II, 1955, 356 ff. Schramm and Haseloff incline to a date about 980 or to the time of Archbishop Arnolfo (970–974); cf. Haseloff, *Preromanesque Sculpture in Italy*, 65 ff.; Arslan in *Storia di Milano*, III, Milan, 1954, pp. 569 ff., suggests a date in the first half of the twelfth century; O. Homburger, 'Über eine Federzeichnung des 10.–11. Jahrhunderts und deren Beziehung

zu dem Ciborium in St. Ambrogio zu Mailand', *Atti dell'8° Congresso di studi sull'arte dell'Alto Medioevo*, Milan, 1962, 65 ff. For Milanese Mss. cf. P. Toesca, *La pittura e la miniatura nella Lombardia*, Milan, 1912, 69 ff.; for a Milanese artist working at Fleury in the early eleventh century, cf. C. Nordenfalk, 'A Travelling Milanese artist in France at the beginning of the XIth century', *Arte del Primo Millennio*, 1953, 374 ff.

For the production of enamels at Milan-Pace of Chiavenna (1000), the Bookcover of Aribertus (1018–1045) executed in 'a lively non-Byzantine style', cf. P. J. Kelleher, *The Holy Crown of Hungary*, American Academy in Rome, 1951, p. 74, but the Vercelli Bookcover (c. 1050) possesses strong Byzantine characteristics both in iconography and style.

38 Goldschmidt, *Elfenbeinskulpturen*, II, No. 19. He compares the figure with an Apostle on the Harbaville triptych in the Louvre, a Byzantine court product of the middle of the tenth century.

39 Goldschmidt, *Elfenbeinskulpturen*, II, Nos. 22, 23, 24, 25, 26; P. E. Schramm, *Die deutschen Kaiser und Könige in Bildern ihrer Zeit*, Leipzig and Berlin, 1928, 193 ff.; F. Rademacher, 'Der Trierer Egbertschrein, seine Beziehungen zur fränkisch-karolingischen Goldschmiedekunst', *Trierer Zeitschrift*, XI, 1936, 144 ff.; O. Homburger in *Jb. d. preuss. Kunstgeschichte*, LVII, 1936, p. 130; J. Buchkremer, 'Der Ambo Heinrichs II. im Dom zu Aachen', *Deutsche Kunst- und Denkmalpflege*, Jg. 1937, 107 ff.; *Ars Sacra*, No. 106; *Werdendes Abendland*, No. 387, 421; Schnitzler, *Rheinische Schatzkammer*, I, Nos. 4, 5, 10, 11, 13, 37. On Egbert's generosity, cf. *Gesta Trevorum*, ed. E. Zenz, I, Trier, 1955, p. 57. 'Ecclesiam suam ... largissima liberalitate ditavit, aureis et argenteis crucibus, plenariis, casulis, dalmaticis, tunicis, palliis, cappis, velis cortinusque et possessionibus auxit.' Quoted by H. Schiel, *Codex Egberti*, p. 175, Note 33.

40 Goldschmidt, *Elfenbeinskulpturen*, II, No. 40; Nordenfalk in *Münchner Jb. d. bild.*

Kunst, III, 1950, 75 ff.; Schnitzler in Rheinische Schatzkammer, I, No. 9.

41 Goldschmidt, Elfenbeinskulpturen, II, No. 46, suggests that the style of the relief is similar to Ottonian Mss., of the last third of the tenth century. W. Koehler, 'Die Denkmäler der karolingischen Kunst in Belgien', Belgische Kunstdenkmäler (ed. P. Clemen), I, Munich, 1923, 1 ff.; J. Lejeune, 'A propos de l'art mosan et des ivoires liégeois', Anciens Pays et Assemblées d'États, VIII, 1955, 89 ff.; M. J. Philippe, L'Évangéliaire de Notger et la chronologie de l'art mosan des époques préromane et romane, Brussels, 1956; S. Collin-Gevaert et al., Art Roman dans la Vallée de la Meuse aux XIᵉ et XIIᵉ Siècles, Brussels, 1962, pp. 162–167. Lejeune argues unconvincingly in favour of a date c. 1101–1107 for the Notker relief, which is attached to a tenth-century Evangeliary probably from Reims. There were close connections between Reims and Liège; Notker and Gerbert of Aurillac corresponded when Gerbert was at Reims; the scriptoria at Stavelot and Lobbes followed in the wake of Reims.
The thirty-six years of Notker's episcopate brought to an end the chaos which had long reigned in the diocese of Liège and began a new period of prosperity. Notker rebuilt the Church of Saint-Jean at Liège which was modelled on the palace chapel at Aachen. After the death of Otto II, Notker, with the Archbishops of Cologne and Trier and the Bishops of Metz and Utrecht, at first supported Henry of Bavaria against the Empress Theophano, but Henry's alliance with Lothair of France was unpopular, and after Verdun had been captured by the French and Liège threatened (985), Notker went over to Theophano. He became a trusted servant of the Empress-Regent and her son. His loyal example was to have influence long after his death. The Bishops of Liège resisted Cluniac reform; they objected to their authority being overridden by the abbots of Cluny. Notker's service to the diocese is summed up in the phrase: Nogerum Christo, Nogero cetera debes [(Liège) owes Notker to Christ but the rest to Notker].

42 Goldschmidt, Elfenbeinskulpturen, II, No. 47; Alte Kunst im Schnütgen-Museum, Köln, 1956, No. 9; Schnitzler, Rheinische Schatzkammer, I, No. 23. Because of its reliability and the excellence of its alloy the mint of Cologne was the largest in Germany in the High Middle Ages. Its greatest importance and widest activity fall between 936 and 1288. Cf. W. Haevernick, Die Münzen von Köln, vom Beginn der Prägung bis 1304 (Die Münzen und Medaillons von Köln, I), Cologne, 1935, 162 ff. M. Creutz, Kunstgeschichte der edlen Metalle, Stuttgart, 1909; J. Braun, S.J., Meisterwerke der deutschen Goldschmiedekunst der vorgotischen Zeit, Munich, 1922; E. Medding-Alp, Rheinische Goldschmiedekunst in ottonischer Zeit, Koblenz, 1953; F. Rademacher, 'Eine Krone Kaiser Ottos II.: Ein Beitrag zur ottonischen Goldschmiedekunst', Zeitschrift des Deutschen Vereins für Kunstwissenschaft, I, 1934, p. 79.
On the first Cross of Abbess Matilda, cf. Schnitzler, Rheinische Schatzkammer, I, No. 43. There are four processional crosses at Essen: (1) that of the Abbess Matilda and Otto of Swabia and Bavaria, 973–982; (2) a cross with large enamels representing the Crucifixion and the symbols of the Evangelists – before 1000: (3) 'the second' cross of Abbess Matilda with an enamel portrait of the Abbess kneeling before the Virgin and Child, 973–1011, but with later restorations; (4) the cross of Abbess Theophano (1039–1056). In addition, the crown of the Golden Virgin is believed to date from the time of Abbess Matilda, as does the ceremonial sword of St Cosmas and St Damian. The reliquary of the Holy Nail and the ivory and gold bookcover date from the time of Abbess Theophano. The ivory carving is generally attributed to Metz, but the metalwork might be from Cologne rather than Metz.
On the Cross of Lothair, cf. K. Faymonville, Das Münster zu Aachen, Düsseldorf, 1916, 197 ff., pl. XII, fig. 137; H. Jantzen, Ottonische Kunst, p. 157; J. Deer, 'Das Kaiserbild im Kreuz', Schweizer Beiträge zur allgemeinen Geschichte, XIII, 1955, 48 ff.; Schnitzler, Rheinische Schatzkammer, I, No. 32. The Cross of the

Holy Roman Empire at Vienna was made for Conrad II; cf. A. Weixlgärtner, 'Die weltliche Schatzkammer in Wien, Neue Funde und Forschungen', *Jb. d. kunsthist. Samml. Wien*, N. F. I, 1926, 43 ff. On the Essen Virgin, cf. G. Hamannn, *Die Kunstwerke der Münsterkirche in Essen*, Düsseldorf, 1904, p. 251; H. Keller, 'Zur Entstehung der sakralen Vollskulptur in der ottonischen Zeit', *Festschrift H. Jantzen*, Berlin, 1951, 71 ff.; *Werdendes Abendland*, No. 498; Schnitzler, *Rheinische Schatzkammer*, I, No. 39. The Virgin is almost contemporary with the golden image of Sainte-Foy at Conques and the *Sedes Sapientiae* of Walcourt, the latter dating from the first half of the eleventh century but greatly restored. Also believed to be Cologne work is the silver-gilt relief of St Matthew, incorporated in the pulpit given by Henry II before he was crowned Emperor (1002–1014) to the imperial chapel at Aachen, cf. H. Fillitz, 'Das Evangelisten-Relief vom Ambo Kaiser Heinrichs II. im Aachener Münster', *Karolingische und ottonische Kunst, Forschungen zur Kunstgeschichte und christlichen Archäologie*, III, Wiesbaden, 1957, 360 ff.; for the pulpit, cf. E. Doberer, 'Studien zu dem Ambo Kaiser Heinrichs II. im Aachener Münster', *ibid.*, 308 ff.; Schnitzler, *Rheinische Schatzkammer*, I, No. 36. According to Schnitzler the metalwork was probably executed at Fulda.

43 H. Schnitzler, 'Zur Regensburger Goldschmiedekunst', *Wandlungen christlicher Kunst im Mittelalter, Forschungen zur Kunstgeschichte und christlichen Archäologie*, II, Baden-Baden, 1953, 171 ff.; Munich, *Residenz-Schatzkammer, Katalog*, 1958, No. 8. Gisela was the wife of St Stephen of Hungary.

44 H. Schnitzler, 'Fulda oder Reichenau?', *Wallraf-Richartz-Jb.*, XIX, 1957, 39 ff.; idem, *Rheinische Schatzkammer*, I, No. 31, T. Buddensieg, 'Die Basler Altartafel Kaiser Heinrichs II.', *Wallraf-Richartz-Jb.*, XIX, 1957, 133 ff. Like Schnitzler, Buddensieg argues for Fulda in the second or third decade of the eleventh century, but cf. Nordenfalk in *Early Medieval Paint-*

ing, London, 1957, p. 210, who prefers Mainz to Fulda on the strength of a comparison with three manuscripts executed under Archbishop Aribo (1021–1031): a Sacramentary in the Coll. Bodmer at Geneva, formerly Coll. Duke of Aremberg, a Gospel Book (Berlin, Staatsbibl., theol. lat. fol. 18) and another Gospel Book (Fulda, Landesbibl., Aa 44). Swarzenski, *Monuments of Romanesque Art*, Nos. 41/42, also prefers Mainz to Fulda. It has been suggested that Henry II offered the antependium to Basle Cathedral about 1019 in gratitude for a cure obtained through the intercession of St Benedict, whose aid the Emperor had sought at Montecassino. On either side of Christ, the Archangels, Gabriel, Raphael and Michael, and St Benedict, witness the homage of the Emperor and the Empress.
On Basle Cathedral, cf. H. Reinhardt, *Das Münster zu Basel*, Burg bei Magdeburg, 1928.
On the Aachen antependium, cf. also E. G. Grimme, *Aachener Goldschmiedekunst im Mittelalter von Karl dem Grossen bis zu Karl V.*, Cologne, 1957, pp. 28–29, pl. 71–89.

45 A. Goldschmidt, *Die deutschen Bronzetüren des frühen Mittelalters*, Marburg, 1926; and a review in *Art Bulletin*, X, pp. 394–395; R. Wesenberg, *Bernwardinische Plastik: zur ottonischen Kunst unter Bischof Bernward von Hildesheim*, Berlin, 1955.
On Bernward, cf. F J Tschan, *St Bernward of Hildesheim*, Notre Dame, Indiana, I, 1942, II, 1951, III (Plates), 1952. According to Thangmar of Heidelberg, Bernward's old tutor and biographer, Bernward was said to have made himself gold and silver vessels and to have tried all the crafts 'even though he did not succeed in reaching the apex of perfection', but cf. Swarzenski, *Monuments of Romanesque Art*, p. 18, 'if, for instance, Bernward of Hildesheim is recorded as goldsmith, sculptor and miniature painter, it does not necessarily imply that he actually had a share in the manual execution of his donations'. Among the books that Bernward bequeathed to

St Michael at Hildesheim was a copy of Vitruvius (now Leyden, Ms. Voss. F.88), cf. E. de Bruyne, *Études d'Esthétique Médiévale*, I, Bruges, 1946, p. 245. The monogram of Bernward on a bookcover (Hildesheim, cod. 13, Gospels) copies a Justinianic monogram which the bishop must have seen at Ravenna; cf. W. Oakeshott, *Classical Inspiration in Medieval Art*, London, 1959, pl. 93 (a).

Hildesheim was one of the chief places for the recruitment of imperial ecclesiastical personnel; it may have been the chief centre of Saxon illumination during the reigns of Otto I and Otto II.

46 Wesenberg, *Bernwardinische Plastik*, pp. 117 ff.

47 R. W. Southern, *The Making of the Middle Ages*, London, 1959, p. 241; *idem, Saint Anselm and his Biographer*, Cambridge University Press, 1963; ed. R. W. Southern, *The Life of St Anselm, Archbishop of Canterbury by Eadmer*, Nelson's Medieval Texts, 1962; O. Pächt, 'The Illustrations of St Anselm's Prayers and Meditations', *Journal of the Warburg and Courtauld Institutes*, XIX, 1956, pp. 74 ff.; for a sketch of St Anselm's character and his importance in medieval thought, cf. D. Knowles, *Saints and Scholars*, Cambridge University Press, 1962, 31 ff.

48 For a silver crozier, executed for Erkanbald, Abbot of Fulda (996–1011), Archbishop of Mainz (1011–1021), a relation of Bernward of Hildesheim, cf. R. Wesenberg, '*Curvatura Erkanbaldi abbatis*', *Karolingische und ottonische Kunst, Forschungen zur Kunstgeschichte und christlichen Archäologie*, III, Wiesbaden, 1957, 372 ff.; *idem, Bernwardinische Plastik*, 17 ff.; Christian Beutler, 'Ein ottonischer Kruzifixus aus Trier', *Das erste Jahrtausend*, I, 1962, 549 ff.

CHAPTER THREE

1 Lehmann, *Der frühe deutsche Kirchenbau*, p. 123; Grodecki, *op. cit.*, 103 ff.

2 Lehmann, *op. cit.*, p. 141; H. Schäfer, 'The Origin of the Two-Tower Façade in Romanesque Architecture', *Art Bulletin*, XXVII, 1945, 87 ff.

3 Lehmann, *op. cit.*, pp. 141–142; for the importance of the Constantinian basilica at Trier, cf. E. Gall, *Karolingische und ottonische Kirchen*, p. 68; Th. K. Kempf, 'Die Ausgrabungen am Trierer Dom und an der Liebfrauenkirche von 1943 bis 1950', *Forschungen zur Kunstgeschichte und christlichen Archäologie*, I, 1952, 102 ff.; Jantzen, *op. cit.*, pp. 50–51.

4 Lehmann, *op. cit.*, 117 ff.

5 Lehmann, *op. cit.*, p. 140; W. Hege and H. Weigert, *Die Kaiserdome am Mittelrhein, Speyer, Mainz und Worms*, Berlin, 1933; O. Förster, 'Von Speyer bis Chartres', *Neue Beiträge deutscher Forschung, W. Worringer zum 60. Geburtstag*, Königsberg, 1943, 106 ff.; F. Klimm, *Der Kaiserdom zu Speyer*, Speyer, 1953; Grodecki, *op. cit.*, 104 ff., 206 ff., 296.

6 For reconstruction, cf. Lehmann, *op. cit.*, pl. 17, fig. 37.

7 H. Rahtgens, *Die Kirche St. Maria im Kapitol zu Köln*, Düsseldorf, 1913; Lehmann, *op. cit.*, 120–121; Jantzen, *op. cit.*, pp. 42–43; Grodecki, *op. cit.*, 112 ff. For Lomello, cf. A. K. Porter, *Lombard Architecture*, II, 500 ff.; H. Thümmler in *Röm. Jb.*, III, 1939, 157 ff.

8 Cf. Klimm, *op. cit.*, pp. 10 ff.

9 Schäfer in *Art Bulletin*, XXVII, 1945, 87 ff.; Grodecki, *op. cit.*, p. 296, 'La façade de Notre-Dame de Jumièges, si semblable plastiquement aux façades ottoniennes, et si proche d'elles par les dispositions intérieures de la tribune, commandée par de vastes escaliers, apporte une autre preuve de l'importance historique de l'architecture impériale autour de l'an mil.'

10 J. Bony, 'La technique normande du mur épais à l'époque romane', *Bull. Mon.*, XCVIII, 1939, pp. 153 ff. Bony states

that the classic type of Norman apse was fixed at Saint-Etienne de Caen; *ibid.*, p. 164, note 3.

11 L. E. Tanner and A. W. Clapham, 'Recent Discoveries in the Nave of Westminster Abbey', *Archaeologia*, LXXXIII, 1933, p. 227. Jumièges, *c.* 1040, apart from the ambulatory in the apse, provides the closest analogy to Westminster. For Jumièges, cf. G. Lanfry, 'Fouilles et découvertes à Jumièges; le déambulatoire de l'église romane', *Bull. Mon.*, LXXXVII, 1928, 107ff.; J. Bony, *op. cit.*, 153ff.; G. Lanfry, *L'abbaye de Jumièges: plans et documents*, Rouen, 1954. Ely has been described: 'Fille de Cérisy, Ely reste dans la pure orthodoxie normande', Bony, *op. cit.*, p. 172. Of the building prior to 1106 only three bays of each transept survive; by 1106 the east part of the new church was completed but the choir was replaced by a larger one in the thirteenth century. Cf. G. Zarnecki, *Early Sculpture of Ely*, London, 1958, p. 8.

12 As a rule, the buildings erected by the Normans immediately after the Conquest were devoid of sculptural decoration, Zarnecki, *op. cit.*, p. 10. On the cushion capital and its use in Lower Lorraine and the Rhineland, cf. Zarnecki, *op. cit.*, p. 15.

13 At Durham all the capitals are of the cubic type; there is no sculptural decoration. On the caryatids, formerly in the chapter-house of Durham Cathedral, built between 1133 and 1140, and their relationship to sculpture in North Italy, especially Piacenza cathedral, cf. G. Zarnecki, *Later English Romanesque Sculpture*, 1140–1210, London, 1953, p. 16. Cf. also P. Kidson and P. Murray, *A History of English Architecture*, London, 1962, 46 ff.

14 J. Virey, 'Les différentes époques de construction de l'église St-Philibert de Tournus', *Bull. Mon.*, LXVII, 1903, p. 875; J. Bony, 'Gloucester et l'origine des voûtes d'hémicycle gothiques', *Bull. Mon.*, XCVIII, 1939, 329ff.; *idem*,

'Tewkesbury et Pershore', *Bull. Mon.*, XCVI, 1937, 288ff. 'Rien n'est moins normand, en réalité, que cet art des pays de l'ouest.' Kidson and Murray, *op. cit.*, 46ff., for German influences, via Lotharingia, in the west country, p. 54.

15 H. Thümmler, 'Die Baukunst des 11. Jahrhunderts in Italien', *Röm. Jb.*, III, 1939, 143ff.; for Burgundian influence on Lombard sculpture, cf. de Francovich, 'La corrente comasca nella scultura romanica europea', *Rivista de R. Istituto d'Archeologia e Storia dell'Arte*, V, 1935–1936, p. 293; VI, 1937–1938, p. 47, for Lombard influence in Germany.

16 There is no evidence that the Cathedral of Modena was destroyed by the earthquake of 1117. Cf. review by D. M. Robb of T. Krautheimer-Hess, 'Die figurale Plastik der Ostlombardei von 1100 bis 1178', *Marburger Jb. f. Kunstwissenschaft*, IV, 1928, in *Art Bulletin*, XII, 1930, 196ff.; P. Frankl, 'Der Dom zu Modena', *Jb. f. Kunstwissenschaft*, IV, 1927, 39ff. A. M. Romanini, 'Die Kathedrale von Piacenza, Der Bau des 12. und 13. Jahrhunderts', *Zeitschrift für Kunstgeschichte*, XVII–XVIII, 1954–1955, 129ff.; cf. also D. M. Robb, 'Niccolò: a North Italian Sculptor of the 12th Century', *Art Bulletin*, XII, 1930, 328ff.

17 K. J. Conant, *Carolingian and Romanesque Architecture*, 238ff.

18 Conant, *op. cit.*, pp. 107ff.; J. Evans, *The Romanesque Architecture of the Order of Cluny*, Cambridge, 1938; W. Weisbach, *Religiöse Reform und mittelalterliche Kunst*, Zurich, 1945; and see under II, Note 33. Cluny had extensive connections in Spain: there were foundations at Najera (1052), Las Duegnas (1077) and Carrión (1095). After the reconquest of Valencia, the first bishop was a Cluniac monk, Jérôme de Périgueux.

19 Conant, *op. cit.*, pp. 63–64.

20 Conant, *op. cit.*, 91ff.; for the pilgrim routes, cf. E. Mâle, *L'art religieux du XIIᵉ siècle en France*, Paris, 1928, p. 291;

A.K. Porter, *Romanesque Sculpture of the Pilgrimage Roads*, Boston, 1923. C. Hohler, 'The Badge of St James', *The Scallop. Studies of a shell and its influences on mankind*, 'Shell' Transport and Trading Co. Ltd., London, 1957, p. 54, proposes a date for the adoption of the badge between 1099 and 1106, p. 60. E.R. Labande, 'Recherches sur les pèlerins dans l'Europe des XIᵉ et XIIᵉ siècles', *Cahiers de Civilisation Médiévale Xᵉ–XIIᵉ Siècles*, I, 1958, 159ff., 339ff. There is no evidente to suggest that the pilgrimage to Santiago was organized in the modern sense. Cluniac propaganda has been held responsible for the popularity of the pilgrimage to Santiago, but this theory breaks down on the silence of all the sources connected with the abbey of Cluny itself. Cluny and Rome, however, were certainly interested in war against the infidel, and the pilgrimage, already popular in southern and western France, would seem to have benefited accidentally from the recruitment of northern French soldiery for various campaigns in Spain beginning in 1063. Hohler, *op. cit.*, p. 55.

21 J. Hubert, *L'Art Préroman*, Paris, 1938, 65ff. 'On ne saurait oublier que la crypte carolingienne a légué à l'architecture française la disposition la plus originale et la plus heureuse du plan de nos églises romanes: le chevet à chapelles rayonnantes.' C.K. Hersey, 'The Church of Saint-Martin at Tours (903–1150)', *Art Bulletin*, XXXV, 1943, 1ff.; F. Lesueur, 'Saint-Martin de Tours et les origines de l'art roman', *Bull. Mon.*, CVII, 1949, 7ff. Grabar, *Martyrium*, I, p. 511, Note 1, accepts 904–919 as the date of the first version of an apse with an ambulatory and with radiating chapels, though he believes these to have been very small; they look forward, nevertheless, to the elegance of the twelfth- and thirteenth-century variety (p. 513). Saint-Martin was dedicated in 1014, but the church of Hervé was probably not completed by this date; it had single, groin-vaulted side-aisles surmounted by tribunes, rectangular piers, a choir with an ambulatory and five radiating chapels, and a westwork. Alterations in the middle of the eleventh century introduced barrel-vaulting in the transept. This church was damaged by fire in 1096 and in 1122 or 1123, but early in the twelfth century the western arm of the church had been expanded from three to five aisles and the nave was barrel-vaulted. This operation is noted in the Pilgrim's Guide of the *Codex Calixtinus*: 'ad similitudinem ... ecclesie beati Jacobi'; cf. Jeanne Vieillard, *Le guide du pèlerin de Saint-Jacques de Compostelle*, Mâcon, 1938, p. 60. Permanent restoration of the damage done by fire was not made until the late twelfth century.

Cf. also, Lasteyrie, *L'architecture religieuse en France à l'époque romane*, Paris, 1912, 185ff., 297ff.: for Focillon's views, cf. Note in *Bull. Mon.* XCVII, 1938, p. 97; L. Bréhier, 'L'origine des chevets à chapelles rayonnantes', *La vie et les arts liturgiques*, 1921, 456ff.; Focillon, 'Sur les origines du déambulatoire à chapelles rayonnantes', *Notes et documents d'archéologie*, 1937; E. Fels in *Bull. de la Soc. Nat. des Antiquaires de France*, 1941, 269ff.; Grodecki, *op. cit.*, 214ff.; P. Héliot, 'Les déambulatoires dotés de niches rayonnantes', *Cahiers de Civilisation Médiévale Xᵉ–XIIᵉ Siècles*, IV, 1961, 303ff. M.-M. Gauthier, 'Premier campagne de fouilles dans le "sépulcre" de Saint-Martial de Limoges', *Cahiers archéologiques*, XII, 1962, 205ff.; E. Lambert, 'L'ancienne église abbatiale de Saint-Martin à Limoges', *L'art roman à Saint-Martial de Limoges*, Limoges, 1950, 27ff.

22 A. Heisenberg, *Die Apostelkirche in Konstantinopel*, Leipzig, 1908.

23 O. Demus, The Church of San Marco at Venice, *Dumbarton Oaks Studies*, VI, 1960.

24 A. Grabar, 'Saint-Front de Périgueux et le chevet-martyrium', *Miscellanea Guillaume de Jerphanion, Orientalia christiana Periodica*, XIII, 1947, 501ff.

25 R. Rey, *La cathédrale de Cahors et les origines de l'architecture à coupoles d'Aquitaine*, Paris, 1925; L. Bréhier, 'Les églises d'Aquitaine à coupoles et l'origine de

leur architecture', *Journal des Savants*, N.S., XXV, 1927, 241 ff.; P. Héliot, 'Les portails polylobés d'Aquitaine', *Bull. Mon.*, CIV, 1946, p. 83.
For Fontevrault, cf. Deshoulières, *Éléments datés de l'art roman en France*, Paris, 1936, p. 39; *Congrès archéol., 77ᵉ session*, 1911, p. 48; Conant, *op. cit.*, pp. 171–172.

26 S. Runciman, *The Medieval Manichee*, Cambridge University Press, 1947, p. 118.

27 S. Guyer, 'Der Dom von Pisa und das Rätsel seiner Entstehung', *Münchner Jb. d. bild. Kunst*, N.S., IX, 1932, 351 ff.

28 W. Horn, 'Romanesque Churches in Florence', *Art Bulletin*, XXV, 1943, 112 ff., esp. p. 130; P. Sanpaolese, 'Il restauro della struttura della cupola della Cattedrale di Pisa', *Bolletino d'Arte*, XLIV, 1959, 117 ff.; idem, 'La Facciata della Cattedrale di Pisa', *Rivista dell'Istituto Nazionale d'Archeologia e Storia dell'Arte*, N.S., V–VI, 1956–1957, 248 ff. The cathedral was restored after the fire of 1595 in 1601–1604 and again in the nineteenth century.

29 Conant, *op. cit.*, 104 ff.

30 J. Puig y Cadafalch, *Le premier art roman*, Paris, 1928; idem, *La géographie et les origines du premier art roman*, Paris, 1935. R. Salvini, *Wiligelmo e le origini della scultura romanica*, Milan, 1956, passim.

31 E. B. Garrison in *Studies*, II, 1955, p. 27.

32 Paris, Bibl. Nat., *Manuscrits à Peintures du VIIᵉ au XIIᵉ siècles*, 1954, p. 47.

33 M. Schapiro in *Art Bulletin*, XIII, 1931, p. 499.

34 J. Baltrušaitis, *Art sumérien, art roman*, Paris, 1934, p. 9, 'une contradiction frappante oppose la richesse chaotique de la matière figurée et la stabilité des formes où cette matière prend corps'. H. Focillon, *L'art des sculpteurs romans*, Paris, 1931; idem, in *Hist. Gen.*, VIII, p. 452; J. Baltrušaitis, *La Stylistique ornementale de la Sculpture romane*, Paris, 1931;

G. Lefrançois-Pillion, *Les sculpteurs français du XIIᵉ siècle*, Paris, 1931, pp. 24–25; for capitals, cf. the series from Notre-Dame-la-Daurade, now in the Musée des Augustins at Toulouse, M. Lafargue, *Les chapiteaux du cloître de Notre-Dame-la-Daurade*, Paris, 1940. The capitals were carved in a series of campaigns, the first between 1067 and 1080, the second between 1115 and 1125, the third between 1180 and 1196. R. Rey, *La sculpture romane languedocienne*, Toulouse, 1936, preferred a date up to 1100 for the first series (pp. 113–152) and a date up to 1130 for the second series (pp. 213–239).
For the underlining of the cushion shape of a capital at Canterbury and Reading, cf. G. Zarnecki, *English Romanesque Sculpture 1066–1140*, London, 1951, pp. 22–23.

35 There is considerable disagreement among art-historians over the date of the sculpture at Saint-Gilles. M. Schapiro, 'New Documents on St Gilles', *Art Bulletin*, XVII, 1935, p. 415; idem, 'Further Documents on St Gilles', *Art Bulletin*, XIX, 1936, 111 ff.; W. Horn, *Die Fassade von St-Gilles*, Hamburg, 1937 – I have not been able to consult this work; R. Hamann, *Die Abteikirche von St-Gilles und ihre künstlerische Nachfolge*, Berlin, 1955. Schapiro and Hamann argue for a date in the first half of the eleventh century, but Schapiro also remarks on a document in the archives of the department of the Gard which mentions a Petrus Brunus in Saint-Gilles in 1171; later in 1186 he is described as 'artist in wood and stone'. One of the sculptures on the portal of Saint-Gilles is signed 'Brunus' which would appear to confirm the date preferred by de Lasteyrie, Labande, Deschamps and Aubert. Cf. G. de Francovich, *Benedetto Antelami*, Milan, 1952, 45 ff., for a review of the differing opinions. De Francovich accepts a date in the second quarter of the twelfth century for the portal of Saint-Gilles. The signature 'Brunus' and the fact that the style of Saint-Gilles seems in part under heavy debt to work at Chartres about 1150 would seem in favour of the later date.

36 L. Jacob, *Le Royaume de Bourgogne sous les Empereurs Franconiens (1038–1125)*, Paris, 1906.

37 R.W. Southern, *The Making of the Middle Ages*, London, 1959, 81 ff.

38 H. Beenken, *Romanische Skulptur in Deutschland (11. und 12. Jahrhundert)*, Leipzig, 1924, pp. 32 ff.
D. Grivot and G. Zarnecki, *Gislebertus, sculptor of Autun*, London, 1961.

39 H. Weigert, H. Busch, B. Lohof, *Romanische Plastik in Europa*, Frankfurt am Main, 1961, pl. 9.

40 Beenken, *op. cit.*, 32 ff.

41 G. de Francovich in *Rivista*, VII, 1940, p. 264; W. Bader, *Die Benediktinerabtei Brauweiler bei Köln*, Berlin, 1937, pl. XXIIIa.

42 K. Meyer, 'The Eight Gregorian Modes on the Cluny Capitals', *Art Bulletin*, XXXIV, 1952, 75 ff.; M. Schapiro, 'From Mozarabic to Romanesque in Silos', *Art Bulletin*, XXI, 1939, p. 334.

43 Beenken, *op. cit.*, pp. 44 ff.; Swarzenski, *Monuments of Romanesque Art*, Nos. 227, 228.

44 Beenken, *op. cit.*, 38 ff.; Swarzenski, *Monuments of Romanesque Art*, p. 22, and on pp. 27–28, suggests that the Minden crucifix was the work of the school of Roger of Helmarshausen. For a brief survey of bronze and other metal candlesticks cast in England from the time of King Knut onwards, cf. C. Oman, *The Gloucester Candlestick*, London, 1958, p. 10.

45 O. von Falke and H. Frauberger, *Deutsche Schmelzarbeiten des Mittelalters*, Frankfurt am Main, 1904, pl. 9, 13 ff. The portable altar, dedicated to the Virgin, St Kilian and St Liborius, was given to the Cathedral at Paderborn by Bishop Heinrich von Werl (1085–1127). The drapery folds in a series of concentric triangles look forward to the Bury Bible and the Lambeth Bible. The Abdinghof portable altar at Paderborn (Falke, *op. cit.*, pl. 12–14), executed at Helmarshausen about 1118, also gives evidence of the 'damp-fold' drapery, and the system of concentric triangles. The figures are delineated with great liveliness and vigour but, for all the tricks to suggest corporeality, the forms are never freed from the flatness of the plane. Rich acanthus scrolls and fleshy stems look forward to Winchester work about the middle of the twelfth century. Abdinghof was the Benedictine abbey at Paderborn; Helmarshausen was the Benedictine abbey incorporated in the diocese of Paderborn by Bishop Meinwerk (1009–1036).

46 S. Collin-Gevaert, 'Histoire des arts du métal en Belgique', *Mémoires de l'Académie royale de Belgique*, 2e série, VII, 1951; *idem et al.*, *Art Roman dans la Vallée de la Meuse aux XIe et XIIe Siècles*, Brussels, 1962; H. Swarzenski, *Monuments of Romanesque Art, passim*.
It is probable that the influence of Byzantine style, which was to become general throughout Europe in the first half of the twelfth century, was transmitted in part by the schools of the Empire: Regensburg, Cologne, the Mosan schools (cf. for example carvings in ivory about 1100, Goldschmidt, *Elfenbeinskulpturen*, II, Nos. 160–162) and Salzburg. For Salzburg, cf. G. Swarzenski, *Die Salzburger Buchmalerei*, Leipzig, 1913; on connections between mosaics in San Marco, Venice, and the twelfth-century illumination at Salzburg, cf. O. Demus, 'Salzburg, Venedig und Aquileja', *Festschrift K.M. Swoboda*, Vienna, 1959, 75 ff.; P. von Baldass, W. Buchewiecki, and W. Mrazek, *Romanische Kunst in Österreich*, Vienna, 1962. Rupert of Deutz (b. *c.* 1060; d. 1129), who entered the Benedictine abbey of Saint-Laurent in Liège, went to Siegburg shortly after 1119, and later became Abbot of St Heribert at Deutz, a suburb of Cologne; a learned theologian, he probably sketched out the iconography and symbolism of the font of Rainier of Huy: a composition which embraces the Old Testament, the Gospels, the Acts of the Apostles and the Books of the Apocrypha. In his treatise

De Trinitate, finished in 1117, he alludes to the molten sea sustained by twelve oxen, in groups of three facing towards the four points of the compass: 'What can they mean, these twelve oxen on which rests the font, if not the twelve apostles to whom was directly entrusted the sacrament of Baptism sanctified by the death of Christ? The font is therefore placed on the twelve oxen to indicate that they carry it to all nations by preaching the Trinity to all parts of the world and by bearing witness to the one God in the Trinity' (Migne, *Patr. lat.*, clxvii, 1168). Quoted by J. Puraye, *Les Fonts Baptismaux de l'église Saint-Barthélemy de Liège*, Brussels, 1951, p. 20.

K. H. Usener, 'Rainier von Huy und seine künstlerische Nachfolge. Ein Beitrag zur Geschichte der Goldschmiedeplastik des Maastales im 12. Jahrhundert', *Marburger Jb. f. Kunstwissenschaft*, VII, 1933, 77 ff. When discussing Rainier's font Collin-Gevaert remarks in *Histoire des Arts du Métal en Belgique*, I, p. 140: 'Il faut, de toute nécessité, revenir au chef-d'œuvre classique, à la frise du Parthénon, pour trouver les points de comparaison le plus adéquats.' Contemporary monks called Liège 'the Athens of the North' and compared its school with the Academy of Plato (Swarzenski, *Monuments of Romanesque Art*, p. 31). H. Swarzenski, 'The Song of the Three Worthies', *Boston MFA Bulletin*, LVI, 1958, 30 ff., and *N.B.* 'Under the circumstances it seems desirable to speak of a Godefroi style in a collective sense, rather than to attribute to this famous goldsmith a specific work', p. 32. On Nicholas of Verdun, cf. Drexler, *Der Verduner Altar. Ein Emailwerk des XII. Jahrhunderts im Stifte Klosterneuburg bei Wien*, Vienna, 1903; H. Schnitzler, *Die Goldschmiedeplastik der Aachener Schreinswerkstatt*, Düren, 1934; idem, 'Die spätromanische Goldschmiedebildnerei des Aachener Schreins', *Westdeutsches Jahrbuch f. Kunstgeschichte*, IX, 1936, 88 ff.; idem, 'Nicholas von Verdun und der Albinusschrein', *Wallraf-Richartz-Jb.*, XI, 1939, 56 ff.; A. Weisgerber, *Studien zu Nikolaus von Verdun und der rheinischen Goldschmiedekunst des XII. Jahrhunderts*, Bonn, 1940; F. Müthe-rich, *Die Ornamentik der rheinischen Goldschmiedekunst in der Stauferzeit*, Würzburg, 1941; L. Réau, 'L'Ambon en émail de Nicolas de Verdun à Klosterneuburg', *Mon. Piot*, XXXIX, 1943, 103 ff. For the work executed for Suger, Abbot of Saint-Denis (1122–1151), by goldsmiths from Lorraine, cf. E. Panofsky, *Abbot Suger on the Abbey Church of Saint-Denis and its Art Treasures*, Princeton, 1946, pp. 58–59.

47 For Mosan illumination cf. M. Schott, *Zwei Lütticher Sakramentare in Bamberg und Paris und ihre Verwandten. Zur Geschichte der Lütticher Buchmalerei im XI. Jahrhundert*, Strasbourg, 1931; M. Laurent, 'Art rhénan, art mosan et art byzantin: la Bible de Stavelot', *Byzantion*, VI, 1931, pp. 88 ff. The Stavelot Bible (Brit. Mus., Add. Ms. 28106–28107) is signed by two monks Goderannus and Ernesto. Goderannus states that the two volumes were finished (*in omnia sua procuratione*) in the same year, the second volume finished indeed before the first and is dated 1097. The work occupied them for four years. The superb large Christ in Majesty in vol. II, fol. 136 recto, seems to depend on the Christ in Majesty in the Codex Aureus of Speyer or some closely related model. Swarzenski, *Monuments of Romanesque Art*, p. 29, remarks that Roger of Helmarshausen's drapery style is already evident in the miniatures painted by one of the three chief masters of the great Stavelot Bible of 1097. But cf. E. B. Garrison, 'Comment on the Schloss Pommersfelden Bible', *Studies in the Hist. of Med. Italian Painting*, III, 1958, pp. 179 ff. Garrison points out that some ten to twelve different hands need to be distinguished and implies that the illumination of the Christ in Majesty is later than 1097/98. The Christ is compared with 'an Italian figure as the St Luke in the St Cecilia Evangeliary, from which a date about 1112–1113 has been suggested'. The Schloss Pommersfelden *Creator Mundi* dates not before 1077, as suggested by Nordenfalk (*Romanesque Painting*, London, 1958, p. 190), but in the later first quarter of the twelfth century, perhaps even in the earlier second quarter.

S. Gevaert, 'Quelques miniatures mo-
sanes du XII^e siècle', *Revue belge d'archéo-
logie et d'histoire et de l'art*, III, 1933,
pp. 342 ff.; *idem*, 'Le modèle de la Bible
de Floreffe', *ibid.*, V, 1935, pp. 17 ff.;
idem, 'L'origine de la Bible d'Averbode',
ibid., V, 1935, pp. 213 ff.; *idem, Étude sur
les miniatures mosanes prégothiques, quatre
mss. mosans de la Bibl. Nat. à Paris*, Brus-
sels, Acad. R. des Sciences, des Lettres et
des Beaux-Arts de Belgique, Mém. V, ii,
1948; A. Boutemy's review of the latter
in *Scriptorium*, III, 1949, pp. 145 ff.

48 Paris, Bibl. Nat., *Manuscrits à Peintures du
VII^e au XII^e Siècles*, 1954, No. 239.

49 *Ibid.*, No. 246.

50 *Ibid.*, No. 221; L.W. Jones, 'The Library
of St Aubin at Angers in the Twelfth
Century', *Classical ... Studies in honor
of E.K. Rand*, New York, 1938, 143 ff.

51 E. Maillard, *L'Église de Saint-Savin-sur-
Gartempe*, Paris, 1926; C.-P. Duprat,
'Enquête sur la peinture murale en France
à l'époque romane', *Bull. Mon.*, CI–CII,
1942–1944, 165 ff.; *Bull. Mon.*, CII,
5 ff., 161 ff.; H. Focillon, *Peintures mu-
rales des églises de France*, Paris, 1938;
G. Gaillard, *Les fresques de Saint-Savin*, I,
La nef, Paris, 1944; *idem*, 'Études sur la
peinture murale romane', *Revue histo-
rique*, CCIX, 1953, 24 ff.; A. Grabar,
'L'étude des fresques romanes', *Cahiers
archéologiques*, II, 1947, 147 ff.; *idem*,
'Peintures murales, Notes critiques', *ibid.*,
VI, 1952, 182 ff.; *idem*, *Romanesque
Painting*, London, 1958; P.-H. Michel, *La
Fresque romane*, Paris, 1961, pp. 152–153.

52 De Francovich, 'I problemi della pittura
e della scultura preromanica', *Centro ita-
liano di studi sull'Alto Medioevo, Spoleto,
Settimane*, II, 1955, 400 ff.
Berzé-la-Ville (Saône-et-Loire): a chapel
of a small Cluniac priory half way be-
tween Cluny and Mâcon. According to
some scholars executed between 1103
and 1109 under the supervision of
St Hugh of Cluny. Garrison suggested a
date in the second quarter of the twelfth
century (*Studies*, III, 1958, p. 181); Grabar

suggested the middle of the twelfth cen-
tury under Byzantine influence via
Montecassino and Rome (*Romanesque
Painting*, p. 103 ff.); de Francovich pro-
posed a date between the end of the
eleventh and the beginning of the twelfth
century and compared the style with the
Cluniac lectionary which had already
been noted by F. Mercier, *Les Primitifs
français, La peinture clunysienne en Bour-
gogne à l'époque romane*, Paris, 1931,
pl. XCII ff.; Michel, *La Fresque romane*,
pp. 141–142.

53 J. Porcher, *Le Sacramentaire de Saint-
Étienne de Limoges*, Paris, 1953; Paris,
Bibl. Nat., *Manuscrits à Peintures du VII^e
au XII^e Siècles*, 1954, No. 326.

54 E. B. Garrison in *Studies*, II, 1955, p. 79;
IV, 1960–1961, p. 118; for Farfa, *ibid.*,
II, 1955–1956, pp. 122 ff.; for examples
of Ottonian influence on Umbro-Roman
painting of the late eleventh century (for
example, Vatican, pal. lat. 3/4/5, *c.* 1080–
1090), *ibid.*, II, 1956, 137 ff.

55 *Ibid.*, I, 1953, 56 ff.; III, 1957, 89 ff.

56 Toesca, *Storia*, 1927, p. 1058; Boeckler,
Abendländische Miniaturen, 1930, pp. 68,
70–71 (North Italian, probably Milanese,
second half of the eleventh or beginning
of the twelfth century); Garrison in
Studies, II, 1955–1956, p. 90 (Polirone,
first quarter to second quarter of the
twelfth century), III, 1958, 216 ff.
Garrison points out that two illustrators
divided the work between them; the
better of the two reveals close connections
with Rome but the general appearance
of the book, the marginal illustrations,
especially their backgrounds, and the de-
tails of architecture, cannot have been
based upon any Roman experience. For
some of the scenes, cf. also the Sacramen-
tary of Ivrea, executed for Warmondo,
Bishop of Ivrea, probably *c.* 1000–1002,
after Otto III had helped him in his
struggle with Arduino, Marquis of Ivrea.
Warmondo returned to his see after the
Emperor's entry into Italy in 1000.
L. Magnani, *Le Miniature del Sacramen-
tario d'Ivrea e di altri codici Warmoniani*,

Città del Vaticano, Bibl. Apost. Vaticana, 1934 (*Codices ex ecclesiasticis italiae bibliothecis delecti phototypice expressi* ... Bibl. Vat., vol. VI).
The S. Maria del Fiore Bible at Florence, probably 1130–1140, was executed by an artist under strong influence from scriptoria in the eastern and southern parts of France, Garrison in *Studies*, I, 1954, pp. 164–166; II, 1956, 228 ff.

57 Garrison in *Studies*, II, 1956, p. 179, fig. 193.

58 G. Mathiae, 'Gli Affreschi di Castel Sant'Elia', *Rivista dell'Instituto Nazionale d'Archeologia e Storia dell'Arte*, N.S., X, 1961, 181 ff. On Montecassino, cf. M. Avery, *The Exultet Rolls of South Italy*, Princeton, 1936; H. Bloch, 'Montecassino, Byzantium and the West in the earlier Middle Ages', *Dumbarton Oaks Papers*, III, 1946, 163 ff.; P. Baldass, 'Disegni della scuola cassinese del tempo di Desiderio', *Bolletino d'Arte*, XXXVII, 1952, 102 ff.; idem, 'Die Miniaturen zweier Exultet-Rollen (London, Add. Ms. 30337; Vatican Barb., lat. 592)', *Scriptorium*, VIII, 1954, 75 ff.; Garrison in *Studies*, II, 1955, p. 33. The British Museum Ms. and Paris, Mazarine, cod. 364, a Breviary, are closely related stylistically and are the highest expressions of the school. The initial ornament was influenced by the Regensburg school but besides the 'all-pervading Byzantinism' the native element is strong. On the influence of Montecassino, cf. de Francovich, 'I problemi della pittura e della scultura pre-romanica', *Centro italiano di studi sull'Alto Medioevo, Spoleto, Settimane*, II, 1955, 475 ff.
Cf. also E. Bertaux, *L'Art dans l'Italie méridionale*, Paris, 1903; M. Wackernagel, *Die Plastik des XI. und XII. Jahrhunderts in Apulia*, Leipzig, 1911; C. O. Sheppard, Jun., 'A Chronology of Romanesque Sculpture in Campania', *Art Bulletin*, XXXII, 1950, 319 ff.

59 T. Krautheimer-Hess, 'Die figurale Plastik der Ostlombardei von 1100 bis 1170', *Marburger Jb. für Kunstwissenschaft*, IV, 1928, and review by D. M. Robb in *Art Bulletin*, XII, 1930, 196 ff.; G. de Francovich, 'Wiligelmo da Modena e gli inizi della scultura romanica', *Rivista del R. Istituto d'Archeologia e Storia dell'Arte*, VII, 1940, 225 ff.; R. Salvini, *Wiligelmo e le origini della scultura romanica*, Milan, 1956.
R. Jullian, *L'éveil de la sculpture italienne. La sculpture romane dans l'Italie du Nord*, Paris, 1945.
For the dependence of the sculptor of the throne at Bari, executed for Bishop Elia (d. 1105), on Wiligelmo, cf. de Francovich in *Rivista*, VII, 1940, 252 ff.

60 On Niccolò, cf. D. M. Robb in *Art Bulletin*, XII, 1930, 374 ff.; T. Krautheimer-Hess, 'The Original Porta dei Mesi at Ferrara and the Art of Niccolò', *Art Bulletin*, XXVI, 1944, 152 ff.

61 F. Wormald, 'The Development of English Illumination in the Twelfth Century', *Journ. Brit. Arch. Assoc.*, VIII, 1942–1943, 31 ff.; C. R. Dodwell, *The Canterbury School of Illumination*, Cambridge University Press, 1954.

62 C. Oursel, *La Miniature du XIIe Siècle à l'abbaye de Cîteaux*, Dijon, 1926; idem, *Miniatures cisterciennes (1109–1134)*, Mâcon, 1960; Paris, Bibl. Nat., *Manuscrits à Peintures du VIIe au XIIe Siècles*, 1954, Nos. 281, 282; J. Porcher, *L'Enluminure française*, Paris, 1959, pp. 15 ff.

63 Paris, Bibl. Nat., *Manuscrits à Peintures*, No. 173; C. R. Dodwell, *The Great Lambeth Bible*, London, 1959, 17 ff.

64 F. Wormald, O. Pächt, C. R. Dodwell, *The St Albans Psalter*, London, 1960; for Pierpont Morgan Lib. Ms. 736, cf. B. da Costa Greene and M. P. Harrsen, *Exhibition of Illuminated Mss. held at the New York Public Library*, New York, 1933, p. 17, pl. 29; E. G. Millar, *English Illuminated Mss. from the Tenth to the Thirteenth Centuries*, Paris, 1926, 29 ff.; T. S. R. Boase, *English Art 1100–1216*, Oxford, 1953, 113 ff.; M. Rickett, *Painting in Britain: the Middle Ages*, London, 1954, 80 ff. Cf. also H. Swarzenski in *Kunstchronik*, XVI, 1963, 77 ff.

65 Boase, *op. cit.*, 110ff.

66 W. Oakeshott, *The Artists of the Winchester Bible*, London, 1945. Boase, *op. cit.*, 174ff. Winchester foliate ornament was also probably evoked under Mosan influence, cf. the Genesis monogram in the Bible of St Hubert, dating about 1070 (Brussels, Bibl. Roy., Ms. II, 1639, fol. 6 verso). H. Bober, 'In Principio. Creation before Time', *Essays in honor of Erwin Panofsky*, New York University Press, 1961, 13ff.

67 C. Oman, *The Gloucester Candlestick*, London, 1958.

68 M. Chamot, *Medieval English Enamels*, London, 1930.

69 J. Beckwith, 'An Ivory Relief of the Deposition', *Burlington Magazine*, XCVIII, 1956, pp. 228ff.

70 F. Saxl, *English Sculptures of the Twelfth Century*, London, 1954; G. Zarnecki, 'The Chichester Reliefs', *Archaeological Journal*, CX, 1953 (1954), pp. 106ff. Ralph de Luffa, Bishop of Chichester (d. 1123), was probably a German; one of the chapels of Chichester Cathedral was consecrated by Bishop Ralph to St Pantaleon. Fragments from the Church of St Pantaleon at Cologne show resemblance to the Chichester reliefs.

71 G. Zarnecki, *English Romanesque Sculpture 1066–1140*, London, 1951, p. 17.

72 *Ibid.*, pp. 21–22.

73 G. Zarnecki, *Later English Romanesque Sculpture 1140–1210*, London, 1953, pp. 20ff.

74 E. Maclagan, 'A Romanesque Relief in York Minster', *Proc. Brit. Acad.*, X, 1921–1923, pp. 481ff.; Zarnecki, *Later English Romanesque Sculpture*, 29ff. M. Aubert, *La Sculpture française au Moyen Age*, Paris, 1946, p. 60.

75 P. Deschamps, *French Romanesque Sculpture*, Florence, 1930, p. 13, pl. 13–16.

76 R. Rey, *La sculpture romane languedocienne*, Toulouse, 1936; P. Deschamps, 'Étude sur les sculptures de Sainte-Foy-de-Conques et de Saint-Sernin-de-Toulouse', *Bull. Mon.*, C, 1941, pp. 239ff.

77 R. Rey, *La sculpture romane languedocienne*, stresses the importance of Gallo-Roman sarcophagi as models for the sculpture at Saint-Sernin; M. Durand-Lefebvre, *Art gallo-romain et sculpture romane*, Paris, 1937; F. Gerke, 'Der Tischaltar des Bernard Gilduin in Saint-Sernin in Toulouse', *Akad. d. Wiss. u. d. Lit., Abhandlungen*, VIII, 1958, decides, p. 506, that early Christian sarcophagi were the chief models for the Toulousan sculpture of the late eleventh century. But cf. p. 504: 'Die Entwicklung in Toulouse selbst zeigt, wie rasch sie sich zur Eigenständigkeit erhob, so dass bereits in der zweiten Stilphase die altchristlichen Grundlagen nicht mehr dominieren.' Cf. also, J. Evans, *Art in Medieval France*, Oxford University Press, 1948, p. 32, 'there is an obvious relation between bas-reliefs from Saint-Sernin-de-Toulouse, with women holding a ram and a lion, and certain Gallo-Roman stelae', and refers to Espérandieu, *Recueil des bas-reliefs de la Gaule romaine*, IV, 2769 and 2793.

78 E. Mâle, *L'Art religieux du XIIᵉ siècle en France*, Paris, 1928, pp. 5, 17; Paris, Bibliothèque Nationale, *Manuscrits à Peintures*, No. 304.

79 Paris, Bibl. Nat., *Manuscrits à Peintures*, No. 316.

80 J. Beckwith, 'The Influence of Islamic Art on Western Medieval Art', *Middle East Forum*, XXXVI, 1960, pp. 25–26.

81 Goldschmidt, *Elfenbeinskulpturen*, IV, Nos. 81–84, 94, 98, 111.

82 C. R. Morey, 'Sources of Medieval Style', *Art Bulletin*, VII, 1929, p. 49.

83 O. Pächt, 'A Cycle of English Frescoes in Spain', *Burlington Magazine*, CIII, 1961, 166ff.

On Catalan painting, cf. J. Gudiol i Cunill, *La pintura mig-eval Catalonia*, Barcelona, 1927; W.S. Cook, 'The Earliest Painted Panels of Catalonia', *Art Bulletin*, V, p. 85; VI, 31 ff.; VIII, p. 57, 195 ff.; X, pp. 153, 305 ff.; idem, 'Romanesque Spanish Mural Painting', *Art Bulletin*, XI, 327 ff.; XII, 21 ff.; J. Pijoan, *Las pinturas murales románicas de Cataluña*, Monumenta Cataloniae, 1948.

84 M. Schapiro, 'The Romanesque Sculpture of Moissac', *Art Bulletin*, XIII, 1931, 249 ff., 464 ff. Most art-historians detect Burgundian influence in the tympanum of Moissac. M. Lafargue, *Les chapiteaux du cloître de Notre-Dame-la-Daurade*, Paris, 1940, points out that the first series of capitals in the cloister were executed by the first generation of sculptors working at Saint-Sernin and Moissac; the capitals are earlier than the work at Moissac and date probably between 1067 and 1080; the second series date 1115-1125. On the sculpture at Conques, cf. C. Bernoulli, *Die Skulpturen der Abtei Conques-en-Rouerge*, Basle, 1956. For dates at Moissac, cf. V. Mortet, *Recueil des textes relatifs à l'histoire de l'architecture en France au moyen âge*: XIe-XIIe Siècles, Paris, 1911, pp. 146-148; E. Rupin, *L'Abbaye et les cloîtres de Moissac*, Paris, 1897, p. 66, Note 2.
A. Jeanroy, *La poésie lyrique des troubadours*, Paris, 1934; R. Lejeune, 'Rôle littéraire de la famille d'Aliénor d'Aquitaine', *Cahiers de Civilisation Médiévale*, I, 1958, 319 ff.

85 M. Schapiro, 'The Sculptures of Souillac', *Medieval Studies in memoriam A. K. Porter*, II, 380 ff.; P. Mesplé, *Toulouse, Musée des Augustins; les sculptures romanes, Inventaire des collections publiques françaises*, V, Paris, 1961, Nos. 5 and 22.

86 A. K. Porter, 'Spain or Toulouse, and other questions', *Art Bulletin*, VII, 1924, 1 ff.; idem, 'Leonesque Romanesque and Southern France', *Art Bulletin*, VIII, 1925, 235 ff.; idem, *Spanish Romanesque Sculpture*, Paris, 1928, and a review by G. Gaillard in *Bull. Mon.*, LXXXIX, 1930, 189 ff.; G. Gaillard, *Les débuts*

de la sculpture romane espagnole, Paris, 1938; idem, *La sculpture romane espagnole*, Paris, 1946; idem, 'De la diversité des styles dans la sculpture romane des pèlerinages', *La revue des arts*, II, 1951, pp. 81 ff. The chronology of the earliest Spanish Romanesque sculpture would appear to be as follows: Sarcophagus of Doña Sancha (d. 1096-1097), at Jaca, about 1100, or early twelfth century; tympanum in the cloister of San Piedro el Viejo, early twelfth century to the third decade of the century; tympana on the north and south doors of San Piedro el Viejo, third decade of the twelfth century; the sculpture in the Cathedral of Jaca, 1100-1110. Jaca was the first stage on the pilgrimage route on the Spanish side of the Pyrenees; the cathedral was founded in 1063 but construction was slow and interrupted; the sculpture dates after the Panteón de los Reyes at León, which was finished in 1065, and is probably contemporary with the main church of San Isidoro. The transept and the first bays of the nave of San Isidoro were constructed by Doña Urraca before 1101; the remaining bays of the nave were consecrated in 1147. Gaillard believes that the sculpture of Jaca antedates that of León; the figurated capitals of the nave and the apse are related to the school of Jaca; there would seem to be a close connection between the style of the transept portal and that of the Miègeville door at Saint-Sernin, Toulouse.
On the *Puerta de los Platerías* at Santiago, cf. Gaillard, 'Notes sur la date des sculptures de Compostelle et de León', *Gazette des Beaux-Arts*, 6e période, I, 1929, pp. 341 ff. De Francovich in *Rivista*, VII, 1940, 225 ff., esp. p. 233, accepts Gaillard's dating. The beginning of the cathedral in 1078 is established by the *Historia Compostellana* and *Codex Calixtinus*, Book V. According to Gaillard the inscription on a jamb of the *Puerta de los Platerías* should read 11 July 1078, although if '*Anfus Rex*' refers not to Alfonso VI, who died in 1109, but to Alfonso VII, who became king in Galicia in 1126, a later date might have to be considered. Further documentary evidence, however, shows that preparations were

under way by the year 1077 or even 1075; first phase, 1078–1088; second phase, 1100–1124; in 1105 the chapels were dedicated. Upon the completion of the ensemble of the transept in 1117 the nave of the older church was demolished and the new nave was completed by 1122 or 1124. Since the consecration of 1105 did not include the north chapel of the transept Gaillard assumes that the southern portal, the *Puerta de los Platerías*, is the oldest, dating between 1105 and 1112. The greater part of the sculpture of this portal he considers to date before 1112 and he ascribes the anomalies in its arrangement to the reconstruction after the fire of 1117. Relationship with the school of Auvergne becomes evident in certain capitals of the chevet, in details of the ambulatory, the radiating chapels and the nave, and in the square plan of the chapel of San Salvador. The argument is supported further by the evidence of the medallions on the exterior of the chapel of San Pedro, and of a small lintel over a door between the chapels of San Juan and Santa Fé, which has the triangular form characteristic of Auvergne. K.J. Conant, *The Early Architectural History of the Cathedral of Santiago de Compostella*, Harvard University Press, 1926, dated the *Puerta de los Platerías* about 1103.

A. Garcia y Bellido, *Esculturas romanas de España y Portugal*, 2 vols., Madrid, 1949. For Santo Domingo de Silos, cf. M. Whitehill, 'The Destroyed Romanesque Church of S. Domingo de Silos', *Art Bulletin*, XIV, 1932, 316ff.; Gaillard, 'L'église et le cloître de Silos: dates de la construction et de la décoration', *Bull. Mon.*, XCI, 1932, 39ff.; M. Schapiro, 'From Mozarabic to Silos', *Art Bulletin*, XXI, 1939, 313ff.; C. Hohler, 'The Badge of St James', p. 56, gives

plausible iconographic arguments for a date not earlier than 1130.

87 C. Oursel, *L'art roman en Bourgogne*, Dijon-Boston, 1928; D. Grivot and G. Zarnecki, *Gislebertus, sculptor of Autun*, London, 1960. The building was begun by Bishop Étienne de Bâgé (1112–1136); the land had been given by Hugues, Duke of Burgundy (1102–1142). Pope Innocent II consecrated the church on 28 December 1130. Gislebertus served his apprenticeship at Cluny, worked probably at Vézelay between 1120 and 1125, and at Autun between 1125 and 1135. The north door of Autun was probably finished before 1130 and certainly before 1132 but in 1146 the church was still not finished.

88 F. Salet, 'La Madeleine de Vézelay et ses dates de construction', *Bull. Mon.*, XCV, 1936, 5ff.; *idem*, 'La Madeleine de Vézelay: notes sur la façade de la nef', *Bull. Mon.*, XCIX, 1940, 223ff. Work began after the great fire of 21 July 1120; the great doorway was executed about 1125–1130; the nave was completed about 1140. A. Katzenellenbogen, 'The Central Tympanum at Vézelay, its encyclopaedic meaning and its relation to the First Crusade', *Art Bulletin*, XXVI, 1944, 141ff. For an abbreviated version of this scene illustrating the Mass of the Pentecost, cf. the Sacramentary of Saint-Etienne de Limoges (Paris, Bibl. Nat., lat. 9438, fol. 87), J. Porcher, *Le Sacramentaire de Saint-Etienne de Limoges*, Paris, 1953, pl. XII; the Sacramentary dates about 1100.

On the Tower of Babel as the antitype to the Descent of the Holy Ghost Katzenellenbogen refers to Honorius Augustadunensis, *Speculum Ecclesiae, In Pentecosten* (Patrologia latina, 172, col. 964).

List of Illustrations

253

25 Ivory bookcovers; Dagulf's Psalter show-
ing David choosing poets of the Psalms;
David playing the harp; Boniface open-
ing the letter from Pope Damasus before
St Jerome who is asked to correct and
edit the Psalms; St Jerome dictating the
Psalter. Palace School, Aachen. Before 795.
$6^5/_8 \times 3^3/_{16}$ (16.8 × 8.1). Photo: Louvre,
Paris.

26 Ivory bookcover; Christ treading the
Beasts and scenes from the Life of Christ.
Palace School, Aachen. Late eighth or
early ninth century. (Douce M. 176.)
$8^5/_{16} \times 4^7/_8$ (21.1 × 12.5). Photo: Bodleian
Library, Oxford.

27 Ivory diptych; King David and Pope
Gregory the Great. Probably Alpine
monastic school. About 900. Monza Ca-
thedral Treasury. H. $6^8/_{16}$ (16.5). Photo:
R.-G. Zentralmuseum. Nachlass R. Del-
breuck.

28 Ivory bookcover; Christ treading the
Beasts between Angels; below, the Magi
before Herod. Lorsch Gospels. $15 \times 10^1/_2$
(38.5 × 27). Photo: Biblioteca Apostolica
Vaticana.

29 Ivory bookcover; The Virgin and Child
enthroned between Zacharias and St John
the Baptist; below, the Nativity and the
Annunciation to the Shepherds. Lorsch
Gospels. Palace School, Aachen. Early
ninth century. $15 \times 10^1/_2$ (38.5 × 27).
Photo: Victoria and Albert Museum,
Crown Copyright.

30 Manuscript; St Matthew. Coronation
Gospels of the Holy Roman Empire.
Palace School, Aachen. Before 800
(fol. 15). Photo: Kunsthistorisches Mu-
seum, Vienna.

31 Manuscript; St Mark. Gospel book. Pa-
lace School, Aachen. Early ninth century.
(Harley Ms. 2788, fol. 71 v.) $14^5/_8 \times 10$
(37.2 × 25.5). Photo: Courtesy Trustees of
the British Museum.

32 Manuscript; St Matthew. Gospel book of
Archbishop Ebbo of Reims. Hautvillers,
near Reims. Before 823. Bibliothèque de

la Ville, Epernay. (Ms. 1, fol. 18 v.)
$10^3/_{16} \times 7^{13}/_{16}$ (25.9 × 19.9). Photo: Bi-
bliothèque Nationale, Paris.

33 Manuscript; The Four Evangelists. Gospel
book. Palace School, Aachen. Early ninth
century. Photo: Cathedral Treasury,
Aachen.

34 Manuscript; Psalm 88. Utrecht Psalter.
Reims, about 820. (Ms. 32, fol. 51 v.)
$12^7/_8 \times 9^7/_8$ (32.7 × 25.1). Photo: Uni-
versity Library, Utrecht.

35 Manuscript; Psalm 111. Utrecht Psalter.
Reims, about 820. (Ms. 32, fol. 65 v.)
$12^7/_8 \times 9^7/_8$ (32.7 × 25.1). Photo: Uni-
versity Library, Utrecht.

36 Manuscript; Psalm 50. Utrecht Psalter.
Reims, about 820. (Ms. 32, fol. 29 r.)
$12^7/_8 \times 9^7/_8$ (32.7 × 25.1). Photo: Uni-
versity Library, Utrecht.

37 Ivory bookcover; Psalm 50. Reims,
about 860–870. (Lat. 1152.) $4^3/_8 \times 3^7/_{16}$
(11.2 × 8.8). Photo: Bibliothèque Natio-
nale, Paris.

38 Ivory panel; Crucifixion and the Holy
Women at the Sepulchre. Set in the cover
of a Book of Pericopes executed for King
Henry II before 1014. Reims, about 870.
(Cod. Lat. 4452.) 11×5 (28 × 12.8).
Photo: Staatsbibliothek, Munich.

39 Manuscript; Psalm 26. Utrecht Psalter.
Reims, about 820. (Ms. 32, fol. 15 r.)
$12^7/_8 \times 9^7/_8$ (32.7 × 25). Photo: University
Library, Utrecht.

40 Ivory cover; Psalm 26 and Psalm 24.
Prayer book of Charles the Bald. Reims,
about 870. $4^3/_8 \times 3^7/_{16}$ (11.2 × 8.8). Photo:
Schweizerisches Landesmuseum, Zürich.

41 Gold cover set with pearls and precious
stones; Christ on the Cross. Codex Au-
reus of Lindau. Reims (?), about 870.
(Ms. 1.) $13^3/_4 \times 10^1/_2$ (36 × 26.7). Photo:
Pierpont Morgan Library, New York.

42 Arnulf's portable altar. Gold mounted
with enamels and precious stones.

Reims (?), about 870. Photo: Residenz-Schatzkammer, Munich.

43 Gold cover set with pearls and precious stones. Christ in Majesty, the Four Evangelists and scenes from the Life of Christ. Codex Aureus of St Emmeram. Reims or Saint-Denis, about 870. (Cod. 14000.) Staatsbibliothek, Munich. Photo: Max Hirmer.

44 Manuscript; The Ascension and Pentecost. Bible of San Callisto. Reims (?), about 870 (fol. 292 v.). Photo: San Paolo fuori le Mura, Rome.

45 Manuscript; Moses receiving the Tables of the Law and Moses expounding the Law to the Israelites. The Moutier-Grandval Bible. Tours, 834–843. (Add. Ms. 10546, fol. 25 v.) 20 × 14 (51 × 35.7). Photo: Courtesy, Trustees of the British Museum.

46 Manuscript; Genesis scenes. The Moutier-Grandval Bible. Tours, 834–843. (Add. Ms. 10546, fol. 5 v.) 20 × 14 (51 × 35.7). Photo: Courtesy Trustees of the British Museum.

47 Manuscript; King David playing the harp before musicians, imperial guards and the personifications of the imperial virtues, Prudence, Justice, Fortitude and Temperance. Count Vivian's Bible or the First Bible of Charles the Bald. Tours, 843–851. (Lat. 1, fol. 215 v.) 19³/₈ × 14⁵/₈ 49.5 × 37.5). Photo: Bibliothèque Nationale, Paris.

48 Manuscript; The Emperor Lothair I (840–855). Gospels of Lothair. Tours, 849–851. (Lat. 266, fol. 1 v.) 12⁵/₈ × 9³/₄ (32.1 × 24.8). Photo: Bibliothèque Nationale, Paris.

49 Manuscript; The monks of the Abbey of St Martin at Tours, headed by their lay Abbot, Count Vivian, presenting the Bible to King Charles the Bald. Count Vivian's Bible. Tours, 843–851. (Lat. 1, fol. 423 v.) 19³/₈ × 14⁵/₈ (49.5 × 37.5). Photo: Bibliothèque Nationale, Paris.

50 Manuscript; Genesis scenes. The Bamberg Bible. Tours, second quarter of the

ninth century. (A. 1. 5, fol. 7 v.) Photo: Staatsbibliothek, Bamberg.

51 Manuscript; Abbot Raganaldus of Marmoutier blessing the people. Marmoutier Sacramentary. Tours, mid-ninth century. (Ms. 19 bis, fol. 173 v.) Photo: Bibliothèque de la Ville, Autun.

52 Manuscript; The Nativity, the Baptism of Christ and the Last Supper. Marmoutier Sacramentary. Tours, mid-ninth century. (Ms. 19 bis, fol. 8.) Photo: Bibliothèque de la Ville, Autun.

53 Manuscript; The Ascension. Sacramentary of Archbishop Drogo of Metz (826–855). Metz, about 842. (Lat. 9428, fol. 71 v.) 10¹/₂ × 8¹/₄ (26.7 × 21). Photo: Bibliothèque Nationale, Paris.

54 Manuscript; Te igitur. Canon of the Mass from Archbishop Drogo's Sacramentary. Metz, about 842. (Lat. 9429, fol. 15 v.) 10¹/₂ × 8¹/₄ (26.7 × 21). Photo: Bibliothèque Nationale, Paris.

55 Ivory book cover; The Annunciation, the Adoration of the Magi and the Massacre of the Innocents. Metz, mid-ninth century. (Lat. 9393.) 10 × 6¹/₂ (25.5 × 16.5). Photo: Bibliothèque Nationale, Paris.

56 Manuscript; Christ on the Cross, Coronation Sacramentary of Charles the Bald. Court School of Charles the Bald (Metz, Saint-Denis or Compiègne?), second half of the ninth century. (Lat. 1141, fol. 6 v.) 10⁹/₁₆ × 7¹³/₁₆ (26.9 × 19.9). Photo: Bibliothèque Nationale, Paris.

57 Ivory bookcover; The Crucifixion. Studded with gold and originally on a Gospel in the Cathedral Treasury of Verdun. Metz, late ninth or early tenth century. 8¹/₄ × 4³/₄ (21 × 12). Photo: Victoria and Albert Museum, Crown copyright.

58 Ivory bookcover; Adoration of the Magi and the Presentation to the Temple. Metz, late ninth or early tenth century. Formerly at Sens. 7¹/₄ × 4¹/₂ (18.5 × 11.5). Photo: Victoria and Albert Museum, Crown copyright.

59 Rockcrystal; The story of Suzanna. Carved for Lothair II (855–862), King of Lotharingia and formerly in the Abbey of Waulsort on the Meuse. Metz, 855–862. Diameter: $4^1/_2$ (11.5). Photo: Courtesy Trustees of the British Museum.

60 Manuscript; Charlemagne between Pope Gelasius and Pope Gregory the Great (?). Coronation Sacramentary of Charles the Bald. (Lat. 1141, fol. 2v.) $10^9/_{16} \times 7^{13}/_{16}$ (26.9 × 19.9). Photo: Bibliothèque Nationale, Paris.

61 Manuscript; The Adoration of the Lamb. Codex Aureus of St Emmeram of Regensburg. Court School of Charles the Bald (Saint-Denis?), about 870. (Cod. 14000, fol. 6r.) Photo: Staatsbibliothek, Munich.

62 Manuscript; Initial B. Second Bible of Charles the Bald bequeathed by him to the Abbey of Saint-Denis. Saint-Amand, 871–877. (Lat. 2, fol. 234.) $19^7/_8 \times 13^1/_8$ (43 × 33.5). Photo: Bibliothèque Nationale, Paris.

63 Manuscript; Initial Q Folchard's Psalter. St Gall, before 872. (Cod. 23, p. 135.) $15 \times 11^3/_8$ (38.2 × 29). Photo: Stiftsbibliothek, St. Gallen.

64 Manuscript; King David playing the harp before musicians and dancers. Abbot Salomon's Psalterium Aureum. St Gall, 890–920. (Cod. 22, p. 2.) Photo: Stiftsbibliothek, St. Gallen.

65 Ivory bookcover; Christ in Majesty between Seraphim and the Four Evangelists. Executed by Tuotilo at St Gall, about 900. (Cod. 53). $13 \times 6^1/_8$ (32 × 15.5). Photo: Stiftsbibliothek, St. Gallen.

66 Ivory bookcover; The Assumption of the Virgin, scene from the Legend of St Gall. Executed by Tuotilo at St Gall, about 900. (Cod. 53.) $13 \times 6^1/_8$ (32 × 15.5). Photo: Stiftsbibliothek, St. Gallen.

67 Ivory bookcover; probably carved by Tuotilo at St Gall, about 900. (Cod. 60.) $10^1/_2 \times 4$ (26.5 × 10.2). Photo: Stiftsbibliothek, St. Gallen.

68 Church of St Cyriakus, Gernrode; exterior view. Founded 961. Photo: Bildarchiv Foto Marburg.

69 Church of St Cyriakus, Gernrode; interior view. Founded 961. Photo: Bildarchiv Foto Marburg.

70 Plan; Church of St Cyriakus, Gernrode.

71 Fresco; Christ heals the Woman with an issue of blood. Church of St George, Reichenau-Oberzell. Second half of tenth century? Photo: Thames and Hudson Archive.

72 Manuscript; Faith offers the Crown of Victory to the Martyrs, below, Modesty in combat with Lust. Psychomachia of Prudentius. St Gall, Reichenau or Constance, late ninth century. Stadtbibliothek, Bern. (Cod. 264, p. 70.) $10^7/_8 \times 8^1/_4$ (27.5 × 2). Photo: Thames and Hudson Archive.

73 Fresco; Jeremiah. Church of San Vincenzo, Galliano. About 1007. Photo: Thames and Hudson Archive.

74 Fresco; An Apostle. Chapel of St Sylvester, Goldbach. Late tenth century. Photo: Thames and Hudson Archive.

75 Fresco; An Archangel. Church of San Vincenzo, Galliano. About 1007. Photo: Thames and Hudson Archive.

76 Manuscript; St Matthew. Codex Wittikindeus. Fulda. Late tenth century. (Lat. 1, fol. 14v.) Deutsche Staatsbibliothek, Berlin. $11^3/_4 \times 9^1/_4$ (30 × 23.5). Photo: John Freeman.

77 Manuscript; Christ in Majesty. The Lorsch Gospels. Aachen. Early ninth century. Bathyaneum, Alba Julia, Rumania. $14^7/_{16} \times 10^1/_2$ (36.7 × 26.8). Photo: Biblioteca Centrala de Stat a RPR, Bucharest.

78 Manuscript; Christ in Majesty. Book of Pericopes belonging to Archbishop Gero of Cologne (969–976). Reichenau (?). Landesbibliothek, Darmstadt. (Hs. 1948, fol. 5v.) $11^{11}/_{16} \times 8^{11}/_{16}$ (29.7 × 22). Photo: Bildarchiv Foto Marburg.

256

79 Manuscript; Initial *V*. Gero Codex. Reichenau (?), about 969. Landesbibliothek, Darmstadt. (Hs. 1948, fol. 117v.) 11 $^{11}/_{16}$ × 8 $^{11}/_{16}$ (29.7 × 22). Photo: Bildarchiv Foto Marburg.

80 Manuscript; Egbert, Archbishop of Trier (977–993). Egbert's Psalter given by Ruodprecht to the Archbishop of Trier about 983. Reichenau or Trier. (Cod. sanct. 6; Cod. Gertrudianus, fol. 17.) 8 $^{1}/_{4}$ × 10 $^{5}/_{8}$ (19.8 × 27.1). Photo: Museo Archeologico Nazionale, Cividale.

81 Manuscript; The Annunciation. *Codex Egberti*. Executed by the Master of the *Registrum Gregorii*. Reichenau or Trier, about 985. (Fol. 9r.) Stadtbibliothek, Trier. 8 $^{1}/_{4}$ × 10 $^{5}/_{8}$ (21 × 22). Photo: Bildarchiv Foto Marburg.

82 Manuscript; Egbert, Archbishop of Trier (977–993), presented with the *Codex Egberti* by two monks of Reichenau, Keraldus and Heribertus. Reichenau or Trier, about 985. Stadtbibliothek, Trier. (Fol. 2v.) 9 $^{3}/_{8}$ × 7 $^{7}/_{16}$ (23.8 × 18.8). Photo: Bildarchiv Foto Marburg.

83 Manuscript; Pope Gregory the Great. Executed by the Master of the *Registrum Gregorii* from a copy of the *Registrum Gregorii* presented by Archbishop Egbert to the Cathedral of Trier. About 983. Stadtbibliothek, Trier. Photo: Bildarchiv Foto Marburg.

84 Manuscript; Otto II or Otto III enthroned receiving the homage of the four parts of the Empire: Germania, Alemannia, Francia, and Italia. By the Master of the *Registrum Gregorii* from a copy presented by Archbishop Egbert to the Cathedral of Trier. About 983. Musée Condé, Chantilly. 10 $^{5}/_{8}$ × 7 $^{7}/_{8}$ (27 × 20). Photo: Thames and Hudson Archive.

85 Manuscript; Otto III enthroned receiving the homage of the four parts of the Empire: Slavinia, Germania, Gallia and Roma. Gospel book of Otto III. Reichenau or Court School of Otto III, 997–1000. Staatsbibliothek, Munich. (Clm. 4453, fol. 23v., 24r.) 13 × 9 $^{3}/_{8}$ (33 × 23.8). Photo: Max Hirmer.

86 Ivory panel; The Death of the Virgin. Executed at Constantinople in the late tenth century. Set into the cover of the Gospel book of Otto III together with classical intaglii, Byzantine bloodstones, pearls and precious stones in filigree on a gold ground. Staatsbibliothek, Munich. Photo: Max Hirmer.

87 Manuscript; Otto III Christomimetes. Gospel book presented to the Emperor by Liuthar. Reichenau or Court School of Otto III, about 1000. (Fol. 16r.) Photo: Cathedral Treasury, Aachen.

88 Manuscript; Christ's Entry into Jerusalem. Gospel book of Otto III. Reichenau or Court School of Otto III, 997–1000. (Clm. 4453, fol. 234v.) Staatsbibliothek, Munich. 13 × 9 $^{3}/_{8}$ (33 × 23.8). Photo: Max Hirmer.

89 Cover of the Book of Pericopes. Carolingian ivory panel framed by Byzantine and western enamels, pearls and precious stones on a gold ground. Executed for King Henry II and given by him to the Cathedral of Bamberg probably for the consecration in 1012. Staatsbibliothek, Munich. (Clm. 4452.) 13 × 9 $^{3}/_{8}$ (33 × 23.8). Photo: Max Hirmer.

90 Manuscript; The Adoration of the Magi. Gospel book of Otto III. Reichenau or Court School of Otto III, 997–1000. (Clm. 4453, fol. 29r.) 13 × 9 $^{3}/_{8}$ (33 × 23.8). Photo: Staatsbibliothek, Munich.

91 Manuscript; St Matthew. Gospel book of Otto III. Reichenau or Court School of Otto III, 997–1000. (Clm. 4453, fol. 25v.) Photo: Staatsbibliothek, Munich.

92 Manuscript; The Crucifixion. Henry II's Sacramentary. Regensburg, 1002–1014. (Clm. 4456, fol. 15r.) 9 $^{1}/_{2}$ × 11 $^{3}/_{4}$ (24 × 29.7). Photo: Staatsbibliothek, Munich.

93 Manuscript; The Holy Women at the Sepulchre confronted by the Angel of the Resurrection. Henry II's Book of Pericopes. Reichenau or Court School of Henry II, 1002–1014. (Clm. 4452, fol.

116v., 117r.). $10^3/_8 \times 7^1/_2$ (26.4 × 19). Photo: Max Hirmer.

94 Manuscript; Christ crowning King Henry II and Queen Kunigunde between St Peter and St Paul, the patrons of Bamberg, before the personifications of the Empire. Henry II's Book of Pericopes. (Clm. 4452, fol. 2). $10^3/_8 \times 7^1/_2$ (26.4 × 19). Photo: Staatsbibliothek, Munich.

95 Manuscript; Christ crowning King Henry II, attended by angels and supported by the Church. Henry II's Sacramentary. Regensburg, 1002–1014. (Clm. 4456, fol. 11r.) $9^1/_2 \times 11^3/_4$ (24 × 29.7). Photo: Staatsbibliothek, Munich.

96 Manuscript; Christ in the house of Martha. Henry II's Book of Pericopes. Reichenau or Court School of Henry II, 1002–1014. (Clm. 4452, fol. 162r.) $10^3/_8 \times 7^1/_2$ (26.4 × 19). Photo: Staatsbibliothek, Munich.

97 Manuscripts; Christ on the Cross between personifications of Life and Death, and, St Erhard celebrating Mass before the *ornamenta palatii* of the Carolingian house. Gospel book of Abbess Uota of Niedermünster. Regensburg, 1002–1025. Staatsbibliothek, Munich. (Clm. 13601, fol. 3v. and fol. 4r.) $15 \times 10^5/_8$ (38 × 27). Photo: Max Hirmer.

98 Manuscript; Abbess Hitda offers the codex to St Walburgis. Hitda Gospel book. Ordered by Abbess Hitda of Meschede at Cologne (978–1042). (Hs. 1640, fol. 6.) $13^3/_8 \times 8^5/_8$ (29 × 22). Photo: Hessische Landes- und Hochschulbibliothek, Darmstadt.

99 Manuscript; Marriage at Cana. Hitda Gospel book. Cologne (978–1042). Hessische Landes- und Hochschulbibliothek, Darmstadt. (Hs. 1640, fol. 169.) $11^3/_8 \times 8^5/_8$ (29 × 22). Photo: Bildarchiv Foto Marburg.

100 Manuscript; Canon Hillinus offering the codex to St Peter. Hillinus Codex. Produced by two monks, Purchardus and Chuonradus, working in the Reichenau

or Court style at Cologne and intended for the altar of St Peter in Cologne Cathedral. Early eleventh century. Cathedral Treasury, Cologne. (Cod. 12, fol. 16v.) Photo: Thames and Hudson Archive.

101 Manuscript; Christ asleep during the storm on the Sea of Galilee. Hitda Gospel book. Cologne (978–1042). (Hs. 1640, fol. 117.) $11^3/_8 \times 5^5/_8$ (29 × 22). Photo: Hessische Landes- und Hochschulbibliothek, Darmstadt.

102 Manuscript; Empress Gisela visiting Echternach. Book of Pericopes. Echternach, between 1039 and 1043. (Hs. b. 21, fol. 3.) $5^3/_4 \times 7^1/_4$ (14.5 × 18.5). Photo: Staatsbibliothek, Bremen.

103 Manuscript; King Henry II and Queen Agnes offering the codex to the Virgin. *Codex Aureus* of Speyer. Echternach, between 1045 and 1046. (Cod. Vitrinas 17, fol. 3r.). $19^5/_8 \times 13^{13}/_{16}$ (50 × 35). Photo: Escorial Library, Madrid.

104 Manuscript; Christ in Majesty adored by the Emperor Conrad II and the Empress Gisela. *Codex Aureus* of Speyer. Echternach, between 1045 and 1046. (Cod. Vitrinas 17, fol. 2v.) $19^5/_8 \times 13^{13}/_{16}$ (50 × 35). Photo: Escorial Library, Madrid.

105 Manuscript; Page of decoration based on a textile. *Codex Aureus Epternacensis.* Echternach, about 1040. (Fol. 75v.) Germanisches Museum, Nuremberg. $17^1/_4 \times 12^3/_8$ (31.5 × 44). Photo: Thames and Hudson Archive.

106 Ivory panel; Christ teaching in the Temple. So-called Magdeburg Antependium. Probably North Italian, late tenth or early eleventh century. 12.7 × 11.7 (5 × $4^5/_8$). Photo: Staatsbibliothek, Berlin.

107 Ivory panel; An emperor offering a church to Christ. So-called Magdeburg Antependium formerly in the Abbey of Seitenstetten. $4^5/_{16} \times 3^7/_8$ (11 × 9.9). Photo: Metropolitan Museum of Art, New York.

108 Crown of the Holy Roman Empire. Enamels, pearls and precious stones set in filigree on a gold ground. The arch bears the name of the Emperor Conrad II (1024–1039). Workshop uncertain, late tenth or early eleventh century. Kunsthistorisches Museum, Vienna. Photo: Thames and Hudson Archive.

109 Ivory panel; Christ in Majesty between the Virgin and St Maurice attended by angels and adored by Emperor Otto II, Empress Theophano and the future Otto III. Milan, about 980. Photo: Museo del Castello Sforzesco, Milan.

110 Ivory situla; St Matthew. Given by Archbishop Gotfredus of Milan (974/975–980) to the Basilica of Sant'Ambrogio, Milan, about 980. H. 7 1/4 (18.5), diam. 4 7/8 (12.4). Photo: Cathedral Treasury, Milan.

111 The Basilewsky Situla; ivory bucket carved with scenes of the Passion and Resurrection of Christ and bearing an inscription referring to Otto Augustus. Milan, about 980. H. 6 1/4 (16), diam. 5 (13). Photo: Victoria and Albert Museum, Crown copyright.

112 Basilewsky Situla; detail, Judas receiving the thirty pieces of silver from the High Priest. Milan, about 980. Photo: Victoria and Albert Museum, Crown copyright.

113 Ivory diptych; Scenes of the Passion and Resurrection of Christ. Probably Milan, ninth century. Photo: Cathedral Treasury, Milan.

114 Ivory diptych; Detail, Judas receiving the thirty pieces of silver from the High Priest. Probably Milan, ninth century. Photo: Cathedral Treasury, Milan.

115 The Ciborium of Sant'Ambrogio, Milan Second decade of the eleventh century. Photo: Thames and Hudson Archive

116 Ivory panel; St Matthew. Milan, late tenth century. 7 1/4 4 1/4 (18.5 × 10.7).

Photo: Courtesy Trustees of the British Museum.

117 Ivory relief; Christ in Majesty between the Four Evangelists. Trier, late tenth century. 8 1/4 × 4 7/8 (21 × 12.4). Photo: Staatliche Museen, Berlin.

118 Ivory reliefs; Moses receiving the Tables of the Law, St Thomas and the Risen Christ. Trier, late tenth century. Formerly in the Abbey of Kues. Photo: Staatliche Museen, Berlin.

119 Ivory situla mounted with precious stones on a gold ground. Trier or Aachen, about 1000. H. 7 (17.7), lower diam. 4 5/16 (11). Photo: Cathedral Treasury, Aachen.

120 Ivory panel; Christ on the Cross between Longinus and Stephaton. Enamels, pearls and precious stones on a gold ground. Cover of the Codex Aureus Epternacensis. Trier, 983–991. Germanisches Museum, Nuremberg. 8 × 5 (12.4 × 10.3). Photo: Thames and Hudson Archive.

121 Reliquary of the Foot of St Andrew. Enamels and precious stones set on a gold ground. Trier, 977–993. Cathedral Treasury, Trier. Photo: Bildarchiv Foto Marburg.

122 Ivory relief; Virgin and Child enthroned. Trier or Mainz, late tenth century. 8 5/8 × 3 15/16 (22 × 10). Photo: Altertumsmuseum, Mainz.

123 Ivory relief; Christ in Majesty blessing St Victor and St Gereon. Cologne, about 1000. From the Church of St Gereon. Photo: Schnütgen-Museum, Cologne.

124 Ivory relief; The Vision of Ezekiel, with an inscription referring to Bishop Notker of Liège (972–1008). Liège, late tenth or early eleventh century. 7 1/2 x 4 6/8 (19 x 11). Photo: Curtius Museum, Liège.

125 The Cross of Lothair; The cameo of Augustus, the rock-crystal seal of Lothair II of Lotharingia (855–869), pearls and precious stones set in filigree on a

gold ground. Cologne, about 1000. Photo: Cathedral Treasury, Aachen.

126 The First Cross of Abbess Matilda of Essen (973–1011); Enamels, pearls and precious stones set in filigree on a gold ground. Cologne, 973–982. Photo: Cathedral Treasury, Essen.

127 First Cross of Abbess Matilda of Essen. Detail of Abbess Matilda and her brother, Otto, Duke of Bavaria. Photo: Cathedral Treasury, Essen.

128 The Cross of Lothair; Detail of the cameo of Augustus. Cologne, about 1000. Photo: Thames and Hudson Archive.

129 The Golden Virgin of Essen. Cologne, about 1000. Photo: Cathedral Treasury, Essen.

130 The Cross of Gisela of Hungary. Enamels, pearls and precious stones on a gold ground. Regensburg, 1006. Photo: Residenz Treasury, Munich.

131 The Cross of Gisela of Hungary; Detail. Photo: Residenz Treasury, Munich.

132 Cover; Christ in Majesty between the Symbols of the Evangelists of the Codex of Abbess Uota of Niedermünster. Enamels, pearls and precious stones on a gold ground. Regensburg, early eleventh century. (Clm. 13601.) $15 \times 10^5/_8$ (38.2×27). Photo: Staatsbibliothek, Munich.

133 Gold antependium; Christ adored by the Emperor Henry II and the Empress Kunigunde between the Archangels Michael, Gabriel and Raphael and St Benedict. Mainz or Fulda, about 1019. Formerly in Basle Cathedral. Musée de Cluny, Paris. Photo: Eileen Tweedy.

134 Bronze column cast for Bernward of Hildesheim for the Church of St Michael about 1020. Scenes from the life of Christ. Photo: Cathedral, Hildesheim.

135 Bronze doors cast for Archbishop Bernward of Hildesheim (993–1022) for the Church of St Michael in 1015. Left, Genesis scenes, right, scenes from the life of Christ. Photo: Cathedral, Hildesheim.

136 Bronze doors (detail); Adam and Eve before God after the Fall. Cast for Bernward of Hildesheim for the Church of St Michael in 1015. 23×43 (58.6×1.96). Photo: Bildarchiv Foto Marburg.

137 Bronze column (detail); The parable of the fig-tree. Cast for Archbishop Bernward of Hildesheim for the Church of St Michael about 1020. Photo: Bildarchiv Foto Marburg.

138 Bronze doors (detail); The meeting of Christ and St Mary Magdalene after the Resurrection. Cast for Archbishop Bernward of Hildesheim for the Church of St Michael in 1015. 23×43 (58.6×1.96). Photo: Bildarchiv Foto Marburg.

139 Crucifix in silver. Commissioned by Bernward of Hildesheim about 1007–1008. Photo: Bildarchiv Foto Marburg.

140 Crucifix. Ivory, enamels and precious stones on gold. Trier, 977–993. Photo: St Servatius, Maastricht.

141 Crucifix; wooden with traces of pigmentation. Probably carved for Gero of Cologne (969–976) about 970. 6 ft. 2 in. (1.88). Photo: Cathedral, Cologne.

142 (Detail of 141). Head of Christ.

143 Plan; Limburg an der Haardt.

144 Abbey Church, Limburg an der Haardt; interior view. Photo: Helga Glassner-Schmidt.

145 Plan; Cathedral, Trier, rebuilt in the early eleventh century, completed 1070.

146 Cathedral, Trier; west front. Photo: Helga Glassner-Schmidt.

147 Cathedral, Speyer; crypt. 1030–1040. Photo: Helga Glassner-Schmidt.

148 Second Cathedral building, Speyer; east end. 1092–1106 and later. Photo: Helga Glassner-Schmidt.

149 Plan; Cathedral, Speyer. Shaded area indicates First, Second and Third building campaigns. 1092–1106 and later.

150 Plan; Saint-Etienne, Caen. 1064–1087.

151 Saint-Etienne, Caen; interior view. 1064–1087. Photo: Archives Photographiques.

152 Plan; Durham Cathedral. 1093–1133.

153 Cathedral, Durham; interior view. Photo: Edwin Smith.

154 Plan; third Abbey Church of Cluny. 1088–1130.

155 Plan; Church of Santiago de Compostela. 1078–1124.

156 Church of Santiago de Compostela; interior view. Photo: Mas, Barcelona.

157 Cathedral, Baptistry and Tower, Pisa; exterior view. Founded 1063, consecrated in 1118, but not completed until the fourteenth century. Photo: Mansell Collection.

158 Plan; Cathedral, Pisa. Founded in 1063, consecrated in 1118 but not completed until the fourteenth century.

159 Limestone relief; Seated nuns from an altar or altar screen, probably carved about the time of Abbot Adalwig (1066–1081). Crypt of the Abbey Church, Werden. Photo: Bildarchiv Foto Marburg.

160 Stone relief; Christ. From a representation of the Last Judgment on the west front of Abbot Adalbert's church at Bremen. About 1050. Photo: Rheinisches Landesmuseum, Trier.

161 Gregorian modes; Limestone capitals from the third Abbey Church of Cluny carved about 1088–1095. Photo: Musée Ochier, Cluny.

162 Limestone relief; Female saint. East tower of the Church of St Maurice built by Bishop Friedrich von Meissen (1063–1084). Landesmuseum, Münster. Photo: Bildarchiv Foto Marburg.

163 Manuscript; St Pantaleon. Gospel book of St Pantaleon. Cologne, mid-twelfth century. (Harley Ms. 2889, fol. 66 v.) Photo: Courtesy Trustees of the British Museum.

164 Bronze tomb cover; Rudolph, King of Swabia (d. 1080). Merseberg Cathedral. Photo: Bildarchiv Foto Marburg.

165 Bronze; Christ on the Cross. Formerly in the Abbey of Helmstedt at Werden. Cast about 1070. Abbey Church. Werden. Photo: Bildarchiv Foto Marburg.

166 Portable altar of St Kilian and St Liborius; Five Apostles. Commissioned from Roger of Helmarshausen by Bishop Heinrich von Werl (1085–1127) for Paderborn Cathedral about 1100. Cathedral Treasury, Paderborn. Photo: Bildarchiv Foto Marburg.

167 Stavelot Triptych; Scenes from the life of Constantine the Great. Attributed to Godefroi de Claire on commission by Abbot Wibald of Stavelot (1130–1158) after 1154. Champlevé enamel on gilt copper. Formerly in the Abbey of Stavelot. Photo: Pierpont Morgan Library, New York.

168 Alton Towers Triptych; In the centre, the Crucifixion, the Holy Women at the Sepulchre and the Harrowing of Hell; on the wings, Old Testament types of the Redemption: Jonah and the Whale, the Sacrifice of Isaac, Leviathan caught with a hook, a dead man raised by the body of Elisha, Moses and the brazen serpent, and Sampson carrying off the gates of Gaza. Champlevé enamel on gilt copper, borders stamped and engraved. Mosan, about 1150 14¼ × 18¼ (36.5 × 46.5). Photo: Victoria and Albert Museum, Crown copyright.

169 Brass font; Baptism of Christ. Executed by Rainier of Huy on commission from

Abbot Hellinus (1107–1118) for the Church of Notre-Dame-des-Fonts. Photo: Saint-Barthélemy, Liège.

170 Brass font; Detail of two male figures. Executed by Rainier of Huy on commission from Abbot Hellinus (1107–1118) for the Church of Notre-Dame-des-Fonts. Photo: Saint-Barthélemy, Liège.

171 Manuscript; Christ, St Denis and his companions. Missal of Saint-Denis. Saint-Denis, mid-eleventh century (Lat. 9436, fol. 106 v.). Photo: Bibliothèque Nationale, Paris.

172 Manuscript; Christ on the Cross between the Virgin and St John the Evangelist, the Symbols of the Evangelists and personifications of the Sun and Moon. Psalter from Saint-Germain-des-Prés, mid-eleventh century. (Lat. 11550, fol. 6). Photo: Bibliothèque Nationale, Paris.

173 Fresco; Angels. Saint-Savin, about 1100. Photo: Thames and Hudson Archive.

174 Fresco; Christ in Majesty. Berzé-la-Ville, late eleventh or early twelfth century. Photo: Thames and Hudson Archive.

175 Manuscript; Death of St Aubin. Life of St Aubin. Angers, second half of the eleventh century. Photo: Bibliothèque Nationale, Paris.

176 Manuscript; The Ascension. Sacramentary of the Cathedral of Saint-Etienne, Limoges. Limoges, about 1100. (Lat. 9438, fol. 84 v.) Photo: Bibliothèque Nationale, Paris.

177 Manuscript; David playing the harp among musicians. Psalter. Probably Polirone, about 1125. (Com. Ms. C. III 20, fol. 1 v.) Photo: Biblioteca Comunale, Mantua.

178 Drawing; Christ enthroned between saints with three patrons (?). 1104 (Cod. 3. 210, fol. 1 v.). Biblioteca Piana, Cesena.

179 Marble relief; Slaying of Cain. Executed by Wiligelmo (1099–1106). Modena Cathedral. Photo: Thames and Hudson Archive.

180 Marble relief; Jeremiah. Executed by Niccolò, 1135–1141. West doorway, Ferrara Cathedral. Photo: Courtauld Institute of Art, London.

181 Historiated initial; St Gregory. *Moralia in Job*. Executed by an English artist at Cîteaux before 1111. (Ms. 168, fol. 4 v.) 13 $\frac{3}{4}$ × 9 $\frac{1}{4}$ (35 × 23.5). Photo: Bibliothèque de la Ville, Dijon.

182 Manuscript; St John the Evangelist. Gospel of Liessies. Illustrated by the English artist responsible for the Lambeth Bible. About 1146. Société archéologique, Avesnes. Photo: Thames and Hudson Archive.

183 Illuminated initial; The Word of the Lord given to the Prophet. Book of Isaiah Winchester Cathedral Bible by the Master of the Gothic Majesty. Late twelfth century. Photo: Courtesy, Dean and Chapter of Winchester Cathedral.

184 Manuscript; St Edmund crowned by angels. Life of St Edmund illustrated in the style of the Alexis Master. Bury St Edmunds, about 1130–1133. (Ms. 736, fol. 42.) Photo: Pierpont Morgan Library, New York.

185 Illuminated initial; The Calling of Jeremiah. Winchester Bible. Executed by the Master of the Leaping Figures. 1140–1160. Winchester Cathedral Bible, Jeremiah I, 4–10. 22 $\frac{13}{16}$ × 15 $\frac{1}{2}$ (58.2 × 39.5). Photo: Courtesy Dean and Chapter Winchester Cathedral.

186 Manuscript; Moses expounding the law of the unclean beasts. Bury Bible executed by Master Hugo. Bury St Edmunds, between 1130 and 1140 (Ms. 2, fol. 94 r.). 20 $\frac{3}{5}$ × 14 (51 × 35.7). Photo: Courtesy Corpus Christi College, Cambridge.

187 Candlestick; Given by Abbot Peter (1104–1113) to the monastery of St Peter

at Gloucester. 1 ft. 11 in. (58.5). Photo: Victoria and Albert Museum, Crown copyright.

188 Stone statue; Virgin and Child. English, mid-twelfth century. York Minster crypt. Photo: Edwin Smith.

189 Plaque; The Last Judgment. Champlevé enamel on gilt copper. Winchester, 1150–1160. Victoria and Albert Museum, London. $5\,^1/_2 \times 3\,^1/_2$ (14 × 9). Photo: John Webb.

190 Plaque; St Paul disputing with the Greeks and the Jews. Champlevé enamel on gilt copper. Winchester, about 1160. Victoria and Albert Museum, London. $5 \times 3\,^1/_2$ (12.7 × 9). Photo: John Webb,

191 Limestone carving; Six Apostles and an Angel. South porch. Malmesbury Abbey, Wilts. 1170–1175. Photo: Edwin Smith.

192 Marble relief; Christ in Majesty. 1094–1096. Now in the ambulatory of the choir. Saint-Sernin, Toulouse. Photo: Thames and Hudson Archive.

193 Tympanum; The Ascension. Miègeville Door carved in the first or second decade of the twelfth century. Saint-Sernin, Toulouse. Photo: Archives Photographiques.

194 Base of the statue of St James from the Miègeville Door carved in the first or second decade of the twelfth century. Saint-Sernin, Toulouse. Photo: Archives Photographiques.

195 Tympanum; The Last Judgment. Doorway of the south porch of the Abbey Church of Saint-Pierre, Moissac. Executed about 1115. Photo: Thames and Hudson Archive.

196 Manuscript; The Host of God. Apocalypse, Chapter XIX, 11–16. Beato's Commentary on the Apocalypse, executed about 1086. (fol. 73). Photo: Cathedral, Burgo de Osma, Spain.

197 Ivory; Christ on the Cross. Carved for King Ferdinand I of León and Castile, about 1063. Photo: Museo Arqueológico, Madrid.

198 Stone trumeau figure; Jeremiah. Support for the tympanum of the doorway of the Abbey Church of Saint Pierre, Moissac. Early twelfth century. Photo: Archives Photographiques.

199 Stone abutment; Isaiah. Originally an abutment of the doorway, now inside the church at Souillac. About 1120. Photo: Archives Photographiques.

200 Stone figure; St Thomas. Executed for the Chapter-house of Saint-Etienne at Toulouse and signed by Gilabertus. About 1120–1130. Photo: Réunion des Musées Nationaux, Versailles.

201 Tympanum; Christ in Majesty. West doorway of the third Abbey Church of Cluny. After an 18-century engraving. Photo: Archives Photographiques.

202 Tympanum; The Last Judgment. West doorway, Cathedral of Saint-Lazare, Autun. Carved by Gilabertus before 1135. Photo: Thames and Hudson Archive.

203 Tympanum; The Ascension and the Mission to the Apostles. Inner west doorway of the Abbey Church of Sainte-Madeleine, Vézelay. About 1125–1135. Photo: Thames and Hudson Archive.

204 Tympanum; Christ in a mandorla supported by two angels and the symbols of the Evangelists. Below, the Virgin, two angels and the Apostles. Church of Saint-Fortunat, Charlieu. Middle of the twelfth century. Photo: Thames and Hudson Archive.

205 Tympanum; Christ in Majesty and, below, the Last Supper. Saint-Julien-de-Jonzy. Late twelfth century. Photo: Archives Photographiques.

206 Stone capital; Samson and the Lion. Church of Saint-André-le-Bas. Vienne. About 1152. Photo: Archives Photographiques.

Selected Bibliography

General Works

BOASE, T. S. R. *English Art 1100–1216*, Oxford, 1953.
A Baedeker-like survey

BUCHEWIECKI, W., and MRAZEK, W. *Romanische Kunst in Österreich*, Vienna, 1962

EVANS, J. *Art in Medieval France*, Oxford, 1948

GRODECKI, L. *Au Seuil de l'Art Roman, L'Architecture ottonienne*, Paris, 1958.
An excellent study

HINKS, R. *Carolingian Art*, London, 1935

HUBERT, J. *L'Art préroman*, Paris, 1938

JANTZEN, H. *Ottonische Kunst*, Munich, 1947.
Good introduction

MÂLE, E. *L'art religieux du XII^e siècle en France*, Paris, 1928

SOUTHERN, R. W. *The Making of the Middle Ages*, London, 1959.
One of the best introductions to the period

SCHRAMM, P. E. *Die deutschen Kaiser und Könige in Bildern ihrer Zeit*, Leipzig and Berlin, 1928.
– and MATHERICH, F. *Denkmäler der deutschen Kaiser*, Munich, 1963.
An indispensable survey and catalogue

SWARZENSKI, H. *Monuments of Romanesque Art*, London, 1954.
An indispensable pictorial survey

WALLACE-HADRILL, J. *The Long-haired Kings*, London, 1962.
A sound study of Merovingian kingship

WEISBACH, W. *Religiöse Reform und Mittelalterliche Kunst*, Zurich, 1945

Architecture

BANDMANN, G. *Mittelalterliche Architektur als Bedeutungsträger*, Berlin, 1951.
Stimulating

CONANT, K. J. *Carolingian and Romanesque Architecture 800–1200*, London, 1959.
Visionary but on the whole sound

LASTEYRIE, DUSAILLANT, R. C. DE, Count. *L'architecture religieuse en France à l'époque romane*, Paris, 1912

FISHER, E. A. *The Greater Anglo-Saxon Churches*, London, 1962

GALL, E. *Karolingische und ottonische Kirchen*, Burg bei Magdeburg, 1930.
An excellent little book

LEHMANN, E. *Der frühe deutsche Kirchenbau*, Berlin, 1938.
Still one of the best studies of early medieval architecture

VERZONE, P. *L'architettura dell'alto medioevo nell'Italia settentrionale*, Milan, 1942

Ivories

GOLDSCHMIDT, A. *Die Elfenbeinskulpturen aus der Zeit der karolingischen und sächsischen Kaiser*, Berlin, 1914.
Basic and indispensable

VOLBACH, W. F. *Elfenbeinskulpturen der Spätantike und des frühen Mittelalters*, Mainz, 1952.

Metal Work

BRAUN, J. *Meisterwerke der deutschen Goldschmiedekunst der vorgotischen Zeit*, Munich, 1922

CHAMOT, M. *Medieval English Enamels*, London, 1930

GOLDSCHMIDT, A. *Die deutschen Bronzetüren des frühen Mittelalters*, Marburg, 1926.
A basic study

TWINING, Lord. *A History of the Crown Jewels of Europe*, London, 1960.
Good general survey

VON FALKE, O., and FRAUBERGER, H. *Deutsche Schmelzarbeiten des Mittelalters*, Frankfurt am Main, 1904.
Still useful

Painting and Illumination

ANTHONY, E. W. *Romanesque Frescoes*, Princeton, 1951

BIBLIOTHÈQUE NATIONALE, PARIS, *Les Manuscrits à Peintures en France du VII^e au XII^e siècles*, Paris, 1954.
An excellent small catalogue

GOLDSCHMIDT, A. *German Illumination*, New York and Paris (1928)

GRABAR, A., and NORDENFALK, C. *Early Medieval Painting*, London, 1957.
Stimulating introduction
– *Romanesque Painting*, London, 1958.
Stimulating introduction

KOEHLER, W. *Die karolingischen Miniaturen*, Berlin, 1930–3.
Basic and indispensable

MILLAR, E. G. *English Illuminated Mss from the Tenth to the Thirteenth Centuries*, Paris, 1926.
A good survey

PORCHER, J. *L'Enluminure française*, Paris, 1959.
An excellent introduction

RICKETT, M. *Painting in Britain: the Middle Ages*, London, 1954.
A good survey

SWARZENSKI, H. *Early Medieval Illumination*, London, 1951.
Stimulating

Sculpture

BEENKEN, H. *Romanische Skulptur in Deutschland (11. und 12. Jahrhundert)*, Leipzig, 1924.
Useful

DESCHAMPS, P. *French Romanesque Sculpture*, Florence, 1930

FOCILLON, H. *L'Art des sculpteurs romans*, Paris, 1931.
A brilliant approach

GAILLARD, G. *Les débuts de la sculpture romane espagnole*, Paris, 1938
– *La Sculpture romane espagnole*, Paris, 1946.
A careful study

HASELOFF, A. *Preromanesque Sculpture in Italy*, Florence, 1930

JULLIAN, R. *L'éveil de la sculpture italienne, La sculpture romane dans l'Italie du Nord*, Paris, 1945

PORTER, A. K. *Spanish Romanesque Sculpture*, Paris, 1928

SAXL, F. *English Sculptures of the Twelfth Century*, London, 1954.
Stimulating

ZARNECKI, G. *English Romanesque Sculpture, 1066–1140*, London, 1951.
Excellent, brief study
– *Later English Romanesque Sculpture 1140 to 1210*, London, 1953.
Excellent, brief study

Index

Numbers in italics refer to illustrations